Plunder and Survival

Plunder and Survival

Stories of Theft, Loss, Recovery, and Migration of Nazi-Uprooted Art

Suzanne Loebl with Abigail Wilentz

BLOOMSBURY ACADEMIC
NEW YORK • LONDON • OXFORD • NEW DELHI • SYDNEY

BLOOMSBURY ACADEMIC
Bloomsbury Publishing Inc, 1359 Broadway, New York, NY 10018, USA
Bloomsbury Publishing Plc, 50 Bedford Square, London, WC1B 3DP, UK
Bloomsbury Publishing Ireland, 29 Earlsfort Terrace, Dublin 2, D02 AY28, Ireland

BLOOMSBURY, BLOOMSBURY ACADEMIC and the Diana logo are trademarks of Bloomsbury Publishing Plc

First published in the United States of America 2025

Copyright © Suzanne Loebl and Abigail Wilentz, 2025

For legal purposes the Acknowledgments on p. ix constitute an extension of this copyright page

Cover design by Jen Huppert
Cover image © Archives du ministère des Affaires étrangères (Quai d'Orsay, Paris, France) – Catalogue Artcurial 2017

All rights reserved. No part of this publication may be: i) reproduced or transmitted in any form, electronic or mechanical, including photocopying, recording or by means of any information storage or retrieval system without prior permission in writing from the publishers; or ii) used or reproduced in any way for the training, development or operation of artificial intelligence (AI) technologies, including generative AI technologies. The rights holders expressly reserve this publication from the text and data mining exception as per Article 4(3) of the Digital Single Market Directive (EU) 2019/790.

Bloomsbury Publishing Inc does not have any control over, or responsibility for, any third-party websites referred to or in this book. All internet addresses given in this book were correct at the time of going to press. The author and publisher regret any inconvenience caused if addresses have changed or sites have ceased to exist, but can accept no responsibility for any such changes.

A catalog record for this book is available from the Library of Congress.

ISBN: HB: 978-1-5381-9422-5
ePDF: 979-8-8818-5752-3
eBook: 978-1-5381-9423-2

Typeset by Deanta Global Publishing Services, Chennai, India
Printed and bound in the United States of America

For product safety related questions contact productsafety@bloomsbury.com.

To find out more about our authors and books visit www.bloomsbury.com and sign up for our newsletters.

To Walter Gerstmann,
and to David Loebl, always.

Contents

Acknowledgments ix
Preface xiii

1 Growing Up with Art in Pre–World War II Germany 1
2 German Expressionist Art Finds Its Champions 19
3 The Nazis Cleanse Their Museums 39
4 Hitler's Sales Force 57
5 The Lucerne Auction and Other Sales 71
6 Austria: Ripe for Plunder 85
7 Émigré Art Dealers and Their Artists 103
8 Artists in Exile: Adieu, Europe, Hello, America 117
9 Two-Faced France 135
10 Holland: A Good Country Confronts Evil 161

Appendix A: A Treasury of Looted and Migrant Works in US Museums 183
Appendix B: Selected Cast of Characters 189
Notes 193
About the Authors 215
Index 217

Acknowledgments

Writing *Plunder and Survival* was a labor of love and a tremendous challenge. The book would not exist were it not for the many writers, researchers, and scholars who have devoted themselves to the study of art history long before the fate of this particular body of artwork became my all-consuming interest. During the eight years it took me to write this book, the topic has continued to evolve, and the public's attitude toward "looted," migrant, and recovered art has changed.

From the beginning, the task of writing a meaningful book on this subject appealed to both my intellectual and emotional selves. The slice of history covered by *Plunder and Survival* shaped my life. I was the Jewish child growing up in Nazi Germany; the hidden teen in German-occupied Belgium; the refugee failing to obtain a visa to escape continental Europe before it was too late; the fortunate European Jew to have survived the Holocaust; and the immigrant determined to live a productive American life.

After all of that tumult, I became a writer. In this book, I revisit a period I lived through but in the role of a historian, examining Hitler's notoriously vicious war on art. *Plunder and Survival* is a carefully researched work that presents new developments in the evolving study of Nazi-looted art. It primarily focuses on the story of the artworks that, like me, survived. My unique qualification for writing this book is my position as both a history student and an eyewitness.

The book is also a tribute to my family, especially my mother, who handed me a magic wand when I was young by opening my eyes and ears to art. From early on, I was delighted by beautiful things, especially the visual art that played an outsized role in my family. During the Holocaust, my mom managed to save her paintings as she did her daughters. It is because of her artistic sensibility that I have always viewed beloved artworks as if they were living creatures. Art has remained important throughout my life, and I have considered it a unifying factor between strangers regardless of nationality.

I want to thank the many authors who have written about the art catastrophe that befell Europe during the Nazi era and related topics. These include Hubertus Czernin, Robert M. Edsel, Hector Feliciano, Catherine Hickley, Pieter den Hollander, Lynn H. Nicholas, Johnathan Petropoulos, Cynthia Salzman, Peter Selz, William L. Shirer, Elizabeth Simpson, and many others.

I am grateful to the journalists who have followed the development of this rapidly changing field. Let me also thank the Central Registry of Information on Looted Cultural Property

1933–1945 for its archival information and its Looted Art newsletter for breaking so many important stories.

Many thanks are due to the research libraries that helped me assemble the stories packed into *Plunder and Survival*. The Frick Art Reference Library is New York's best-kept secret. It owns almost every well-known and obscure art book published; its staff is helpful and knowledgeable, and its reading room is a delight. Across the street on New York City's Museum Mile, the Met's Thomas J. Watson Library often provided what the Frick lacked and vice versa. MoMA's Library and Archives proved essential to gathering information on those who shaped this era of art history: Alfred Barr, Curt Valentin, Paul Rosenberg, and others. I thank the Morgan Library and Museum for letting me examine Jean Matisse's archive. The New York Public Library was indispensable, as was the Avery Architectural and Fine Arts Library of Columbia University and the Southwest Harbor Public Library in Maine.

An art book needs illustrations. In our legally and technologically obsessed world, this is more complicated than it was in 1970, when I asked MoMA to send me a copy of Vincent van Gogh's *Bedroom in Arles* and the image promptly arrived in the mail.

Nevertheless, I gratefully acknowledge the "landing" on my computer of twenty-three high-density illustrations for this book. Most of the originals belong to America's art museums. An increasing number of these have adopted "open access" policies, in which they share their collections virtually. I thank the Allen Memorial Art Museum at Oberlin, the Museum of Fine Arts in Boston, the Art Institute of Chicago, the Cleveland Museum of Art, the Harvard Art Museums, the New York Metropolitan Museum of Art, and the National Gallery of Art for helping to illustrate this book. Diana Edkins of Art Resource and others helped me to complete the selection. I also owe thanks to Dr. Frank Mecklenburg of the Leo Baeck Institute for help with the "Simplicissimus" cartoon.

During World War II, staff at America's art museums urged President Franklin D. Roosevelt to form a tiny army unit named the Monuments Men. The unit was charged with protecting Europe's art sites and resources. This group played an enormous role in recovering art, a few examples of which migrated to US institutions headed by former members of the unit. I thank the Monuments Men and Women Foundation for helping me identify American museums that owned Nazi-era looted art.

One of the most pleasant aspects of my research was to personally or remotely visit many of the artworks celebrated in *Plunder and Survival*. On my actual or virtual visits, I interacted with the art world's newest professionals: the provenance curators, who specialize in an artwork's past. I fondly remember Victoria Reed's tour at the Museum of Fine Arts in Boston. She steered me to more looted works than I could use and supplied interesting information. I thank her.

Scores of people helped me complete this book. Special thanks go to my coauthor, Abigail Wilentz, who not only dug up additional details about the numerous individuals and artworks that appear in the book but also checked its accuracy, edited it, and put up with my typos.

She created the extensive endnotes, as well. I am grateful to my agent, Regina Ryan, who sold the book to Rowman & Littlefield, and to Charles Harmon for buying it. Many thanks are also due to editorial assistant Natalie Plahuta, who shepherded it through production at Bloomsbury Publishing.

I am very grateful to John Gordon, my son-in-law, who came to my rescue, masterminding the illustrations and the appendix with its clever links, checking on endless details, and guiding the art through its electronic submission process. Granddaughter Naomi Gordon-Loebl, by now a writer in her own right, did extensive editing.

I want to thank David Rubinstein, former professor of history, Adelphi University, New York, for being my art expert and for reading the manuscript several times. Other early readers included Joseph Ahern, Rochelle Field, Judge Edward R. Korman of the Eastern District of New York, Lois Lowenstein, and Harriet Mayer. I thank Wesley A. Fisher, research director of the Claims Conference, for reviewing early chapters and advising me on statistics, and Melissa Solomon, who supported me editorially and prevented me from chucking the project. Thanks are due to Elisabeth Gareis for putting me in touch with Sue Lupton, the source of the story of the miraculously recovered Lyonel Feininger; my friend Walter Gerstmann for getting used to calming a stressed author; Wendy Millette for keeping my home livable; and Viva, my poodle, for instinctively knowing when to provide a lick.

Last, I want to thank other family members—Ernest, Judy, Ana, and Sean—for their emotional and technical support. They all contributed their computer savvy and became used to my cries for help with lost files, malfunctioning keyboards, near-crashes, and other miseries. My daughter Judy, in addition, made "life outside the book" as easy as she could in every way she knew how.

My helpmates and I have done our best to accurately report this incredibly complex story. I alone am responsible for the book's imperfections and errors. Now, *Plunder and Survival* faces its readership. I hope you will forgive me for my lapses, mourn what was lost, and pay tribute to the art that escaped its destruction in so many different ways.

Preface

In *Plunder and Survival*, I tell the stories of artworks uprooted during the Nazi era. I focus on just a sample of the vast multitude of items displaced, as the Nazis looted as many as 650,000 pieces of art. This figure includes works confiscated from museums and homes, as well as those that accompanied refugees, dealers, and artists who escaped Germany and its occupied territories. I feature many individuals associated with this mass of art: the artists who created it, the dealers who sold it, the collectors who bought it, the museums that exhibited it, and the villains who burned, destroyed, stole, and sold it.

To set the scene, I briefly examine Hitler's assault on modern art—the looting and "cleansing" of art institutions and targeted collections throughout Europe to outlaw and destroy what Nazi philosophy called "degenerate art." The term referred to works that featured unnatural colors, appeared "unfinished," or exhibited other elements of modernism. Much of the art the Nazis looted falls under the umbrella of German Expressionism and its related styles.

In 1937 the Nazis held up Expressionism to disgrace and ridicule at the famous *Degenerate Art* Exhibition in Munich. The show featured about 650 works by E. L. Kirchner, Franz Marc, Otto Dix, Georg Grosz, Marc Chagall, Max Beckmann, and many more. Like many new art movements, the German Expressionists were initially rejected, but by the 1920s, they were gaining recognition in the art world.

During the Nazi era, two factions labored for and against the cause of modern art. On the one hand, the Fascists hoped to destroy Expressionist works or profit from their sale outside Germany; on the other hand, champions of modern art secretly or sometimes inadvertently saved these artworks from harm. *Plunder and Survival* tells the story of both groups. Examining the journeys of artworks and the various ways they survived, these tales reveal the turmoil and uncertainty that governed the art world during these dark years. (Throughout the book, I refer to this displaced art as "migrant.")

The Nazis' efforts at eradicating "degenerate art" included robbing Jews of their art collections. Art flooded the European market, and auction houses did enormous business. Traditional art became very inexpensive since its owners often sold it under pressure to save their lives. But whereas most of society understood the value of the traditional art that had been looted from Jews, the Nazis also looked at modern art as a quick source of valuable foreign currency.

The Nazi assault on art required an enormous staff. Hitler appointed a dedicated sales force of four leading art dealers—Karl Buchholz, Hildebrand Gurlitt, Ferdinand Möller, and Bernard Böhmer—to handle the art confiscated from museums. This book is the first to discuss the scope of the entire group's activities despite the attention paid to Gurlitt, its best-known member.

Plunder and Survival describes the odysseys of many looted and migrant artworks. During their relocation, some accompanied influential members of the European art world. Artists like Max Beckmann, Georg Grosz, Hans Hoffmann, and the faculty of the Bauhaus, for instance, found teaching positions and critical success in the United States. Art professionals like Justus Bier and Georg Swarzenski assumed museum curator positions and directorships, and art dealers such as Justin Thannhauser, Otto Kallir, Curt Valentin, Klaus Perls, and Serge Sabarsky imported great art treasures from Europe and endowed many American museums with gifts of essential paintings. This mass migration of people and art contributed to the shift of the art world's center to America, where it has remained ever since.

The initial wave of Nazi-era migrant art arrived in America before the start of World War II. After the German surrender, a second wave of migrant art—found by the Monuments Men—came to America and was returned to those who had fled Europe during the war. The pace of restitution slowed for another half century, but by the 1990s, the return of looted art to its rightful owners came to the fore. In 1998, the Washington Conference on Holocaust-Era Assets developed the Washington Principles on Nazi-Confiscated Art, which forty-four countries adopted. These resolutions transformed the public attitude toward the return of plundered property, and many restitution cases that had lingered for years were finally resolved. Even today, many unresolved cases and purloined and lost works continue to come to light.

In *Plunder and Survival,* I review a wide variety of cases, from long restitution processes for the heirs of Dutch dealer Jacques Goudstikker and Italian collector Federico Gentili di Giuseppe, who spent decades rebuilding their families' lost collections, to recent restitutions of major Expressionist works to the grandnephew of Alfred Flechtheim, the quintessential German-Jewish art dealer. Many of these stories are so dramatic and suspenseful that they could stand alone. Together, however, they underscore the enormity of the Nazi crime against art and its champions. An appendix lists a sizable selection of these artworks now owned by American art museums. Today's technology allows readers to easily view these works online. Readers of the e-book can do so directly by clicking the provided links.

Plunder and Survival also contains a personal element. The book includes a number of my own pertinent recollections: as a Jewish child in Germany, a hidden teen in Belgium during the Holocaust, and an immigrant to the United States, I personally experienced or witnessed many happenings of the Nazi era.

I hope you will enjoy this book despite its tragic foundation. It is a testament to humanity's immense creativity, love of beauty, and resourcefulness, without which Adam and Eve would not have survived their exodus from Paradise.

1

Growing Up with Art in Pre–World War II Germany

Art—original paintings, reproductions, prints, photographs of churches and cathedrals—lined the walls of our house in Hanover. My father's collection of apothecary jars crowded the tops of our glass-fronted bookcases in our living room; art books covered the surface of the coffee table. Within this colorful environment, I loved to curl up in one of the room's black velvet-upholstered fauteuils. In our home, art was simply part of everyday life.

Then everything changed. We switched countries and continents. I learned French, then English, a trade. I bonded to the museums of my third hometown: New York, an art-lover's dream. I was homesick for Belgium and was particularly happy that New York's museums contained both great European art of the past as well as contemporary works. I became very interested in the provenance of these paintings. Many had arrived decades ago, but some, like me, were recent immigrants.

Increasingly the art world questioned their origins, too. Around 2000, museum directors and art experts grew concerned over certain artworks' shaky provenance and listened to the clamor of "rightful heirs," who had failed to retrieve their lost treasures for decades. The press and the public joined their efforts, and a renewed interest grew in looted and migrant art.

As a writer specializing in art, I began reflecting on the background of "favorite" paintings in major museums—the Metropolitan, the Museum of Modern Art, the Guggenheim, Boston's Museum of Fine Arts, the Art Institute of Chicago, and many more. This curiosity turned into years of exciting research investigating such artworks chiefly in American museums, which resulted in this book. Given my eyewitness view as a child, this account includes personal experiences and insights from growing up surrounded by my mother's modest collection.

Other catalysts led me to write this book. During a 1977 trip to Israel, I came across an artwork that illustrated the role of chance in the migration of art. The experience confirmed art's surprising ability to connect one's past and present, in this case, providing a link to my German roots. So let me share this unique tale:

While visiting the Israel Museum in Jerusalem, I wandered into a tiny, reconstructed synagogue or prayer room (Figure 1.1). Its wooden walls and vaulted ceiling were covered with illustrations of flowers, Hebrew inscriptions, a view of Jerusalem, trumpeting lions, and shofars. In 1733, the small Jewish community of Horb had commissioned Eliezer Sussmann, an itinerant synagogue painter, to decorate their sanctuary located on the second floor of a Tudor-style house. The name Horb struck a chord. I dimly remembered reading that some of my ancestors hailed from that small town in the German region of Franconia. Could I have stumbled across the place where my forebears worshipped centuries ago? After my return to New York, I confirmed with records of my family genealogy that, during the eighteenth and nineteenth centuries, three generations of my ancestors had lived in Horb, including my great-grandmother Adelheit Grabfelder (1829–1892), who married my great-grandfather David Bamberger (1811–1890).

The story of the unlikely salvation of the Horb synagogue feels appropriate to a book dealing with rescued art. In 1908, just as workers were about to demolish the old house that sheltered the prayer room, Heinrich Poelmann, a Protestant minister, accidentally discovered it and its imagery. He believed that it was a "cultural jewel, perhaps the only one existing in Germany."[1] Even more poetically, he likened the abandoned shul to a "[m]ourning, plaintive creature

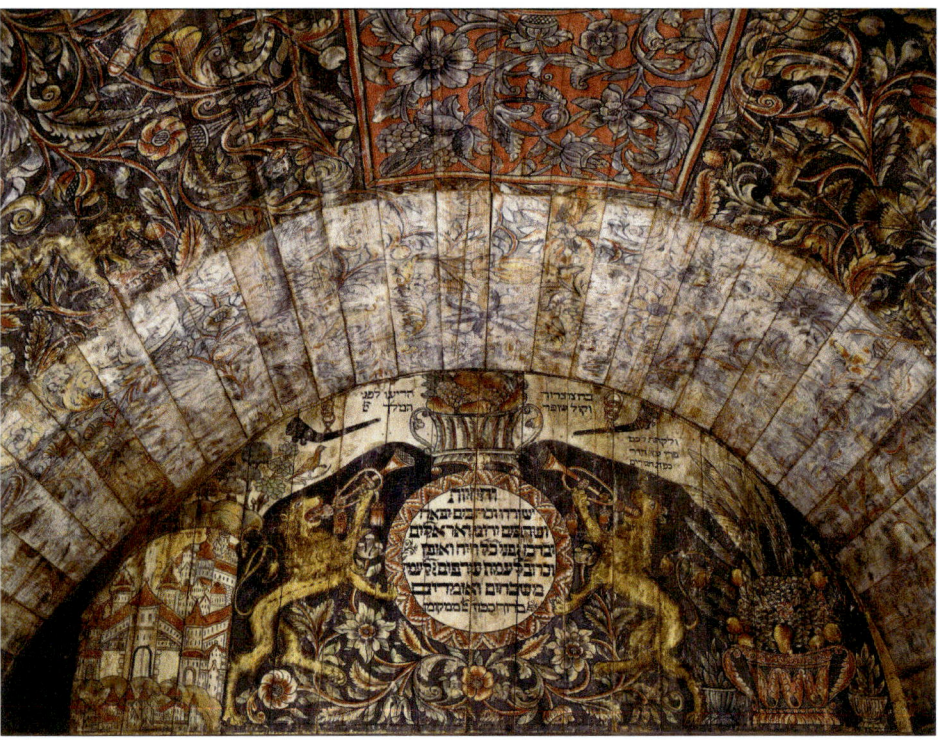

Figure 1.1 *Eliezer Sussmann of Brody, Interior of the Horb Synagogue, Horb am Main, Germany (1735). On permanent loan to the Israel Museum from the Bamberg Municipality since 1968. Credit: Israel Museum (Jerusalem)*

that rapidly plunged toward extinction unless it was saved by warm, feeling, devoted hands." Poelmann persuaded the nearby Historical Museum of Bamberg to detach the painted walls and ceiling of the crumbling structure and put them back together in the museum as a period room. The barreled ceiling of the little synagogue, however, was too tall to fit the available space, so all the painted wood boards went into storage and were forgotten. This was fortunate. If it had been reassembled in a museum, the Horb shul might well have been torched in 1938 as were hundreds of other Jewish sanctuaries in Germany during the pogrom known as *Kristallnacht* (Night of Broken Glass).

The Horb synagogue slept until 1960. Then it was rediscovered and exhibited in Germany. Shortly after, the Israel Museum expressed the desire to display the extraordinary room in Jerusalem and the Germans agreed to a permanent loan arrangement. Workmen packed it into twenty-three crates, and it arrived in Jerusalem in October 1967, a witness to Jewish life in Franconia 250 years earlier.

A Deep German-Jewish History

Both sides of my family had lived in the southern part of Germany for hundreds of years. My great-grandmother Adelheit Grabfelder was born in Horb and married David Bamberger around 1850. My great-grandfather, a merchant, profited from the gradual emancipation of German Jews, as well as from the country's economic boom. By 1870, the state had revoked most antisemitic legislation. Jews could now attend institutions of higher education, teach, and practice medicine and law. The latter two professions were extremely popular, though some Jews selected science, journalism, and art dealerships.

Many Jews, however, continued to be merchants. My own great-grandfather David had begun by trading wicker furniture and baskets in Lichtenfels, a municipality aptly described as Germany's basket town. The business—David Bamberger, Lichtenfels, or DBL, for short—prospered and became one of the region's major employers. By 1900, the firm imported reeds from Africa and participated in Leipzig's trade fair, one of Bavaria's major commercial events. David's sons, my grandfather Philip and his brother Fritz, inherited the ever-growing business. Philip and his wife Serry had four sons. Otto, the eldest, and Ludwig, the youngest, stayed in Lichtenfels and managed the family enterprise. Otto modernized DBL, adding educational toys to its merchandise. Anton, brother number two, became a businessman in Hanover, where Hugo, my father and brother number three, joined him in 1920. Lichtenfels continued to be a beloved family base, where my cousins, my younger sister Gabrielle, and I spent pleasant summers. I loved the vegetable stalls of its open-air market, my aunt's beautiful house, DBL headquarters with its sample room's tantalizing toys, and the spectacular landscape of southern Germany.

I also felt at home in Frankfurt am Main and Nuremberg, the seats of my mother's family. The Mayers were my most elegant ancestors. Isaac Mayer, my great-grandfather, had ascended from peddling geese to owning an upscale game and poultry store in Frankfurt. In time, Isaac partnered with his nephew Gustav Mayer, whose aggressive efforts grew the business into a wholesale poultry empire. As a teen, Gustav was already waking at 5 a.m. to force feed the geese to turn their livers to foie gras. Later he masterminded the import of Hungarian geese and participated in the development of refrigerated railroad cars, which the Kaiser would requisition during World War I. Gustav's ambitious wife Emma did her best to scale the social ladder. To the rest of the family's amusement, she had her staff wear white gloves while serving meals. Allegedly Emma even consulted the German Imperial court on the proper way to eat asparagus. Gustav and Emma also collected fine art.

All this glory ended with the rise of Hitler. Eighty-two-year-old Gustav, his aging wife Emma, and their son Ernst fled to Brussels in 1938. They managed to travel on to England, where they joined their daughters and grandchildren. Much of their personal effects, however, remained in Belgium. So imagine my surprise and delight to read a *New York Times* article in June 2021, which reviewed an exhibit of looted art held at the Jewish Museum, reporting that "[t]he Museum of Fine Art in Brussels returns a still life by Lovis Corinth to the family of Gustav and Emma Mayer, Jewish refugees from Germany whose belongings were looted in Nazi-occupied Belgium."[2]

In 1875, my thirty-eight-year-old great-grandfather Isaac Mayer married twenty-two-year-old Mathilde—his junior by sixteen years. Mathilde was a rabbi's daughter, but her husband insisted that she abandon her orthodox customs. Isaac was very patriotic; he died in 1918 before he knew that his beloved Germany had lost World War I. Mathilde lived another twenty years in a patrician apartment filled with palm trees and grand furniture above the retail store. She remained the center of her thriving family. I remember the diminutive lady, her white hair coiffed in a pompadour. She passed away in 1938, shortly before she would have been carted off to a concentration camp. Her death freed my grandparents, who would never have left her, to escape Hitler's Germany.

Emmanuel Schwarzhaupt, my other maternal great-grandfather, was in the clothing business. He too had started as an itinerant merchant, but in time opened a small department store in Regensburg. He helped his numerous sons open additional stores throughout Bavaria. Two of his sons, my Opa Joseph (my grandfather) and his brother Heinrich, moved to Nuremberg where they opened a multilevel clothing and dry goods store. My sister and I visited Joseph and his wife Emma twice a year in their stylish Biedermeier-furnished apartment. A reproduction of Rembrandt's *Syndics* (advocates) *of the Clothmaker's Guild* hung over the sofa. Unlike the rest of my family, Opa remained a practicing Jew. He prayed daily and kept the Sabbath, and when we visited, blessed the two of us every day.

My mother was born in 1902. Gretel Schwarzhaupt—Joseph and Emma Schwarzhaupt's daughter—was a pretty child with dark brown eyes and blond curls and grew into a beautiful woman. Vivacious, highly creative, and very independent, she was a born storyteller and poet. She had an excellent eye for art and would turn out to be a gifted amateur artist herself.

World War I, which erupted when Gretel was twelve years old, was her defining experience. As it dragged on, food and fuel were in short supply. Gretel was always hungry, cold, and scared. Her three male cousins had volunteered for the army, which remained a bastion of antisemitism. Two of them were among Germany's many dead. Twenty years later, the Nazis would claim the Jews had shirked military service.

Gretel's formal education ended at sixteen. She would have liked to continue her studies, but at the time only very determined girls managed to obtain their parents' permission to do so. She did not and therefore studied art on her own. She also learned to bind books using her own handmade paper, volunteered at a well-baby clinic, and tutored Bettie, a needy, bedridden child. My mother would always regret that she did not have a profession or career; indeed, her loss fueled my determination to have one. In 1924 she married Hugo Bamberger, her senior by fifteen years.

My father had studied chemistry at German and Swiss universities. He had hoped for an academic career, but World War I intervened. My father served four years in the Kaiser's army, then became the manager and, eventually, the owner of a small chemical factory in Hanover. During his four-year sojourn as a bachelor after the war, he had assembled a pleasant circle of mostly Jewish friends who were kind, worldly, and economically comfortable. They welcomed my charming mother with open arms. None of my parents' friends were practicing Jews, and as a child, I lacked a basic knowledge of the most rudimentary practices of my creed.

When my parents moved to their first apartment in Hanover, they purchased heavy, nondescript furniture: a round, extendable mahogany dining table, an enormous buffet which they stuffed with monogrammed silver platters, Rosenthal China, silverware for twenty-four, fruit bowls, and other accoutrements. An Art Deco silver coffee and tea set topped the buffet. When the apartment was ready, Gretel was expected to host dinner parties. Inexperienced in keeping house, she alerted her grandmother Mathilde, and in due time, the Frankfurt poultry store sent festive fare. Fortunately, she had Marie Peilike, my father's faithful housekeeper and cook from his bachelor days, who produced excellent meals, and all was well.

My mother conceived me within months of her wedding. She firmly believed that her activities and state of mind during pregnancy would influence her growing fetus, so she decided to study art history. She registered for a course taught at Hanover's *Technische Hochschule* by Professor Paul Schubring, an authority on the Italian Renaissance. Gretel adored his lectures. Italy, especially Florence, became one of her favorite travel destinations. Until the end of her long life, my mother would use Schubring's pronouncements on Italian art as a form of mantra.

I was surrounded by love. My dad—Vati—considered me the world's most beautiful newborn; my Schwarzhaupt grandparents were ecstatic, but Marie, our cook, was my biggest champion. Because she feared her little darling would be short-changed, she convinced my mother "not to have another child too soon." Marie lived with us until I was about five, and I believe that I owe her my upbeat attitude and good nature. I never repaid her for her devotion and kindness.

In 1929, my parents rented a Victorian townhouse in Kleefeld, a suburb of Hanover. A small rivulet separated our house from the Eilenriede, the town's remaining primordial forest, turned into a city park. Elderly Marie resigned because she felt that "the stairs were too much." Kaulbach Strasse 3, our new address, was named for Wilhelm von Kaulbach, a now mostly forgotten nineteenth-century German painter—Hitler adored his genre scenes. We lived in that old house for a short six years. Yet, of all the abodes I occupied since, it remains the closest to my heart. Sometimes, when I can't sleep at night, I revisit its high-ceilinged rooms, navigate the worn stone steps to the basement kitchen, and climb upstairs to my bedroom, whose four windows face the dark woods across the street. My mind listens to the storms that rattled the glass panes during winter nights or smells the intoxicating perfume of the wisteria blossoms that covered the front of the house in spring. I see again the paintings hanging on the walls, the books neatly arranged in their cabinets, the Oriental rugs, the big cacti, and the scraggly plants that filled the winter garden.

Our years in Kleefeld were my mother's golden age. Our two maids, Anna, the cook, and Detta, the nanny plus chambermaid, adored her. Ruth Daman, her best friend, shared her unconventional, artistic side—a side that welcomed the advent of modern art and deplored Germany's excessive, rigid formality.

One day Gretel and Ruth Daman took a train and visited the studio of Expressionist painter Christian Rohlfs, who lived and worked in the nearby town of Hagen. My mom bought a large watercolor of a young woman she nicknamed "the brat," with whom she personally identified, as the unknown sitter somewhat resembled her younger self. To honor its native son, the town of Hagen founded a Christian Rohlfs Museum in 1929. Just a few years later, the Nazis would declare his art "degenerate" and remove it from German museums.

Ruth's lover was an artist—the painter Karl Dannemann. In 1927, he was commissioned by the port of Bremen to paint a mural memorializing the dinner in its town hall honoring President Paul von Hindenburg, who had been a World War I hero. He created a striking work, titled *Banquet for Hindenburg in the Town Hall*, showing the festive banquet table in the hall, its ceiling festooned with models of ancient boats and intricate chandeliers. Hindenburg, who was president when Hitler became Germany's all-powerful chancellor, sits at the table alongside other dignitaries. Red and yellow tones dominate Dannemann's image, the room's ornate light fixtures illuminating the scene.

Before embarking on the final version of the mural, Dannemann painted three sketches, one of which my mom bought. She was very attached to the work, and when we had to leave

Germany, she brought it with us from Hanover to Brussels, then stored it while we were hiding during the war. Thereafter, the banquet scene moved with us to New York. After my mother's death in 1991, I decided that I simply could not live with a celebratory portrait of Hindenburg. I also could not discard a work my mom had taken such pains to preserve, so I donated it to the Focke Museum in Bremen. The museum was delighted to receive the image because the mural had been destroyed along with the town hall during Allied bombardments. This reverse migration of the rescued work pays homage to a fine artwork and a majestic building.

My mother also shared her interest in modern art with her brother-in-law, Otto Bamberger, head of the family business. Otto's art collection included works by Max Liebermann, Leo Putz, Marc Chagall, Max Beckmann, Paula Modersohn-Becker, Hermann Lismann, and Wilhelm Lehmbruck. Works on paper were a great passion of Otto's. He especially loved Alfred Kubin's mysterious, if often-creepy, drawings and lithographs depicting oversized crabs and other creatures. Kubin became a personal friend of Otto's, frequently visiting him and his wife Jetta in Lichtenfels. Like the families of Ludwig and Rosy Fischer and Alfred and Tekla Hess, who socialized with the artists they collected (see chapter 2), my uncle hosted many of his favorite artists in his Lichtenfels villa.

Uncle Otto was also fascinated by the work of the Bauhaus. German architect Walter Gropius had founded the influential design school in 1919, which promoted the integration of fine and graphic arts. Its faculty included Marcel Breuer, Mies van der Rohe, Paul Klee, Vasily Kandinsky, and others, whose groundbreaking design would shape the art and architecture of the twentieth century. The school was a bête noire of Hitler's regime, which shut it down in 1933.

Before the Nazis forced the Bauhaus to close, Otto became one of its major advocates and private clients. In 1926, Otto Bamberger engaged Erich Dieckmann, one of the school's furniture designers, to develop a new design for DBL's line of wicker lounge chairs. My uncle was so pleased with the results that he asked Dieckmann to design furniture for his library, then for his entire villa. The elegant, unadorned shapes of Dieckmann's bookcases, cabinets, armchairs, and tables were a perfect foil for Otto's life-size sculpture, Wilhelm Lehmbruck's *Kneeling Woman*. For commissioning the Bauhaus to redesign and furnish a complete building—the only one of its kind—some regard him as the Bauhaus's greatest sponsor. The home, Sonnenhaus, has been landmarked since 1994.

Otto was very persuasive and convinced his siblings to redecorate their abodes with Dieckmann's furniture, as well. My parents commissioned a bedroom set; my Uncle Anton and his wife Else refurnished their salon. Their living room set, including a glass-topped table, a couch, and four armchairs crafted from a rare African wood, would eventually travel to America, and, since 1951, I have been its fortunate owner. The aesthetic is disarmingly simple, devoid of embellishments; its pieces are designed for uncomplicated, inexpensive production—a Bauhaus requirement. While angular and heavy, each piece is well-proportioned and elegant. The

upholstered part—two big cushions per armchair—is separate and easy to reupholster, and the entire set has now survived three generations of growing children.

It was during these happy Hanover years, filled with art and children, that my parents met Jussuf Abbo and invited him to be our guest while he sculpted their likenesses. I vaguely recall the slight, dark-haired, Palestinian-born Jewish artist. Abbo turned one of our rooms into his studio. Watching him mold my father's head and my mother's bust became my favorite pastime. My mother and I accompanied him on walks in the Eilenriede, where he gathered dandelion

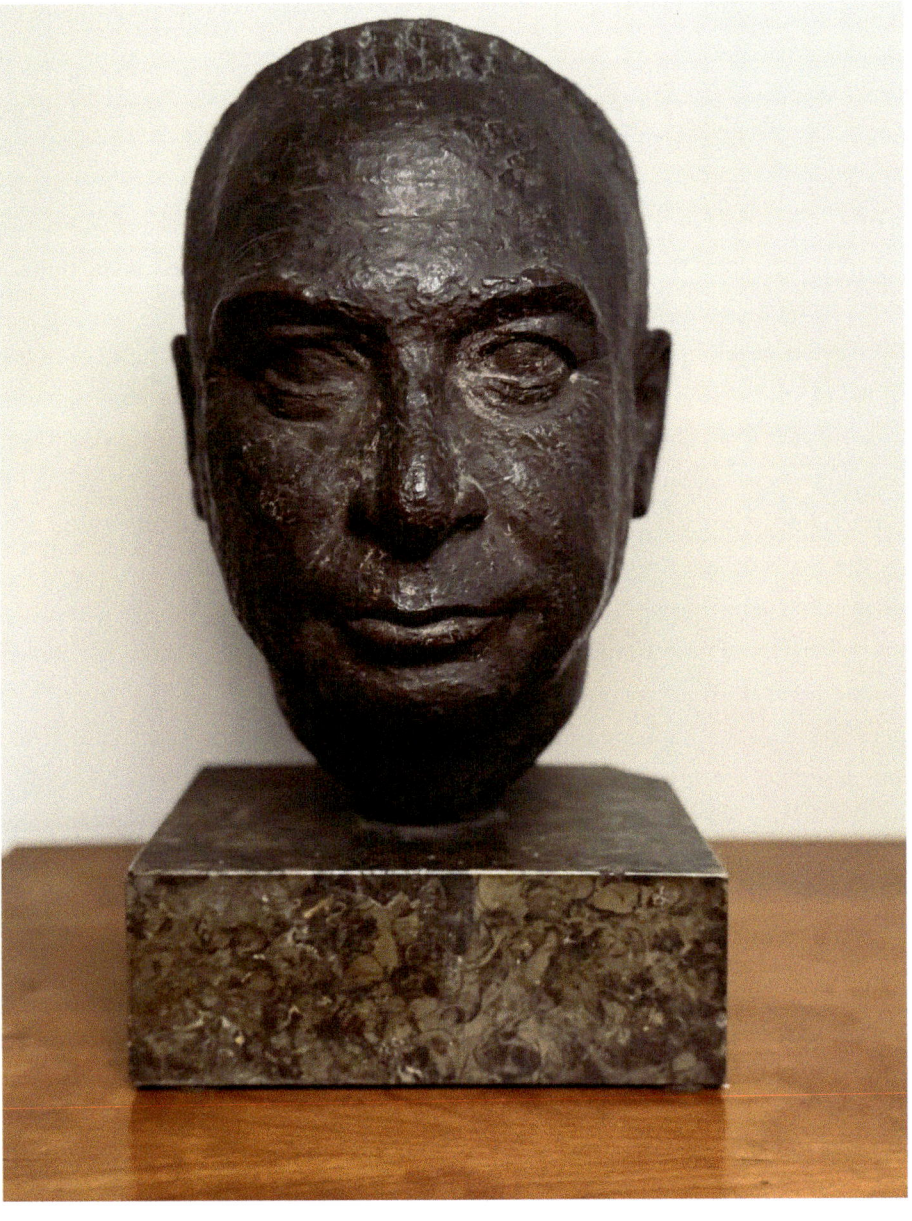

Figure 1.2 *Jussuf Abbo*, Bust of Dr. Hugo Bamberger *(1933). Credit: Private Collection*

and other wild herbs for his evening salad. Abbo was supposed to stay at our house for two months but kept postponing his departure. It took all my father's cunning to finally get him to leave. Abbo never completed my mother's bust, but my father's bronze likeness now resides at my nephew's home in Portland, Oregon (Figure 1.2).[3]

The Kestner Society

Once my mother had settled in Hanover as a young bride, she joined the Kestner Society, a small club promoting modern art. It was typical of art associations established at the turn of the twentieth century in midsize European and even American cities. Many would grow into art museums. Dating from 1916, the Kestner Society included founding members Hermann Bahlsen, whose Hanover-based bakery still manufactures cookies sold around the world, and the Fritz Beindorffs, father and son, who developed the Pelikan brand of high-quality fountain pens. The Kestner Society was extremely active. During its first five years it mounted fifty or so groundbreaking exhibitions, featuring artists that eventually would achieve worldwide fame: Paula Modersohn-Becker, Lovis Corinth, Erich Heckel, James Ensor, Paul Klee, Karl Schmidt-Rottluff, Alexej von Jawlensky, Wilhelm Lehmbruck, Georg Grosz, Christian Rolfs, and Emil Nolde.

The Kestner Society organized many festivities, including masked balls. My parents sometimes attended these, each in the guise of being single. On one such occasion, Kurt Schwitters, the Dada collage and Surrealist artist, picked up Gretel, while Hugo chose a cute secretary. Schwitters was a Hanover native. Today his work is renowned across the globe: Hanover's Sprengel Museum (see chapter 4) established a comprehensive Schwitters Archive in 1994, and he is the pride of his hometown. However, his art was not taken seriously at the beginning of his career, even though the Kestner Society had exhibited his work since 1917. On the evening he was my mom's date, he failed to provide her with refreshments. Noting that my father piled his date with delectable nibbles, my hungry mother sat at Hugo's table. As she expected, he ordered additional treats. Schwitters joined the party and proceeded to help himself to my mom's food. Decades later, when I asked her why she had not bought any of Schwitters's collages—at the time very inexpensive—she matter-of-factly declared, "He was rude; besides, I did not like his work."

My mother must have met the art dealer Freiherr Herbert von Garvens-Garvensburg (known as "von Garvens") at the Kestner Society. She liked to quote him as an infallible expert, much as she did Paul Schubring, her Italian Renaissance art professor. She claimed that she owed to von Garvens "her best art."[4] Von Garvens was an enthusiastic collector, art dealer, gallerist, writer, and cofounder of the Kestner Society.

In 1921 von Garvens opened a short-lived, much-admired gallery-*cum*-house museum in his parents' former Hanover mansion. In 1926–1927, he held a major sale of his artworks, and my

mom caught shopping fever. She bought numerous items, including a six-foot Korean ancestor portrait and a huge oil painting by Georg Grosz portraying Native Americans, an unusual subject for him. It hung in our winter garden in Hanover, where it harmonized with the plants. The Grosz made it to Brussels, where my mother sold it for a pittance. Several smaller items from the sale survived. They included an ink drawing of a peasant couple from one of Chagall's sketchbooks; an etching by Alfred Kubin; a Franz Marc lithograph of horses printed on a silver background; a Rembrandt etching of Saskia's head; and *Blue,* a print by Vasily Kandinsky.

The Nazis would have certainly pursued von Garvens: in addition to handling African masks, German Expressionist and Far Eastern art, he was also gay. In 1931, the gallerist moved to Bornholm, an island off the coast of Denmark. His collection followed. Despite Denmark's occupation by the Germans, von Garvens survived the war. Following his death in 1957, his heirs auctioned off his collection. I discovered that Jussuf Abbo had made a portrait of von Garvens, which would explain how the mysterious artist ended up at our house.

During the German hyperinflation of the 1920s, the Kestner Society was so financially stressed that it almost closed down. By 1930, however, the lean years were over, and the institution appointed thirty-two-year-old Justus Bier as director. The six short years that Bier spent in Hanover became the art society's glory days. Though he wrote his doctoral thesis on Tilman Riemenschneider, a German sculptor and wood carver from the late Middle Ages, Bier promoted German Expressionists at the society.

The Nazi regime therefore regarded Justus Bier's tenure at the Kestner Society as doubly offensive: he was Jewish and also endorsed modern and "degenerate" art. Since the Nazis came to power in 1933, they had pressured the board of directors of the Kestner Society to fire Bier, but thanks to chairman Fritz Beindorff's personal courage, the institution retained him until the summer of 1936.

The last exhibit Bier curated at the Kestner Society featured Riza Abbasi's recently restored seventeenth-century Persian frescos. An evening lecture was scheduled to celebrate the opening of the show. Soon after the talk began, several members of the SS—Himmler's Secret Service police—arrived, asking to speak to chairman Fritz Beindorff, who requested that the intruders wait until the lecture was over. The men of the SS refused, declaring they must close the exhibition immediately since a Jew had created it. A month later, the Kestner Society was banned from holding cultural events.

Despite the prevailing Nazi thuggery, the Kestner Society awarded Bier a generous severance package. He and his small family relocated to rural Bavaria, where he completed his Riemenschneider trilogy. Meanwhile, Kentucky's University of Louisville, inspired by the German Refugee Scholars Program, offered Bier a professorship that he eagerly accepted. In August 1937, Justus Bier wrote Beindorff a farewell note. He thanked the chairman for having tried to shield him from the Nazis. In part, the note reads, "I have only one wish, that the ideas that you defended during the years that we worked together, will one day again be accepted as

common truths."[5] Bier goes on to tell Beindorff how much he enjoyed working with him. Though external circumstances were highly unfavorable, Bier told him he hoped to see him in Germany the following summer, unless by then Beindorff would have been able to visit him in the United States. In fact, it would take twenty years for Bier to pay a return visit to the Kestner Society.

Spurned by the Nazis, European intellectuals—artists, dealers, and art historians—would flee Germany for the United States, where their talents and expertise forever changed the approach to art in America. Justus Bier taught at University of Louisville from 1937 to 1960 and published two hundred pieces of art criticism in the *Louisville Courier-Journal*.[6] In 1960, the North Carolina Art Museum offered him the directorship of its museum in Raleigh. He would succeed William Valentiner, the founding director whom J. Pierpont Morgan had hired at the Metropolitan Museum in 1908, with the recommendation of celebrated art historian and curator Wilhelm von Bode of Berlin's Nationalgalerie.

Justus Bier retired from the North Carolina Museum of Art in 1970. In his honor, the museum purchased Tilman Riemenschneider's *Female Saint, (No 68.33.1)*. Unlike the Städel Museum's George Swarzenski, another brilliant director forced to leave his post (see chapter 3), Bier visited Germany and the Kestner Society after World War II; the society reopened in 1948, and Bier presented guest lectures there. In 2009, some of his German colleagues were instrumental in establishing the Justus Bier Prize for Young Curators, given annually to the curator who has made the greatest effort to promote twentieth and twenty-first-century artists. Bier, who died in 1990, would have appreciated the honor.

Alexander Dorner, also of Hanover, moved on to a career in the United States, as well. Dorner had been president of the Kestner Society from 1929 to 1934 and director of Hanover's regional Provinzial Museum from 1925 to 1937. He pioneered new methods for displaying art and led the opposition to the Nazis' 1937 *Degenerate Art* exhibition. When Nazi authorities confiscated the modern art from his museum's collection, he resigned and fled for America, where he assumed the directorship of the museum of the Rhode Island School of Design (Alfred Barr, Director of MoMA [Museum of Modern Art], had recommended him). Though the Nazis had cost him his career in Germany, the FBI falsely accused the Aryan Dorner of being a Nazi sympathizer in 1941 largely because he was German and had a brother flying in the Luftwaffe. Deeply hurt, the staunch liberal left his post. Thereafter Dorner taught at nearby Brown University and at Bennington College in Vermont; he would never work for a museum again.[7]

The Nazis Target My Uncle Otto and His Art

During the ascendency of Hitler's power in the early 1930s, the Nazis took aim at my Uncle Otto Bamberger's avant-garde art collection, his Bauhaus furniture, and his liberal ideas. The local press published a derogatory article, illustrating the text with images from his collection. In 1933,

the Nazi authorities took my uncle into "protective" custody for a week in Frankfurt, supposedly to shield him from the wrath of the German people. Jetta, his determined wife, managed to have him released; nevertheless, Otto, who suffered from heart disease, was weakened by his incarceration and died of a heart attack a few months later. Ruth and Claude, his children, were attending school in Berlin and Switzerland, but Jetta remained in Lichtenfels, watching over the Bamberger wicker business and guarding her art-filled villa.

One evening in 1938, Mr. Aumer, a neighbor and employee of the municipality, knocked on her back door. "Mrs. Bamberger," he said,

> we have known each other for a very long time. You know what is happening in this town and all over Germany. I don't really agree, but I have a job and a family to feed. I hope that you understand that I cannot be seen communicating with you in an official capacity. I came to tell you that orders have come from Berlin today, that within the next two weeks we will have to confiscate the passports of all Jewish families living in our district. I know you still have a valid passport, and I urge you to leave as quickly as possible.[8]

My aunt fled the next day, abandoning her possessions. She managed to get to the United States and, for years thereafter, supported herself as a housekeeper and lady's companion.

Soon after she left Lichtenfels, the Nazis confiscated her "degenerate" art collection, including Lehmbruck's *Kneeling Woman*, his *Female Torso*, and other precious paintings. These artworks never resurfaced. Allegedly the Nazis stored them in Nuremberg, where they perished in an Allied air raid. The Nazis looted an alternate cast of *Kneeling Woman* from the Kunsthalle Mannheim that is now at MoMA in New York; another is at the Metropolitan Opera.

My parents did their best to shield my sister and me from the oppressive atmosphere that surrounded Jews living in Germany after January 1933, when Hitler was named chancellor. They also maintained their busy lifestyle. Six days a week, Vati left early each morning for his factory; my mother attended to her involvement with museums, painting lessons, and friends. Both were gone most evenings. We neglected Jewish traditions and celebrated Christmas and Easter. I recall my childhood as being essentially happy. My birthday celebrations were lavish and attended by the children of the neighborhood. I enjoyed our Swiss and Italian vacations. Visits to my grandparents in Frankfurt and my father's family in Lichtenfels were heartwarming and fun.

From 1935 to 1938, I attended Hanover's Rudolf Steiner School, located in the mansion formerly belonging to von Garvens. My teachers and the parents of most of the students were anti-Nazi. Within reason, I felt accepted. Ruth Iris Freudenthal, the only other Jewish child in

my class, and I were excused from the mandated weekly National Socialist indoctrinations. Nazi propaganda nevertheless intruded on my consciousness. I can still hear the terrifying sound of Hitler's diabolic voice and the incomprehensible ramble of his speeches. At my streetcar stop I regularly read the prominently posted issues of the antisemitic *Stürmer*. I hated the cartoon of the Jewish baby who, at birth, grabs the wedding band of the obstetrician.

I tried to toughen myself. During the winter it was already dark when I returned from school. I walked into the woods bordering my house and willed myself not to run. After five minutes or so I retraced my steps and went home. Perhaps it taught me not to panic during a crisis. It was only much later that I realized my feelings of inadequacy date from growing up in Nazi Germany. My parents, too, tried to prepare for the unknown. Each had packed a small suitcase to grab in case the Gestapo arrested either of them in the middle of the night.

In September 1935, the Nazis passed the Nuremberg Race Laws to protect the purity of German blood. The regulations outlawed sexual relations between Jews and Germans, as well as Jews' employment of household workers under forty-five years of age. The regulations upset my mother's smoothly running home. Anna, our cook, and Detta, our nanny, had to leave. My mother hired makeshift help. Fortunately, my beloved Marie occasionally returned to cook dinner. Since her age placed her outside the employment restrictions, she could continue working for us.

My Family Emigrates from Germany

At first many Jews believed that Hitler was a passing phenomenon, but by the mid-1930s, they realized he was there to stay. My parents started searching for a safe haven abroad. It was a tall order. Most countries had strict quotas and were reluctant to admit Jews. My father was determined to remain in Europe to continue supplying his faithful clients in Spain, Belgium, and Holland with chemicals for the food industry. In 1937, he obtained Belgian residence permits. After much red tape, my parents were allowed to export their household goods, a professionally equipped laboratory, and my mother's small art collection. It took Gretel months to reduce the furnishings of a large Victorian house to those fitting a two-bedroom apartment in Brussels. In 1938, we were the first members of my extended family to leave Germany. We delighted in the Belgian capital, but not for long.

We arrived in Brussels on April Fools' Day, 1938. My fifty-two-year-old father had founded a small chemical factory there, hoping it would support his family. My mom managed her own household for the first time in her life, a task accompanied by much yelling. Gaby and I went to school. My parents tried to break their emotional bonds to the country their families had considered home for centuries. Even though I spoke no French, I could feel I was no longer ostracized—a palpable relief.

It turned out that we had not moved far enough when we left Germany. On May 10, 1940, two years after we had arrived in Brussels, the Germans invaded Belgium, Holland, and France. As soon as the war broke out, the Belgian authorities arrested all foreigners, including German nationals like us. My school served as the local makeshift detention center. Women and children were released that evening, but they held the men, including my father, and shipped them to France. Over the next year, Hugo was confined in two different French concentration camps. During his incarceration, he obtained an American visa with the help of his brother Anton, who had already reached the United States. My father left for New York in the summer of 1941, a few months before America entered World War II. Once settled, he reestablished his business of manufacturing fine chemicals. These were in great demand because the war had curtailed the customary imports from Germany. We would not see my father again for the next six years.

My mother, now a single parent, also tried to flee Belgium with my sister and me as soon as the Nazis invaded the country; however, our attempts at crossing the French border were unsuccessful, and we returned to our apartment in Brussels. Over the next two years, my mom sold much of her fancy household goods, furniture, linens, and some of her art. Then, in the summer of 1942, the authorities ordered the three of us to report to a concentration camp. Like Anne Frank's family in nearby Holland, we decided to go into hiding instead. From 1942 until 1944, I worked as a mother's helper for four families who risked their lives to save mine. I worked hard and my feelings oscillated between excitement and boredom, gratitude and resentment, fear and fantasy. For various reasons, Belgium was a safer place to hide than Holland or even France, and all three of us survived. It was an extraordinary way of growing up. Strange as it may seem, the Holocaust left me a stronger, more compassionate person.

On September 3, 1944, the Allies liberated Brussels, and I greeted the British army with a flood of tears. My family had survived, but the cost had been too high: between 50 and 80 million people had perished.

Unfortunately, my wanderings were not yet over. Two years later we left Brussels and joined my father in New York. We settled in a small row house in Queens. After six years of separation, we had a tough time functioning again as a family. Soon the remaining contents of our large Hanover house arrived.

My mother's enthusiasm for art remained undiminished. As soon as she landed in New York, she started exploring the museums of her new city. One evening when she returned home from a visit to the Metropolitan Museum of Art, she reported that she had met a very old friend. He turned out to be Dr. Gachet, in the portrait by Vincent van Gogh. "I used to see him every time I went to the Städel Museum in Frankfurt," she told us. Knowing that my mom's information was not always correct, I figured that the Met owned another version of this famous picture. I could not imagine that a world-renowned museum like the Städel had divested itself of one of its most cherished treasures. It took me years to discover that my mother had been absolutely correct (see chapter 5).

By now I have lived in the United States for over seventy years. I married, had children, found a profession and rooted in a third country. My Brooklyn apartment is filled with objects rescued from Nazi Germany. My Aunt Else Bamberger gave me her massive Bauhaus furniture; my mother left me artworks by Christian Rohlfs, Vasily Kandinsky, Jussuf Abbo, Marc Chagall, and others. The Art Deco Sterling silver coffee-and-tea service displayed on my buffet harks back to my family's bourgeois past.

Closest to my heart is a large double portrait of Paolo Malatesta and Francesca da Rimini from 1923, painted by Hermann Lismann (Figure 1.3). The ill-starred lovers who figure in Dante's *Inferno* are reimagined in an extraordinary work. The piece strikes me as a cross between an early Picasso and the German Expressionists. The adulterous couple sits silently at a table, reading a large book. They do not touch each other, though the viewer feels their passion. Their expression is sad because they sense that their love is doomed. The massive upper half of their bodies fills the entire canvas. The painting is devoid of detail or ornamentation except for their carefully rendered hands and their elongated fingers. Francesca is clad in crimson, Paolo in black. A green cloth covers the table. The light gently glints off the figures' smooth, dark hair.

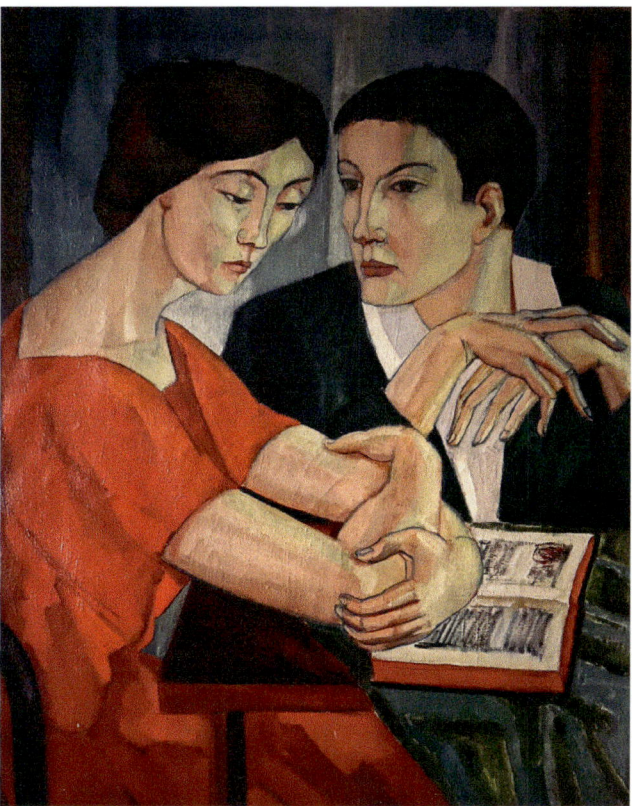

Figure 1.3 *Hermann Lismann,* Paolo Malatesta and Francesca da Rimini *(1923). Lismann's painting migrated to the United States with the author's aunt in 1958. Credit: Private Collection*

Lismann lived, worked, and taught in Frankfurt and belonged to the town's art colony. Like other German painters of the period, he obtained some of his training in France. When the Nazis took over Germany, Lismann was doubly targeted as a Jew and as a modern artist. In 1938, he fled to France, a country he venerated, but by then, times had changed. As directed by the 1941 armistice, some French citizens helped apprehend refugees like Lismann and eventually hand them over to the Germans. The Nazis sent Lismann to Gurs, the same camp in southern France that had incarcerated my father.

Fortunately, with the help of his brother in New York, my father obtained his American visa, a document that allowed him to leave camp Gurs, since it provided the proof that he could complete his journey to the United States. Hugo departed from Europe for America in 1941, six weeks before the Nazis banned those with immediate relatives in Europe from leaving. I remember his ecstatic letter from his arrival in the United States, marveling at the white tablecloths in the restaurant where he ate his first decent meal in ten months.

Lismann was not that fortunate. He could not find anyone in the United States to provide an affidavit of financial support and thus failed to obtain a life-saving visa. In 1943, he was deported to the Majdanek death camp in Poland, where he died alongside scores of other victims. By then, his *Paolo and Francesca* had already reached the United States along with my Tante Else's Bauhaus furniture. My family gave me the furniture in 1951 and the painting in 1958. I have treasured both ever since. Many years later, the city of Frankfurt would memorialize Lismann with a retrospective exhibition (December 1979 to January 1980).

Those who survived the Nazi maelstrom did their best to rebuild their lives. They hunted for relatives, found safe places to live and means of supporting themselves. Searching for lost belongings was part of the recovery process. Money mattered—many refugees were penniless—but reparation and justice were more important.

Occasionally, restitutions proceeded smoothly. In 1945, seven or so years after the Nazis had confiscated my Uncle Otto's art collection in the small town of Lichtenfels, Gerald P. Bamberger, another cousin, by then a lieutenant serving in the US Eighth Army, visited Lichtenfels' small-town hall.

He told me later, "As an American Army officer stationed in newly vanquished Germany, I felt entitled to nose around." There, he stumbled across half a dozen mildewed crates marked "Bamberger—Jewish property." Closer investigation proved them to contain the remains of Otto's vast print collection. Gerald mailed several hundred works on paper, including works by Otto Dix, Käthe Kollwitz, Alfred Kubin, Erich Heckel, and Max Beckmann to our Aunt Jetta in America. In 1948, Jetta tried to sell these works but found no takers. Expressionist and post-Expressionist German and Austrian art had not yet caught on in the US. Forty years later, Jetta's son Claude exhibited the same works at the Galerie St. Etienne in New York, where they sold briskly.

Most restitutions were not this simple. For example, in 1942, before our underground existence, my mom had convinced our landlord to shelter her spectacular Bauhaus bedroom furniture. When she asked him to return it after the Nazis departed, the landlord was most reluctant, pointing out that he had gotten rid of his bedroom to accommodate ours; eventually, he relented. Another common problem was that persecuted individuals often had to sell their possessions for a fraction of their true worth, but if buyers were later asked to return such items, they claimed a sale was a sale. Wrangling over what belongs to whom continues today, ninety years after Nazi confiscations took place.

The survivors' need to rehabilitate their sense of self was much more important than material losses. Even I, whom good and courageous people had sheltered, emerged with hatred and fear of my birthland, particularly my mother tongue. I dislike my German accent and have seldom volunteered that my German was still fluent. Around 1948, my Hanoverian Waldorf school classmates started writing me letters that did not acknowledge the horrors of World War II. After they failed to list among the class's dead my Jewish classmate Ruth Iris Freudenthal, whose life was lost in a concentration camp, I stopped answering their letters.

My discovery of the Horb shul in Jerusalem, which underlined my family's twisted roots, made me think I should not let Hitler's ghost prevent me from revisiting my ancestors' past. I traveled to Lichtenfels in 1978. Years later, I went to Hanover and Berlin. My attitude softened. I finally accepted the German traits of my personality.

Researching and writing *Plunder and Survival* has become part of my lifelong healing process. My journey began with investigating two Jewish art dealers and some of their key clients. All lived and worked in pre–World War II Germany when the nation's cultural life had reached a zenith of creativity. The story begins here.

2

German Expressionist Art Finds Its Champions

Born in Frankfurt am Main in 1852, Ludwig Schames became, in many ways, a typical example of the art dealers of the nineteenth and first half of the twentieth century. On close examination of my family tree, I discovered that Schames was the great-grandfather of my cousin Richard, with whom I bonded when both our families ended up in New York. Like my great-grandparents, the Schames ascended from peddling and shopkeeping to being entrepreneurs. Their leading enterprise—selling feathers to stuff mattresses and comforters—flourished after the unification of Germany in 1870, and the family expected Ludwig to eventually take the reins of the business. So, in 1885, he went to Paris to refine his commercial skills. He achieved that but also discovered French art and was enthralled. He began collecting French Impressionist and Fauvist works and, a decade later, opened an art gallery in Frankfurt.

Today, art dealers are essential members of the art world, but this has not always been the case. Throughout history, art was commissioned either by the church or the temporal rulers of the land. During the Italian Renaissance, the upper-middle class began collecting art. But it was not until the seventeenth century, when citizens in Holland—then a democratic nation-state known as the Dutch Republic—started purchasing paintings to decorate their homes, that a strictly regulated art trade emerged. In the coming centuries, art collecting by sophisticated and well-to-do citizens spread throughout Europe. By World War II, the role of the art dealer had grown to an entirely new level. These professionals would play a critical part in the Nazis' war against modern art, including the disposal and salvage of endangered and looted works.

Dealing in art appealed to upwardly mobile Jews. The métier combined commerce with keen intellectual activity and a passion for beauty. Buying and selling expensive art also felt familiar as a profession. Like jewelry, gold, or other financial assets, paintings are precious and portable and can easily be transported in the case of a pogrom.

So many Jewish art dealers emerged in Germany during the first decades of the twentieth century that the German press made antisemitic slurs on the topic. In 1904, the popular satirical

magazine *Simplicissimus* published a cartoon strip titled "Metamorphosis" that mocked the ascent of a downtrodden Jewish peddler to an upscale merchant (Figure 2.1). The first of three images portrays a rag picker named Moishe Pisch. In the second image, Moishe changes his name to Moritz Wasserstrahl and becomes a salesman of fashionable Parisian clothes. By the third, Moritz—now Maurice de la Fontaine—is a respectable art dealer. The nastiness of the cartoon highlights the enduring antisemitism of the German population.

Dealer Ludwig Schames and the Expressionists

When Ludwig Schames opened his small Frankfurt gallery in 1895, he mainly represented the late Impressionist and Fauvist painters who had captivated him in France. He presented works by Parisian artists like Maurice Vlaminck, Albert Marquet, and Picasso. Soon, however, he added contemporary German art, which was experiencing a remarkable resurgence through Expressionism.

Expressionist art, with its characteristically strident colors, angst, rawness, directness, spontaneity, and fantasy, which reflected the fear, uncertainty, horror, and excitement of the early twentieth century, would inflame the Nazis. It had grown out of the dissatisfaction of late nineteenth-century artists with simply creating beautiful images. The Industrial Revolution had brought about significant social change, and some painters wanted to record the harsh new realities of daily life: the misery of overcrowded cities and their smoke-belching factories, the prevailing urban poverty, and the subsequent wretchedness of everyday existence. Others sought to depict the novel structures of machinery appearing all around them or were influenced by the magic of African tribal art and the stylistic elements of Japanese woodcuts. Both types of artworks were arriving in Europe and America and profoundly impacted Western modernists.

Vincent van Gogh was a pioneer in this innovative movement of expressive painting. Particularly fascinated by Japanese art, he explored its vibrant colors, unconventional cropping, and flat spaces in his painting. The largely self-trained artist soon began to violate the prevailing rules of the art academies with broad and undisciplined brush strokes and thick streaks of dried paint marring the smooth surface of his works. The grim facial expressions of his early subjects—the impoverished miners of Belgium's coal district—revealed their emotional turmoil. His technique and his subject matter initially met with ridicule. Still, other painters soon followed his lead: Edvard Munch and other avant-garde pioneers, too, became more emotional in their work and mirrored the intensity and alienation of modern life. Artists realized that a painted image did not necessarily have to depict a realistic or plausible perspective. French artists responded with Cubism, Fauvism, Surrealism, Post-Impressionism, and Dada; the Italians with Futurism, the United States with the Ashcan School, and the Germans with Expressionism.

The images produced by the German Expressionists are both stylistically diverse and highly evocative. Ernst Ludwig Kirchner's work is colorful, quick, and edgy, while Franz

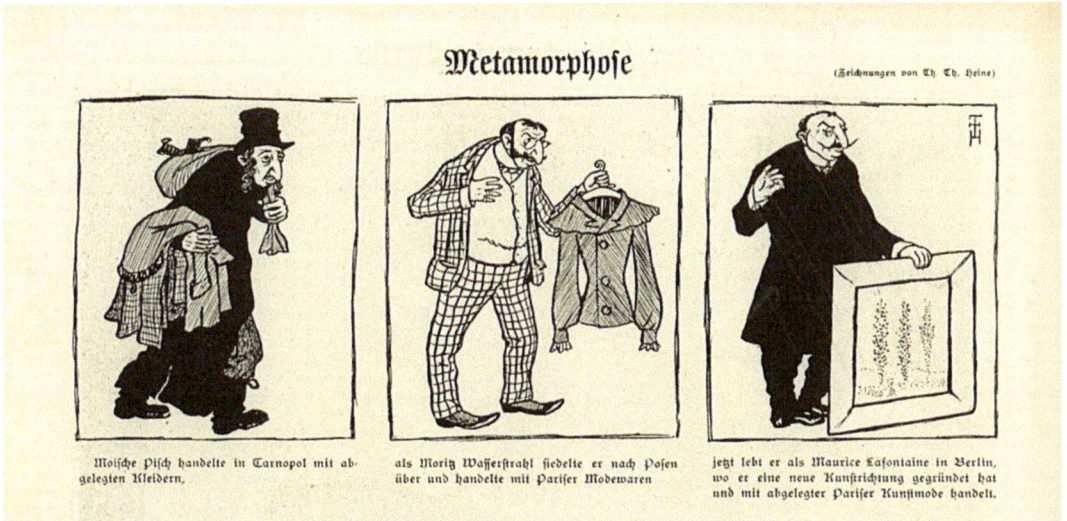

Figure 2.1 *Theodor Heine, "Metamorphosis," a cartoon strip mocking German Jews' efforts to climb the social and economic ladder. The character Moishe Pisch transforms from a lowly peddler to a reputable art dealer with an elegant French name to match. Published in* Simplicissimus *magazine, June 2, 1903. Source: "Metamorphose" ["Metamorphosis"], Simplicissimus, Jg. 8, Heft 10 (June 2, 1903). Available online at: http://www.simplicissimus.info*

Marc's is enchanting and lyrical. Vasily Kandinsky's paintings are abstract and melodic; Oscar Kokoschka's clever and playful; Max Beckmann's fantastical, densely chaotic, and intense; Georg Grosz's political and satirical—at once nasty and comic; Christian Rohlfs's romantic; and Lyonel Feininger's whimsical. During their glory days, these artists and others produced thousands of images, many ensconced in German art museums and private, often Jewish, collections.

The Nazis, who hated this new form of art with a passion, would do their best to destroy this treasure trove. Fortunately, they would not quite succeed. Though, as a movement, the Expressionists would infuriate the Nazis beyond reason, they were championed by people like Schames, other art dealers, collectors, and museum directors and, much later, the world at large.

The Expressionist artists Ludwig Schames took under his wing cherished his connoisseurship, kindness, and understanding and appreciated the elaborate catalogs and lectures accompanying each show he mounted. Franz Marc and August Macke treasured his "wonderful, small [exhibition] rooms" and felt that he was a "wonderfully selfless dealer."[1] Schames developed close relationships with Wilhelm Lehmbruck, Emil Nolde, and especially Ernst Ludwig Kirchner.

Artist Ernst Ludwig Kirchner

Kirchner was born in Aschaffenburg in 1880 and grew up in Chemnitz, a small town near Dresden. As a child he had already decided to be an artist. He drew constantly and made carvings in wood. Nevertheless, upon enrolling at the Technical Hochschule, Dresden in 1901, he decided

to major in architecture, though he soon switched to graphic arts. He was never totally at ease with the world and, throughout his life, suffered from mental instability. However, while in Dresden he met with other artists bent on challenging academic art. In 1905 they founded the Brücke, a group that would play a crucial role in the development of German Expressionism.

In 1915, Kirchner volunteered for the Field Artillery Regiment #75 of the German Military Reserve to avoid being drafted and sent to the front. He managed to escape combat duty, but the brutality of World War I was nevertheless too much for his fragile constitution. Within months of enlisting, Kirchner had a major nervous breakdown, and the army discharged him. The painter self-medicated his depression and insomnia with morphine and sleeping pills and soon became addicted. In 1916 Kirchner entered Dr. Kohnstamm's sanatorium in the pleasant Taunus Mountains. Over the next few years, he spent several months at this and other clinics: wherever he was, he continued to paint. During this period, he contacted Schames's gallery in nearby Frankfurt.

World War I did not interfere with the affairs of the gallery, and in 1916, Schames presented the first of his five Kirchner solo exhibits. Taking on the emotionally frail Kirchner imbued the gallerist with a fatherly role. In 1918, Kirchner would portray Schames in an arresting woodcut featuring a voluminous beard that lends the dealer the appearance of a prophet.

Though the army had released Kirchner in 1915, he continued to suffer from the traumatic events he had witnessed in World War I. He once said, "I paint with my nerves and my blood. The heaviest burden of all is the pressure of the War and the increasing superficiality. It gives me incessantly the impression of a bloody carnival. All the same, I keep on trying to get some order in my thoughts and to create a picture of the age out of confusion."[2]

Much of Kirchner's work is characterized by vitriolic colors, rough brushstrokes, and extreme vitality. His subjects seem in constant motion; indeed, the painter instructed his models to move about while they posed.

In *Self-Portrait as a Soldier* (Figure 2.2), he depicts himself wearing his regiment's blue uniform with red epaulets and a cap, which has been identified as a driver's uniform. His right hand is severed at the wrist, the arm's bloody stump eliciting shock and revulsion. Peter Seltz, a leading art historian, professor, MoMA curator, and Berkeley Art Museum director, who had fled Nazi Germany himself in 1936, describes the image as "a bitter condemnation of the military conscription and war." He notes, "Instead of wearing the eager, intense look of his previous self-portraits, Kirchner now stares expressionlessly. The eyes, lacking pupils and irises, are hollow like the eye socket of a statue from which the jewels have been plundered . . . the face is thin and drawn. A cigarette hangs from the lips."[3] Selz interprets the amputated hand as a metaphor for Kirchner's fear of undergoing physical harm in the war that would leave him unable to paint. Schames brought the painting to the attention of Georg Swarzenski, the renowned director of Frankfurt's Städel Museum, who acquired it for the museum in 1919. The Nazis confiscated it in 1937.

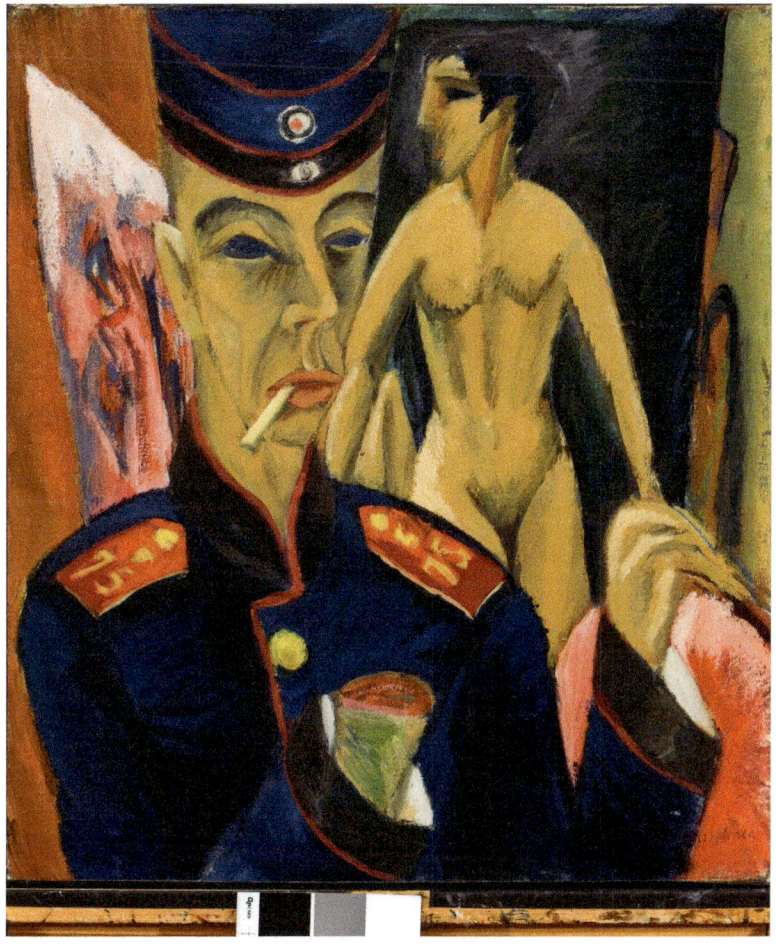

Figure 2.2 Ernst Ludwig Kirchner, Self-Portrait as a Soldier *(1915). Seized in 1937, the painting was sold clandestinely in Germany to Kurt Feldhäusser, who subsequently died in an Allied air raid. After WWII, the painting traveled to the United States with Feldhäusser's mother. Credit: Allen Memorial Art Museum, Oberlin College*

Collectors Ludwig and Rosy Fischer

Astute art dealers and passionate collectors are like two sides of the same coin, often developing relationships to benefit both. One especially notable client of Schames was the couple Ludwig and Rosy Fischer, whose collection of Expressionist art earned them a unique place in art history. The Fischers were well-educated, highly liberal members of Germany's Jewish upper-middle class. Ludwig was born in 1860 in Breslau; Rosy, fifteen years his junior, came from Frankfurt. Their sons Max and Ernst were born in Frankfurt in 1892 and 1896, respectively. Ludwig had founded a successful molasses business, but because he suffered from tuberculosis, he retired around 1900, devoting the rest of his life to studying art, literature, and science. As his son Ernst would recall in his memoirs some sixty years later in Virginia,

A significant change occurred in his parents' life in 1905. For once, [his parents] had taken a vacation [without their children], and on their way back from Italy, they had visited an art exhibition in Munich. They had decided: "to live with art," partly, one assumes, because they thought that they might enjoy being collectors, but also as a social gesture to financially help artists.

A few days after Ludwig and Rosy returned home . . . three large boxes filled with paintings were delivered. They were so heavy that they had to be unpacked on the street in front of our apartment house. From that time on, the walls of our large dining room, of the salon and of the library—and eventually even the walls of the bedrooms—were adorned with oil paintings. Each year less wallpaper could be seen.[4]

At first, the Fischers acquired traditional, generally unremarkable works, but gradually, they turned their attention to contemporary art. Another ten years passed before they visited the Kirchner exhibit at the Galerie Schames. The strength of the artist's work, as well as the connoisseurship of the gallery owner, impressed them. The Fischers bought Kirchner's *Portrait of Dr. Alfred Döblin*, a cheerful likeness of the young German novelist in tones of blue, black, white, and beige. The subject's crown of disorderly hair, his twinkling eyes, his smile, elegant moustache, and small goatee were unlike anything the Fischers had encountered before. They were smitten. Leaning on Schames's expertise and perhaps also on the advice of Max Fischer, their elder son, by that time a Berlin journalist with tight links to the German avant-garde, they rapidly formed one of Germany's great collections of Expressionist art. The couple amassed works by many of the Brücke and Blaue Rider artists—the founding Expressionist groups. By 1922, they owned five hundred works. Often, they established personal contacts with their favorite artists. Ernst Fischer recalled Mrs. Ada Nolde and Mrs. Erna Kirchner arriving at the Fischer home with canvases rolled up under their arms because "their husbands hated travelling."[5]

Ludwig Fischer died in 1922, and German hyperinflation wiped out much of Rosy's fortune. To improve her immediate financial situation, she made a deal in 1924 with the Staatliche Galerie Moritzburg in Halle to sell twenty-four works by the nine painters E. L. Kirchner, E. Heckel, E. Nolde, K. Schmidt-Rottluff, O. Mueller, O. Kokoschka, F. Marc, A. Weisgerber, and P. Picasso in exchange for a ten-year annuity. This transaction included Nolde's *Woman of Mixed Race* (formerly *The Mulatto*), the painter's best-known work. Though Rosy didn't ultimately negotiate an impressive sum, the sale was mutually beneficial, freeing Rosy from economic concerns and enabling the Moritzburg museum to acquire in a single deal "the highest-quality selections of German modernist paintings in any German public museum."[6]

Anne Rosenberg, who would marry Ernst Fischer, first visited her future in-laws' apartment in 1922. She had been told to meet the Fischers, who were friends of friends, because they owned "these funny pictures, and were interesting people." Six decades later, Anne still remembered walking through the door and "seeing . . . pictures like I had never seen before."[7] During that

visit Anne fell in love with the Fischers' son Ernst, a medical student, as well as the unfamiliar art whose fate would play such an important role in her own life. Anne and Ernst married in 1922. Four years later, in 1926, Rosy Fischer died; fortunately, she had carefully inventoried her collection the previous year. Ernst and Max Fischer divided the art between them, each inheriting about 250 works.

By 1934, a year after Hitler came to power, Ernst had become a physician, and he and Anne left Germany for Richmond, Virginia. At that time, they could still freely export their share of the paintings to America. Ernst went on to build a successful career in Richmond, eventually chairing the physiology department at the Medical College of Virginia.

Ernst and Anne felt responsible for the collection assembled by his parents. At first, there was little interest in America in German Expressionism. Gradually, this changed. Occasionally, Anne and Ernst would lend some pictures to small exhibitions. They sold a few artworks, but basically their collection remained intact. In 1958 they lent twenty paintings by Ernst Ludwig Kirchner to the North Carolina Museum of Art, at the time still headed by its founding director William Valentiner (see chapter 1). Decades earlier, Valentiner had unsuccessfully tried to familiarize Americans with his beloved German Expressionists in a 1923 exhibition. It would take more than half a century for his efforts to bear fruit.

When Ernst Fischer died in 1981, the Germans had long since fallen in love with their Expressionists. They also tried to make amends to the descendants of the Jews they had viciously expelled when the Nazis were in power. During the late 1980s, the new Jewish Museum Frankfurt—Germany's first municipal Jewish Museum, which opened in 1988—asked Anne Fischer to loan them works from her collection to remind the German people of Jewish collectors' cultural contribution. Anne acquiesced readily. She informed organizers that she welcomed the opportunity to demonstrate that artworks erstwhile classified as "degenerate" had been preserved and cherished by their Jewish caretakers. During the Frankfurt show, Ernst Fischer's pictures reunited with some of the works Max Fischer inherited and a few of those Rosy had sold to the Moritzburg Museum in 1924.

In 2009, Anne Fischer donated the bulk of her parents-in-law's collection to the Virginia Museum of Fine Arts (VMFA) in Richmond. As of now, it is the largest collection of German Expressionist art in the Southern United States. Unfortunately, because of space limitations, only a few of the Fischer pictures are exhibited at any one time. While the work is not always on view, Kirchner's *Six Dancers* is one of the collection's best-known paintings. The ballerinas in their pink costumes perform so vigorously that one can almost hear the music. Their swinging arms and tapping feet illustrate Kirchner's love of music. *Two Streetwalkers* is from Kirchner's more angular period. The sharp-featured prostitutes wear fancy hats and tailored suits. The Fischer gift also comprised works by Otto Dix, Max Beckmann, and Ernst Heckel. Surprisingly to me, the collection contains nine artworks by Jussuf Abbo, the almost-forgotten sculptor who stayed with my family in Hanover in 1930 while fashioning a bust of my father.

Two important items of the original Ludwig and Rosy Fischer collection are now at the Harvard Art Museums. The first is Kirchner's *The Portrait of Alfred Döblin*, the very first Kirchner the Fischers purchased from Ludwig Schames. The Harvard Art Museums acquired it from the Buchholz-Valentin Gallery in New York, whose dealings I return to in chapter 7. The second is Emil Nolde's *Woman of Mixed Race:* one of the twenty-four Expressionist paintings Rosy sold to the Moritzburg Museum; this work had the dubious honor of being shown at the *Degenerate Art* exhibition in Munich. The painting survived in Germany in a private collection. In 1954, the Feigl Gallery in New York, founded in 1942 by a Czech émigré, sold it to Harvard.

Created in 1913, *Woman of Mixed Race* is a quintessential German Expressionist work that admirably complements Harvard's extensive collection. Painted in bright reds and yellows, she resembles a pagan goddess celebrating her power. Her bright red lips baring two white front teeth; her arched eyebrows floating above half-closed eyes; her vivid green headband setting off her voluminous Afro that beautifully crowns her round face—all make her appear at once fierce and soft. Her museum label at her Boston home states that her "jewelry and heavily applied makeup suggests that she is a stage performer," but "the work's title hints at Nolde's primary interest in his subject: her race." Nolde was not alone in exploring this racial element. "Like many of his expressionist contemporaries . . . Nolde cultivated an interest in non-European people and cultures, believing them to possess elemental 'authentic' qualities."[8]

Max Fischer was not as fortunate as his brother Ernst. He tarried in Germany because he believed that the ascension of the führer would be short-lived. By 1935, Max realized that he had been wrong; but by the time he left for America, the export laws had changed, and he had to abandon most of his collection in Germany. He entrusted the bulk of it to his companion Charlotte Wanzke, but she failed to protect it, and, so far, very few of Max Fischer's pictures have surfaced. One exception is Kirchner's *Dunes at Fehmarn* painted in 1913, which was acquired by Kurt Feldhäusser, a Berlin art historian. Though Nazi policy had strictly forbidden acquiring "degenerate" art within Germany, Feldhäusser purchased this landscape in 1938 from Ferdinand Möller, one of the four modern art dealers the Nazis appointed to handle the sales of "degenerate" art confiscated from museums and private collections (see chapter 4).

Feldhäusser proved extremely discerning in his acquisitions. In 1943, he penned a short analysis of his collection, which is preserved in MoMA's archives. He wrote that he was particularly fond of the early work of Ernst Ludwig Kirchner and Marc Chagall. It appears that Feldhäusser owned Kirchner's *Dunes at Fehmarn,* formerly belonging to Max Fischer, as well as Kirchner's *Self-Portrait as a Soldier,* described earlier, and his *Portrait of Oskar Schlemmer,* previously in the collection of the Folkwang Museum. He also owned several paintings by Marc Chagall, including *The Crucifixion* (1912), *The Birthday* (1912; now at MoMA), *Purim* (1916–1917), and *The Watering Trough* (1923), the last two now at the Philadelphia Museum of Art.[9]

In 1945 an Allied air raid killed Kurt Feldhäusser in Germany. Marie Luise Feldhäusser, his mother, inherited his collection. After the war, she joined one of her other children in Brooklyn.

She arrived with Kurt's collection. She consigned paintings such as Kirchner's *Dunes at Fehmarn* and *Self Portrait as a Soldier,* as well as Chagall's *Birthday,* to the Weyhe Gallery in New York. The Allen Memorial Museum at Oberlin College (Oberlin, Ohio) purchased Kirchner's *Self Portrait as a Soldier.* Feldhäusser's unexpected death and his mother's subsequent move to America with his paintings underscores the role of chance that often governs the migration of art.

MoMA purchased *The Dunes at Fehmarn* in 1949. The painting's vivid colors illuminate what may have been, in reality, a rather tame landscape. The rolling peaks, fronted by evergreens, are painted in bright yellows and subdued browns. A brilliant red sky occupies the upper right, beyond a faint outline of a watchtower. In 1913, Kirchner might well have summered on Fehmarn Island off Denmark's Baltic coast with other Expressionists. However, the style and palette of the work suggested Kirchner painted it five years later when he spent much of his time in Switzerland. Furthermore, the knolls in *Dunes* resemble landlocked sand hills rather than dunes along a seacoast. Therefore, in 1967, MoMA changed the title to *Sand Hills in Engadin* (a region in the Swiss Alps) and dated it 1917–1918.

Fast forward to the early 2000s: The Washington Principles adopted in 1998 (see chapter 6) would encourage current owners of looted art to compensate legal rights holders or return stolen works. They established new attitudes toward looted art, and MoMA consequently published a list of approximately eight hundred artworks with potential World War II connections. Their entry on *Sand Hills in Engadine* identified Max Fischer as one of the former owners. This information electrified Eva and George Fischer—Anne and Ernst Fischer's daughter and son—who were searching for their Uncle Max's lost collection. They wondered whether MoMA's *Sand Hills in Engadin* was perhaps the same painting as *Sand Hills in Grünau* (near Berlin) their grandmother Rosy had listed in her 1925 catalog. The Fischer grandchildren engaged David Rowland, a restitution lawyer, who assembled an impressive file documenting Eva and George Fischer as the owners of their Uncle Max's painting. In 2004, however, MoMA dismissed the young Fischers' claim.

The Fischers persisted with their search, and eventually a MoMA researcher unearthed an antique postcard of the Müggel Hills in Grünau whose sand hills and fire tower matched up perfectly with the landscape depicted by Kirchner. It was our "[a]ha! moment," lawyer Rowland concluded. In 2015, MoMA graciously returned the work to Max Fischer's heirs, who decided the painting should join the family's collection at the VMFA. The museum consequently reverted the work to its original name: *Sand Hills in Grünau*.[10] Along with the Kirchner painting, George Fischer donated *South Seas Landscape* by Emil Nolde to the VMFA, one of the few pictures his uncle had been able to export from Germany.

Soon after the transfer of *Sand Hills in Grünau,* the Fischer children decreed that in future all works recovered from their Uncle Max's lost collection would become the property of the VMFA. In 2020, a German art collector attempted to sell a Kirchner painting that fit the description of one formerly belonging to Max. Further investigation confirmed Max as the

owner. Negotiations between the German seller and the VMFA subsequently yielded *Taunus Road,* completed in 1916, the same year Kirchner created *Sand Hills.* A VMFA press release on the acquisition conveyed that *Taunus Road* provides "[a] strong example of Kirchner's vibrant landscapes produced between 1915 and 1918, a period that scholars have described as Kirchner's 'crisis' years. He painted the scene in the midst of World War I, during his stay at the sanatorium in Königstein. . . . Paint is applied in thin, loose layers to the canvas, producing a quickly executed, dynamic work."[11]

Dealer and Collector Alfred Flechtheim

Alfred Flechtheim's beginning in the art trade mirrors that of Ludwig Schames. The Flechtheims were successful grain traders who expected their son to take charge of the firm. But Alfred, like Ludwig, was seduced by art. He once declared, "Art makes me crazy. A passion stronger than gambling, alcohol, or women. I'm possessed by Art. I gamble for the sake of Art, I'm drunk by Art. Art is everything to me, I am nothing compared to Art."[12]

Although he was gay, he agreed to marry Bertha (Betty) Goldschmidt, the daughter of a wealthy merchant, in 1910, to satisfy his parents. During their Paris honeymoon, he spent most of her large dowry on contemporary French art, buying works by George Braque, André Derain, and Pablo Picasso. He wrote to assuage his father-in-law's distress: "Don't worry, they'll double in value." Despite Flechtheim's sexual preferences, he and Betty seem to have had a satisfying, open relationship. Flechtheim became a prominent art collector. He operated galleries in Düsseldorf, Berlin, Vienna, Lucerne, Cologne, and Frankfurt. He published an influential magazine called *Der Querschnitt* (Cross Section) and adored publicity. His fiftieth birthday party was a major event.

French art was Flechtheim's great love, but his galleries handled German art, as well. He represented Max Beckmann, sometimes considered the most gifted of the German Expressionists, and George Grosz, politically the most vociferous. Flechtheim also trained dealer Curt Valentin, whose transcontinental career is explored in chapters 4 and 7. In the years after Flechtheim was forced to leave Germany, Valentin would become Beckmann's art dealer and helpmate.

Flechtheim could never decide whether he was primarily a gallerist or a collector. French contemporary art filled the walls of his private quarters, with Picasso a particular favorite. Indeed, Flechtheim lent many of his pieces to the Moderne Galerie Thannhauser in Munich, when it held one of Germany's early Picasso retrospectives in 1909. He collected German contemporary artwork, as well. Eighteen years later, when New York's two-year-old MoMA organized its groundbreaking *Modern German Paintings and Sculptures* exhibition, Flechtheim supplied 27 out of 123 works shown. On that occasion, Flechtheim gifted the museum Rudolf Belling's sculpture *Der Boxer (Max Schmeling),* depicting the celebrated German boxer.[13] Yet these achievements did not guarantee his financial success. The Great Depression bankrupted

the over-expanded Flechtheim, and he closed most of his satellite enterprises. While many German and French art dealers eventually managed to transfer their business from Europe to America, Flechtheim—a target of Nazi persecution—failed to do so and would die nearly penniless. In 1936 Alfred and Betty even divorced so she would not be liable for his debts.

Before his decline, however, Flechtheim was always the life of the party. He could charm and seduce, though some he incensed. In 1927 Jules Pascin, whose work he represented, painted his portrait as a glamorous toreador, a delightful likeness Flechtheim willed to the Musée National de l'Art Moderne in Paris. However, some German artists resented Flechtheim's penchant for French art, which they viewed—inaccurately—as a rejection of German art. For example, Otto Dix's unflattering 1926 portrayal, now hanging in Berlin's National Gallery, shows him as a moneygrubbing dealer. Of course, Flechtheim enraged the Nazis: his showmanship and Semitic features filled the Nazis with such loathing that they placed his unmistakable profile on posters for the 1937 *Degenerate Art* exhibition. Sculptor Rudolf Belling, on the other hand, found his nose so distinctive he rendered it in an abstract sculpture.

Nazi hatred for the dealer soon turned into a direct attack on his business: in March 1933, Nazi stormtroopers obstructed an auction of Flechtheim-owned works, holding a protest around his gallery that prevented the event from taking place. Alexander Vömel, his former business partner and a devout Nazi, Aryanized Flechtheim's gallery in Düsseldorf and appropriated the art. Flechtheim fled Germany. He hoped to settle in his beloved France, but during the 1930s few places welcomed homeless Jews. Virtually destitute, Flechtheim moved to London and sent pleading letters to former friends. To Museum of Modern Art director Alfred Barr he wrote that he had nothing left but "my name, my experience, my knowledge of nearly every French modern picture, [and] my connections in Europe."[14] Barr urged Abby Aldrich Rockefeller to purchase and gift to MoMA Wilhelm Lehmbruck's towering nude, *Standing Youth* (1913), one of Flechtheim's last possessions. She bought it in 1936, paying prevailing rock-bottom prices. Flechtheim suffered from diabetes, so when he slipped on the ice and injured his foot on a rusty nail, he contracted blood poisoning. His wife Betty flew to London to nurse him, but he died in St. Pancras Hospital in 1937. He was just fifty-nine years old.

Betty returned to Berlin. When she was ordered to report for deportation to the Minsk ghetto in 1941, she committed suicide with an overdose of barbiturates. The Reich confiscated the Flechtheims' possessions, but exactly what that comprised is still open to debate. Important paintings once owned or sold by Flechtheim are now distributed worldwide. Here are the titles of just a few:

- *The Aviator*: Fernand Léger, Cleveland Museum of Art
- *Red Villa Quarter*: Paul Klee, SF MOMA
- *Le Lapin Agile*: Pablo Picasso, Metropolitan Museum of Art

- *Two Poplars in the Alpilles at Saint Rémy*: Vincent van Gogh, Cleveland Museum of Art
- *Madame Cézanne in a Red Dress*: Paul Cézanne, São Paulo Museum of Art
- *Flechtheim as Toreador*: Jules Pascin, Centre Pompidou, Musée National d'Art Moderne, Paris
- *Portrait of Alfred Flechtheim*: by Otto Dix, National Galerie, Berlin
- *Viaduct at Estaque*: Georges Braque, Tel Aviv Museum
- *The Watering Place*: Pablo Picasso, Metropolitan Museum of Art
- *Soldatenbad*: E. L. Kirchner, Neue Galerie, New York
- *Woman with Pears*: Pablo Picasso, MoMA
- *The Boxer*: Rudolf Billings, MoMA
- *Standing Youth*: William Lehmbruck, MoMA
- *Kneeling Woman*: William Lehmbruck, MoMA
- *Lighthouse with Rotating Beam*: Paul Adolf Seehaus, Kunstmuseum Bonn
- *Joseph de Montesquiou-Fesensac*: Oskar Kokoschka, formerly Sweden's Moderna Museet

Collectors Alfred and Thekla Hess

Like the Fischers, Alfred and Thekla Hess were middle-class German Jews who became passionate about the art of their time. Thekla Pauson Hess came from the provincial town of Lichtenfels, where her family, like mine, dealt in wicker goods. Thekla's brother Stefan Pauson, like my Uncle Otto Bamberger, inherited the family business. Interestingly, both men collected contemporary art.

Alfred Hess, Stefan Pauson's brother-in-law, owned a major shoe factory in the city of Erfurt. He and Thekla began to purchase German Expressionist art. With the advice of Edwin Redslob, the knowledgeable director of the Erfurt Museum, and Walter Kaesbach, his successor, the Hesses soon assembled an impressive collection. It would ultimately comprise more than four thousand works. They befriended the artists whose work they acquired, and many spent their weekends at the Hess villa in Ehrfurt. The guests memorialized their visits in a small book that was eventually published in 1962. Colorful drawings, notes, and recollections by Paul Klee, Max Pechstein, Lyonel Feininger, Christian Rohlfs, Martin Buber, Lotte Lenya, and Kurt Weill fill the pages, attesting to the good time had by all.

Like Ernst Fischer, Hans Hess, the couple's only child, remembers crates filled with pictures constantly arriving at the Hess abode. Soon the house overflowed with art—the work of some artists occupied entire rooms. As in a museum, the Hesses repainted walls in different colors

to complement new acquisitions and rehung pictures according to the guest list. A Marc room featured yellow walls and a blue ceiling. Feininger, a particular favorite, and Kirchner had their own rooms, as well. Nolde, Pechstein, Schmidt-Rottluff, and Mueller shared the hall.

Today, the Hesses' best-known surviving painting is *Berlin Street Scene*, which Alfred bought between 1919 and 1922, either directly from Kirchner or from Ludwig Schames (Figure 2.3). It belongs to a series of more than eleven paintings, mostly created between 1913 and 1915, a period during which Kirchner felt particularly alienated and estranged. Many experts consider the Street Scene series to be the high point of the artist's career. The paintings portray fashionable women, often prostitutes, strolling along the streets of Dresden or Berlin. In 2008, MoMA's chief curator of prints and illustrated books, Deborah Wye, organized an exhibition titled *Kirchner and the Berlin Street*. For the first time the show brought together seven major paintings from the series. According to Wye, "Through a range of effects, these paintings present a complex view of the modern city. Created in a period of rapid change and development, they mark a distinct time not only in Kirchner's life, but also in the history of Berlin and of Germany as a whole."[15]

The Hesses' *Berlin Street Scene* depicts two prostitutes, one dressed in red, the other in blue. Their elongated faces, slashed with red lipstick, convey a haughty expression. Blue-garbed men in bowler hats, puffing on cigarettes, surround the women, one barring their way. Kirchner features strident tones and his imagery is hard-edged, almost savage.

The fame of the Hess collection spread, and art connoisseurs came to view it from all over Germany; though according to Hans Hess, not everyone praised this new "crazy" art, or even tolerated those who admired it. Bear in mind that Erfurt was in Thuringia, a strongly Nazi province, where animosity against Expressionist art was particularly intense.

Alfred Hess died suddenly in 1931, at fifty-two years of age, leaving his wife and son in difficult circumstances. By that time Hans worked as an editor for the publisher Ullstein Verlag in Berlin, and the Great Depression had left the finances of the Hess shoe factory in dire straits. For a while there was talk of selling the collection to settle company debts, but Thekla Hess managed to preserve most of her pictures. She moved back to the Pauson family home in Lichtenfels, where she befriended my Aunt Jetta. Amid the beauty of the Franconia landscape, the two widows discussed their art collections and the relative merits of Expressionist painters. Thekla Hess tried to convince my aunt to buy some pieces by Lyonel Feininger, but Jetta disliked his work and declined.[16]

In 1933, Ullstein Verlag fired Hans, who escaped to Paris, then continued on to England. He settled in London, unsuccessfully trying to support himself by writing articles about Nazi Germany. Thekla remained in Germany, determined to save her collection. During the following years she attempted to export it, but the hefty flight tax levied by the Nazis made this unfeasible. To circumvent this tax, Thekla eagerly accepted an invitation from the Bern Art Museum— the same institution that eighty years later would inherit Cornelius Gurlitt's ill-gotten goods— to mount a loan exhibition of German Expressionist art. She shipped seven crates filled with

fifty-eight oil paintings, including her *Berlin Street Scene*, and thirty-four works on paper to Switzerland. After the Bern show, the works moved on to the Zurich Art Museum. By 1936, the Nazis suspected Thekla of trying to spirit her art out of Germany and insisted that she repatriate the works. To preserve her own life, she agreed.

Reluctant to abandon her aging mother, Thekla Hess remained in Lichtenfels until after the *Kristallnacht* pogrom of November 9, 1938. The Nazis arrested her brother Stefan Pauson and sent him to the Dachau concentration camp, though a few weeks later, they released him, unharmed. At last, Thekla prepared to emigrate; she sold some artworks at radically reduced prices and hid a few others in the furniture she was allowed to ship to England. Resigned to losing the rest of her art, she reached England, as did the Pausons, before World War II broke out.

Prior to Thekla's departure from Germany, rumors had circulated among collectors that items from a major modern art collection were available for sale. In 1937, chemist and art collector Carl Hagemann acquired the Hesses' *Berlin Street Scene*. As an early enthusiast of Expressionist art, Hagemann had been a personal friend and longtime patron of Kirchner, first purchasing his work from Schames. Details of the transaction are lost, but it is known that Thekla Hess received no monetary compensation.

When Hagemann was fatally crushed by a streetcar just a few years later in November 1940, his siblings inherited his extensive collection: nearly 1,900 paintings, watercolors, sculptures, drawings, and prints, including about ninety paintings by the Brücke artists and other Expressionists. The collection remained their joint possession until 1948, when they divided it between them. To protect the "degenerate" works from Nazi plunder, Städel Museum director Ernst Holzinger hid the entire Hagemann collection in the Städel. After the war concluded, the Hagemann siblings thanked Holzinger by asking him to select a painting for himself from their brother's collection. He chose Kirchner's *Berlin Street Scene*, which he promptly lent to the Städel, where it remained on display for the next thirty-two years; its label read simply: "on loan from a private collector." While in the Städel's possession, *Berlin Street Scene* traveled widely to exhibits throughout Germany and abroad. In 1980 Holzinger's widow finally sold *Berlin Street Scene* to Berlin's Brücke Museum, which presented the painting to the public as one of German Expressionism's most important works.

In the years following World War II, Thekla and Hans Hess tried to recover portions of their collection with little success. After their deaths, the family's sole heir Anita Halpin (Thekla's granddaughter and Hans's daughter) continued the quest and, in the end, achieved extraordinary results partially based on a legal report she commissioned on the history of the *Berlin Street Scene* from two independent experts, historian Monika Tatzkow and lawyer Gunnar Schnabel. Halpin submitted the report to a special committee of the Berlin Senate House of Representatives. After lengthy deliberations and exploring alternative solutions, the committee awarded Halpin the painting in 2006. As part of the transaction, Halpin reimbursed the Brücke Museum approximately one million euros, the amount the museum had paid Holzinger's widow.

Figure 2.3 *Ernst Ludwig Kirchner,* Berlin Street Scene *(1913–1914). Mirroring the vitality of city life, this painting is often considered an icon of twentieth-century German Expressionism. Credit: Neue Galerie New York/Art Resource, NY*

Three months later, on November 8, 2006, Anita Halpin auctioned off *Berlin Street Scene* at Christies, where Ronald Lauder purchased it for his Neue Galerie in New York for $38.1 million, a record for a Kirchner painting. It is ironic that this fortune went to the sixty-two-year-old Halpin, who, as an ardent Communist—she had been the chair of the British Communist Party and nicknamed "Stalin's Granny"—was opposed to personal inheritance.

Halpin collected yet another million from the Neue Galerie when she proved that the museum also owned Karl Schmidt-Rottluff's *Nude*, another work looted from the Hess family. This work, too, had been shipped by Thekla Hess to Bern and Zürich and had disappeared on its return to Germany. It resurfaced there during the 1990s, and the Neue Galerie acquired it at auction for about $800,000. The museum returned it to Halpin and promptly repurchased it in September 2016.

Thanks to Hitler's war on modern art, a number of Kirchner's Street Scenes now reside in America. Ludwig Schames sold *Street, Berlin* (1913) to the National Galerie in Berlin in 1920. The Nazis confiscated the work in 1937 and exhibited it at the *Degenerate Art* exhibition in Munich before consigning it to dealer Karl Buchholz of Hitler's sales force. Buchholz passed it on to his associate Curt Valentin in New York, who sold it to MoMA. That institution displayed it at its 1939 *Art of Our Time* exhibition, celebrating MoMA's move to 53rd Street in Manhattan. In 1951, MoMA had also bought Kirchner's *Street, Dresden*, begun in 1908 and reworked until 1919. Embodying the isolation and anxiety of modern urban life, this work had remained with Kirchner in Switzerland and belonged to his estate when he committed suicide in 1938.

The Hess guest book survived the Holocaust, and in 1962 Hans Hess published it with the title *Thanks in Color*. Hess added his own memories of happy and dark times when the artists visiting his family's home in Ehrfurt were not as celebrated as they are today. He concludes with the following thoughts:

> The collection exists no more. Alfred Hess died in 1931 and soon thereafter his era—the era of the German Republic—was over. The new regime suppressed the German culture and exiled modern art. The guestbook was saved. Since its colorful pages, from the 1920s, with drawings and inscriptions of the many who once visited the house and whose names are now part of history, can now be published in Germany, it is proof of the lasting value of art. It survives the worst of times and does not abandon its right to be part of the historical record.[17]

The art world holds another memorial to the Hess and Pauson families, as well. When World War II began, the British took many enemy aliens into custody. They sent Hans Hess to Canada and allowed him to return to Britain in 1942, provided he would assist in the war effort. He therefore worked as a farm laborer in England's Midlands. To be near her son, Thekla moved from London to Leicester, where she soon struck up a friendship with Thomas Trevor, the gifted curator-director of the New Walk Museum.

Trevor had come to New York in 1938–1939 on a Rockefeller study grant and fallen in love with German contemporary art at the *Art in Our Time* and *Bauhaus 1919–1928* exhibits he had seen at MoMA. In 1944, with World War II still raging, Trevor mounted an exhibition of Mid-European art, consisting of sixty-two mainly German art works at the New Walk Museum. Thekla Hess and her brother Stefan loaned most of these works. Though Germany was still Britain's enemy at that time, the show proved a great success. At the exhibition's conclusion, the Leicester Museum acquired four of the artworks: *The Red Woman* by Franz Marc, *Behind the Church* by Lyonel Feininger, *The Mask* by Emil Nolde, and *View from My Window* by Max Pechstein. On a more personal level, Trevor managed to appoint Hans Hess as his art assistant, thereby releasing him from his farming duties.

More than half a century later, the story continues. In 2014 Peter Pauson donated the collection of his father Stefan Pauson to the New Walk Museum, demonstrating that even the most malevolent circumstances often bring about some good. Today the museum—now renamed the Leicester Museum and Art Gallery—owns five hundred pieces of German Expressionist art and its related styles, the largest collection of such works in the United Kingdom.

Before moving on from the Hess-Pausons, I cannot resist including a remarkable anecdote told to me by Sue Lupton, Robert Pauson's granddaughter, whom I met through a common acquaintance. When we discovered that we both were descendants of Jewish families who made wicker goods in Lichtenfels, the center of Germany's wicker industry, and that both our families collected modern art in rural Bavaria during the 1920s, Sue and I formed an immediate bond. She recounted the following story. (Since it took place over eighty years ago and has been passed down orally from one storyteller to the next, some details may not be totally accurate.)

To save their own lives in 1938, Thekla Hess and her brothers Robert and Stefan Pauson had to abandon their mother Rosa Pauson to her fate in Lichtenfels. On November 9, *Kristallnacht*, hoodlums ransacked her home. They grabbed a 1910 Lyonel Feininger painting titled *Street Scene at Dusk* from a wall and threw it out of a second-floor window. It landed on the spike of a fence, which damaged the work. Rosa perished during the Holocaust, but the painting survived.

During the occupation of Franconia by the US Army, an American soldier appropriated the disfigured painting and shipped it back to his home in America. Years later, a visitor to the soldier's house recognized Feininger as the artist of the work and contacted him. Feininger then persuaded the former soldier to return it to its rightful owners, the Pausons. Feininger repaired the painting himself and sent it back to England, where Sue Lupton's grandmother and mother met it at the boat.

By this time Sue's grandfather Robert Pauson was an elderly man. He had always been uncomfortable with his émigré status in Leicester and now insisted on returning to Germany, though his wife and daughter balked. Despite their protests, he left in 1959, taking the Feininger with him. He subsequently sold it to the Sprengel Museum in Hanover, my birth town.[18]

The Schames Legacy

The tales of the Fischers, the Hesses, and dealer Alfred Flechtheim have taken the story far from Ludwig Schames, an early admirer of Expressionist art; all these figures had come to share Schames's vision. Schames died in 1922, a dozen years before Facism would destroy his beloved world. To honor him, Kirchner published his 1918 woodcut of the dealer in Flechtheim's publication *Querschnitt* and wrote, "That was the art dealer Ludwig Schames, the fine and selfless friend of art and the artist. In the noblest fashion, he made it possible for myself and others to create and live. In him we lose the person who was like a good father, a true friend, a sensitive and understanding sponsor of the art of our time."[19]

After Schames's death, his nephew Manfred continued to operate the gallery. Manfred did not have his uncle's charm or artistic sensitivity, and sales dropped, especially during the Great Depression. Once the Nazis assumed power, they branded the Schames gallery a Jewish enterprise and declared many of its artists "degenerate." Artists withdrew their art from the gallery, and lecturers canceled their presentations. In 1933 the German authorities ordered Manfred to stop trading in art, and in October of that year, Manfred asked Kirchner to remove his canvases from the premises.

Manfred appears to have continued business from home until *Kristallnacht*. Like thousands of others, he was arrested during the pogrom but released after four weeks, and he reached Israel with his family in 1939. The authorities confiscated the Galerie Schames's remaining twenty-nine art works by Maurice Vlaminck, Otto Mueller, Erich Heckel, and E. L. Kirchner. After the war, when Manfred applied for reparations, the authorities claimed his records were incomplete and paid him a total of 60,000 DM. The gallery was no more, but the name of Ludwig Schames persists in provenance records as a supporter of an important art movement that had initially struggled for recognition with the art establishment.

Others of Ludwig Schames's nephews fared better. Born in Frankfurt in 1898, Samson Schames studied art at the city's famous Städel art academy, graduating in 1923. His explosive style attests to the influence of the German Expressionists as well as the Bauhaus, and he rapidly established himself as a set designer for productions at German and Jewish theaters. Early on, he began creating deeply emotional mosaics.

After the Nazis assumed power, they destroyed Samson Schames's career and most of his works. He and his wife lingered in Germany but finally managed to escape to England, where they briefly participated in London's emigrant art movement. In 1940–1941, the British interned Schames, along with thousands of other enemy alien refugees. These prisoners included scores of German Jews who had escaped to Great Britain and were no threat to the Allied cause.

Undaunted, Schames continued to create. Devoid of art supplies at the camp, he fabricated brushes from his own hair and paints from soot—the best black he ever used, he claimed—red

beet juice, and shoe polish. After his release to the Civil Defence Service, a civilian volunteer organization, Schames worked in London as a Fire Guard.[20] During off hours he created monumental mosaics incorporating irregular shards of glass and ceramic, hemp, screws, nails, and other "useless debris" from buildings destroyed during the German air Blitz. The artist's intense grief and despair, as well as his devotion to Judaism, are palpable in the few mosaics that survive from the 1940s: *Crown of Thorns, Kindling of Lights, Yellow Star, Execution, Promised Lebensraum,* and *Blowing the Shofar*. The power, harmony, and effective coloration of these images is particularly remarkable, considering their fabrication from haphazard materials.

Eventually Samson Schames relocated to the United States. Once more he rekindled his career, produced mosaics and stained-glass windows, presented four one-man shows at New York's Jewish Theological Seminary, and contributed art to Congregation Habonim, founded by German-Jewish Exiles in Manhattan. Today Yeshiva University Museum owns six of his mosaics, The Jewish Museum in Frankfurt holds two, and the Leo Baeck Institute in Manhattan possesses one. The search for others is on. Devoted to the history of German-speaking Jews, the Leo Baeck Institute produced a short film on Samson Schames in 2019, emphasizing the contemporary relevance of his art—they hope to one day exhibit his mosaics all together.

By 1922 Expressionism had become widely accepted by the art community. Dozens of art dealers handled modern art in Germany; museums and collectors vied for paintings, sculptures, and works on paper. But when the Nazis came to power eleven years later, the bubble burst. For the initial four years of their control (1933–1937), they contented themselves with merely vilifying the art; but by 1937, their attacks became physical, from plunder to outright destruction. At first, the Nazis mostly targeted Germany's magnificent art museums, many of which had embraced modern and Expressionist art during the early part of the twentieth century, to confiscate "undesirable" art. In the next chapter, I turn to the Nazis' loathsome policies that would bring these great institutions to their knees.

3

The Nazis Cleanse Their Museums

I was eight when the Nazis assumed absolute power in Germany. The takeover that would change the world was masterfully—and legally—executed. Years before, in October 1918, Germany had first looked to the United States to negotiate an armistice that would end the disastrous World War I. But the task would fall to the Allied Forces' Commander Marshal Ferdinand Foch. Following weeks of diplomacy, an armistice was signed on November 11, and hostilities ceased.[1] In November 1918, Germany forced Kaiser Wilhelm II to abdicate the throne, then in 1919 it established a democratic Weimar Republic; the people duly elected a president, chancellor, and a parliament (*Reichstag*, in German) to take over the reins of government. During its thirteen years, the Weimar Republic faced troubled waters: postwar starvation, unemployment, hyperinflation, and the payment of exorbitant war reparations imposed by the Versailles peace treaty. In addition, there was political infighting, a worldwide influenza epidemic, and an economic depression.

Despite Germany's many predicaments, its scientific and cultural achievements during the Weimar period were remarkable. The accomplishments of Jewish scientists, such as Albert Einstein, were particularly noteworthy. Jews won 24 percent of Germany's Nobel prizes, even though the Jewish community represented just three-quarters of a percent of the German people.[2] The arts, too, saw prodigious output, with impressive works created by writers, filmmakers, musicians, and visual artists. Second only to Paris, Berlin became the art capital of the world.

Politically, however, the Germans were restless, especially the unemployed and other dispossessed. The country was afraid of a Communist takeover, and numerous political factions took root: among them, a small, initially insignificant far-right group, going by the acronym "Nazi" (the National Socialist German Workers Party), was particularly boisterous. In 1919 a young Adolf Hitler attended a meeting of a handful of these men who, like him, were filled with rage at the current state of affairs.[3] Hitler's oratorical skills quickly became apparent, and he was asked to join the executive committee. He and his associates proved exceptionally skillful at

promoting the organization. From the very beginning, the Nazi Party proclaimed its aims loudly and clearly. Its program included establishing a rigid dictatorship, strengthening national bonds between the members of the former German Federation, abrogating the terms of the Treaty of Versailles, rearming Germany, vanquishing Jews and other "inferior" races, eliminating the Communist threat, and cleansing the German culture.

The rise of the Nazi Party was swift. In 1928, it obtained only 2.6 percent of the vote, entitling it to twelve parliamentary seats. By 1930, the party had won 18.3 percent and 107 seats, and by July 1932, it scored 37.4 percent or 230 seats, making it Germany's largest political party.[4]

The rise in party membership paralleled the Nazis' political clout. Members infiltrated the police, provoked unrest and confrontation with both Jews and Communists, and terrorized those opposed to Nazi doctrine. *Cabaret*, the popular musical based on Christopher Isherwood's *Berlin Stories*, perfectly illustrates the oppressive atmosphere, police raids, and fear that poisoned life in Germany during the years that preceded the Nazi takeover.

Even though the Nazi Party did not hold a majority, Paul von Hindenburg, a World War I hero and president of the Weimar Republic, made Hitler chancellor on January 30, 1933. A month later, a fire attributed to an arsonist burned down the Reichstag building. The ill-fated Marinus van der Lubbe, an unemployed Dutch construction worker found with lighters in his possession, was arrested and tried along with several trumped-up associates. Lubbe confessed and was beheaded. He was pardoned seventy-five years later in 2008.[5]

The Nazis most likely had a hand in setting the Reichstag on fire. They certainly exploited the event. As a result of the fire, Hitler convinced Hindenburg to issue the Enabling Act, an emergency decree suspending most civil liberties in Germany, including free expression, freedom of the press, proper assembly, and protection from home searches. These rights remained suppressed for twelve years.[6] Other decrees permitting the chancellor to take action without the Reichstag's consent soon followed. Germany effectively became a dictatorship.

At eight years old, I had little comprehension of the enormity of the change that had befallen my birthland, but I recognized the gravity. I absorbed my parents' anxiety about Hitler: I still can "hear" his hysterical harangues blasting from the radio in our peaceful Hanover home. As previously mentioned, my politically active Uncle Otto Bamberger had been arrested; though quickly released thanks to my Aunt Jetta's intervention, he died of the ensuing stress.

By and large, the German population quickly accepted Hitler and complied with the Nazis' hate-filled demands. Compared with the atrocities ahead, these initial requirements were pretty minor. Nevertheless, I noticed that the attitude of some children toward me changed. At first, I did not know why. A group of boys my age scared me on my way to school, but I still believed that it was ordinary bullying rather than mere antisemitism.

The Jews were the Nazis' first target. Within months of Hitler's ascent, antisemitic laws began to go into effect across Germany. Schools and universities dismissed Jewish teachers and professors. They also instituted a strict Jewish quota. New regulations disbarred Jewish lawyers,

restricted the practice of Jewish physicians, and convinced respectable enterprises to fire their Jewish employees. Fortunately, most breadwinners in my family owned their businesses, so their income remained unaffected for some years.

"Degenerate" Art and Göbbels's Manifesto

The Nazis also lost no time in curtailing Germany's thriving cultural life. On May 10, 1933, Joseph Göbbels, the minister of propaganda and public enlightenment, organized a massive burning of twenty-five thousand books at the Berlin firehouse in front of forty thousand spectators.[7] However, it was the visual arts the new regime regarded with particular attention, as Hitler considered himself an artist and connoisseur. Decades earlier, in 1907 and 1908, Hitler had unsuccessfully applied to the Academy of Fine Arts in Vienna and still smarted from the school's rejection. During his Vienna years, he barely managed to support himself by illustrating postcards with landscapes and street scenes. (Ironically, his surviving paintings now sell at premium prices).[8] Once Hitler rose in power, collecting art became for him—and hence for the upper echelons of his party—a passion that fueled massive looting.

Hitler had definite artistic tastes. He admired specific traditional genres but was enraged by modern art, which the Nazis described as "degenerate." This term was coined initially by Max Nordau (1849–1923), a Jewish physician, Zionist leader, author, and social critic; in his treatise *Degeneration* (1892), Nordau applied the term to images of ailing individuals whose bodies were deformed or otherwise deviant from the norm. Nordau felt that artists who exploited such appearances in their work had lost self-control and suffered from mental illness. He believed their affliction resulted from rapid urbanization and similar stressful conditions. The Nazis adopted this idea of degeneracy as a key tenet of their philosophy—astonishingly, from a member of the race they so despised.

Hitler instinctively hated modern art, but according to Frederic Spotts, author of *Hitler and the Power of Aesthetics*, he had difficulty rationalizing why. During one of his early speeches, he likened modern artists to "incompetents and charlatans." As Spotts explains, Hitler believed that "Cubists, Futurists, and Dadaists" were "saboteurs of art, either imbeciles or shrewd impostors, sensationalists, plasterers, and canvas smearers." Hitler hated ugliness and believed "that it was not the function of art to wallow in dirt for dirt's sake" or to draw "cretins as a symbol of motherhood."[9] He had also declared that degenerate art was the product of Jews and Bolsheviks and a threat to the German national identity. Since Hitler was often inconsistent, some experts have suggested that his criterion for acceptable art was simply art that Hitler liked.

In 1933, Joseph Göbbels published a five-point manifesto, reproduced below (with notes from Stephanie Barron, author of *"Degenerate Art"*). These guidelines henceforth governed the attitude of museum directors and artists toward modern art:[10]

Manifesto:

- All works of a cosmopolitan and Bolshevist nature should be removed from German museums and collections, but first they should be exhibited to the public, who should be informed of the details of their acquisition, and then burned.
- All museum directors who "wasted" public money by purchasing "un-German" art should be fired immediately.
- No artist with Marxist or Bolshevist connections should be mentioned henceforth.
- No boxlike buildings should be built [an assault on Bauhaus architecture].
- All public sculptures not "approved" by the German public should be immediately removed [this applied especially to Barlach and Wilhelm Lehmbruck].

It took four years for the Nazis to implement the first point of the Manifesto—removing museums' unacceptable art, then displaying, and destroying it; but they executed the second—firing directors who purchased "un-German" art—immediately. Ludwig Justi, Georg Swarzenski, and Hans Posse were among the many museum directors affected by this measure. At first, Justi and Swarzenski stayed in lesser positions rather than leave their beloved art institutions entirely. Ludwig Justi of the Berlin Nationalgalerie did not fight the authorities' verdict that cost him his directorship; he continued at the museum in a lower capacity and, after the war, was reinstated to his rightful post. He even assembled a new modern art collection. Georg Swarzenski's story had a different outcome: he managed to continue at the Städel Museum until December 1938, but by then, the board had no choice but to force the Jewish director's resignation.

Hans Posse was shocked to learn that, as director of the Dresden Gemäldegalerie, he was charged with the alleged "crimes" of supporting the avant-garde artists of the groundbreaking Brücke Group, founded in Dresden in 1905, and sponsoring Oskar Kokoschka, an Expressionist who taught at the Dresden Academy of Fine Arts. Posse also purchased several "degenerate" paintings, including Ernst Ludwig Kirchner's *Street Scene in Front of the Hair Salon*, painted in 1926. Seven years later, with the Nazis in control, Posse's politically opportunistic colleagues used these "transgressions" to try to have him dismissed. Posse fought back, stressing that only 33 of the 310 artworks he purchased as director were produced after 1910; indeed, in 1937, when the Nazis confiscated mass quantities of "degenerate" artworks, Dresden's museum possessed only fifty-six such objectionable paintings, a minimal number compared to other institutions.

The Nazis would sell *Street Scene in Front of a Hair Salon* to Curt Valentin, an art dealer who played a significant role in transferring confiscated art to the United States. Many decades later, the painting would resurface at a Christie's auction in London in 2008, where yet another art dealer acquired it; finally, in 2016, patrons of Dresden's museum repurchased the Kirchner and returned it to the collection.[11]

Despite Posse's alleged missteps, Hitler asked him to acquire art for his dream museum in Linz, Austria (see chapter 6). Posse's performance in this role delighted the führer, who reappointed him as director of the Dresden Gemäldegalerie. Posse's story comes full circle, a reminder that this turncoat director, who initially recognized the genius of the young Kokoschka, Kirchner, and the German Expressionists, would later betray them to save his career.

George Grosz and *Eclipse of the Sun*

Many targeted art professionals left Germany immediately. One was George Grosz, a founder of the Berlin Dada movement, whose political cartoons had mocked the rising Nazi Party. He was even briefly a Communist, but the Nazis considered him "Cultural Bolshevist Number One" for the content of his art.[12] Even before the Nazis officially assumed power, Grosz eagerly accepted an offer by the New York Art Students League in 1932. Grosz taught part time at the school until the late 1950s. He lived first in New York and, in 1947, moved to the small town of Huntington, Long Island. During his years in America, the painter influenced the work of Romare Bearden, Ben Shahn, and William Gropper.

When Grosz fled to America in 1932, he brought the oversized painting *Eclipse of the Sun*, a seven-by-six-foot Dada oil he had created in Berlin (Figure 3.1). The painting depicts a medal-emblazoned President Paul von Hindenburg, the World War I hero and president of the Weimar Republic. Whispering into Hindenburg's ear is a warmongering "man of industry," bearing a load of weapons under his arm.[13] They share a felt-covered gaming table with four neatly dressed headless financiers. Standing upon a board on the table is a sweet donkey wearing blinders, but, ominously, this board is tied to a skeleton below. Meanwhile, blocking out the sun is a large dollar sign—the "eclipse"—of America's aid to Germany after WWI. In this complex work, "Grosz vividly captures the rampant political and social corruption that characterized Germany in the mid-1920s. . . . It offers a microcosm of the Weimar Republic, alluding to the competing interests that struggled to control the fledgling democracy."[14]

The path of this now iconic painting to the Heckscher Museum in Huntington is a bit of a mystery. According to Sabine Rewald, Curator Emerita at the Metropolitan Museum of Art,[15] Grosz may have sold *The Eclipse* to a colleague at the Art Students League, who eventually used it to pay an outstanding bill of $104 he owed Thomas Constantine, his house painter. Constantine left it rolled up for years. He attempted to sell the work to various museums when he learned that Grosz was a known entity. In 1968, the Heckscher Museum agreed to buy it for $15,000, funded by public donations from 213 residents and even Governor Nelson A. Rockefeller.[16] Later, when the institution intended to sell the painting to raise funds for an expansion,[17] the community protested, so the Heckscher desisted.

Figure 3.1 *Georg Grosz,* Eclipse of the Sun *(1926). Regarded a masterpiece of political art, the painting satirizes the greed and corruption of the Weimar Republic. It arrived in the United States in 1932 with an asylum-seeking Grosz. Credit: The Heckscher Museum of Art, Huntington, NY, Museum Purchase, 1968. © 2025 Estate of George Grosz/Licensed by VAGA at Artists Rights Society (ARS), NY*

Eclipse of the Sun is a scathing indictment of the military-industrial complex's promotion of war. Grosz would have been delighted to know that during the anti–Vietnam War protests, *Eclipse* became an object of pilgrimage. Today, the painting is often on the road. In 2019, it was the centerpiece of an exhibition titled *Eclipse of the Sun: Art of the Weimar Republic* at New York's Neue Galerie.

In September 1933, the first year of the Nazi reign, Joseph Göbbels created the Reich Chamber of Culture to regulate the country's cultural activities. The chamber was subdivided into seven subgroups, each overseeing a different discipline: visual arts, sculpture, music, film, and so on.

The Reich Chamber of Visual Arts had specific artistic directives: to promote wholesomeness, heroism, motherhood, and peasantry and to repress "degenerate" art, as well as art created by Bolshevists and Jews. Initially, the Chamber admitted forty-two thousand members, who were allowed to teach, paint, exhibit, and sell their work.[18]

Artists classified as "degenerate" could not join; some were even forbidden to paint. The Gestapo enforced adherence to the chamber's regulations by surprise visits to artists' studios. Some nevertheless continued to paint clandestinely. Emil Nolde, a leading Expressionist, was also an ardent Nazi; however, the Nazis disapproved of his art and forbade him to buy paints or canvas. Nolde, therefore, created what he called "unpainted pictures"—small watercolors on paper. Unlike oils, watercolors have no scent that would give him away.

Some artists denied membership survived through alternative forms of work. Oskar Schemmer, another successful Expressionist, camouflaged military buildings for the German army. Architect and former Bauhaus student Franz Ehrlich was imprisoned by the Nazis; as a forced laborer, he designed the gates at the Buchenwald concentration camp, which display the motto "To Each His Own," but defiantly used Bauhaus-style lettering.

While modernists persisted on the fringes, the Nazi faction of the German art world embraced Hitler's anti-modern art campaign. Even before the Nazis mounted the major show of "cosmopolitan and Bolshevist" works announced in their manifesto, various groups publicized the dangerous nature of "degenerate" art. On April 4, two months after Hitler became Germany's chancellor, the Kunsthalle Mannheim opened a so-called Chamber of Horrors (*Schreckenskammer*); this exhibit of sixty degenerate works by more than two dozen artists allegedly demonstrated the Judeo-Bolshevic threat of these images. Similar events followed in several other cities, including Mannheim, Karlsruhe, Nuremberg, Chemnitz, Stuttgart, Dessau, Ulm, Dresden, Breslau, and Halle an der Saale.[19]

MoMA's Alfred Barr Visits Germany

The United States took little note of the cultural changes occurring in Germany. However, it had a key witness on site: Alfred Barr, the legendary founding director of New York's Museum of Modern Art. Since 1929, he had tirelessly shaped the new museum. After three years of work, this fragile perfectionist was suffering from severe insomnia and other symptoms of exhaustion. He gradually became so overwrought that Abby Rockefeller and other key figures at MoMA decided he should take a sabbatical.

In September 1932, Alfred and his wife Marga took off for Europe. They first visited Marga's family in Italy, then traveled to Switzerland to learn skiing; after a six-week course, they grew bored and were ready to move on. As Barr's insomnia persisted, a fellow skier recommended the treatment of Dr. Otto Garth, who was practicing in Stuttgart, Germany. Considering

Alfred's fondness for the Bauhaus and contemporary German art, the Barrs eagerly took their new friend's suggestion. They anticipated a pleasant stay in this midsize town of four hundred thousand inhabitants, a dozen museums, several theaters, an excellent opera house, a profusion of concerts, and notable modern architecture.[20]

However, in the spring of 1933, Stuttgart, like the rest of Germany, was not the place for a modern art aficionado. Hitler had just assumed power, and the Nazis were quickly imposing their cultural tastes. Out of curiosity, the Barrs attended a meeting of the new *Kampfbund für deutsche Kultur* (Association for the Assertion of German Culture) in an auditorium filled with painters, sculptors, musicians, architects, teachers, critics, and many other cultural leaders. At the meeting—a prime example of the prevailing indoctrination sweeping the nation—the organizers gave the audience a voluminous tome defining eleven new guidelines that would govern German culture.

The Barrs lasted four months in Stuttgart; disgusted by the constant parades and ever-present Nazi propaganda, they left Germany for Ascona, Switzerland. Barr wrote four articles about the catastrophe that had befallen German culture. Even in hindsight, Barr's prose is chilling.

> The flag and flagpole merchants did an enormous business; the swastika was everywhere.... The surviving newspapers resounded with the glory of the National Resurgence. Rathenau Street, named for a Social Democrat murdered by the Nazis in 1922, was renamed Göring Street; postcards of the Leader, grim of face, his arm raised in the Fascist salute, spoke from all shop windows; and there were parades night and day. In the evening, one heard from every other house the strained voices of Hitler or Goebbels shouting into a Berlin microphone.[21]

Barr goes on to describe how, on March 1, 1933, the regional Würtemberg Art Club in Stuttgart organized a retrospective exhibit of paintings by its native son, Oskar Schlemmer, a former Bauhaus teacher and creator of the Folkwang Museum's fountain court frescos. Schlemmer's show in Stuttgart was a disaster. Kowtowing to Nazi ideology, the art critics panned it. As Barr reported, one critic urged his readers to visit the show so that "they could witness art-Bolshevism for the last time." Another art critic, writing for the *National-Sozialistische Kurier*, rhetorically asked his readers:

> Who takes these pictures seriously? Who respects them? Who wants to defend them as works of art? They are unfinished in every respect. One may say that in their decadent spiritual attitude, they might as well be left on the junk heap where they could rot away unhindered. It is certainly no accident that Oskar Schlemmer belonged to the graveyard of the Dessau Bauhaus and the Breslau Academy.[22]

After reading the newspaper reviews, the Stuttgart Art Club hastily moved the Schlemmer exhibit to restricted quarters and closed the show. To spite the Nazis, Alfred Barr asked architect Philip Johnson to buy Schlemmer's *Bauhaus Stairway* from the exhibition (Figure 3.2). Nine

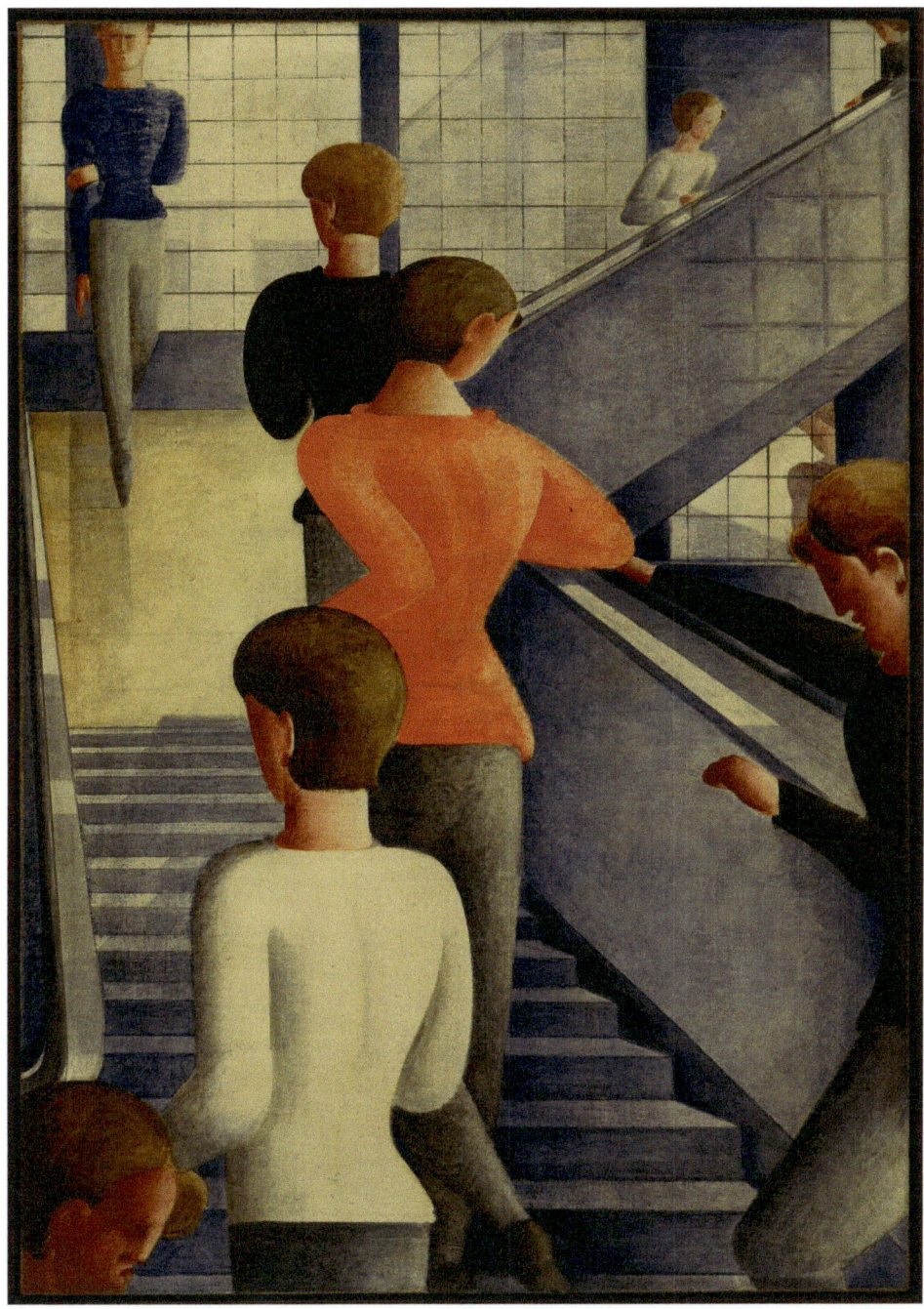

Figure 3.2 *Oscar Schlemmer,* The Bauhaus Stairway *(1932). A group of stylized figures ascends a precisely drawn staircase in Schlemmer's depiction of the Bauhaus school. The painting marks the end of an era; in 1933, the Nazis closed the Bauhaus. At the request of Alfred Barr, Philip Johnson bought the work in Germany and eventually donated it to MoMA. Credit: Digital Image © The Museum of Modern Art/Licensed by SCALA/Art Resource, NY*

years later, Johnson donated the picture to MoMA, where Schlemmer's stylized figures have been viewed by the public ever since. The backward glance of one of the figures on the staircase has been interpreted as a farewell to what she leaves behind.[23]

Barr had hoped that a major US news outlet would publish his articles, but, except for the one discussing music picked up by Harvard's small publication *The Hound & Horn*, America's press turned a deaf ear to Barr's cautionary writing about Germany's plight. Barr tossed his articles in a drawer and forgot about them. In 1945, a dozen years later, the *Magazine of Art* finally published the material, though, by then, its content was no longer breaking news. Barr illustrated the article with reproductions of eight confiscated artworks, which by then hung in American museums.[24]

The Nazis had a somewhat sporadic approach to their violence against modern art until after the 1936 Olympics summer games in Berlin; during the festivities in Berlin's brand-new stadium, the Nazis also camouflaged other repressive measures, including their vicious antisemitism. The numerous signs declaring "Jews unwanted," recently posted at restaurants, swimming pools, on park benches, and other venues, were temporarily removed.[25] Newspapers toned down their virulent articles about Jews and "degenerate" art, and museums displayed some of their modern art. It would be those artworks' last hurrah.

With some exceptions, most of the art that displeased the Nazis remained on exhibition in state-owned museums until 1937, though it may have been moved to out-of-the-way galleries. Adherence to Nazi policies depended on individual circumstances. Private institutions like the Kestner Society continued to exhibit "degenerate" art.

Alfred Rosenberg, the Nazis' chief philosopher, and Joseph Göbbels, the Reich's minister of propaganda and public enlightenment, shared the task of enforcing Hitler's art policies. The two men disagreed about the exact nature of banned and acceptable art, which may have caused the delay in cleansing the museums. Rosenberg was the more intolerant of the two, favoring so-called *völkisch* (populist) art, characterized by natural colors and traditional perspective, created by artists with Nordic roots. Göbbels, however, actually appreciated some Expressionist art. During the early 1930s, paintings by Emil Nolde and sculptures by Ernst Barlach had decorated Göbbels's Berlin home.[26] He felt that the vigor and chaos of Expressionist art mirrored the robust spirit of the *Hitler Jugend* (Nazi youth movement).

By 1937, the more rigid, conservative faction of the party gained dominance, causing the more liberal wing to pull back. Göbbels's artistic judgment was overruled, and he became an enthusiastic proponent of cultural cleansing instead. It was now time for the Nazis to execute the first point of their cultural manifesto: "All works of a cosmopolitan and Bolshevist nature should

be removed from German museums and collections." Also declared by this same point: they would first put on a mammoth shaming exhibit. Joseph Göbbels appointed Adolf Ziegler, an early Nazi and a sometime head of the Reich's Chamber of Visual Arts, to carry out these tasks.

Ziegler was one of Hitler's favorite painters.[27] His style was academic. He favored "racially pure," perfectly proportioned though oddly asexual female nudes rendered in flesh-colored pink. His women were so carefully executed that their creator was dubbed "the German master of the pubic hair." Hitler acquired several of Ziegler's masterpieces, including the *Four Elements* and *The Judgment of Paris*, for his Munich residences. To remind museum visitors of the führer's kitschy taste, the Neue Galerie in New York City included the *Four Elements* in its 2014 commemoration of the original historic exhibit of "degenerate" art.

The *Degenerate Art* Exhibition

The *Degenerate Art* exhibition opened July 19, 1937. It had taken Ziegler and his committee of five a mere six weeks to confiscate a sufficiently substantial quantity (the precise number is unknown) of potential artworks for the show; from these, they selected 650 works by 120 artists to hang in the former Institute of Archaeology in Munich. During the opening ceremonies, Hitler declared a merciless war against Germany's "cultural disintegration." Though the Nazis denigrated this art, the exhibition may very well have been the most popular art show ever. Each day, long lines formed at its entrance. Daily attendance averaged twenty thousand, and by the end of November, a total of 2 million visitors had seen it.

Though not the first of such "horror shows," the Munich *Degenerate Art* show was much larger and more complex. It also became the best-remembered event of Hitler's war against art. In 1991, Stephanie Barron, a senior curator at the Los Angeles Museum of Art, recreated the *Degenerate Art* exhibition with venues in Los Angeles and Chicago and published a massive catalog *"Degenerate Art": The Fate of the Avant-Garde in Nazi Germany* that offers extraordinary detail about the show, as well as other information about this deplorable chapter of art history.[28] The book memorializes the ridiculed artists, citing their statements and reproducing their work. In stark terms, Barron and her coauthors specify the fate of each picture and sculpture: destroyed, location unknown, privately owned, or belonging to a museum. Many of the works look familiar because they managed to survive the Holocaust. According to Barron, the following now reside in US museums:

- Max Beckmann: *Descent from the Cross*, MoMA
- Max Beckmann: *Christ and the Adulterous Woman*, SLAM
- Marc Chagall: *Village Scene*, Philadelphia Museum of Art
- Lyonel Feininger: *Street of Barns*, NGA

- Lyonel Feininger: *Portfolio of Twelve Woodcuts*, Philadelphia Museum of Art
- Ernst Ludwig Kirchner: *Street Scenes*, MoMA
- Paul Klee: *Around the Fish*, MoMA
- Paul Klee: *The Twittering Machine*, MoMA
- Emil Nolde: *Nudes and Eunuch: The Keeper of the Harem*, The Sidney and Lois Eskenazi Museum of Art[29]
- Emil Nolde: *Woman of Mixed Race*, Harvard Art Museums

In the entrance lobby of the Munich exhibit, Otto Freundlich's *Monumental Head* greeted visitors. This 4.7-foot sculpture, perhaps inspired by Easter Island's mysterious figures and Picasso's mask-like paintings, set the brutal tenor of the show. Freundlich was a German abstract artist residing mainly in France. Posters for the show as well as the cover of the catalog depicted Freundlich's head;[30] the poster design also included a caricature of the profile of dealer Alfred Flechtheim, whom the Nazis viewed as the Judeo-Bolshevik embodiment of modern art.

By design, the art was sloppily displayed. Unframed pictures were crowded wallpaper-style and surrounded by hostile slogans with Nazi interpretations, such as "Insult to German Womanhood," "Defamation," "Crazy at any Price," "Dada," "Mockery of the Divine," or "German Peasants—a Jiddish View." Quotes from speeches by Hitler and Göbbels reinforced the messages.

Individual labels affixed next to each artwork listed the artist's name, the work's title, the date of its creation, and its provenance. Additional information provided the acquisition price, emphasizing the improvidence of the purchase. These prices seemed extravagantly high since many of the artworks had been acquired during Germany's hyperinflation.

Today, most audiences are accustomed to modern and Expressionist art. But in 1937, many people still reacted negatively to works such as Oscar Kokoschka's eerie *Bride of the Wind*, Wilhelm Lehmbruck's angular *Kneeling Woman*, Emil Nolde's vibrant *Woman of Mixed Race*, or Ernst Ludwig Kirchner's provocative *Street Scenes*. Some visitors laughed, some were indignant, and some came to view this art, perhaps regretfully, for the last time. Others were enthused, like Bernard Sprengel, a Hanover chocolate manufacturer, or Peter Guenther, a high-school student. Even though it was illegal, Sprengel was so impressed by Nolde and other artists that he began collecting modern art.

Eyewitness accounts of those who attended the Munich *Degenerate Art* exhibition are hard to come by. Still, Peter Guenther, then just seventeen years old, recalled his experience some fifty-four years later in a moving essay titled "Three Days in Munich, July 1937."[31] Guenther's father was an art critic, so his son was already familiar with modern art and greatly admired the genre. Reproductions of van Gogh's *Sunflowers* and of Franz Marc's *Blue Horse* hung in his childhood room.

Organizers of the show forbade visitors under age eighteen from entering the exhibit, because they felt the images on view might damage children's delicate psyche. But underage Guenther managed to sneak in. He recollected,

> Specific details have faded, but the shock, dismay and sadness I experienced during my visit are as vivid as if it happened just a short while ago. In the first room I was overwhelmed by the brilliant colors of several paintings by Emil Nolde, including the nine panels of his *Life of Christ*. Again it was obvious to me that the artist, by his choice of these flaming colors and the deformation of the figures, had tried to remove the events of Christ's life from the standard accepted depiction, and force the viewer to gain a new insight into these events.

Peter Guenther was particularly moved by the emaciated body of Louis Gies's *Crucified Christ*, formerly part of a war memorial in the Lübeck Cathedral. Guenther reflected, "My good, sensible pastor might not have liked these representations, but at least would have recognized the artist's attempt to break away from the sweetness and sentimentality that had been adopted for so much of Christian art." To Guenther, the deformed figure of Christ perfectly illustrated the inhumanity of war. Gunther recalled seeing Oskar Kokoschka's *Bride of the Wind*, Lovis Corinth's *Ecce Homo* (now both at the Basel Art Museum), Lyonel Feininger's *Hopfengarten* (now at the Minneapolis Institute of Art), and Alex Jawlensky's *Head* (now in a private collection in Houston). He was disturbed by the reaction of the other visitors, who seemed to agree with the derogatory slogans posted throughout the exhibit.

After his second visit to the exhibit, Guenther was distressed that the creators of this moving art had been "placed in the pillory." He did not realize then that most of the exhibited artists had been forced to emigrate, were forbidden to paint, or had lost their livelihoods. He wished he could express his dismay but realized that "a seventeen-year-old in Germany in 1937 did not challenge the opinions of his elders, especially in the atmosphere of disdain, hostility and latent anger created by the organizers of the Degenerate Art Exhibit." Eventually Peter Guenther joined Germany's brain drain, emigrating to the United States and teaching art at the University of Houston.

After two months in Munich, the *Degenerate Art* show toured Germany and Austria for four years. Although its content varied over time, the adverse reaction of most visitors remained the same. After the show closed, its artworks were stored. Sales of "degenerate art" abroad began in 1938, with the better-known artworks selling first.[32]

The Nazi authorities had paired the *Degenerate Art* exhibition with the first carefully curated annual art exhibitions in the newly built *Haus der Deutschen Kunst* (House of German Art). It was the first building the newly elected Hitler had commissioned in 1933. After its completion, the neoclassic art temple was irreverently nicknamed "Palazzo Kitschi" or "Munich's Art Terminal."[33]

The German Art Show intended to contrast brilliantly with the *Degenerate Art* exhibition located almost across the street, but to the Nazis' embarrassment, its insipid art proved

unpopular. Idealized nude statues inspired by Greek and Roman art, portraits of the führer, and genre paintings featuring motherhood, farm life, or heroism filled the galleries. The images lacked passion and focus and were highly forgettable.

Mounting the *Degenerate Art* show was not Ziegler's only assignment. Confiscation of any offending art from Germany's museums came next. Institutions whose leadership agreed with Nazi philosophy had already started to dispose of their offensive art before 1937, but now matters accelerated. As instructed by Hitler, Göbbels empowered Ziegler on July 27, 1937, to impound "degenerate art" from museums, galleries, and collections owned by the Reich, the individual regions, or the local communities. By October 1937, Ziegler, aided by various confiscation committees, had seized about twenty thousand modern artworks from about a hundred institutions.[34] (Again, the precise number has never been determined.) Of these twenty thousand, about five thousand works would be incinerated "on 20 March 1939 in a secret bonfire—quite unlike the public book burning of 1933." The remaining works would be sold or "remain in storage, out of public view, until the war's end."[35]

The confiscations of art hit certain museums with particular severity. The Folkwang Museum in Essen lost about 1,200 works; the Kunsthalle Hamburg about 1,300; and the Kunsthalle Mannheim about 600. The appropriated items included paintings by Vincent van Gogh, Paul Cézanne, and Henri Matisse and prominent German contemporary works by Max Liebermann, Max Beckmann, Ernst Ludwig Kirchner, and Wassily Kandinsky. A retroactive law passed on May 31, 1938, decreed that the museums whose art had been seized receive no compensation.

Georg Swarzenski and the *Portrait of Dr. Gachet*

For the pre-Nazi-era museum staff who survived the purges, the emotional grief of surrendering their cultural possessions was immensely more significant than the financial loss. Georg Swarzenski of the Städel Museum in Frankfurt provides a good example of such art professionals' suffering.

Adolph Hanns Swarzenski, Georg's father, was a prosperous Dresden merchant. Instead of joining the family business, Georg elected to study medieval art and embarked on a brilliant career. In 1906, the town of Frankfurt appointed him director of its Städelisches Kunstinstitut. Swarzenski's jurisdiction rapidly expanded, and soon he oversaw several of the city's art institutions. One of his more pleasant tasks was to expand their collections, predominantly filled with old masters. Swarzenski enthusiastically purchased modern and contemporary art, including works by local artists. He favored pieces by his friend Max Beckmann but also purchased works by Ernst Ludwig Kirchner (see chapter 2, *Self-Portrait as a Soldier*) and French Impressionists and Post-Impressionists.[36] He also promoted the museum's Art Institute, hiring Max Beckmann and Hermann Lismann (see chapter 1) to teach.

In 1911, Swarzenski acquired van Gogh's *Portrait of Dr. Gachet* with funds supplied by his future father-in-law, Victor Mössinger.[37] The purchase had been daring, but the citizens of Frankfurt soon fell in love with the image of the brooding blue-eyed doctor holding a few stems of the medicinal foxglove plant, the source of one of the few effective drugs of the time.

Van Gogh had completed painting the *Portrait of Dr. Gachet* in June 1890, just six weeks before his death. He still hoped to become a successful portraitist. In one of his frequent letters to his family, he described his latest achievement:[38]

> I have done the portrait of M. Gachet with a melancholy expression, which might well seem like a grimace to those who see it. And yet I had to paint it like that to convey how much expression and passion there is in our present-day heads in comparison with the old calm portraits, and how much longing and crying out. Sad but gentle, yet clear and intelligent for a long time, and that maybe, is how many portraits ought to be done. There are modern heads that may perhaps be looked back on with longing a hundred years later.
> —VINCENT VAN GOGH TO WILHELMINA VAN GOGH
> JUNE 11 OR 12, 1890

Van Gogh's wish came true. Today, the portrait of the doctor, with his piercing blue eyes, white cap, and pensive head propped up by his right hand, is considered one of his most important paintings.

Throughout his short life, Vincent van Gogh remained practically unknown. However, not long after his death, his work gained much popularity in Germany—as did his letters, primarily addressed to his brother Theo, which his sister-in-law Johanna van Gogh-Bonger had translated and published. I remember the hefty tome containing about eight hundred of these letters plus reproductions of ink drawings of many of his paintings, prominently displayed in my family's house in Hanover.

As director of the Städel Museum, Swarzenski had made many significant purchases besides the van Gogh. As previously mentioned, the Nazis tried to oust Swarzenski from his directorship as soon as they rose to power. An unabashed modern art lover, Swarzenski had befriended and supported such artists throughout his long Frankfurt tenure. Now he rightfully feared that the Nazis would confiscate their works, including his beloved van Gogh. At his insistence, the staff locked the endangered artworks in a secret room under the museum's roof.

Despite the Nazis' unrelenting war on "degenerate art," the Städel Museum led a relatively carefree existence from 1933 to 1937, thanks to Friedrich Krebs, Frankfurt's mayor. According to Uwe Fleckner, professor of Art History at Hamburg University, and Max Hollein, director of the Städel Museum, then of New York's Metropolitan Museum of Art, Krebs interfered little in the affairs of the museum and the liberal University of Frankfurt, despite being an established Nazi. He extended a protective arm over both Georg Swarzenski and his longtime deputy Alfred Wolters, who quite openly opposed the Nazis' stand against modern art.[39]

By 1937 the protection of the mayor, as well as the attempt to hide art within the museum, had become futile; the Nazis seized from the Städel's collection over seventy-five major paintings and 399 works on paper. These included van Gogh's *Portrait of Dr. Gachet*, Max Beckmann's *Descent from the Cross*, and Ernst Ludwig Kirchner's *Self-Portrait as a Soldier*. Dr. Oswald Goetz, Swarzenski's assistant, would never forget packing the *Portrait of Dr. Gachet* into a specially constructed wooden crate for the initial step of its voyage to what turned out to be Berlin.[40]

The confiscation of Frankfurt's beloved *Dr. Gachet*—reported in the *Frankfurter Zeitung*, an influential German newspaper—shocked the Frankfurt community. The newspaper also published an unsigned editorial reminding its readers that the image "has become the most prized possession" of the museum and provides anyone who remembers this physician's face "with comfort." Unsurprisingly, the editorial upset the Nazi authorities. Swarzenski was a fine writer who had contributed many articles to the *Frankfurter Zeitung*, so they suspected it was planted either by Alfred Wolters or Georg Swarzenski, both of whom they questioned but fortunately escaped with minor inconvenience.[41, 42]

In December 1937, while Georg Swarzenski hosted guests at lunch, the Gestapo arrested him at his home. They only held him overnight but forced the board of the Städel to finally oust him entirely from the institution. In September 1938, Swarzenski and his Aryan wife Marie departed for the United States. His baggage contained some works by Max Beckmann, his lifelong friend.[43]

The United States welcomed Swarzenski with open arms. From 1938 to 1939, he lectured at the Institute of Advanced Studies in Princeton. Thereafter, Boston's Museum of Fine Arts (MFA) appointed him as curator of medieval art. In Frankfurt, he had been responsible for an entire museum, but in Boston, this sixty-two-year-old medieval arts scholar could finally focus on his chosen discipline. Swarzenski's son Hanns, a medievalist, joined him at the MFA. As so carefully detailed by Shirin Fozi, associate curator of medieval art at the Metropolitan Museum, the two significantly developed the medieval art department at the MFA.[44] Art prices had lowered because of the war and accompanying economic unrest; so taking advantage of lesser costs and utilizing their intimate knowledge of the field, the Swarzenskis could acquire marvelous examples of medieval art to deepen the MFA's collection. More broadly, the two Swarzenskis impacted the field in America. In 1940, Georg Swarzenski organized the *Art of the Middle Ages*, an exhibit that stimulated America's interest in European art from 1000 to AD 1400. When Georg retired from the MFA in 1956, Hanns Swarzenski assumed his father's position.

For Georg's seventy-fifth birthday, his friends honored him with a book of essays. Oswald Goetz wrote the introduction. For the book's frontispiece, Max Beckmann painted a portrait of Swarzenski, finishing it just days before his death. The celebratory volume paid tribute to a

man who, despite obstacles and grief, accomplished much on both sides of the Atlantic.[45] Georg Swarzenski never forgave Germany for its treatment of the Jews, and for the remainder of his life, he would not return to his homeland. He died in Brookline, Massachusetts, in 1957.

The Nazis now faced the task of disposing of approximately sixteen thousand artworks they had confiscated, mainly from their own country's exceptional museums. The following two chapters will examine their efforts.

4
Hitler's Sales Force

Though the task would be challenging, top members of the Nazi leadership haggled over who would direct the sales of the art confiscated by Ziegler and his committee. Most of these works consisted of still unpopular German Expressionist and modern art. In the end, Joseph Göbbels prevailed because he had gained the support of Hermann Göring by promising him the right to sell thirteen of the most valuable looted paintings. Among others, these included van Gogh's *Portrait of Dr. Gachet* (see chapter 5).[1] Hitler still retained final control over the ultimate fate of this mass of art, but Göbbels had the authority to establish the government's policy regarding the art's liquidation.[2] He hoped that it would be successful. His July 29, 1938, diary entry reads that he intended to "make some money from this garbage." The execution would be more complex than expected.

The Nazis would sell confiscated art via three principal channels:

- A unique sales force
- Individual sales of high-value works
- International auctions, like the one in Lucerne

Sales did not always involve cash. Both the sales force and Nazi officials would often barter several "undesirable" or "degenerate" artworks for one or more works considered "desirable" (i.e., traditional) by Nazi standards.

In 1937, Joseph Göbbels, advised by other experts and approved by Hitler, selected an official sales force consisting of four well-established modern art dealers: Bernard Boehmer, Karl Buchholz, Hildebrand Gurlitt, and Ferdinand Möller. All were highly experienced and familiar with the German and international contemporary art market. Their assignment was essential to the story of Europe's migrant art. Their primary assignment was to sell the confiscated "degenerate" art outside Germany for foreign hard currency such as the dollar or the Swiss franc, money the Nazis sorely needed to purchase raw materials for arms. ("Hard" currencies were those that remained steady and belonged to countries with strong economies, like the United States or Switzerland, as opposed to German Reichsmarks, a "soft" currency that had

little value because of its poor exchange rate.) Within Germany, production, display, and sale of unsanctioned art was strictly prohibited, though neither the dealers nor certain collectors adhered to these dictates.

Because of the abundance of looted art on the market, the Nazi condemnation of "degenerate" art, and the continued unpopularity of Expressionist artists, the confiscated works offered by the sales force were very inexpensive. This meant that, despite the high number of sales, the commissions earned by the art dealers were meager. To make matters worse, the Nazis paid them in reichsmarks (RM). However, despite all this, as we shall see, the members of Hitler's sales force became wealthy and built impressive collections.

By 1942, after the United States joined World War II, the sale of confiscated art slowed, and the official disposal of art through sales halted. The liquidation of this art had not provided the expected bonanzas. The sum barely exceeded a million RM, over half of which derived from the Lucerne auction (see chapter 5).[3]

While "degenerate art" had little value in the marketplace, traditional art, on the other hand, was in short supply. It was also considered a good investment, and its price skyrocketed. Hitler and Göring were Europe's most eager art collectors of traditional art, and other members of the Nazi brass followed their initiative. Germany's art museums, which had lost so many objects during the Nazi purges, replaced them by acquiring "acceptable" works. Hitler's salesmen learned to trade costly, old-fashioned, traditional pieces, such as nineteenth-century genre scenes or third-rate classic paintings, for inexpensive first-class contemporary artworks. These exchanges were highly lucrative for the dealers, who either kept the "degenerate" acquisitions for themselves or sold them abroad for a profit. Their official positions as dealers also gave them easy access to the upper echelons of Nazi functionaries, who were building their collections. Finally, some dealers would profit from the similarly rapacious art trade in Germany's occupied territories.

When Hildebrand Gurlitt's collection of 1,400-plus items surfaced in 2011, the art world gasped. Less well known, perhaps, are the collections of the other three dealers, such as Bernard Böhmer's notable assortment, a portion of which has been on display in Rostock, Germany, for decades.

There is no question that the sale of looted art by the four men appointed to Hitler's sales force to a variety of buyers preserved many vital artworks, saving "degenerate" art from destruction or dispersal. Ferdinand Möller, for example, managed to prevent several important Expressionist paintings from leaving Germany and eventually, after the war, returned some to the museums from which they'd been removed. However, their supplying the Nazis with precious hard currency, as their trades undeniably did, nevertheless remains in the minds of most an ethically dubious act. Author and "degenerate" art scholar Jonathan Petropoulos accurately describes purchasing endangered art from the Nazis as a "Faustian Bargain,"[4] the title of one of his major books.

Though their assignments were identical, each dealer followed a unique path. Here is a brief look at who these dealers were and how they carried out their assignments.

Bernhard Alois Böhmer

Over the years, the portrayal of Bernhard Alois Böhmer (1892–1945) has not been positive. Most accounts have accused him of profiteering, greed, and consorting with his fellow Nazis. However, his reputation is now changing for the better. Art historian Meike Hoffmann of Berlin's Degenerate Art Research Center writes that his personality had two sides—profiting from the Third Reich's art policies and simultaneously protecting jeopardized art. The sculptor Ernst Barlach shared this view and referred to Böhmer as his "good" and "bad" angel.

Böhmer grew up in an art-minded family, and as a child, he had already shown an aptitude for art. He became a sculptor and attended art school in Bielefeld, where he met Marga Graeber, his first wife. In 1924, the couple bought an estate in Güstrow, near Rostock in eastern Germany, which would eventually become their full-time residence. There, the two met sculptor Ernst Barlach. Böhmer became Barlach's secretary and assistant, and Marga Böhmer soon divorced her husband for the sculptor. Böhmer then married Hella Ottes, the wealthy daughter of a local industrialist, and the two couples maintained a genial relationship.

For years, Alfred Flechtheim had been Barlach's art dealer; after the Nazi takeover, Böhmer became the sculptor's representative, paying him a regular stipend for his output. Böhmer enjoyed living well, spending money on cars and luxurious clothes. He was also one of the most successful art dealers in the Third Reich. Böhmer socialized with the Nazi leadership, and in 1937, Göring appointed him a member of Hitler's special sales force. In this role, Böhmer would contribute art to Hitler's never-realized Linz museum.

Like Gurlitt and Möller, Böhmer built an extensive collection of his own. He was a master at exchanging artworks desirable to the Nazis for ones they maligned. In one such trade, for example, he received from the Nazis forty-eight "degenerate" works by essential artists in exchange for *Homecoming of the Monks to the Monastery* (1816–1818) by Carl Gustav Carus, a German nineteenth-century romantic painter. By 1945, Böhmer possessed an estimated two thousand pieces of art, including numerous works on paper, which he stored and hid in both his own and Barlach's homes and surrounding buildings.

By the spring of 1945, the Germans were losing the war, and it was evident that the Soviets would occupy Germany east of the Oder, including Berlin, Dresden, Rostock, and Güstrow. Bernard and Hella Böhmer considered fleeing in 1944 but failed to do so. When the Russians invaded Güstrow, they began plundering homes; when they reached Barlach's residence, occupied by Marga, Barlach, Bernhard and Hella Böhmer, their twelve-year-old son Peter, and a housekeeper, Bernhard and Hella decided to commit suicide by swallowing cyanide. According

to several accounts, after they carried this out, the housekeeper released the cryptic report: "Böhmer dead, Peter alive, Marga raped." (During World War II, this poison was frequently used for suicide. Both my parents kept a supply—my mother's sewn into the lining of a handbag along with gold coins smuggled from Germany—for all of us to take our lives, if and when they deemed it necessary. When my family was separated in 1940, each parent worried whether the other had decided to resort to this measure.)

We know little about the provenance of the works in Böhmer's two-thousand-item art collection because he had, unfortunately, destroyed all his records and business correspondence before his suicide. In addition to the works he had acquired himself, the Berlin Nationalgalerie and other institutions had transferred art to Böhmer toward the end of the war for safekeeping. It is most likely, nevertheless, that Böhmer acquired the bulk of his artworks during his service as a Nazi sales agent.[5]

When the Soviets occupied the Böhmer residence, the mass of art stored in and around the property fell into complete disarray. The Soviets used the back of selected prints for posters and other needs. Hella's sister, now in charge of her nephew Peter, auctioned off some of the art on his behalf while neighbors and others appropriated other works. Eventually, the authorities transferred about a thousand artworks to the Museum of the City of Rostock. The museum returned some of these objects to their rightful owners, but 613 works—537 prints, 29 drawings, 27 paintings, 23 watercolors, and 6 sculptures—became the museum's property.

Today, the mix of art at the Rostock Cultural History Museum (renamed in 1968) in Germany vividly resembles photographs of the Nazis' *Degenerate Art* exhibit of 1937 except for the fact that art in the Rostock exhibit is carefully and tastefully hung. Rudolf Belling's glittering *Head in Brass* (1925) commands attention; works by Ewald Mattaré, Oskar Schlemmer, Lyonel Feininger, and other artists the Nazis banned look familiar. Indeed, advertisements for the city of Rostock describe the museum as a historic view of "Ostracized Art."

Ferdinand Möller

Ferdinand Möller has traditionally been the most lauded member of Hitler's sales force. He was opposed to the Nazi defamation of modern art, and his primary purpose in joining the sales force seems to have been to minimize the damage wrought by the Third Reich and to protect condemned art in Germany.

In 1912, Möller had decided to become an art dealer, opening his first gallery in 1917, a year before the end of World War I. In the beginning, he specialized in German Impressionism and rapidly became one of Germany's leading modern art dealers. He was also an early admirer of Expressionist art. In 1922 Möller organized a German Expressionist art exhibition with US-based curator William Valentiner (see chapters 1 and 2) at the Anderson Gallery in New York;

unfortunately, America wasn't ready to embrace Expressionism, and the show did not make much of an impact. After 1933, Möller maintained his support of modern art despite Nazi opposition. He continued to exhibit works by Lyonel Feininger, Emil Nolde, Oskar Schlemmer, and others in his Berlin gallery until 1937.

That year, Göring recruited Möller as part of Hitler's sales force. According to Möller's biographer Eberhard Roters, Möller aimed to save the modern art he loved from destruction. He minimized international sales of confiscated works, even selling defamed art within Germany despite it being forbidden by the Nazis—he actually sold to German collectors until his gallery was bombed in 1943—and personally acquiring as much art as he could, craftily arguing with those who favored its outright annihilation.[6]

As an official salesman for the Reich, Möller acquired Otto Dix's *Self-Portrait* (1912). The Düsseldorf Museum had bought it in 1925, and the Nazis confiscated it twelve years later during their "cleansing" of museums. The painting is a thoughtful likeness of a soberly clad twenty-one-year-old Dix, whose moody countenance is somewhat at odds with the carnation clutched in his rough right hand. According to the work's museum label, its style refers to "masters of the German and Flemish Renaissance in its composition and execution. . . . The intensity of his penetrating gaze enlivens the spare, formal rendering of the young man." The confident self-portrait starkly contrasts with his later depictions of the horrors of World War I—a subject Dix frequently chose to portray in years to come. In 1938, Möller sold the painting to Robert H. Tannahill, heir to the Hudson's department store fortune in Detroit, Michigan.[7]

To save more condemned art, Möller sent twenty "degenerate" paintings to the Detroit Institute of the Arts (DIA), then headed by his old friend William Valentiner. The undertaking was presented as a series of loan exhibitions throughout America, though the real purpose of the scheme was to shield the paintings from possible destruction in their homeland.

In 1947, after the war was over, Möller contacted the DIA and requested the paintings' return only to learn that—because they were considered enemy property—the US government had seized them. Protracted negotiations followed and were on the verge of resolution when Ferdinand died in 1956. His wife Maria Möller and their youngest daughter Angelika traveled to Washington to resolve the case in person.

In the end, the Möllers reached a compromise with the US government. The Möllers would donate Vasily Kandinsky's *Picture with White Form 1* (1913) to the DIA and Lyonel Feininger's *Green Bridge* (1916) to the North Carolina Museum of Art in Raleigh (another connection to William Valentiner, who had been the museum's founding director). The Möllers would buy the rest of the paintings from the United States for $16,000, approximately the insurance value of the paintings in 1937. These remaining eighteen pictures were shipped to Germany and arrived at the Cologne airport on January 11, 1958. Most likely, they ended up in private collections, but Karl Schmidt-Rotluff's *The Last Cartload* went to the Folkwang Museum in Essen.

Founded by collector and avant-garde advocate Karl Ernst Osthaus in 1902, the Folkwang Museum was a pioneering modern art institution, exhibiting paintings from Gauguin, van Gogh, and Matisse to iconic German Expressionist works. The Nazis made the Folkwang a particular target of their hatred, confiscating and ultimately destroying many of these. The museum's director, Klaus Graf von Baudissin, a professional art historian who had once shown enthusiasm for German Expressionist art, had drastically changed his views with Hitler's rise and now reviled it. Baudissin proceeded to rid the Folkwang of any artworks the Nazis found objectionable. To prove his loyalty to the Nazis and the extremity of his beliefs regarding contemporary art, Baudissin collaborated with Adolf Ziegler and his team, who assembled the items for the *Degenerate Art* exhibition.

Baudissin and the Folkwang are involved in another example of Möller's efforts to save endangered works in Germany by selling them overseas. During his purge of the Folkwang Museum, Baudissin had made it known that a sizable Kandinsky painting, *Improvisation 28 (Second Version)*—in his view, a "characteristic document of the errors of a directionless time"[8]—was for sale. Auspiciously, Ferdinand Möller was at that moment assisting Solomon Guggenheim in assembling an enormous Kandinsky collection for his future museum. Möller contacted Baudissin and purchased the painting for the Guggenheim Museum in New York.

Möller also sold confiscated art within Germany even though it was illegal. One dedicated German client of Möller's was the collector Kurt Feldhäusser, introduced in chapter 2. An art historian specializing in modern art, Feldhäusser had switched his focus to music once the Nazis condemned contemporary art, teaching music at the Reich Chamber of Music, a Nazi institution.[9] Feldhäusser kept buying art from Möller and acquiring essential works by Kirchner, like *Self-Portrait as a Solder* and *Sand Hills in Grünau*. He also purchased Chagall's *Purim* and *In the Night*, which would ultimately be donated to the Philadelphia Museum of Art.

Like the other four authorized dealers, Möller often bartered works the Nazis cherished in exchange for "degenerate" art. He once swapped a single nineteenth-century romantic landscape for six confiscated paintings, including the Chagalls mentioned above, three works by Heckel, and one by Nolde! Even though Möller's collection was partially destroyed during Allied air raids, enough of it remained intact for his daughter to establish a foundation in her father's name. Since 1995, the Ferdinand Möller Foundation has supported the study of Expressionist art and World War II art restitution by funding the "Degenerate Art" Research Center at Berlin's Freie Universität, which provides a free database of thousands of Nazi-confiscated works. Through scholarly research of this invaluable database, Berlin's Museum of Modern Art has been evaluating the provenance of the Möller estate since 2006.[10]

Karl Buchholz

Karl Buchholz, the third art dealer selected by the Nazis, was the least knowledgeable about modern art. In 1925, he founded a very successful bookstore in Berlin. In 1934, he added a fine art gallery and engaged the astute Curt Valentin, a trainee of Nazi-persecuted art dealer Alfred Flechtheim, as director of this new enterprise. The fact that Buchholz could maintain this modern art gallery alongside his Berlin bookstore for years after Hitler came to power illustrates how, at first, the Nazis only haphazardly enforced their restrictive art policy.

The Buchholz Gallery featured works by Max Beckmann, who had followed Valentin from the Flechtheim gallery to Berlin, Wilhelm Lehmbruck, and other artists considered "degenerate." Both Buchholz and Valentin established lasting bonds with these and other German Expressionists. Buchholz did not acknowledge Valentin's Jewish identity for as long as possible; by 1936, however, Buchholz could no longer avoid the issue. He came up with a constructive alternative: rather than dismissing him, Buchholz asked Valentin to open a branch of the Buchholz Gallery in New York. Valentin agreed.

In preparing for his move to America in September 1936, Valentin asked the Reich's Chamber of Fine Arts in Berlin for permission to exploit his art contacts in Germany to provide him with confiscated art to sell in America. The German agency ratified the plan in their letter of November 14, 1936:

> The President of the Reich's Chamber of Fine Arts instructed me to tell you that there would be no objection if you made use of your connections with the German art circle and thereby establish supplementary export opportunities if [this is done] outside Germany. Once you are in a foreign country, you are free to purchase works by German artists in Germany and make use of them in America.
>
> SIGNED AS DIRECTED: REINHELDT.[11]

The phrase "no objection" reveals how lax and changeable the regulations sometimes were during the early years of the Nazi regime. Exporting art was then still fairly easy. As time went on, however, the net tightened until finally, fugitives were forced to hand over their art, leaving the country with as little as ten marks to their name.

Valentin landed in Manhattan in 1937, his luggage stuffed with art. Until the United States entered World War II in December 1941, much of the "degenerate" art that ended up in America arrived via the Buchholz-Valentin combine. Michael Hulton, Alfred Flechtheim's great-nephew and heir, estimates that Buchholz handled 706 "degenerate" works from the Nazi regime, 644 of which were sent on to Valentin in New York.[12] Once in America, Valentin would develop relationships with important museums, especially the Museum of Modern Art, which would purchase significant works through his gallery (see more on Valentin in New York in chapter 7).

Hildebrand Gurlitt

Hildebrand Gurlitt is perhaps the best-known member of Hitler's sales force. During his tenure in the group and his subsequent stint as a purveyor of art for the never-realized Führermuseum in Linz, he assembled a personal collection of more than 1,400 works of art. Knowledge of this enormous cache burst dramatically upon the world in 2012, when the German authorities became suspicious of the dealings of his son and heir Cornelius Gurlitt.

Hildebrand Gurlitt was born into a learned, artistic family in Dresden in 1895. His grandfather was a painter, and his father taught architecture. Gurlitt served in the German army during World War I, then studied art history in Berlin. Modern and Expressionist art fascinated him.

In 1925, at the recommendation of his friend Hans Posse, director of the Dresden Gallery, Gurlitt assumed the directorship of the small König-Albert Museum in Zwickau. From the moment he arrived, he sponsored the German avant-garde. He mounted several contemporary art shows and spent his small budget on Expressionist art. The small town unfortunately did not share his enthusiasm, and the museum dismissed him in 1930.

Gurlitt's next post—in 1932—was director of Hamburg's Kunstverein, where he zealously acquired and displayed modern art. He even courageously defied Nazism, sawing off the flagpoles in front of the museum so they couldn't fly the Nazis' swastika flags during the annual national May 1 celebrations. Within a year of his appointment, however, the Nazis gained power, and they dismissed him from the museum in 1933.

Gurlitt's artistic leanings were not his only Achilles' heel in the Nazis' eyes. His paternal grandmother was Jewish, so he was considered a *Mischling*, or a person of mixed race. To minimize this problem, Gurlitt capitalized on the fact that during World War I, he had been a *Frontkämpfer*, or front-fighter, which, for some years, yielded Brownie points in the Nazi world. (My father had also served in the war, so my parents considered using the same ploy to enroll me at Hanover's elite middle school for girls but decided against it.)

Following this second career mishap, Gurlitt became an art dealer, opening the *Kunstkabinett Dr. H. Gurlitt* in Hamburg in 1935. To placate the authorities, he handled both traditional and Expressionist art. Nevertheless, he worried about the fate of his gallery, and in 1937, he transferred the business to his Aryan wife, Helene, a professional modern dancer.

The gallery flourished. Though it was strictly forbidden to sell "degenerate" art within Germany, Gurlitt, like some other art dealers, traded it quite openly in his establishment. In his biography, *Hitler's Kunsthändler* (Hitler's Art Dealer*): Hildebrand Gurlitt, 1895–1956*, Meike Hoffmann and Nichola Kuhn[13] report that Gurlitt's gallery displayed a stack of "degenerate" watercolors and works on paper retailing at 1 reichsmark per item (at that time, 2.5 reichsmarks equaled about $1 US dollar). Meanwhile the supply of available art continued to grow, especially after the Nazis confiscated twenty thousand works from Germany's museums.

Gurlitt helped German clients form extensive collections of modern art. Hanover's chocolate manufacturer Bernard Sprengel and his wife Margit visited the *Degenerate Art* exhibit in Munich in 1937, and, as opposed to its intended effect, the exhibition inspired their enthusiasm for "degenerate" art. They became frequent customers of Gurlitt and assembled an outstanding collection of twentieth-century art from him when it was against the law for Germans to do so. The couple was partial to Emil Nolde, purchasing 409 of his works on paper from Gurlitt in 1942. Such "degenerate" art sales were not recorded, making the works' provenance challenging to trace. In 1969, Sprengel donated his collection to Hanover's Provincial Museum, renamed the Sprengel Museum in 1979. Today, it holds one of Germany's most important collections of twentieth- and twenty-first-century art. In 2013, the Sprengel Museum returned the Nazi-looted work *Marshland with Red Windmill* by Karl Schmidt-Rottluff to the heirs of its rightful owner, Max Rüdenberg.

It was fortunate for Gurlitt's career that in 1938, he was appointed the fourth member of Hitler's sales force. According to *Gurlitt: Status Report* (2018)—the official catalog of the two-part exhibition of Gurlitt's cache by the Kunstmuseum Bern and the Bundeskunsthalle in Bonn—he was the most active of the quartet. Throughout the period of his employment, Gurlitt acquired 3,879 confiscated works, almost four times as many as any of his colleagues—3,471 of these were prints, Gurlitt's specialty being works on paper. Many of these he absorbed into his growing personal collection. *Gurlitt: Status Report* provides a glimpse of the art treasury he assembled, though by the time the Swiss museum displayed it, the collection had already been depleted.[14]

Gurlitt's taste was excellent. For instance, he acquired Ernst Ludwig Kirchner's *Two Nudes on a Bed*, which the Nazis had confiscated in 1937, for about 4 Swiss francs, at the time, approximately $8 in US currency. It so happened that Gurlitt had purchased this same pastel years before in 1928 for the collection of the Zwickau Museum. Dozens of other great German Expressionists, including works by Franz Marc, Max Beckmann, Otto Mueller, Oskar Schlemmer, and Georg Grosz, soon entered his collection, as well.

The sale of art confiscated by the Reich officially ended the summer of 1941, and Gurlitt began to look for other creative opportunities to profit in the European art free-for-all. By then, he had already embarked on allegedly "helping" persecuted Jews liquidate their valuable collections and turned to exploit alternative art markets of Nazi-occupied countries beyond Germany; he focused mainly on France, even maintaining a Paris residence from 1941 to 1944. Collectors considered French art an excellent investment; Gurlitt's clients often included German museums that hoped to fill their stripped walls with nineteenth-century French paintings, and they were eager to buy. In Paris, Gurlitt worked closely with art dealers to fulfill clients' demands. According to the Holocaust Art Restitution Project, these dealers were often "recycling art looted from Jews who had fled the capital to avoid capture, internment, and deportation."[15]

In 1942, the Gurlitts' apartment in Hamburg was destroyed by bombs, and the family, now consisting of Hildebrand, Helen, and their children Cornelius and Benita, moved back to their

ancestral home in Dresden. By December of that year, Hans Posse, in charge of assembling Hitler's gigantic Linz museum, had died. Hermann Voss succeeded him, and in 1943, he made Hildebrand Gurlitt his chief art supplier for the museum for works gathered in France, Belgium, and the Netherlands. During one of these trips to Holland, he visited Max Beckmann in Amsterdam and bought *Bar, Brown* (1944), which remained part of Gurlitt's collection until 1968 and is now at the Los Angeles County Museum. According to Catherine Hickley, author of *The Munich Art Hoard* (2015), Gurlitt provided Hitler with about 360 artworks while he was a chief buyer for Linz.

By the spring of 1945, World War II was over, and the Gurlitt mansion in Dresden had been destroyed, as well. The family packed their possessions, including their art collection, into forty-seven crates, loaded them aboard a truck, and fled the advancing Soviets. Their flight terminated in Aschbach, Franconia, in the American Zone.

During the summer of 1945, the Allies seized a small part of Gurlitt's collection and interrogated him in depth. He extricated himself brilliantly as he explained his manifold activities, stressing that not only had he remained a staunch supporter of avant-garde art but also that he had been victimized for having a Jewish grandmother. He managed to convince his interrogators of his innocence, and they declared him denazified. The Americans also scrutinized his collection, though part of it escaped examination because Gurlitt had concealed it; later, he claimed that much of his art had perished during the firebombing of Dresden in 1945. He insisted that the rest he had acquired legally. Five years later, the Allies returned his collection to him.

After the war, Gurlitt participated in the rehabilitation of the German art world, eventually moving to Düsseldorf. In 1948, the West German government appointed him director of the city's art association for the Rhineland and Westphalia. Few were aware of his enormous art collection. According to *Gurlitt: Status Report*, Hildebrand Gurlitt had informally subdivided his collection into several parts: some public, others concealed from the world. During the Cold War, Gurlitt was happy to loan works from the public collection to exhibitions promoting West German art in Europe and the United States.[16] One portion consisted primarily of traditional paintings passed down to him from Gurlitt's grandfather and sister Cornelia. The secret portions of the collection included Gurlitt's most valuable "pearls" that he sold whenever the family needed cash. By 2014, these gems had mainly been sold, but top-notch works by Eduard Manet, Gustave Courbet, Auguste Rodin, Georges Seurat, Claude Monet, and Paul Cézanne remained. Hildebrand had hidden these treasures, first in a mill in Franconia and later at a family estate in Bad Aussee, Austria near the salt mines where Hitler stored thousands of plundered artworks. The home was known to be filled with art as recently as 2012.[17]

Hildebrand Gurlitt died in a car accident in 1956. Helen and their son Cornelius remained in Düsseldorf but eventually moved to Munich. Gradually, the art world forgot about his collection. Helen passed away in 1968, and the priceless art passed on to Cornelius, a recluse who hid it in

a Munich apartment and a humble two-bedroom house (just over a thousand square feet) he owned in Salzburg.

Cornelius Gurlitt

To the best of his ability, Cornelius retreated from the world. Occasionally, he sold one of his father's pictures to support his modest lifestyle. Around 2010, he decided to sell Max Beckmann's *The Lion Tamer*, a gouache and pastel portraying a muscular trainer wielding a spear and facing a huge lion sitting on its haunches. The Lempertz Kunsthaus in Germany arranged and advertised the sale, which tipped off the attorneys of Michael Hulton, who had taken on the mission of locating his great-uncle Alfred Flechtheim's many stolen works. They contacted Cornelius Gurlitt, who admitted that Alfred Flechtheim had sold *The Lion Tamer* to his father under duress. Cornelius and Hulton reached a satisfactory financial settlement, and on December 2, 2011, the picture sold for 864,000 euros (US $1.17 million).[18, 19]

The Lion Tamer was one of Cornelius Gurlitt's last sales. He grew frailer and less able to avoid public awareness. On a September 2010 trip from Zürich to Munich, he attracted the attention of German customs officials for carrying 9,000 euros in cash. The government was suspected of tax evasion and investigated. Cornelius Gurlitt's official documentation was defective, though he had not committed any crime. On March 2, 2012, officials searched his Munich flat and discovered his spectacular art trove, numbering over 1,400 works. Then, in 2014, a search of the Salzburg residence yielded another significant discovery: 238 additional works ranging from Monet, Renoir, and Gauguin to Picasso and Munch.

The world was horrified, and officials deliberated over what action to take. After a lengthy investigation, Gurlitt and the Free State of Bavaria established that a task force would examine the findings. Gurlitt agreed to restitute frankly looted artworks to the original owners or their heirs, and several significant paintings would finally be returned. Works such as Matisse's *Seated Woman* and Max Liebermann's *Two Riders on the Beach* were successfully reclaimed by the heirs of Paul Rosenberg and David Friedmann.

Until Kristallnacht, *Two Riders on the Beach* by Max Liebermann, one of Germany's most respected Impressionists, had hung in the villa of David Friedmann, a successful Breslau industrialist with a spectacular art collection numbering more than fifty works (Figure 4.1). As a child, David Toren, Friedmann's great-nephew, especially admired *Riders* because he was fond of horses, and his great-uncle's stable master had taught him to ride.

Toren's father was a successful lawyer who had failed to heed the Nazis' viciousness. Still, in 1939, within days of the Nazi invasion of Poland, he managed to send his son aboard the last Kindertransport to Sweden. These rescue operations transported ten thousand Jewish children from their homes in the Reich into the "arms of strangers" throughout Western Europe. Toren

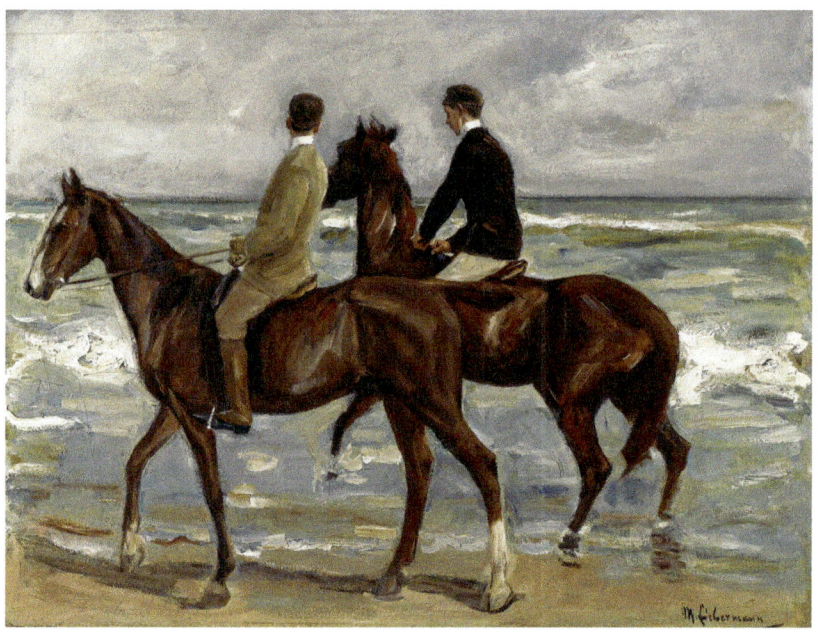

Figure 4.1 *Max Liebermann,* Two Riders on the Beach *(1901). Hildebrand Gurlitt looted this joyous painting from David Friedmann in Breslau in 1939. The work eventually descended to Hildebrand's son Cornelius Gurlitt. In 2015, it was restituted to Friedmann's grandnephew David Toren—who had escaped Germany via Kindertransport—and his family. Credit: Vicimages/Alamy Stock Photo*

would never again see his great-uncle or parents, who died in Auschwitz. In time, he studied chemistry, changed his name, traveled to England, became a successful patent lawyer, and eventually moved to New York.

I did not know David Toren, but I remember my best friend, Elisabeth Wolf, who arrived in Brussels in 1939 via Kindertransport. All of Elisabeth's mementos were packed in a small suitcase. To protect the feelings of her host family, who had adopted her as their own, she never dared openly mourn her parents. Eventually, time erased Elisabeth's wrenching wartime memories, and she developed amnesia. As in my friend's case, David must have been deeply scarred by this abrupt tearing from the family nest.

David Toren always remembered his great-uncle Friedmann's collection and resolved to get it back one day. When Gurlitt's trove surfaced, he recognized Max Liebermann's painting. It was one of Liebermann's most popular works, depicting stallions trotting through the sand and crests of foam crowning the waves of the North Sea in Scheveningen, Holland.

Toren spent two years fighting for the work's eventual return, even though by then, he was blind and could no longer admire it. The painting finally arrived in New York in 2015, two weeks after Toren's ninetieth birthday, which he had celebrated with sixty guests at his Upper East Side Manhattan apartment. However, journalist Catherine Hickley said the painting's return did not give him the expected sense of closure. When Toren passed away in 2020, his feelings

were echoed in his *New York Times* obituary by his son Peter, who resolved, "We will continue to search for and hopefully locate additional works of art looted by the Nazis. My father would have expected no less."[20] The family hopes to reclaim more than fifty missing paintings. They recently recovered *The Basket Weavers*, another Liebermann work that an unknown collector—who turned out to be a Holocaust survivor in Israel—had purchased at auction in 2000.[21, 22]

When Cornelius Gurlitt died on May 6, 2016, he had designated the Kunstmuseum in Bern as his sole heir. Though the Nazis and their sales force used bartering—rather than the traditional exchange of money—to obtain works of art, Hildebrand Gurlitt's transactions within this system showed that he had owned most of the 1,500 artworks in his ill-gotten "private" collection; therefore, his son and heir Cornelius were able to will the works to the Bern Museum.

After some hesitation, the museum in Bern accepted most of the artworks. It took another year for the museum and its associate, the Bundeskunsthalle in Bonn, to organize part of the collection for public view, and the two-part exhibit opened in 2017. On visiting the exhibition, Michael Kimmelman, art critic of the *New York Times*, reported, "The Frick Collection, it's not. . . . It's a dealer's inventory, this and that, about as curated as the cosmetics counter of a department store."[23] Nonetheless, he wrote that he was happy the collection had ended up in the public domain.

Gurlitt, like Alfred Flechtheim, was undoubtedly addicted to art. Without Hitler and the opportunities he received from the dictator, he might have become a respectable museum director, furthering the cause of avant-garde art. Instead, he succumbed to greed and temptation. When the nightmare was over, he did not attempt to rectify the evil he had committed by restituting the treasures he had helped to steal but, on the contrary, kept most of them hidden away.

Like Gurlitt, Buchholz and Möller resumed their professions after the war. They, too, acquired some of the confiscated art at rock-bottom prices and profited financially. Yet, overall, the sales force's efforts saved some artworks from incineration. Since the sales force was under contract to sell its offerings outside Germany, some works ended up in the United States, especially before World War II.

Hitler's official sales force was not the Nazis' only outlet for disposing of plundered art. The next chapter shines a light on their other methods—private sales and auctions, including the fate of van Gogh's *Portrait of Dr. Gachet*, the large purchase by Basel's extraordinary museum director Georg Schmidt, and the most notorious auction for selling art ransacked from Germany's museums.

5

The Lucerne Auction and Other Sales

Van Gogh's *Portrait of Dr. Gachet*, safely encased in its wooden crate, traveled to Berlin where it joined thousands of other confiscated artworks. Since Göbbels had awarded Göring the privilege of selling Gachet and twelve other valuable artworks (see chapter 4), Göring sold some of the paintings immediately and bartered others to acquire Gobelin tapestries, his personal passion. He also contacted Franz Koenigs, a gentile German banker who had moved to Amsterdam in the 1920s. Koenigs was an enthusiastic art collector. Despite his principal interest in old masters' drawings, he hoped to buy the *Portrait of Dr. Gachet*.

Dr. Gachet's Journey

Siegfried Kramarsky, manager of the Jewish bank Lisser and Rosenkranz (L & R), had also moved to Amsterdam during the 1920s. He and Koenigs were good friends. They shared an interest in business and in collecting art. Unfortunately, Koenigs's finances fluctuated, and in 1938, he owed Kramarsky a large sum.

When Koenigs learned that high-quality art was available in Germany, he decided to purchase three paintings: the *Portrait of Dr. Gachet*, confiscated from the Städel Museum in Frankfurt, van Gogh's *Daubigny's Garden* (one of three versions), seized from the Nationalgalerie in Berlin, and Cézanne's *La Carrière de Bibémus*, removed from the Folkwang Museum in Essen. Koenigs did not plan to keep these for himself; he intended to pass them on to Siegfried Kramarsky to pay down his debt. Details of the negotiations between the two bankers are unknown, but Koenigs arranged the terms of the sale in Berlin, picked up the artworks in Paris, and delivered them to Kramarsky in Amsterdam.[1]

By then, Siegfried and Lola Kramarsky had decided to leave Holland. Siegfried shipped his new possessions to America, and his family set off from Europe. They eventually settled with their collection on Manhattan's Central Park West.[2]

Kramarsky was an enthusiastic collector, but he also used this transaction to convert money into valuables and transfer them from Europe to America. This was a common subterfuge; my mother had similarly purchased Paul Klee's *Parade on Wheels* in Germany and mailed it to our Swiss cousins in Zürich. In 1946, she sold the drawing in New York for $500 and used the money to furnish our new home in America.

Lola Kramarsky eventually disposed of van Gogh's *Daubigny's Garden* and Cézanne's *La Carrière de Bibémus* (*The Quarry at Bibémus*)[3]—the two other paintings delivered to her husband with *Dr. Gachet*. The Folkwang Museum in Essen, which had lost the Cézanne to the Nazis, ultimately reacquired it in 1964.

Over the next half century, the Kramarskys frequently loaned *Dr. Gachet* to the Metropolitan Museum of Art; to his surprise, Oswald Goetz, Georg Swarzenski's assistant in Frankfurt (and future curator at the Art Institute of Chicago), discovered it there in 1941 as part of an exhibition titled *French Paintings from David to Toulouse-Lautrec*.[4] (As mentioned earlier, the Met is also where my mom encountered her "old friend" Dr. Gachet.)

The Metropolitan, however, was not Gachet's final home. In 1990, the Kramarsky family consigned the painting to Christie's, where its sale price of $82.5 million to Japanese businessman Ryoei Saito made auction history. Following the sale, the portrait moved to Japan and disappeared from public awareness. However, the painting returned to Europe after Saito died in 1996. According to Martin Bailey of *The Art Newspaper*,[5] Sotheby's most recently sold the work to an anonymous Italian collector in Switzerland, known as "the Lugano Man," who is no longer living.

The Städel Museum in Frankfurt still mourns the loss of its beloved *Dr. Gachet*. Eighty-four years after the painting's seizure, the museum mounted a major van Gogh exhibit in October 2019 titled *Making van Gogh: A German Love Story*. The show featured approximately 150 works, many of which had belonged to German museums or private citizens before World War II. The most poignant display was the empty gold frame from which the painting was stolen, symbolically marking its absence.[6]

Koenigs continued to have financial woes. In 1939, he still owed Kramarky's bank L & R a large sum. He had secured the loan with some of his fabulous drawing collection as collateral. At his insistence, these drawings were stored at the Boijmans Museum in Rotterdam, which housed much of his art collection. World War II began in September 1939, and by the following spring,

the Nazi invasion of Holland seemed imminent. Koenigs ultimately defaulted on his debt, so L & R sold its share of the drawings to Dutch businessman and collector Daniel G. van Beuningen, who initially seemed willing to keep them at the Boijmans Museum.

Unbeknownst to van Beuningen, however, in the fall of 1939, his son-in-law Lucas Peterich met with Hans Posse about the possibility of his acquiring some of Koenigs's beloved drawings for the future Führer Museum in Linz. On May 10, 1940, the Nazis invaded Holland; three months later, Peterich reminded Posse of their conversation.[7] Posse needed little persuasion. He bought 527 items, including twenty-four drawings by Dürer and forty by Rembrandt.[8] Soon, the artworks were on their way to the Gemäldegalerie in Dresden. Eight months later, Franz Koenigs died while trying to catch a moving train in the Cologne train station.[9]

Fortunately, much of Koenigs's encyclopedic old masters drawing collection survives at the Museum Boijmans Van Beuningen. According to its official website, 177 purloined drawings were returned, and 301 more are now at the Pushkin Museum in Moscow.[10]

Koenigs's dealings with Goering also yielded the United States a rare masterpiece: *The Small Crucifixion* by sixteenth-century German painter Matthias Grünewald (Figure 5.1). Only twenty paintings by the mystical artist still exist. *The Small Crucifixion* is the only work by Grünewald in the United States and possibly in the Western Hemisphere. Koenigs purchased the painting in 1927. As part of his negotiations with Göring, Koenigs obtained permission to export the Grünewald to America. In 1953, his heirs sold the painting to the Samuel H. Kress Foundation in New York, which donated it to the National Gallery of Art in Washington in 1961.[11] The unexpected path of this important German painting offers a good example of the bizarre ways in which World War II impacted art's migration.

The German Expressionists, though modern, claim Grünewald as one of their precursors. One artist that looked to Grünewald was Max Beckmann, whose *Descent from the Cross* the Nazis confiscated from the Städel Museum in 1937. The two crucifixion paintings, separated by four hundred years, share a deep emotionality. Beckmann's version now belongs to MoMA.

A Notable Purchase by Kunstmuseum Basel

Another exceptional sale was made to Georg Schmidt, director of the Kunstmuseum Basel. When the director learned that Germany was selling artworks the Nazis had confiscated from their own museums, he recognized a golden opportunity. The Basel administration provided him with a special loan. Schmidt journeyed to Berlin where he acquired thirteen "degenerate" masterpieces; he would buy another eight at the Lucerne auction. The total of twenty-one pieces includes Paula Moderson-Becker's *Self-Portrait as Semi-Nude with Amber Necklace*, Franz Marc's *Fate of the Animals*, and Max Beckmann's *The Nizza in Frankfurt am Main*. By purchasing

Figure 5.1 *Matthias Grünewald,* The Small Crucifixion *(1511–1520). A private arrangement between the work's owner Franz Koenigs and Hermann Göring yielded an export license for this jewel of a painting by a leading member of the Northern Renaissance. Credit: Courtesy National Gallery of Art, Washington/Art Resource, NY*

"vilified and endangered works," Schmidt turned a neglected area of Basel's collection into a mainstay of the museum. Schmidt's selection also included Oskar Kokoschka's *The Bride of the Wind*, often considered Kokoschka's best-known work, which had been removed from the Hamburg Kunsthalle. The painting depicts Oskar Kokoschka entwined with his lover, Alma Mahler, floating amid the clouds. In 2022, the museum reminded the world of Schmidt's purchase of twenty-one spectacular artworks in an exhibition titled *Castaway Modernism: Basel's Acquisition of "Degenerate Art."*[12] Today, the Museum of Fine Arts Boston owns *Two Nudes*

(*Lovers*), another—perhaps less mesmerizing—version of the Mahler/Kokoschka relationship portrayed in *The Bride of the Wind*, which Viennese refugee art dealer Otto Kallir brought with him to America in 1938 (see chapter 7).

The 1939 Auction, Galerie Fischer, Lucerne

Though the Nazis handed over the sale of confiscated art to the four dealers introduced in the preceding chapter, they decided to hold an auction selling the cream of such items themselves. The event would take place on June 30, 1939, in Switzerland, two years after the *Degenerate Art* show and two months before the onset of World War II. Run by the Galerie Fischer in Lucerne, Switzerland, the auction would feature 125 works: 109 pictures and sixteen sculptures the Nazis considered the most marketable pieces. The collection for sale was of an extremely high caliber, including works by Chagall, Corinth, Derain, Dix, Gauguin, van Gogh, Klee, Kokoschka, Kirchner, Marc, Modigliani, Matisse, and Picasso. However, the works selected were hardly the most radical in style: the pieces for sale were all figurative works; none of them were abstract. All Dada, Surrealist, and Cubist works were excluded.

Since the spring of 1939, the auction had been widely advertised. Potential buyers debated whether it was ethical to participate in the event since the Nazis would profit financially from its outcome. The opposition to attending the sale had been very strong. Many attendees, therefore, found themselves faced with a terrible conflict. One explained: "If the work was bought, we knew the money was going to a regime we loathed. If it was not bought, it would be destroyed."[13]

Some art dealers, collectors, and countries refused to participate; others yielded to temptation. France boycotted the sale, but neighboring Belgium did not, and delegations from museums in Liège, Brussels, and Antwerp arrived with large budgets. Several US dealers, such as Curt Valentin, chose to be present. Some would bid on artworks for specific clients who preferred not to attend or wished to remain anonymous.

About 350 potential buyers attended the event at Lucerne's Grand Hotel National. To minimize the Reich's revenue, the prospective buyers had agreed beforehand not to bid against one another, and participants mostly adhered to the arrangement.[14] Most auctions are spirited affairs, but the atmosphere of this one was glum. Even Theodore Fischer, the auctioneer, was joyless and did not hide his dislike for the avant-garde merchandise he was selling. When Max Pechstein's *Man with a Pipe* did not elicit any bids, Fischer quipped that the repulsive-looking man shown in the picture must be a self-portrait of the artist. When other lots failed to sell, Fischer remarked, "Nobody wants that sort of thing" or "This lady does not please the public."[15] In the end, eighty-eight of the pieces found new homes. Unsold works lingered in Switzerland, where some were disposed of through alternate channels; others were eventually returned to storage in Germany.

The most coveted picture of the sale was van Gogh's *Self-Portrait Dedicated to Paul Gauguin* (Figure 5.2). In this self-portrait, van Gogh takes an unsparing look at himself. His head is shaved, his beard scraggly, and his ice-blue eyes stare out at the viewer. His lips are unsmiling, his expression determined, and his left cheekbone creates a sharp outline against the flat lime background.

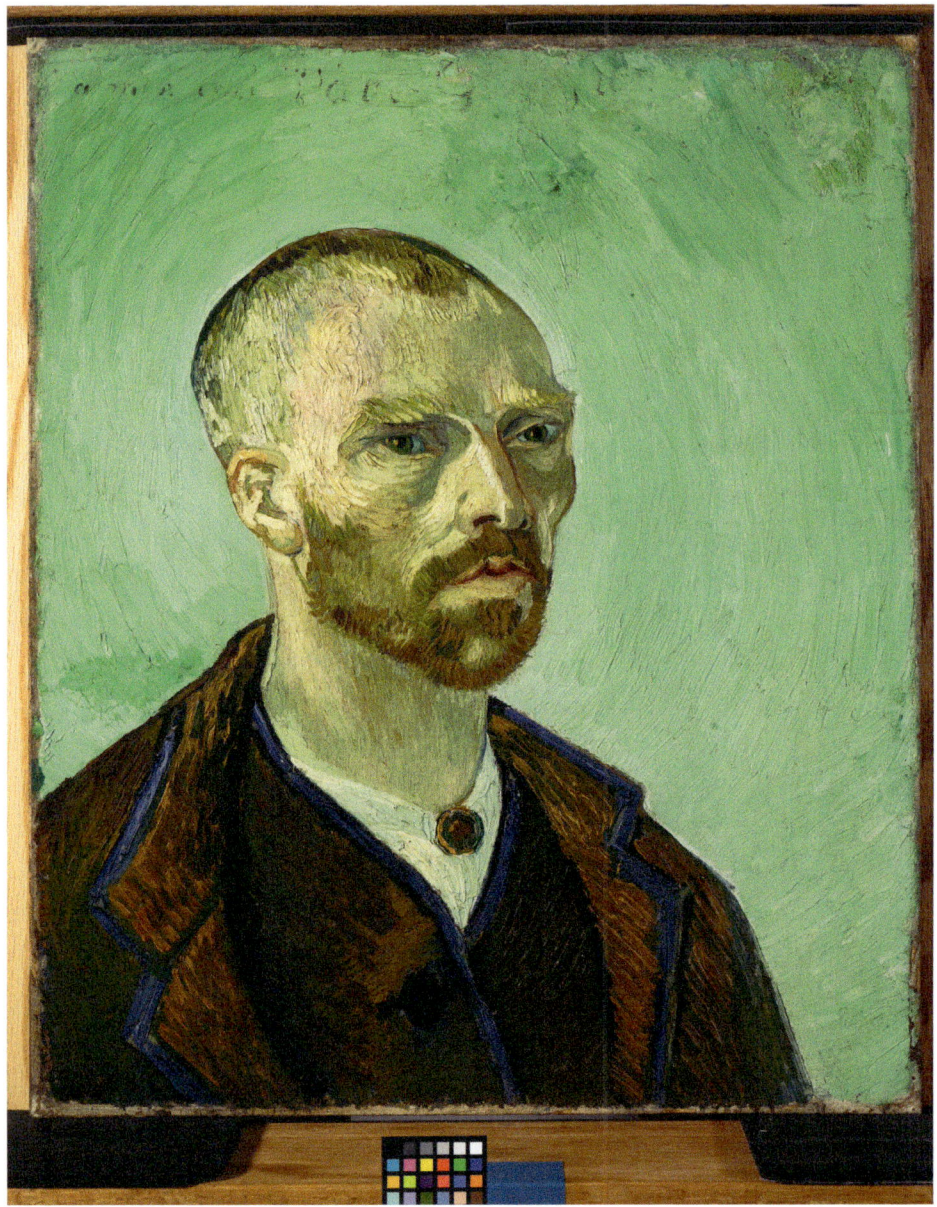

Figure 5.2 *Vincent van Gogh,* Self-Portrait Dedicated to Paul Gauguin *(1888). Van Gogh sent this severe, monastic portrait to his friend Paul Gauguin in 1888. Auctioned in Lucerne in 1939. Credit: Harvard Art Museums/Fogg Museum, Bequest from the Collection of Maurice Wertheim, Class of 1906*

When the painting was complete, van Gogh inscribed the self-portrait to Gauguin and sent it to his address in Brittany. Following van Gogh's death, Gauguin sold the work for 300 francs to French art dealer Ambrose Vollard, who passed it on to Paul Cassirer, a German colleague. The latter sold it in 1906 to Hugo von Tschudi, the controversial director of Berlin's National Galerie, who did much to promote Germany's acquisition of modern and French art. The Kaiser, however, did not approve of Tschudi's taste in modern art, and when Tschudi purchased Paul Gauguin's provocative painting *The Birth*, the Kaiser dismissed him. Tschudi then moved—bringing the van Gogh self-portrait with him—to Munich, as director of the Neue Pinakothek.[16] After Tschudi died, his widow donated the van Gogh to the Neue Staatsgalerie. It was from here the Nazis plundered the celebrated work.[17]

Maurice Wertheim, a prominent New York lawyer and financier, was determined to acquire the painting for his collection. He dispatched Alfred Frankfurter, a well-known art historian, to Lucerne to buy the van Gogh on his behalf. The painting sold for nearly $40,000, the highest price of the event. Wertheim, Harvard class of 1906, would leave his art collection to his alma mater in 1974. Today the portrait remains one of the cherished possessions of the Harvard Art Museums. It is used to teach students about the changes in popularity that have governed the art world throughout history.

Another important piece listed was Henri Matisse's *Bathers with a Turtle*. The painting had originally been acquired by Karl Ernst Osthaus, founder of the Folkwang Museum, in 1908; twenty-nine years later the Nazis confiscated it from Osthaus's extraordinary collection. Pierre Matisse, Henri's son, had emigrated to New York in 1924 and become a successful art dealer; now that he realized the Fischer auction catalog included his father's significant work, he feared for its safety and immediately searched for a potential buyer.

Twenty-six-year-old Joseph Pulitzer Jr.—grandson of Hungarian-born Joseph Pulitzer Sr., publisher of the *St. Louis Post-Dispatch*—came to mind. Young Pulitzer Jr., heir apparent to the paper, had become fascinated by modern art while attending Paul J. Sachs's legendary museum course at Harvard. He bought his first painting, Amadeo Modigliani's *Elvira Resting at a Table*, while he was still an undergraduate and soon became a devoted client of Pierre Matisse. Serendipitously, the young man was on his European honeymoon and able to attend the auction. There, he purchased *Bathers with a Turtle*, as well as two other works.[18] Sixty years later, at Joseph Pulitzer Jr.'s funeral, Angelica Zander Rudenstine described Pulitzer's bond to the Matisse:

> Decades later, Pierre [Matisse] still vividly recalled his young friend's quiet but intense determination to own Matisse's painting from the moment he saw it. This was no casual purchase. It was an act inspired by Joe's passionate inner response to a work now recognized as one of Matisse's great achievements, but at the time appreciated by few. It required astonishing maturity of judgment to grasp the stature of this complex painting; it required courage."[19]

Table 5.1 Selected Works from the Fischer Auction Now in the United States

Artist	Title	Former Museum Owner	Current Owner
Rudolph Belling	Head in Brass (Portrait of Toni Freeden)	Nationalgalerie, Berlin	Walker Art Center, Minneapolis, MN
Marc Chagall	Purim	Folkwang Museum, Essen	Philadelphia Museum of Art, Philadelphia, PA
Lovis Corinth	Still Life with Fruit Bowls	Bayrische Staatsgemälde Sammlung, Munich	The only work of the group still privately owned.
Lyonel Feininger	Zirchow VI	Städtische Museum für Kunst und Kunstgewerbe, Halle	Memorial Art Museum University of Rochester, Rochester, NY
Vincent van Gogh	Self-Portrait Dedicated to Paul Gauguin	Bayrische Staatsgemälde Sammlung, Munich	Harvard Art Museums, Cambridge, MA
Oskar Kokoschka	The Duchess of Montesquiou-Fezensac	Folkwang Museum, Essen	Cincinnati Art Museum, Cincinati, OH
Oskar Kokoschka	Tower Bridge, London	Kunsthalle Hamburg	Minneapolis Institute of Art, Minneapolis, MN
Wilhelm Lehmbruck	Head of a Young Girl, Pensive	Wiesbaden, Landesmuseum	Norton Simon Museum, Pasadena, CA
Franz Marc	Bathing Women	City Museum of Düsseldorf	Norton Simon Museum, Pasadena, CA
Ewald Mataré	Standing Cow	Berlin Nationalgalerie	Museum of Modern Art, New York, NY
Henri Matisse	Bathers with a Turtle	Folkwang Museum, Essen	Saint Louis Art Museum, Saint Louis, MO

[1]Hitler's dealer Bernard Böhmer also owned a cast of this work, now at the Rostock Cultural History Museum in Rostock, Germany. (See chapter 4.)

Time vindicated young Pulitzer's judgment. Today, many experts consider this painting one of the most relevant modern works of art in the United States.

Eventually Louise and Joseph Pulitzer Jr. donated the mysterious and enigmatic *Bathers with a Turtle* to the Saint Louis Art Museum (SLAM). The painting delights its home audience but often travels to special exhibitions, where critics and viewers still puzzle over the meaning of the three simplified female nudes feeding and fussing over a small turtle. In 2010, the work temporarily returned to the Folkwang Museum in Essen, where it was reunited with several other pictures scattered by the Nazis. The SLAM also owns three other major works confiscated by the Nazis from their own museums: *Circus Rider* and *View from the Window* by Ernst Ludwig Kirchner, which Kurt Feldhäusser managed to buy in Germany after they were looted, and Beckmann's *Christ and the Woman Taken in Adultery*.[20]

Another notable work for sale in Lucerne was Oskar Kokoschka's *The Duchess of Montesquiou-Fezensac*, also confiscated from the Folkwang Museum (Figure 5.3). At the suggestion of Adolf Loos, a Viennese architect, art critic, and sponsor, twenty-four-year-old Kokoschka had spent some time at the Mont-Blanc Sanatoria for Lung Diseases in Lysin, Switzerland painting portraits of aristocratic tubercular patients, whom the painter described as "shriveled plants for whom even Alpine sun could not do much." The duchess was one of them. Her highly exotic portrait depicts an emaciated middle-aged woman whose twisted, bejeweled hands and pained expression betray her anguish. The painting is part of a group of early Kokoschka works now considered the epitome of Expressionist portraiture.[21]

Figure 5.3 *Oscar Kokoschka,* The Duchess of Montesquiou-Fezensac *(1910). Portrait of the duchess while she was a patient suffering from tuberculosis at a Swiss sanatorium. Characteristic of Expressionism, Kokoschka portrays the fragile figure lost in thought, consumed by her life within. Auctioned in Lucerne in 1939. Credit: Photo © Cincinnati Art Museum/© 2008 Fondation Oskar Kokoschka/Artists Rights Society/Bridgeman Images © 2025 Fondation Oskar Kokoschka/Artists Rights Society (ARS), New York/ProLitteris, Zürich*

Most sources record that Paul E. Geier purchased the painting at the auction, but according to Marc Masurovsky, cofounder of the Holocaust Art Restitution Project, it is more likely that Geier's future wife Gabriele Brougier (at the time, still married to her first husband, the noble-born Wilhelm zu Solms-Rödelheim und Assenheim) is the one who bought both *The Duchess* and Franz Marc's *The Red Horses* (aka *Grazing Horses IV*). When the sale took place in Lucerne in 1939, Geier was still attending Harvard Law School in the United States.

Gabriele Brougier divorced her first husband in 1947 to wed Cincinnati-born Paul E. Geier, by then a member of the American Foreign Service. The Geiers divided their time between Italy and Ohio. They joined the Cincinnati Art Museum (CAM), eventually donating a group of artworks that included *The Duchess*. After a 1996 falling out with CAM, Gabriele Geier donated Marc's *Red Horses* to the Harvard Art Museums instead. Though both the Kokoschka and Marc were classified as "degenerate," their styles could not be more different. Where the face of the aging *Duchess* is realistic, angular, and unflattering, the horses are romantic and almost magically beautiful.

Less well known until recently is that Kokoschka also painted the Duke Joseph de Montesquiou-Fezensac. First owned by dealer Alfred Flechtheim, the portrait passed into the possession of Nazi Alexander Vömel when he took over Flechtheim's gallery in 1934. Sweden's National Museum of Fine Arts in Stockholm purchased it that year. Eighty-four years later—in 2018—Sweden's Modern Art Museum restituted it to Michael R. Hulton, Alfred Flechtheim's grandnephew and heir. On November 13, 2018, Sotheby's sold the Duke's portrait for $20.4 million.[22]

Belgium Obtains Significant Works at Lucerne

Surprisingly, tiny Belgium made extensive purchases at the Lucerne auction. In the months leading up to the auction, the event came to the attention of Jules Bosmant. A future curator of the Musée des Beaux-Arts in Liège, Bosmant was aware of the Nazis' radical art policy and resolved to acquire some pieces for his hometown. He recruited a group of allies, and together they raised 5 million Belgian francs. The Liège delegation, enlarged by representatives from Brussels and Antwerp, traveled to Lucerne. Altogether they acquired sixteen lots.[23] Liège bought the following nine:

Works Acquired by the City of Liège at the Lucerne Auction

- Marc Chagall: *Blue House*
- James Ensor: *Death and the Masks*
- Paul Gauguin: *The Sorcerer of Hiva Oa*

- Oskar Kokoschka: *Monte Carlo*
- Marie Laurencin: *Portrait of a Young Girl*
- Max Lieberman: *The Rider on the Beach*
- Franz Marc: *Horses in a Meadow*
- Jules Pascin: *The Breakfast*
- Pablo Picasso: *The Soler Family*

Upon its return, the delegation arranged a temporary display of the newly purchased art at the Cité Miroir, a large civil center Liège had developed during the 1930s in the center of town. In addition to other facilities, the center included galleries for temporary exhibits. Thereafter the canvases moved to the town's Musée des Beaux-Arts.

Unlike France, which boycotted the sale, Liège felt that its participation supported the victimized artists, even though its purchase supplied funds to the Nazis. At the opening presentation of the paintings, senator Auguste Buisseret's speech underlined the city's desire to "mak[e] Liège a center for arts exploring modern aesthetics."[24] Liège enjoyed its art treasures for just a few months before World War II began; the pictures were then moved to Brussels, where they sheltered with that city's impressive art treasures.

A Memorial Exhibition in Liège

I had not known of Liège's shopping expedition, but when in 2014 Liège announced that it was going to commemorate the seventy-fifth anniversary of the Lucerne auction with a memorial exhibition, I decided to attend.

Even before entering the exhibition space hosting *Degenerate Art According to Hitler* at the Cité Miroir, in Liège, Belgium (October 17, 2014, to April 28, 2015) I heard the recording of the shrill voice of the auctioneer and the periodic thud of a hammer as he sold priceless art for a song. The organizers of the show had managed to reassemble seventeen lots from the auction: the nine artworks purchased by the Liège delegation, augmented by loans.

I had not seen the Liège paintings before, but they were so iconic of the artists' styles that they felt familiar. *La Famille Soler*, Picasso's large 1903 rendition of the group, was perhaps the most surprising to me—the work's realistic style so unlike his mature work. It was commissioned by Benet Soler, a Barcelona tailor who supported his young client early in his career. Perhaps inspired by Edouard Manet's *Dejeuner sur l'Herbe*, Picasso based the figures of the Solers on a formal family photograph. The painting is actually the center image of a triptych, whose side panels of the husband and wife are split between the Hermitage in Saint Petersburg and the Pinakothek der Moderne, Munich (the portrait of the wife in Munich has in fact been taken down due to a claim by the heir of collector Paul von Mendelssohn-Bartholdy).[25]

The Liège exhibition also included Marc Chagall's *Blue House* painted in 1920 in his native Russia, where he had been marooned due to World War I. A blue log house occupies the foreground of the painting, contrasting with the bright white dwellings of the town hovering in the distance. In depicting his hometown Vitebsk, Chagall combines elements of Cubism and childhood memory.[26]

At the Lucerne sale the Liège buyers had also purchased a work by one of their own artists: Belgian painter James Ensor's *Death and the Masks*. Here a grinning figure of death, clad in a white sheath, is surrounded by a group of singing masked men. Ensor frequently included masks in his work; he had written, "Behind the masks there is violence and glamor."[27] The joyous colors of the blue sky and brightly costumed men seem at odds with the macabre skeleton, but Ensor was a man consumed by his own mortality.

Other pieces from Liège's collection on view included important works by Paul Gauguin and Franz Marc. Gauguin's *The Sorcerer of Hiva Oa*, painted in 1902, portrays a red-caped figure against the lush Tahitian landscape of the Marquesas Islands. The sorcerer may in fact have been a "mahu"—a man in Polynesian society who lives as a woman.[28] Also set in nature, Marc's *Horses in a Meadow* (1910), presents a lyrical depiction of two blue and tan horses grazing in a pastoral landscape. Marc saw in animals such as horses an element of the divine he felt humanity had lost.[29]

Some US galleries made loans that filled out the show. The Memorial Gallery of the University of Rochester, New York sent *Zirchow VI* (1916) by Lyonel Feininger. In this arresting, modern image, Feininger displays his own unique form of Cubism. The Karl Nierendorf Gallery purchased it at the Lucerne auction, and the University of Rochester acquired it in 1946. A second loaned work came from the Minneapolis Institute of Art: Oskar Kokoschka's *Tower Bridge London*. Originally owned by the Hamburg Kunsthalle, this birds-eye view of the Thames was purchased by movie director Josef von Sternberg at the Lucerne auction. After Sternberg's death, it moved into private hands and was finally bequeathed to Minneapolis Institute of Art (MIA).

It was gratifying that my granddaughter Naomi accompanied me on this extraordinary return to Belgium where I had grown up and survived the Holocaust. Our gracious host and chauffeur was Jean Pierre Grosfils—as a teen hiding from the Nazis, I had been his nanny. Naomi was living proof that in the end Hitler's evil purpose had failed, though the cost in suffering, lost lives, and lost art is too enormous to fathom.

One of Hitler's many goals for the Thousand-Year Reich was to increase the *Lebensraum* (territory) for the Germanic people and spread the spirit of National Socialism. His first major

objective was to appropriate Austria, Europe's other German-speaking nation. The center of the mighty Hapsburg Empire, Austria had been Germany's ally during World War I and now shared many of Germany's grievances. To see how Austrian citizens handled this first key expansion of Nazi Germany, one must backtrack by about fifteen months from the Lucerne auction. The "Fatherland" annexed Austria on March 12, 1938. It was the first country beyond Germany to listen enthusiastically to Hitler's harangues.

The Lucerne auction had been the last event in a nominally peaceful Europe. For years Europe had feared that aggressive Germany would invade its neighbors. In 1938 it annexed Austria without violence, but to prevent a similar fate, many countries had built fortifications that would prove ineffective. Germany kept harassing its neighbors, and the Western Allies had long countered Hitler's aggressive behavior with attempts to appease him. By the summer of 1939, these endeavors stopped working, and in September 1939, the English and French declared War on Germany—twenty-one years after the conclusion of World War I and eighteen months after the occupation of Austria. Millions of people—both civilian and military alike—would perish.

When the Nazis annexed Austria, they immediately began looting the country's great private art collections. As German expansion progressed, extortion, forced sales, and plunder intensified. This mass of artworks pillaged from individual collectors continues to make headlines today. The next chapter turns to Austria and the journeys forcibly taken by some of its great artworks.

6

Austria

Ripe for Plunder

In January 2006 a colorful poster plastered Vienna's streets. It depicted a young woman wearing a fanciful dress. The caption of the poster wished the portrait farewell. Gustav Klimt, one of Austria's most beloved painters, had painted "Austria's *Mona Lisa*" a hundred years earlier. The Belvedere Museum, Vienna's Museum of Modern Art, had displayed the portrait since 1938, the year that Nazi Germany had annexed Austria. Adele was Jewish, but the museum had minimized this fact by suppressing her name with the title *Portrait of a Lady* (Figure 6.1).

Now the painting was about to leave for America. Hordes of Austrians waited in line to see it one last time. After more than half a century, Adele's portrait and four other paintings by Klimt were finally joining their rightful owners in the United States.[1]

Since the armistice in 1918 spelled the end of the Austro-Hungarian Empire, the Austrian Democratic Republic had faced hard times, both politically and socially. Like the Weimar Republic, it battled economic depression, wartime reparations, unemployment, and political unrest. Austria also had a nascent Fascist party. Chancellor Engelbert Dollfuss introduced a right-wing dictatorial regime in 1933. After Dollfuss's assassination in 1934, Kurt Schuschnigg took his place. In 1938, the new chancellor proposed a plebiscite on Austrian independence for March 13, but on March 11, he canceled it at Hitler's insistence and was forced to resign. The next day the German armies marched into Austria; most of its citizens were jubilant. Evidently, the "Anschluss," or "Union," as the annexation is commonly known, had been carefully orchestrated.[2]

On April 1, 1938, three weeks after the Germans took over Austria, my family left Germany for our secure haven in Belgium. That day, the führer was to celebrate his victory with a grand rally in Frankfurt, our point of departure. The city was on high alert, its citizens festive but also uneasy. They knew to fear severe reprisals for any show of opposition to the Reich. Our plane departed in the evening, but we left my grandparents' apartment early in the morning to reach

Figure 6.1 *Gustav Klimt,* Portrait of Adele Bloch-Bauer I *(1907). This portrait, sometimes dubbed Austria's* Mona Lisa, *is undoubtedly the Nazi era's most famous looted artwork. Its restitution to Adele's heirs made judicial history. Credit: Neue Galerie New York/Art Resource, NY*

the airport unmolested. We snuck down the back stairs so that my seventy-year-old *Opa*, who suffered from heart disease, would not witness our departure. We would never see him again.

Germany's takeover of Austria marked a turning point in the Third Reich's history. The Nazis hoped that, from that moment on, Fascism would rule the civilized world. The annexation also changed the Nazi attitude toward art. Until 1938 the party had mostly emphasized eradicating "degenerate" art. Moving beyond Germany, the Nazis turned to appropriating traditional art, particularly from collections of private Jewish citizens. Just days after the Anschluss, the Nazis knocked on the doors of Jews known to possess art and other valuables.

For years, Austrian Jews had feared the joining of the two countries; some had already left by the time it occurred. They were aware of recent Fascist measures Germany had taken against Jews, such as the Nuremberg Race Laws, and were frightened by the rampant antisemitism around them in Austria. As the atmosphere grew increasingly threatening, some Austrian Jews attempted to leave their homeland.

Within months of the Anschluss, Austria had played catch up with Germany. Jews were dismissed from their jobs, including their professorships. Public schools segregated their students according to religious lines. Restaurants restricted their clientele. Big businesses were

nationalized and small Jewish enterprises Aryanized. Most often, buyers took advantage of the Jews' desperate situation and paid the former owners a pittance. Occasionally, such takeovers were friendly, with the new owner promising to return the enterprise "in the future."

It had taken the Nazis years to tighten the grip of Hitler's dictatorship in Germany, revving up the people's widespread antisemitism; in Austria, the party achieved these goals much more rapidly. Ernest Loebl, my future husband, then a fourteen-year-old boy, recalls masses of onlookers welcoming the German troops as they goose-stepped down Vienna's thoroughfares. The crowds of spectators waved swastika flags, so the Austrian Nazis had obviously prepared for the event.

Hitler had crossed the German–Austrian border during the afternoon of March 12 in Braunau, his birthplace. He deposited a wreath on his parents' tomb. That evening, the nearby town of Linz gave him a hero's welcome. Three days later Vienna repeated this reception. Europe's two major German-speaking countries were now united. The adulation must have pleased Hitler: his childhood and youth had been deprived and miserable.

Despite Hitler's failed attempts at becoming an artist in his youth, art remained his personal passion and escape. His tastes, however, were narrow, with a preference for saccharine genre scenes and watered-down copies of classic art. Now that he had power, he hoped to transform Linz—that had greeted him with such fervor—into a modern Athens. Did that idea first germinate during his state visit to Florence in 1938, when he saw that a provincial town could be the artistic center of a nation? Did Karl Haberstock, Nazi Germany's most powerful art dealer, suggest that he could build a giant museum? Or did this occur to him while he stopped in Linz and Braunau on his triumphal entry into freshly annexed Austria? Once conceived, the Linz or Führer Museum became Hitler's cherished project. A blueprint and model for the building, developed by architect Hermann Gielser, with much input from Hitler himself, accompanied him to the Berlin bunker where he committed suicide on April 30, 1945.[3]

In 1939 Hitler appointed Hans Posse, the "on leave" director of the Dresden Museum, as the founding director of the future Führer Museum in Linz. Posse, a highly educated museum man, was an excellent choice. Posse worked closely with Alfred Rosenberg, the Nazi philosopher who also headed the EER, short for Einsatzstab Reichsleiter Rosenberg (Task Force of the Reich Leader Rosenberg), an organization in charge of gathering masses of cultural goods from occupied Europe. The EER oversaw frankly looted art as well as objects obtained by forced sales and other machinations. To procure such goods, the Nazis extensively plundered Jewish collections as well as other sources of art from German-occupied territories; Austria's annexation marked the beginning of this type of looting. Only once the führer had made his choice of looted artworks were others free to pick. The Nazis made a big show of paying laughably low prices for some of the art, despite the fact that Hitler was by then a very rich man. (His fortune had grown from a combination of profits from sales of *Mein Kampf* and postal stamps bearing his likeness.[4])

Posse's ill health cut short his glory of directing the planned museum even before the Nazi defeat in 1945 sealed the project's fate. Posse would die of cancer in December 1942. But while he labored for the führer, Posse had the time of his life. By his death, Posse had gathered thousands of paintings for the future museum, including Michelangelo's *Madonna* looted in Bruges, the van Eyck brothers' *Mystic Lamb* altarpiece from Ghent, and Johannes Vermeer's *The Astronomer* from the French Rothschilds. Today, the Madonna and the altarpiece are back where they belong, and *The Astronomer* resides at the Louvre. Hermann Voss succeeded Posse as future founding director of Linz. When Hitler's regime ended in 1945, the stillborn Führer Museum had collected between five thousand and eight thousand art works.[5] One important source for this cache of stolen art had been the major Jewish art collectors of Vienna.[6] These included the Bloch-Bauers, Bondys, Lederers, Lilienfelds, and Rothschilds.

The Bloch-Bauers

On December 19, 1899, in the last few days of the nineteenth century, eighteen-year-old Adele Bauer married thirty-five-year-old Ferdinand Bloch, the brother-in-law of her sister Therese. Ferdinand was Austria's super-rich sugar king. He doted on his young bride and, on her wedding day, presented her with a golden choker, now recognized the world over.[7]

Ferdinand and Adele remained childless, and Adele, an early feminist, filled her days with books and study. She organized a literary salon. She immersed herself in intellectual pursuits, social issues, and Vienna's world of art and music. Just then, music was experiencing major advances, as composers Bruckner, Brahms, Mahler, and Schoenberg developed new rules of composition. In other art forms, writers like Arthur Schnitzler created new formats and questioned traditional mores, while painters like Oskar Kokoschka challenged perspective and natural colors. Though little understood, Sigmund Freud explored the makeup of the human soul in the modest surroundings of his private practice. As in Germany, Austrian Jewish collectors so fervently supported these novel developments that appreciating the work of these cultural figures was equated with having *le goût juif* (Jewish taste).

Gustav Klimt was a celebrated Viennese painter whose portraits were highly prized. Soon after the Bloch–Bauers' wedding, Ferdinand ordered a likeness of his young spouse. Klimt started painting in 1903, the same year he had visited Italy. Ravenna's sixth-century Byzantine mosaics in the Church of San Vitale and Siena's golden twelfth-century Madonnas so profoundly influenced him that Klimt entered his "golden" period, and for years his paintings were suffused with precious metal.

In her portrait, Adele appears small and delicate. Her head, hands, and throat occupy a fraction of the canvas, and her body is lost in an enormous, dazzling swirl of filmy gold. Despite all the surrounding glamour, her expression is direct and true. Her brown hair is coiffed in a pompadour, her full red lips are slightly parted, and her dark eyes gaze straight at the viewer.

Her dress and shimmering cloak are patterned with strange symbols, including Egyptian eyes of Horus, triangles, rectangles, and spirals. Since Klimt left no explanatory notes about the symbols' meaning, viewers must bring their own interpretations appropriate to a Vienna grappling with Freud's explorations of the unconscious.

Adele's long twisted hands betray some anxiety. Their odd positioning hides a deformity of the right middle finger, resulting from a childhood accident. This hallmark helps identify the artworks for which she modeled.[8]

Casual love affairs and open marriages, the subjects of Arthur Schnitzler's 1897 play *La Ronde*, were common in some Viennese social circles. Gustav Klimt was a well-known libertine who likely had a sexual relationship with Adele Bloch-Bauer during the seven years it took him to complete her portrait.

Adele also served as the model for *Judith I* and *Judith II*, the Hebrew heroine who murdered Holofernes, the Assyrian general sent to subdue her people. *Judith I* (1901) and *Adele Bloch-Bauer I* (1907) depict spectacularly beautiful women, their features animated with passion. Both triumphantly wear Adele's famous jeweled wedding choker. Conversely, no signs of ardor can be discerned in the portraits she posed for after *Adele Bloch-Bauer I*. In *Judith II*, completed in 1909, her hands have become claw-like and her entire being appears cold and soulless. In 1912 Ferdinand commissioned a second portrait of his wife. Opposed to the strikingly seductive figures Klimt created in Adele's early likenesses, he depicts her in *Adele Bloch-Bauer II* as an elegantly attired but demure young matron in a wide-brimmed hat.

The same year that Klimt painted Adele's second portrait, Otto Primavesi commissioned portraits of his wife and daughter, both known as Mäda. Today the likeness of the young Mäda is part of the Met's collection of European paintings (Figure 6.2). The fierce expression of the ten-year-old girl is at odds with the bow in her hair and the frothy, flower-strewn dress. This self-declared tomboy is the subject of Gustav Klimt's only child portrait. According to the Metropolitan's notes on the painting:

> Klimt made numerous sketches for this portrait, experimenting with different poses, outfits and backgrounds before deciding to show Mäda standing tall in a specially made dress amid a profusion of springlike patterns. The picture testifies to the sophisticated taste of her parents, banker and industrialist Otto Primavesi and his wife Eugenia, who were ardent supporters of progressive Viennese art and design.[9]

The Primavesis divorced, and by 1928, Mäda's portrait was available for sale at the Neue Galerie in Vienna, owned by dealer Otto Nierenstein-Kallir. Jenny Pulitzer Steiner bought the portrait and in 1938 the Nazis confiscated it along with the rest of Steiner's collection. The painting was restituted to her in 1951 and eventually passed on to her daughter Clara Steiner who lived in America with husband André Mertens. In 1964, the Mertens donated the painting to the Met in memory of Jenny Pulitzer Steiner, Clara's mother.

Figure 6.2 *Gustav Klimt,* Mäda Primavesi *(1912–1913). This nine-year-old self-declared tomboy, dressed in girlish finery, is Klimt's only child portrait. Seized from Jenny Pulitzer Steiner in 1938 and returned to her in 1951, the painting was donated in her memory to the Metropolitan Museum of Art by her daughter and son-in-law Clara and André Mertens in 1964. Image source: Art Resource, NY. Image copyright © The Metropolitan Museum of Art*

In 1987, seventy years after Klimt had painted her as a girl, Mäda Primavesi was living in Canada, where she recalled traveling to Vienna every few months to model for her portrait: "Professor Klimt was awfully kind. When I became impatient, he would just say, 'Sit for a few minutes longer.' He made at least 200 sketches."[10]

When Klimt died in 1918, Adele mourned his loss. She assembled her two portraits and four Klimt landscapes in a room by themselves. She added the painter's photograph and saw that there were always fresh flowers. In 1923, she wrote a letter of intent to her husband specifying that if she predeceased him, he should donate her two Klimt portraits to an Austrian museum at his death. Adele had been prescient. In 1925 she contracted meningitis and died at the young age of forty-three. Her husband was heartbroken. The Klimt room, with Adele's two portraits, now became the memorial room. As before, there were always fresh flowers.

Ferdinand continued to live in the Bloch-Bauers' palatial home and remained involved in the Viennese art world. He cherished his neoclassic porcelain collection and a series of paintings by Ferdinand Georg Waldmüller (1793–1865), a well-known Austrian painter also favored by Adolph Hitler. Most Sundays, Ferdinand's brother and sister-in-law, as well as their three children, Luise, Robert, and Maria, came to lunch. A visit to Adele's memorial room was part of the ritual.

By 1938 the time had come for another glamorous Bloch-Bauer wedding. Maria, Ferdinand's youngest niece, wed Fritz Altmann, an aspiring opera singer. There was dancing and singing, and the stunning bride wore Adele's priceless gold choker—a present from her uncle. It would not be hers for long.

In March 1938 the Nazis arrived. The Gestapo agent in charge of the newly married Altmanns visited their apartment. Disappointed by the jewelry Maria kept at home, the agent insisted that Maria take him to the family safe, where he pocketed Adele's famous necklace. To obtain complete control of the Altmann family's international business, the Nazis took Fritz Altmann hostage and sent him to the Dachau concentration camp. Fritz later wrote that the Nazi officials informed his brother Bernhard that "if he wanted to see me again, he would have to transfer all his foreign possessions including the factory he has in Paris, and he would have to declare that he would not start a new factory anywhere in the world."[11]

On the eve of the Nazi annexation of Austria, Ferdinand fled to his grand summer residence in Czechoslovakia. Yet this self-exile did not protect him from the Nazis' extensive reach. The Austrian Sugar Industry AG declared that "he was not agreeable to the new rulers" and Aryanized his company. They also imposed a 1.43 million reichsmark fine for alleged tax evasion and other misdeeds. Soon he was destitute.[12]

Meanwhile, Ferdinand's collections of art and other objects were dispersed. Hans Posse thought Ferdinand's beloved Austrian porcelain collection should be kept intact and go on display, but Hitler wasn't interested. The porcelain was therefore sold at auction in 1941. On the other hand, Posse selected several of Ferdinand's Waldmüller paintings for Hitler's Linz museum. Then, the Belvedere Museum, using Adele's letter of intent, claimed ownership of the Klimt paintings, consisting of Adele's two portraits plus three landscapes: *Birch Forest*, *Apple Tree I*, and *Houses at Unterach on the Attersee*. The rest of the vast art collection went to other museums or was auctioned during a three-day sale.

As the signing of the Munich agreement surrendered the Sudetenland, a portion of Czechoslovakia, to Germany, Ferdinand was no longer safe at his Czech refuge. In the autumn of 1938, he fled to Paris, eventually settling in a Zürich hotel. He could barely meet his living expenses. His glittering lifestyle and cherished young wife had become a distant memory.

Like many other fortunate refugees, Maria and her husband escaped to the United States. Fritz would end up working for Lockheed and singing whenever he could. Maria opened a dress

shop. The couple had four children and forgot about their lost fortune, but not quite. Every so often, they thought of their uncle Ferdinand.

As soon as the war was over, Ferdinand initiated attempts to recover his possessions, including his art. He was mostly unsuccessful except for his portrait by Oskar Kokoschka, now at the Kunsthaus Zürich Museum. Three weeks before his death, in November 1945, Ferdinand made yet another will, leaving his entire estate to his and Adele's nephew Robert and their nieces Luise and Maria. They, too, sporadically attempted to obtain some compensation but soon abandoned their efforts.

By relying on antiquated laws, refusing to issue export licenses, or other chicaneries, Austria's museums had demonstrated their particular reluctance to relinquish plundered artworks. In the Bloch-Bauer case, the Belvedere Museum clung to Adele's nonbinding testamentary letter of 1923 as its claim to the family's Klimt paintings. However, it was legally evident the paintings had belonged to Ferdinand and not to Adele. Austrian journalist Hubertus Czernin, who had studied the museum archives, discovered that the museum authorities were aware of this fact.[13] (Czernin found that the archives had even falsely listed Ferdinand as the donor of the looted Klimt works.)

In early 2000 Maria Altmann once more petitioned Austria to return her paintings. When the government dismissed her claim in a particularly abrupt manner, she decided to sue. Maria engaged E. Randol (Randy) Schoenberg, the twenty-two-year-old grandson of Austrian Expressionist composer Arnold Schoenberg. He accepted the case on a contingency basis, risking years of lost income.

Austria demanded prepayment of approximately 1.75 million euros to hear the case, a sum far beyond Maria's financial means. Instead, Randol Schoenberg chose to file a civil claim in the US court system. The case, named "the Republic of Austria vs. Altmann" eventually reached the US Supreme Court, which ruled that it could be tried in the United States. Since Maria Altmann was already ninety years old at that point, she opted for a binding opinion issued by three Austrian legal scholars. After much debate these scholars ruled that the five Klimt paintings belonged to the heirs of Ferdinand Bloch-Bauer. Maria and Randy were overjoyed, and many Austrians, by then familiar with the case, felt that "the woman deserved her paintings." The five Klimt paintings endured a tearful Viennese sendoff and a transatlantic flight to Los Angeles where the County Museum of Art greeted them with a warm welcome.

The paintings stayed for a short visit. The Bloch-Bauer heirs decided to auction off the five works at Christie's. Prior to that sale, however, Ronald Lauder privately purchased *Adele Bloch-Bauer I* for his Neue Galerie in New York.[14] As a teenager visiting Vienna, he had fallen in love with the portrait and was thrilled to have the opportunity to acquire it.

The Washington Principles

By the mid-1990s, a transformation had taken place in the general climate surrounding looted art. The publication of important books like *The Rape of Europa* detailing the enormity of Hitler's war against art raised awareness of Nazi plunder. The refusal of governments, museums, and individuals to return stolen property to its rightful owners had also caught the public's attention. As a result, academicians, advocacy groups, and selected branches of government began organizing conferences and symposia on restitution.

Elizabeth Simpson, a professor at the Bard Graduate Center for the Decorative Arts, planned one such gathering in 1995. The three-day international symposium, The Spoils of War—World War II and Its Aftermath: The Loss, Reappearance, and Recovery of Cultural Property, marked the fiftieth anniversary of the end of World War II.[15]

It was a daring move for Simpson, an academic at a small college in Annandale-on-Hudson, to convene such a meeting. However, Simpson had guessed correctly that the time had come for an open discussion about the consequences of the Nazi-initiated art rampage. Many of the forty-eight invited speakers, often representing their governments, came ready to deliberate on the question of wartime plunder.

The Spoils of War symposium did not arise in a vacuum. World War II had resulted in the displacement of hundreds of thousands of looted artworks and other objects. Many had been moved to safe locations to avoid destruction or damage from bombing, but figures regarding postwar collection and repatriation of these items remained vague. Immediately following the war, the Western Allies (the United States, UK, and France) who had discovered such art in salt mines, distant castles, and other storage sites in the former Reich sent it to central collecting points. The objects were returned to museums or other suitable organizations in their country of origin. The intent was to restore the artworks to their rightful owners but this often failed for one or more of the following reasons:

- The original owners had perished during the Holocaust.
- The institutions that received the art tried to keep it.
- The art vanished into private hands.

Beyond these factors, the restitution process was often laden with excessive taxation and insurmountable bureaucracy. It took half a century for a consensus of world leaders to try to rectify some of these wrongdoings.

Art was not the only form of stolen property that, decades later, a kinder society sought to return to the Nazis' victims. To fund the Nazi war effort, the Germans had looted and transferred hundreds of millions of dollars in gold to Switzerland. For three days, concluding December 4, 1997, the London Conference on Nazi Gold "took a hard look at the level and degree of looting,

movement and disposition of Nazi gold." In his closing remarks, US Department of State Under Secretary Stuart Eizenstat lauded participants for their achievements in "coming to terms with this painful period of history and doing justice for its victims."[16] At the time, Eizenstat also announced a forthcoming conference in Washington to explore the restitution of artworks. The US Holocaust Museum offered to host the meeting.

As Eizenstat promised, the Washington Conference on Holocaust-Era Assets took place by the end of 1998, where participants from forty-four nations, as well as thirteen representatives of nongovernmental organizations, drew up and approved eleven guidelines to help settle disputes over matters of Nazi-looted art. These recommendations were known as the "Washington Principles on Nazi-Confiscated Art," or "Washington Principles" for short.[17] Compliance was nonbinding, but following these parameters quickly resolved the most egregious offenses, like museums' refusal to let go of plundered art.

Unfortunately, interpretations of the principles have varied, leading to confusion and controversy. To clarify their intent, the guidelines were refined on the twenty-fifth anniversary of their adoption in a new agreement titled "Best Practices for the Washington Principles on Nazi-Confiscated Art."[18]

The Lederers

Viennese industrialist August Lederer and his wife Serena were serious art patrons who had assembled a huge collection of works by Gustav Klimt. The couple had also commissioned the artist to paint various family members. Following the death of her husband in 1936, Serena stayed with the collection in Vienna but eventually fled to her native Hungary in 1940. Her many magnificent Klimts did not fare well. The Austrian State had confiscated her collection in 1938 and moved it to Immendorf Castle. Then in 1945, to prevent the artworks from falling into Soviet hands, the retreating Nazi troops set fire to the castle. Fifteen Klimt paintings went up in flames.

The Lederer family portraits managed to survive only because Nazi regulations exempted images of Jews from confiscation, deeming them not worth stealing. Klimt's portraits *Serena Lederer* and *Baroness Elisabeth Bachofen-Echt* were therefore not in the castle but at the Dorotheum, a Vienna pawnshop-*cum*-auction house. They were eventually returned to Erich Lederer, Serena and August's son, who had survived in Switzerland. After Erich's death, his widow sold his collection, and the Met acquired Serena's portrait in 1980. This impressionistic work dates from 1899, before Klimt developed his distinctive style (his golden period would begin just a few years later). Serena's carefully rendered face and abundant hair are the focal point of the full-length figure; her body, in a cloud-like white gown, melts into the background.

Klimt's portrait of Baroness Elisabeth Bachofen-Echt, Serena Lederer's daughter, now belongs to a private collection; in 2017, it was loaned to the National Art Gallery of Canada in Ottawa for three years. The image depicts Elisabeth in a fantastic white dress surrounded by tiny Chinese figures. In one of the endless, remarkable stories that crop up throughout the Holocaust, the Klimt portrait contributed to the survival of the sitter. After the Nazis annexed Austria, Baron Bachofen-Echt divorced Elisabeth because she was Jewish. Without her husband's protection, she was in danger of being sent to an extermination camp. Therefore, Elisabeth approached the authorities claiming that the philanderer Klimt had been her mother's lover, and she was, in fact, the artist's biological daughter; this would make her only half Jewish and excused from deportation. Elisabeth asked her mother to sign a paternity certificate; her former brother-in-law, an influential Nazi, also extended a helping hand. The Nazi authorities must have accepted her story, as she was spared. But despite this victory, she still had a tragic end, dying prematurely in 1944.[19]

The Neue Galerie also owns *The Dancer*, a posthumous portrait of Serena Lederer's niece Maria ("Ria") Munk. She had committed suicide in 1911 after her fiancé, the German writer Hanns Heinz Ewers, broke off their engagement. According to the museum's notes, Ria's parents commissioned a posthumous portrait from Gustav Klimt. They rejected his first submission, so *The Dancer* is allegedly Klimt's second effort, which he then reworked. The Neue Galerie explains: "In this canvas, the figure and the background meld together almost seamlessly in a complex layering of floral ornament. The woman's kimono links the lush bouquet of anemones on the table with the mosaic-like aureole of flowers behind her."[20] The painting remained unfinished at the time of Klimt's death. Today the captivating image shares a gallery with Adele Bloch-Bauer.

The Rothschilds

Within days of the Anschluss, the Nazis called on the Viennese Rothschilds, descendants of the family patriarch Meyer Amschel Rothschild. Born in the Frankfurt ghetto in 1744, Amschel became an astute businessman dealing with Europe's reigning monarchs. The name of the Rothschild dynasty derives from the red shield (*Rotes Schild*) that had marked Amschel's home. Even when he had become a mighty financier, Meyer Amschel continued to live in the ghetto, but at the turn of the nineteenth century, he directed his sons to go out and establish banks in Europe's major capitals.[21] Thus, from Amschel's house, the five sons fanned out across the continent, founding banks, building palaces, and assembling magnificent art collections the Nazis would eventually plunder on a grand scale.

Salomon Mayer Rothschild settled in Vienna in 1820. He and his descendants prospered, and by 1938 Barons Alphonse and Louis von Rothschild's enterprises had become bastions of Austrian economic and cultural life. The family also owned fabulous art. Particularly

noteworthy was Alphonse von Rothschild's collection, which he had inherited from his childless uncle Nathaniel. Studded with paintings from the Dutch Golden Age and eighteenth-century France, the collection also abounded with tapestries, furniture, jewelry, illustrated manuscripts, and more. According to Melissa Müller in *Lost Lives, Lost Art*, Alphonse von Rothschild's collection comprised 3,444 pieces of art, while his brother Louis von Rothschild's was smaller at 919 objects.[22]

Given developments in Germany, members of the Rothschild family considered leaving Austria even before the Anschluss took place. When the event actually occurred, Alphonse von Rothschild, his British-born wife Clarice, and their son Albert happened to be abroad. Unfortunately, their daughters Bettina and Gwendolyn remained in Vienna, so their parents instructed the governess to escort the girls to Switzerland. However, when their train reached the Austrian border at Innsbruck, the Nazis ordered Jews, including the Rothschild girls, to get off. Bettina von Rothschild remembered that moment all her life: she believed "she was done for."

Meanwhile, Louis von Rothschild, their uncle, had also stayed behind in Vienna to take care of business. When the Germans marched into Austria, he also tried to escape, but it was too late; at the airport the Nazis confiscated his passport, and the baron returned home for lunch. There, he almost collided with the Gestapo, who had come to arrest him. A story goes that his valet told the police to wait until the baron had finished eating. Once Louis was in jail, his nieces were released, and they joined their parents in Switzerland. Louis von Rothschild remained in custody for sixteen months until all the Rothschild assets, including their art, had been transferred to the Nazis.

Considering the fate of many other European Jews, the Viennese Rothschilds were lucky to have escaped. Most of the family managed to resettle temporarily or permanently in the United States. Baron Alphonse von Rothschild arrived in New York with Clarice and the children in 1940. (He died in Bar Harbor, Maine, in 1942.) His brother Louis married and settled on a farm in Vermont.

The Rothschild art, which had filled several family palaces, was much to Hitler's liking. Hans Posse walked away with 324 objects. The rest of the art, including Frans Hals's *Tieleman Roosterman*, a portrait of a wealthy Amsterdam merchant (Figure 6.3), and David Teniers II's extraordinary *Archduke Leopold William in his Gallery in Brussels*—a painting depicting a multitude of paintings—ended up in Vienna's major museums. Other treasures went into storage or were sold to the highest bidder.

Most of the Rothschild's non-dispersed artwork survived the war. The Nazis had stored them in salt mines to protect them from the Allies' firebombs. In 1945 America's Monuments Men liberated these works from underground and returned them to the Austrian government, assuming it would restitute the art to the family. However, the Austrians refused to grant export licenses unless the Rothschilds "donate" approximately 250 of their most valuable artworks and

Figure 6.3 *Frans Hals,* Tieleman Roosterman *(1634). Hals's rendering of a Dutch Golden Age cloth merchant—showing off the fine details of his attire—radiates confidence, contentment, and cheer. Confiscated in 1938 from the Austrian Rothschilds and restituted to the family by the Austrian government in 1999. Credit: Courtesy of the Cleveland Museum of Art*

precious objects to Austria: Clarice was even coerced into signing over specific paintings as a gift to commemorate her deceased husband.[23]

Both Louis and Clarice Rothschild continued to pursue the restitution of their possessions until their deaths in 1955 and 1967 respectively. Clarice's daughter, Bettina, by then married to Matthew Looram, an American diplomat, took up the struggle to release the "prisoners" on display in Austria's museums. Bettina was fond of the objects she had grown up with and occasionally visited them in their new surroundings. When warranted, she alerted their custodians to touch up varnish or repair plaques identifying the paintings as coming from the Rothschild family.

Austria's attitude toward Nazi-looted art changed with its voluntary adoption of the Washington Principles in 1998. One day, Bettina Looram's phone rang unexpectedly. It was Elisabeth Gehrer, Austria's minister of culture. Gehrer had concluded that Austria's postwar law requiring Jews to surrender certain goods in exchange for exporting others had been wrong, and the moment to right past wrongs had arrived. According to the *New York Times*, she felt "it was time for 'moral,' not 'legal' decisions."[24] The Rothschilds would therefore recover the art they had been forced to abandon in Austria. Given Gehrer's new directives, Austria's museums had to relinquish the works they had long considered their property. But as Gehrer pointed out, "We have so many art treasures there is no reason to be stingy about this."

By then Bettina Looram, the teen who had been a ordered off her train to freedom in 1938, was seventy-three years old. Though it broke her heart, she consigned most of the restituted items to auction. "We all live very differently than my parents did," she told a reporter. "Not only are there security questions . . . and the insurance costs are prohibitive, but this type of eighteenth-century French furniture needs a butler and two housemaids. . . . This is not the way we live now."[25]

Some auctions are particularly memorable, and the July 1999 sale at Christie's London featuring the Rothschild treasures certainly was. Estimated to bring in $40.5 million, it topped out at $89.9 million. According to Bettina Looram, the family only kept a selection of "knickknacks" and souvenirs. Not surprisingly, Teniers's *Archduke Leopold Wilhelm in His Picture Gallery* (1653) and *The Rothschild Prayer Book*, (1510–1515), an exquisitely illuminated Book of Hours from the Flemish Renaissance, were highlights of the sale, as well as three portraits by Frans Hals.[26] The Cleveland Museum of Art purchased Hals's magnificent *Tieleman Roosterman*, which it would reunite with Hals's *Portrait of a Woman*, a painting it had acquired from the Rothschilds in 1948, when the family sold selected works of art restored to them earlier.[27]

Before Bettina Looram died in 2012, she discussed the fate of the "knickknacks" the family had kept with her daughter Bettina (Nina) Burr. By then the younger Bettina had established close ties with the Museum of Fine Arts in Boston (MFA). Nina had started as a volunteer guide

at the museum in 1996 and became a board member in 2006. She and her mother decided to donate the remnants of the Rothschild collection to the MFA. In a *Boston Globe* interview of February 23, 2015, Bettina Burr recalled, "We both agreed that it would be a good thing to do ... the pieces are here together. They're not going to different corners of the world ... and I know they'll be cared for."[28] According to Victoria Reed, the MFA's curator of provenance, this varied collection helps the museum teach about the Holocaust.

The Museum of Fine Arts lost no time displaying its gift. In 2015 it organized *Restoring a Legacy: Rothschild Family Treasures*, an exhibition showcasing about eighty of the 186 donated pieces. The most personal item of the exhibition was Philip de László's elegant portrait of Baroness Clarice de Rothschild, painted in 1925, the year after she gave birth to her daughter, the future Bettina Looram. It depicts an aristocratic Clarice, coiffed in the period's fashionable bob, wrapped in a blue shawl, a long strand of pearls draped around her neck. She holds a white flower in her folded hands, perhaps a symbol of the opulence of her life. Nearby Clarice's portrait, a glass-topped table displayed pieces of her exquisite jewelry that escaped the Nazis because they accompanied Clarice when she left Vienna days before the Anschluss. Other jewel-like objects from the family collection included eighteenth-century pieces like an intricate gold and agate *carnet de bal* (a lady's dance card), and an oval gold and enamel snuff box, with a miniature of Catherine the Great of Russia.[29]

As a girl, Bettina Burr had been especially fond of a romantic portrait of Emma Hart, Lady Hamilton, by George Romney dating from about 1784. The newly cleaned painting, featured at the MFA, emphasizes the young woman's beauty. Emma Hart, a courtesan, became the mistress of Charles Francis Greville, who sat in the House of Commons. Greville introduced her to George Romney (1734–1802), the most fashionable British portraitist of his day, and she became his muse. Emma married Sir William, Lord Hamilton, but she is best remembered for her passionate love affair with an ailing Admiral Lord Nelson.

Lady Hamilton figured in many of Romney's paintings. In this example from the Rothschild collection, a jaunty feathered hat and white ruffled bib frame Emma's face. She is entirely clad in black and white, so a drawn-back red velvet curtain adds color and warmth to the picture—one Hitler had selected for inclusion in his Linz museum.

Also on view was *A Dordrecht Nobleman on Horse with Retainers and Groom* by Nicholas Maes (1634–1694), a finely detailed portrayal of an aristocratic figure astride his shining black horse, attended by his servants and his dog. In the background, Maes portrays the Dutch city of Dordrecht. The reverse of the painting attests to its World War II journey: Hans Posse had chosen this work for the Führer Museum, so it displays a swastika along with the Rothschild insignia, and both Nazi and Allied inventory numbers bear witness to its theft and rescue.

The Lilienfelds

Scientist and inventor Dr. Leon Lilienfeld and his wife Antonie had fled Vienna for Milan by the time the Nazis annexed Austria.[30] The couple had left their well-known collection of old masters in the hands of their lawyer Emmerich Hunna, who managed to protect the paintings from Nazi seizure; one of these was the stunning *Portrait of a Man* by Frans Hals. Dr. Lilienfeld had owned the painting since 1917, and Hans Posse was particularly eager to acquire it for the Linz museum.

When Dr. Lilienfeld died of pneumonia in Italy in 1938, his Christian widow inherited the collection. She moved to Switzerland and tried to retrieve the art, but eight of the paintings were not permitted to leave Austria, so they remained in Vienna in Hunna's care. In 1941, Hunna decided to pawn two of these—the Hals and a work by Hendrick Gerritsz Pot—to the Dorotheum auction house for safekeeping, claiming that he needed cash to settle the Lilienfelds' taxes.

The rapacious Nazis had a curious respect for the law. According to Erik Ledbetter, director of international programs and ethics at the American Association of Museums, "[t]he Nazis had a morbid fascination with committing their crimes under the cover of legitimacy. . . . They had a twisted genius for inventing legal mechanisms which seemed to be legitimate but in fact were mechanisms of theft."[31] Given the circumstances of Antonie Lilienfeld's paintings, the Nazis may have felt they could not simply confiscate the works. In 1944 the Austrian Monuments Protection Agency transferred the two artworks from the Dorotheum to the Alt Aussee salt mines to protect them from ongoing bombing.[32] It was in these mines that the Allied soldiers discovered them at the end of the war.

Meanwhile, Antonie moved to Winchester, Massachusetts, near Boston, in 1941. It took years to obtain export licenses and settle pawn fees with the auction house, but with the help of Andrew Ritchie, then still active as a Monuments Man in Austria, the paintings were shipped to Boston's MFA in 1948. As a show of gratitude, Antonie first donated *Woman Seated at a Table* (*Vanitas*) by Hendrick Gerritsz Pot (long attributed to Gerrit Dou) to the MFA in memory of her husband. Later she also donated Frans Hals's *Portrait of a Man* to the museum in honor of the hundredth anniversary of its founding.[33]

Most Dutch burghers depicted in Frans Hals's earlier portraits wear traditional dark clothes and ruff collars. Hals painted *The Portrait of a Man* when he was in his eighties and his style is unusually free. According to museum literature,

> The picture's energetic salad of visible brushstrokes was daring for the times and would have appealed only to certain art lovers. . . . The man here wanted to be shown in a cutting-edge kind of portrait, one that advertised his cosmopolitan taste. He wears his hair long, in the French fashion, and is dressed in a Japanese-style dressing gown made of silk.[34]

The Bondys

Oscar Bondy is another Czech "sugar king" who acquired more than two thousand art works. These consisted mostly of old masters—Dutch, Flemish, and German, as well as Italian Renaissance—and nineteenth-century Austrian art, along with sculpture and decorative arts. The Nazis had a keen eye for the old-world artists Bondy had assembled, and when Germany overtook Austria in 1938, they seized the collection.

Figure 6.4 *Giovanni di Paolo,* The Adoration of the Magi *(ca. 1460). The extraordinary details of this densely packed predella, or base of an altarpiece, indicate the Sienese artist's training as a miniaturist. The painting is from the Bondy collection of 2000 works the Nazis seized in Vienna in 1938. The collection was partially restituted to Oscar Bondy's widow and sold at the Kende Gallery in New York in 1949. Credit: Image source: Art Resource, NY. Image copyright © The Metropolitan Museum of Art.*

Before the Anschluss, Bondy and his wife Elisabeth had managed to flee to Switzerland, and soon after, they emigrated to America. In 1944 Bondy died in New York. Once the war ended, Elisabeth fought quite successfully for restitution; within a few years, much of the art was returned. On March 3, 1949, New York's Kende Galleries on West 57th Street held an auction titled "The Renowned Painting Collection of the late Oscar Bondy," where Elisabeth sold a significant catalog of works. Collectors Jack and Belle Linsky acquired Giovanni di Paolo's beautifully preserved *Adoration of the Magi*, which they later donated to the Metropolitan Museum, where it enriches the museum's early Italian Renaissance treasures (Figure 6.4). Other pieces from the Bondy collection would find their way into American art museums, as well. The Wadsworth Atheneum in Hartford purchased Battista Dossi's *Combat Between Roland and Rodomonte*, and the Getty is now home to Adriaen Isenbrandt's *Crucifixion*—another gift of Jack and Belle Linsky.

World War II forever crushed the joyous, sophisticated spirit that characterized Vienna at the beginning of the twentieth century. By 1938 Jews accounted for approximately 9 percent of its population[35] and represented a range of economic classes. For those Austrian Jews who had achieved great financial success, collecting art was a favorite pastime, and these enthusiasts took full advantage of Vienna's creative riches.

Despite Austria's plunder, harassment, and mass murder of Jews during the war, the country would later claim that it had been the Nazis' "first victim." As a result, restitution of stolen art only began seriously there as late as 1985–1990. By now the artworks from the numerous Jewish collections seized in Austria have traveled far and wide; some are still making news today. Many were handled by émigré art dealers, the subject of the next chapter.

7
Émigré Art Dealers and Their Artists

According to the US Holocaust Memorial Museum, between 180,000 and 220,000 European refugees arrived in the United States between 1933 and 1945.[1] Many came from Germany and Austria; most were Jewish, and an unusually high percentage were skilled professionals. Many who left during the early years of the Nazi regime were still financially secure, which helped them meet the costs of emigration to America. However, as time passed, and the Nazis stripped Jews of both their professions and their assets, escaping Europe became ever more difficult.

Even for those for arrived safely in the United States, starting over in a new country was daunting. Many of the refugees were middle-aged and did not speak English, which impacted their ability to support themselves and their families. In addition, many of the new arrivals were traumatized by their expulsion from the homelands they held dear.

Nevertheless, the German-speaking groups fared well in America. Some benefited from the war's effect on international trade: my father, a pharmaceutical chemist who arrived in 1941, profited from the fact that Germany ceased shipping its medicines abroad. Some German-speaking luminaries, including writer Thomas Mann, composer Arnold Schoenberg, director and screenwriter Billy Wilder, and actor Erich von Stroheim, moved to Hollywood, where, according to Susan King of the *L.A. Times*, they transformed Los Angeles from a provincial town to a sophisticated center of the 1930s.[2] Women expats found themselves exploring new roles: many of the wives who had never been employed in Europe took jobs in the garment industry or as secretaries, manicurists, or caterers. Meanwhile, young immigrants often joined the army, where some served as interpreters.

Curt Valentin

As discussed in previous chapters, immigrants to the United States included important art dealers such as Curt Valentin, who played a significant role in the migration of art from Europe to America. When he arrived in New York, Valentin wasted no time deploying his skills. Armed with a permit from the Reichskammer der Bildenen Künste in Berlin to use his German contacts to sell German works abroad, he opened a branch of the Buchholz Gallery in Manhattan in 1937. Years later, in 1951, he would change the name to the Curt Valentin Gallery.[3]

By Valentin's time, the role of the art dealer had developed considerably. A decisive moment came toward the end of the nineteenth century, with French art dealer Paul Durand-Ruel who had discovered and then championed the Impressionists with great determination. He established new practices for running a gallery, such as offering his artists a stipend in exchange for their most current work and presenting solo exhibitions; he was also expert at creating a market for his artists, promoting them with exhibitions beyond France—throughout Europe and in America—and opening multiple branches of his gallery. Thanks to Durand-Ruel's revolutionary methods, the bond between artists and art dealers strengthened with time.[4]

Valentin immediately contacted some of the artists he had represented in Germany. On March 9, 1937, he wrote to Ernst Ludwig Kirchner, then living in Switzerland, and let him know he had just mounted his first New York exhibition featuring "sculptures and drawings of Lehmbruck, Kolbe, Marcks, Scheibe, Barlach and Sintenis." Valentin hoped the show would be well received. He added that friends had complimented him about his "simple, inexpensive décor." Valentin thanked Kirchner for consenting to exhibit with him and discussed details regarding the shipment of his artworks.[5] The exhibition would be a farewell presentation for Kirchner. (After the Nazis removed over six hundred of his works from museums in 1937, cruelly labeling him as "un-German," the devastated artist committed suicide on June 15, 1938.[6]) Other early shows at the Buchholz Gallery in New York included *Landmarks of Modern German Art*; *Aspects of Modern Drawing*; and exhibitions of works by Paul Klee; Max Beckmann; and Lyonel Feininger.

Valentin remained in close contact with Buchholz, his Germany-based partner. Buchholz's supply of "degenerate" art was plentiful thanks to Valentin's arrangement with the Reich. Godula Buchholz's biography of her father documents his purchase of dozens of "degenerate" works at the Schönhausen Palace or the Köpenicker Strasse depot and shipment of these to Valentin in America. This biography includes copies of the correspondence between Bucholz, Valentin, and the Nazi authorities discussing specific artworks, confirming the 25 percent commission paid by the buyers, and their obligation to secrecy.[7] The artworks in question were extremely inexpensive. Watercolors by Paul Klee, for example, cost between $50 and $200. His *Twittering Machine* sold for $75, and the Museum of Modern Art (MoMA) paid $160 for Kirchner's *Street Scene (Berlin)*. Both works had been confiscated from Berlin's Nationalgalerie and displayed at the *Degenerate Art* show in Munich. Seventy years later, Ronald Lauder would pay $38.1 million for another of Kirchner's *Berlin Street Scenes* (see chapter 2).

In addition to keeping up his European connections, Valentin became an independent force in the American art market. He established good relations with American museum directors, especially Alfred Barr of MoMA and Perry Rathbone of the Saint Louis Art Museum (SLAM). In 1939, Valentin attended the Lucerne auction: at Barr's request, Valentin acquired works for MoMA because the director preferred not to be involved in these transactions himself.[8]

Alfred Barr was very open about his relationship with Valentin. On August 7, 1939, Barr wrote a widely distributed press release reporting that MoMA had purchased exiled art: "Five works of modern art formerly owned by German museums but recently expelled from them by official order. Two outstanding masterpieces are *The Blue Window* by Matisse and the *Kneeling Woman* by Lehmbruck. All have been acquired by the Museum of Modern Art from the Buchholz Gallery, whose New York agent is a German refugee." Barr went on to clarify that the works were not confiscated out of racial prejudice, since the artists who created them were not Jewish but German, French, or Swiss. Barr also stressed that not all Germans approved of Hitler's taste. He praised those who regretted "the terrible damage done to Germany's [cultural] reputation" and to its art, which "stood second only to that of France among European nations."

Barr welcomed "these distinguished exiled works which greatly enrich [the museum's] modern European collection." He would include these newly acquired works in the museum's *Art in Our Time* exhibition, which marked the institution's tenth anniversary and its move to its building on 53rd Street. According to Barr's biographer Alice Goldfarb Marquis, he was not entirely sanguine about these purchases. An ongoing discussion took place among free-world museum directors and collectors on whether it was ethical to buy confiscated or looted art from the Nazis, but many purchased them all the same.

The works Barr acquired from the Buchholz Gallery in 1939 were as follows:

- André Derain, *Valley of the Lot at Vers*, formerly at the Cologne Museum
- Ernst Ludwig Kirchner, *Street Scenes*, formerly at the Nationalgalerie, Berlin
- Paul Klee, *Around the Fish*, formerly at the Dresden Gallery
- Wilhelm Lehmbruck, *Kneeling Woman*, formerly at the Kunsthalle Mannheim
- Henri Matisse, *The Blue Window*, formerly at the Folkwang Museum, Essen

These five paintings represent only a select few of MoMA's works with a possible World War II history. According to museum records, MoMA owns potentially eight hundred pieces of art that fall in this category. To qualify, a work must have been created before 1946 and acquired by the museum after 1932.

One of the works Barr purchased from Valentin was *Around the Fish* by Paul Klee. Born in Switzerland, Paul Klee spent much of his time in Germany. He studied in Munich and joined the Blaue Reiter group, exhibiting his work with them at the Thannhauser Galerie. Klee taught at the Bauhaus and was very prolific, with a lifetime output of about nine thousand works. The

Degenerate Art exhibit presented seventeen examples of his art, including *Around the Fish*, confiscated from the Dresden Gallery in 1937. The work fits well the Nazis concept of "degenerate" art. It portrays a fish with well-defined scales garnished with greenery. The fish lies on a platter, surrounded by unrelated objects: a head with red eyes, a crescent, a full moon, a translucent cylinder, and various abstract forms. The picture is absurd, whimsical, playful, and enigmatic—a distinct contrast to classical painters' traditional still lives depicting food throughout the ages.

Max Beckmann

In 1937, after the Nazis had seized five hundred of his works, Max Beckmann precipitously left Germany. He had hoped to reach the United States but was forced to shelter for ten years in Holland instead. Beckmann's luggage contained some of his art, including *Departure*, often considered his most famous work. He had begun painting this piece, his first triptych, in 1932, a year before the Nazis fired him from his teaching post at the Städel Museum in Frankfurt. He would finish it in Berlin in 1935.

Like many of Beckmann's works, it is a mystical painting whose supernatural and frightening imagery is reminiscent of the heaven and hell created by Hieronymus Bosch, Pieter Bruegel, and Matthias Grünewald, the great masters who worked in Germany and the Netherlands during the fifteenth and sixteenth centuries. In 1937, when Beckmann fled the country, he had feared the Nazis would prevent him from exporting the artwork. To avoid its destruction, Beckmann labeled it "Scenes for Shakespeare's Tempest."[9]

The meaning of *Departure* has always been a mystery. Blindfolded, tortured, and trussed personages occupy the side panels, while a boatman appears about to row a majestic king and his queen across a calm blue sea in the more optimistic center panel (Figure 7.1). Beckmann always denied that *Departure* had any political implications.

At Alfred Barr's request, Curt Valentin, who had already represented Beckmann in Germany, asked him to reveal the piece's significance. The painter did not like to explain his work and responded to Valentin, "[W]ell, if he wants to know what's going on just tell him to return the picture."[10] However, in 1938 he wrote the following reply:

> The picture is a sort of rosary, or a circle of colorless figures which sometimes when the current is turned on, can take on a glorious brilliance. The picture speaks to me of truths impossible for me to put into words, truths of which I did not even know before. It can only speak to people who, consciously or unconsciously, already carry within them a similar metaphysical code. Departure, yes departure, from the illusions of life toward the essential realities that lie hidden beyond. But this after all applies to all my pictures.
>
> —LETTER TO VALENTIN, MARCH 11, 1938[11]

Figure 7.1 *Max Beckmann, Departure, middle panel of triptych (1932–1935). This central image from the artist's best-known triptych features a king and his queen voyaging on a vibrant blue sea— perhaps from the torturous world of the side panels. In 1947, the triptych and its creator arrived in the United States after a ten-year exile in Holland. Credit: Digital Image © The Museum of Modern Art/ Licensed by SCALA/Art Resource, NY. © 2025 Artists Rights Society (ARS), New York*

MoMA would acquire the triptych in 1942 from an anonymous donor, thought to be Valentin.

Beckmann's exile in Amsterdam was a source of financial, emotional, and material stress. Fear was abundant, and food was scarce. During the German occupation from 1940 to 1945, Beckmann's son Peter, a physician in the German army's medical corps, tried to keep him equipped with painting supplies. Occasionally, Peter smuggled a painting back into Germany.

Despite the uncertainty of daily life in wartime, Beckmann managed to sell some work from his place of exile. Karl Buchholz acquired six of his paintings,[12] and Hildebrand Gurlitt visited him in Holland and purchased *Bar Brown*, now at the Los Angeles County Art Museum. Throughout this period, Valentin acted as Beckmann's long-distance dealer. When Valentin opened his New York gallery, he began importing Beckmann's work. Initial sales included *Self-Portrait in a Tuxedo*, now at the Harvard Art Museums, and the *Departure* triptych at MoMA.

Once the United States entered the war in 1941, however, communication between the artist and dealer ceased; not until June 1945, weeks before Holland's liberation, did the two renew contact. Beckmann then informed Valentin that over the past five years, he had completed seventy-five pictures, including four triptychs. He planned to send this enormous output to Valentin in New York and expected an advance on future sales. However, Beckmann's bank account was still frozen, so he could not yet ask for a transfer of funds. Instead, he requested that Valentin send "[t]wo bottles of Champagne or one bottle of White Horse would do too." He explained, "There is no alcohol here at all."[13]

In 1946 Valentin at last opened a Beckmann exhibit at the Buchholz Gallery in New York. It showcased thirty works the artist had created between 1939 and 1945. Georg Swarzenski, who had supported the young Beckmann in Germany and was now at the Museum of Fine Arts (MFA) in Boston, provided an emotional introduction to the catalog.[14]

Following the end of the war, Beckmann was offered a teaching position in Germany, but he refused; instead, he accepted a temporary appointment at Washington University in St. Louis. Beckmann arrived in America in September 1947 and spent the following two years in Missouri. This move accounts for the surprising fact that the Saint Louis Art Museum, squarely located in America's heartland, now owns the world's largest collection of paintings by Max Beckmann. This unexpected claim to fame illustrates once again how deeply and circuitously the Nazis' cultural policies affected the migration of art across continents.

After Missouri, Beckmann moved to New York and taught at the Brooklyn Museum. He died of a heart attack in 1950. His second wife, Mathilde (Quappi) Beckmann, her husband's frequent model, devoted the rest of her life to furthering his postmortem reputation. In 1975, she donated two late works to the National Art Gallery in Washington: *The Argonauts* triptych, which Beckmann had completed the day before his death, and *Falling Man*, depicting a man who plunges headfirst toward earth between two skyscrapers—a visionary portrayal of the 9/11 tragedy, when many trapped in New York City's Twin Towers leaped to their deaths from its fiery heights.

Curt Valentin died in 1954, four years after Beckmann. Given his extensive dealings with confiscated art, at once saving many works from incineration and supplying the Nazis with hard currency, he led a controversial life. But he had made undeniably generous contributions to the museums of his adopted country. One of his early gifts was *Winter Landscape in Moonlight* (1923), a distinctive Kirchner work he donated in 1940 to the Detroit Institute of Arts (DIA), both in memory of the artist and to honor the sixtieth birthday of the museum's director William Valentiner. The Nazis had confiscated that painting from the Kaiser Friedrich Museum in Magdeburg, and it entered the Karl Buchholz-Curt Valentin combine. Kirchner's craggy blue mountains, red spruce, and cloud-filled red sky glow with the same intensity as his colorful prostitutes on the streets of Berlin or the vibrant landscape of his *Sandhills in Grünau*.

After his death, Valentin's friends organized a memorial exhibit of thirty significant artworks at his gallery in New York. Museums across America sent works they had acquired from him. The Busch-Reisinger Museum sent Erich Heckel's triptych, *To the Convalescent Woman*. It is Heckel's best-known painting that once belonged to the Folkwang Museum in Essen. MoMA sent Henri Matisse's *Blue Window*, another former possession of the Folkwang. The Phillips Collection in Washington, DC sent Oskar Kokoschka's *Portrait of Lotte Franzos*, and the University of Iowa sent Beckmann's *Carnival* triptych, which, according to its museum label, reflects the "brutality and agony Europe suffered during the first half of the twentieth century." There were works by Paul Klee, Lyonel Feininger, Franz Marc, and Jacques Lipchitz, as well as by American and lesser-known artists.

In his will, Valentin left to his friend Perry Rathbone, director of the Saint Louis Art Museum, a painting of his choosing. Rathbone picked Beckmann's *Christ and the Sinner*, also known as *Christ and the Woman Taken in Adultery*. It is a powerful image of a clean-shaven Christ with a modern appearance protecting a kneeling woman; the pair is surrounded by threatening soldiers. This is the scene of Christ's familiar command: "He who is without sin among you, let him cast the first stone"—words that also apply to Valentin's traffic in Nazi-confiscated art. The Kunsthalle Mannheim had purchased the painting in 1919, and the Nazis confiscated it in 1937.

Valentin willed *Christ and the Sinner*'s pendant painting *Descent from the Cross* to MoMA. It depicts Christ's followers lowering his emaciated body from the crucifix. Both *Christ and the Sinner* and *Descent from the Cross* are dominated by muted tones with occasional accents of color—but in *Descent from the Cross* these accents turn darker—with black and a deep blood red. Beckmann had possibly painted the image in response to a challenge by Städel curator Gustav Hartmann "to create a modern work as powerful as medieval German art, which they had viewed together in Frankfurt."[15] Hartmann lost the bet and bought the painting for his private collection. However, his wife found the poignancy of the piece disturbing, and Hartmann returned it to the artist. The Städel Museum in Frankfurt acquired it in 1919, and the Nazis subsequently seized it in 1937. Both works were exhibited at the *Degenerate Art* show, and they arrived in America via Buchholz and Valentin.[16]

Egon Schiele

As a child, Egon Schiele (1890–1918) drew constantly. When he was fourteen, his father died of syphilis—an event that caused Schiele devastating pain and would deeply infiltrate his thinking. He rejected traditional school and totally dedicated himself to art. His maternal uncle, who had assumed his guardianship, recognized his nephew's talent and begrudgingly let him attend the Vienna Academy of the Fine Arts. However, Schiele could not abide by the school's rigid, conservative approach to art, and after three years, he left.

Schiele quickly developed a style of his own. His drawings were powerful, sometimes frightening—raw with primal urges and the looming reality of death. A century later, British art critic Lucy Davis noted these same characteristics in her review of a London exhibit focusing on Schiele's women. She explained that Schiele was haunted by his father's progression from sickness to madness to death, and this darkness infused his work. She observed his shocking, agitated, and emotion-laden female nudes, many of them erotic, physically contorted, and strange. She comments, "The women appear inflamed, translucent; all elbows and spines, ribs and eye sockets."[17] Schiele also turned his eye back to himself: his numerous self-portraits are unsparing, often expressing distress or anguish with exaggerated features of the body or face. They relate perfectly to Sigmund Freud's exploration of the inner self.

In 1907 Schiele sought out the artist Gustav Klimt, who took a strong interest in the young man's prodigious talent and helped establish him as an artist. It may have been at his mentor's studio that Schiele first encountered seventeen-year-old Valerie (Wally) Neuzil, since the striking redhead had modeled for Klimt. It is known the two met in 1911, though exactly how has never been confirmed. Wally grew up in the lower-middle class, and the early death of her father had left her family in poverty. To make ends meet, she worked as a model, as well as holding more "respectable" jobs like sales assistant, cashier, and mannequin at a clothing store. Once she had met Schiele, Neuzil became his loyal companion and muse. Over the next couple years, their openly sexual connection developed into a deeper emotional relationship—a change that became visible in the maturity of Schiele's images. Diethard Leopold, son of Schiele collector Rudolf Leopold, commented, "She's not just a model. She looks back. She motivated his self-reflection and was a catalyst for his work."[18]

In 1912, Schiele painted a pair of portraits of Wally and himself (Figure 7.2). When the paintings are placed side by side, their heads incline toward one another, and a flowering Chinese lantern vine encircle them. The white hat and collar of her demure black dress frame Wally's sweet face. Her enormous blue eyes are translucent; her heart-shaped lips and curly hair are flaming red, and her expression is sad as if she senses that her relationship with the painter is doomed. Schiele's expression is puckish. His head tilts atop a craning neck, and his right ear and Adam's apple are prominent. His left outsized eye looks straight at the viewer. His face,

topped by dark, bouffant hair, is rendered in purples and brown. "What *Portrait of Wally* really documents is Schiele waking up to the reality of another person. It's a real portrait of a real person," said Peter Vergo, author of *Art in Vienna 1898–1918*.[19] However, two years after Schiele produced the portraits, he ended their affair. In 1915 he married Edith Harms, whose social standing was much more favorable.[20]

Both Egon Schiele and his wife failed to survive the influenza pandemic of 1918. At his death, he was on the cusp of becoming Austria's leading artist. Fortunately, he had been prolific and left about three thousand drawings and three hundred paintings. He had also developed a small, devoted following in Vienna. The dentist Heinrich Rieger—who would accept art as payment for dental treatments—owned 130 to 150 drawings, watercolors, and paintings. The renowned cabaret performer and art collector Fritz Grünbaum also acquired about eighty pieces. In the last years of his very brief life, Egon Schiele's work began to gain more widespread recognition, and in 1912, Karl Ernst Osthaus of the Folkwang Museum purchased one of his works.

During Hitler's regime, the Nazis would consider Schiele's work "degenerate," but so little of it was on public view that he mostly escaped notice. Today, over a century since his death, Schiele's work has been exhibited throughout museums across Europe and America, and he is regarded as one of the most significant draftsmen of the twentieth century, if not all time.[21]

Figure 7.2 *Egon Schiele,* Portrait of Wally *(1912). An affectionate portrait of Wally Neuzil, the artist's companion and muse, toward the end of their relationship. Stolen from Lea Bondi in Vienna in 1938; restituted to her heirs in New York in 2010. To bring Wally back to Austria, Vienna's Leopold Museum agreed to compensate the heirs $19 million. Credit: Leopold Museum, Vienna, Inv. 453 Erich Lessing/ Art Resource, NY*

Otto Kallir

When World War I broke out, Otto Kallir was twenty years old. (His original name was, in fact, Otto Nirenstein, which he would change officially to Kallir-Nirenstein in 1933, taking Kallir from a family branch.) Like most Austrian Jews his age, he joined the Kaiser's army. Kallir qualified as an officer. In *Saved from Europe*, his granddaughter Jane Kallir reports that, during his time in the military, a fellow officer introduced him to the work of Egon Schiele. Kallir was captivated by Schiele's images, and he asked his father for 100 Kronen to sit for his portrait. His father refused, considering this a waste of money.

When the war ended, Kallir briefly studied engineering but soon realized that, as a Jew in Austria, he would have difficulty finding employment in the field. Instead, in 1919 he joined the Viennese art dealership Galerie Würthle, where he met gallerist Lea Bondi, another Schiele enthusiast.[22] Bondi became a partner of Galerie Würthle by 1922 and sole proprietor by 1926, focusing the business on modern art.[23]

Both Kallir and Bondi would remain lifelong devotees of Schiele, promoting the artist's work after his untimely death.[24] Otto Kallir would write the first Schiele catalogue raisonné, while Lea Bondi purchased for her private collection what would become one of Schiele's most recognized paintings: the *Portrait of Wally*. It occupied a prominent place in her home and in her heart. Its looting and eventual restitution would later make history.[25]

Kallir opened his Neue Galerie in Vienna in 1923. As its name implies, it primarily sold contemporary Austrian art. Given Kallir's predilection for Schiele, it was no surprise the opening exhibition featured the artist who had died five years earlier. During the fifteen years that separated the opening and Austria's annexation by Nazi Germany, the art gallery popularized contemporary and recent artists, including Richard Gerstl, Gustav Klimt, and Oskar Kokoschka.

Kallir astutely assembled a personal collection, as well. In 1921 he purchased his first Schiele oil painting, *Portrait of an Old Man*: a likeness of Johann Harms, the painter's father-in-law. Forty-seven years later Kallir would donate it to the Guggenheim Museum in New York. Acquisitions of other significant works by Gustav Klimt, Oskar Kokoschka, and Alfred Kubin, plus additional Schieles followed.[26, 27] Most of these works were still extremely low in price.

Some people are more perceptive of oncoming catastrophes than others. Otto Kallir anxiously watched the Nazis' ascent in Germany and became convinced that Germany would engulf Austria. Earlier than most, he transferred some assets to Switzerland. With the help of some influential contacts in the art world like Otto Demus of the Bundesdenkmalamt (Federal Monuments Office), Kallir obtained the appropriate export licenses and packed crates containing future treasures, such as thirteen works by Kokoschka. (Interestingly such paperwork wasn't required for all artworks: According to Austrian law, a permit was only necessary for a work if the artist had died twenty or more years before the date of export. So, for example, Kallir could

send Schiele's art abroad without a permit, as he was departing slightly less than twenty years before Schiele's death.²⁸) Some crates and personal belongings he also shipped to France and others to America.

After the Anschluss, Kallir managed to avoid getting arrested and arranged a timely escape from Austria. He transferred ownership of the Neue Galerie to his Aryan secretary, Vita Maria Künstler, who would manage the operation until Kallir returned to Vienna in 1949 to reclaim it. (Even then, Künstler continued as a partner until signing over her portion of the business to Kallir's daughter Eva-Marie in 1952.²⁹)

Kallir had more difficulty finding a haven for himself, his wife Fanny, and their children, John and Eva-Marie, but at last the family left for Lucerne, Switzerland, in June 1938. Kallir had failed to obtain Swiss working papers but managed to secure documents for France, so he opened an art gallery in Paris. He named it Galerie St. Etienne, a reminder of Vienna's parish church. Unfortunately, his wife and children did not receive papers to stay in France, so Kallir had to commute between Lucerne and Paris. Fourteen months later the family left Europe: in August 1939 they arrived in New York City, where Kallir opened his second Galerie St. Etienne.

Like Curt Valentin, Kallir dealt in a genre of art that was mostly unknown in America and had not yet gained popularity with the public. Later on, his domain of Austrian art would become extremely desirable in the United States, but at first, business was slow. Every month, Kallir featured a particular painting that generated some publicity. During Oskar Kokoschka's first American solo show in 1940 at the Galerie St. Etienne, Kallir chose as painting-of-the-month the artist's deeply personal *Knight Errant*, reflecting the state of his affair with the complex Alma Mahler—the same relationship that had earlier yielded the dreamlike *Bride of the Wind*. New York art critics were not particularly enthusiastic about Kallir's show. The critic from the *New York Times* described the colors of the *Knight* as "bilious" and the painter's work as "disturbingly unpalatable." The gallery made only one sale: *London, Large Thames View* to Buffalo's Albright Knox Gallery. Today, *Knight Errant* is at the Guggenheim.

Another early Galerie St. Etienne exhibition, *Saved from Europe*, included about fifty artworks by Gustav Klimt, Egon Schiele, and Alfred Kubin. The works were of such quality that many would eventually enter American museum collections. Although the Galerie St. Etienne was not especially profitable at the outset, its activities contributed to an acceptance of German and Austrian Expressionist art in America that would grow over time to a passion. Several decades in the future, the New York gallery specializing in this genre would thrive under the direction of Otto's granddaughter Jane Kallir. (Jane's efforts promote Expressionist artists both in the US and abroad. In 2025, Kallir co-curated a major Schiele exhibition in Vienna at the Leopold Museum with senior curator Kerstin Jesse, titled *Changing Times: Egon Schiele's Last Years 1914 -1918*.³⁰)

With the new gallery in need of income, Otto Kallir had to be resourceful. In 1940 he discovered the self-taught folk artist Anna Mary Robertson, a.k.a. "Grandma Moses," featuring her in a one-woman show that established her career. One distinguished visitor to the gallery was Eleanor Roosevelt. Throughout his long, productive relationship with the beloved American artist, Kallir continued to show her work; he also wrote her biography *Grandma Moses: American Primitive* in 1947 and her catalogue raisonné in 1973. Her terrific success would help finance the gallery's other artists who had not yet caught on with the American public.

During World War II, the Galerie St. Etienne became a gathering place for displaced Austrian artists and their friends. From 1940 to 1941 Otto Kallir served as chairman of the Austrian-American League, an organization that sought to preserve Austria's pre-Nazi culture and assist refugees. As leader of the group, Kallir provided financial support enabling nearly eighty Austrian refugees to emigrate to America.[31]

With the war's conclusion in May 1945, the world discovered the magnitude of the Nazi genocide. Families searched for lost relatives and mourned the many who had perished. Displaced persons looked for new homes. The Monuments Men uncovered the storage sites of plundered art and attempted to return the masses of items found there to their countries of origin. Meanwhile, Jewish art collectors and their heirs began the hunt for their lost art and other property.[32]

Kallir came through this period of pursuit and restitution particularly well. As mentioned, he retrieved his Viennese Neue Galerie from Künstler, his Austrian caretaker. The artworks he had sent to Paris escaped plunder and finally arrived in New York. He also increased his gallery's stock by purchasing twenty works by Schiele from the collection of performer Fritz Grünbaum, whom the Nazis had killed at Dachau in 1941. (Grünbaum's collection had originally included 80 works by Schiele and more than 440 pieces overall.) In 1948 and 1957, the Galerie St. Etienne held significant retrospectives of Schiele, though Jane Kallir noted that it took until the 1957 exhibit for the gallery to have real success with the artist.[33]

Otto Kallir established positive relationships with the directors of major American museums, both gifting and arranging sales of significant works to their institutions. In 1951, he sold Schiele's *Portrait of Albert Paris von Gütersloh* to the P. D. McMillan Land Company at a reduced price, provided that the work would eventually be donated to the Minneapolis Institute of the Arts. As a result, this Midwestern museum is the proud owner of this unfinished portrait of the Austrian poet, writer, and actor. The painting is the first Schiele to belong to an American museum. In 1956, Kallir donated Klimt's *Pear Tree* to the Fogg Art Museum of Harvard Art Museums, and, in 1957, he sold Klimt's *The Park* (1910) to MoMA. In 1997, Hildegard Bachert, who began as Kallir's secretary in the 1940s and became codirector of the gallery in the 1970s, donated a characteristic Schiele self-portrait in memory of Kallir to the National Gallery of Art (NGA). In this 1912 depiction, the artist emphasizes his piercing, devilish eyes, and unkempt hair. Schiele's red, screeching mouth and jagged lapels add to the image's feel of unrest.

Many of Kallir's other acquisitions had been just as brilliant in his foresight. As his granddaughter Jane Kallir recalls in *Saved from Europe*, commemorating the sixtieth anniversary of the gallery, seven of the thirteen Kokoschkas that Kallir originally brought to New York from Vienna now reside in museums.

Lea Bondi

Lea Bondi did not fare as well as her friend Otto Kallir. Following the Anschluss, Nazi art dealer Friedrich Welz of Salzburg's Galerie Welz had coerced her to sell him the Würthle Art Gallery and its inventory for a fraction of its worth. In 1939 Bondi and her husband Alexander Jaray managed to obtain a visa for Great Britain. However, a day or so before the two left Vienna, Welz appeared at their apartment, presumably to settle additional details about the gallery. He immediately spotted Schiele's *Portrait of Wally*, by then a precious piece of Bondi's private collection. Now Welz insisted that she surrender it. She resisted and an acrimonious argument followed. Her husband soon interrupted, urging his wife to hand over the portrait: "We may want to leave already tomorrow, and don't make any difficulties; you know what he can do."[34] So Welz departed with the *Portrait of Wally*, and the couple reached London, where Bondi opened a small art gallery.

After the war had ended, Lea briefly returned to Vienna and successfully sued Welz for the restoration of her gallery. She was also anxious to recover her treasured *Portrait of Wally*. When she asked for it back, Welz responded that the US military in Austria had confiscated the work in the course of its restitution efforts. Due to a series of mishaps, the Belvedere Museum had then mistakenly purchased the portrait. Pressed for time, Lea did not file an official claim for her painting on that trip. Numerous subsequent requests failed.

Enter twenty-two-year-old Rudolf Leopold, a Viennese ophthalmologist and determined art buyer. A casual visit to Vienna's Kunsthistorisches *Museum* had turned him into a passionate art lover and collector. Gustav Klimt, Oskar Kokoschka, and especially Egon Schiele enthralled him. During the 1950s, drawings by Schiele cost just a few dollars, and soon Leopold owned dozens. He educated himself and acquired paintings voraciously. He declared that he was the world's most significant Schiele authority and wrote several well-received books. By the late 1970s, he owned 250 works by the artist. He had gotten to know most of the world's preeminent Schiele dealers in London, Vienna, and New York.[35]

In his quest for more Schieles, Leopold visited Lea Bondi's London gallery in 1953. Since she found him "a nice, decent person," Bondi told him about her missing portrait and asked if he could help her retrieve it.[36] How wrong she had been to trust him! Leopold contacted the Belvedere Museum and discovered that the institution believed that *Wally* had been the property of the early Schiele collector, dentist Heinrich Rieger (see p. 111). Rieger had died during the Holocaust, and his heirs had sold his recovered art collection to the Belvedere.

The museum had mistakenly categorized *Wally* as one of Rieger's works. Capitalizing on this information, Leopold made a deal in 1954 with the Belvedere: the museum agreed to trade *Wally* to Leopold in exchange for another work from his collection. Lea Bondi's next news came from an exhibition catalog of paintings listing Rudolf Leopold as the *Portrait of Wally*'s owner. He had cleverly altered the work's provenance, as well.

Leopold continued to amass art. In addition to Schiele, he collected works by Gustav Klimt, Oscar Kokoschka, and other modern Viennese masters. He also acquired *Wally*'s pendant: Egon Schiele's 1912 self-portrait. The pair of portraits were a top attraction in his collection. In 1994, Leopold consolidated his five-thousand-piece collection into the Leopold Museum Private Foundation, which he sold to the Austrian government for a third of its value. As part of the arrangement, the State would build a handsome museum and appoint Leopold as its lifetime director. The new museum would open in 2001, but first, in 1997, a selection of about 150 works, including the *Portrait of Wally*, would go on a world tour: one important stop was New York's MoMA.[37] Bondi had died in 1969, but her relatives and Jane Kallir attended the exhibition and noted *Wally*'s presence, whose shady past journalist Judith Dobrzynski publicized in the *New York Times*.

Bondi's heirs informed MoMA that it was exhibiting stolen property and demanded that the museum stop the painting from returning to Austria until the portrait's ownership was resolved. MoMA refused. The museum was in a difficult position, because seizing a loaned painting could adversely affect the international loan of art.[38] Nevertheless, on January 7, the day before the works from the Leopold Museum were to return to Vienna, district attorney Robert Morgenthau, alerted by Bondi's relatives, halted the painting's departure. Morgenthau took action even though many of New York's cultural heavyweights, including Arthur O. Sulzberger of the *New York Times* and Ronald Lauder, then MoMA's chairman, tried to dissuade him. Instead of boarding a plane, *Wally* headed to a warehouse, where the portrait remained for twelve years.[39]

The 2012 documentary the *Portrait of Wally*, directed by Andrew Shea, recaptures the case, utilizing original footage of the trial. Rudolf Leopold testified in his own defense. Jane Kallir testified on behalf of Lea Bondi, mainly using information from her grandfather's correspondence with Bondi—strong evidence in Bondi's favor. At last, seventy-one years after her loss, Bondi was affirmed as the true owner of the *Portrait of Wally*. However, the family decided to cede the work to Leopold for a settlement of $19 million, so *Wally* could go back to the Leopold Museum; permanent signage next to the painting would also detail the Nazi looting and the painting's restitution. Bondi's heirs were generally satisfied with the arrangement, though some, like her grandnieces Ruth Rozanek and Edith Southwell, regretted *Wally*'s departure. Edith wrote, "I personally cannot rejoice that the painting will return to Austria, where [Lea] was so wrongfully deprived of it," but she conceded: "It is satisfying to know that her story and that of the attempts to recover it made in the United States will be displayed alongside it, wherever it is exhibited."[40] To the family, the heart of the suit had never been about money, but the principle of Bondi's rightful ownership.

8

Artists in Exile
Adieu, Europe, Hello, America

In his first novel *The Conquerors*, published in 1928, André Malraux famously said, "Une vie ne vaut rien, mais rien ne vaut une vie"—a life is worth nothing, but nothing is worth a life.[1] The French novelist and statesman recognized earlier than most the evils of Fascism, Marxism, and colonization. His words underline the importance of saving individual lives during human catastrophes of repression and brutality implemented by authoritarian regimes against targeted groups. This was certainly the case when Hitler took aim against "degenerate" artists in 1940.

Exodus

When the people of Belgium and the Netherlands realized that Nazi troops had invaded in May 1940, millions of civilians—my family included—took to the road. In France, masses fled Paris, both before and after the Nazis' arrival, pouring onto the already chaotic roadways. The hordes of refugees moving through Europe were dubbed "the Exodus of 1940."[2] Pandemonium reigned.

Back in Brussels: before my parents, my sister, and I could leave our cozy apartment, the police arrived and arrested us, because now we were German enemy aliens. The officials transported us to my school, which had become a temporary detention center. That evening, the Belgian authorities released women and children but deported my father to an unknown destination. My mother decided to proceed with our escape to France in search of safety. For two fruitless weeks my mother and sister and I attempted to cross the French border; at last, we gave up and returned to our apartment. We were anxious for weeks. Finally, we received a message from my father: he was incarcerated in Saint-Cyprien, an internment camp in the French Pyrenees-Orientales, originally built to house refugees of the Spanish Civil War. We would not see him again for six years.

Following its defeat, France signed an armistice with Germany in June 1940 that divided the country between an occupied Northern zone and a so-called "Free Zone" in the South. A German military government controlled the North, including Paris; Philippe Pétain, a venerated general of World War I, headed the South, also known as Vichy France. Though seemingly independent, the Vichy government did the bidding of the Germans. Given this development, the millions who fled the Germans either returned home, as my family had done, or explored other options.[3]

Varian Fry

Most of the refugees at risk of Nazi detention were desperate to get out of Europe. They spent their days searching for escape routes. They combed telephone books looking for long-lost relatives, former neighbors, colleagues, or other kind souls in the United States—or elsewhere—who might help them secure an affidavit, employment, monetary support or assist in obtaining a visa. Refugees promised anyone who would listen they would settle in undesirable parts of nations, farm in arid regions, or perform menial jobs. Visas to Cuba, Central, and South American countries, or elsewhere were occasionally for sale, though it could be difficult to ascertain if they were genuine. My family's Swiss relatives obtained visas for us to Ecuador, though we never used them. I am eternally grateful that my father managed to secure a US visa in May 1941, just six weeks before the Germans barred those with immediate relatives in Nazi-occupied territory from leaving the continent.

The throng of refugees stagnating in Vichy France included numerous writers, scientists, cinematographers, scholars, and artists. The latter besieged Alfred Barr and other intellectual leaders with pleas for aid.[4] Barr worked ceaselessly to accommodate their requests.

Only a small percentage of the US population favored rescuing European refugees, and Varian Fry was one who did. Fry had cofounded the literary magazine *The Hound & Horn* with Lincoln Kirstein at Harvard in 1927. The magazine was the sole periodical to publish any of Alfred Barr's account of the Nazi takeover in Germany (see chapter 3). Fry graduated Harvard in 1931, and within a few years he was working as a journalist for a variety of liberal publications; he visited Germany to report on the country under Hitler and personally witnessed the reality of the chancellor's extreme racist policies and repressive guidelines for the arts.

Upon returning to the States, Fry could not forget about the rise of Fascism. He was ready to assist Europe's persecuted in their escape. As the borders of the free world were shutting, Fry and his associates organized a fundraising luncheon that brought together more than two hundred distinguished Americans at the Commodore Hotel in New York on June 25, 1940.[5] The event resulted in the founding of the Emergency Rescue Committee (ERC). Its purpose was to increase availability of visas earmarked for artists, writers, musicians, scientists, and

political activists and to facilitate these refugees' departures from Europe. Given the numbers of such refugees at risk, the ERC convinced First Lady Eleanor Roosevelt to lobby for additional US visas. The group also aimed to persuade American employers to offer jobs to incoming immigrants, as employment would fulfill criteria for work papers and visas.[6]

It soon became apparent that the ERC would need a representative on site in Europe to open closed doors and reduce the red tape surrounding visas, transportation, and other emigration issues. After searching in vain for a suitable emissary, the ERC selected Varian Fry. As he later recalled in his autobiography, *Assignment Rescue*, Fry felt he was "not right for the job. . . . All I knew about being a secret agent or trying to outsmart the Gestapo is what I have seen in the movies." However, he informed the committee he would accept the position if a better candidate did not appear.[7] Fry consequently left for France in August of 1940. His official assignment was to rescue a list of about two hundred endangered artists and intellectuals, including Jean Arp, André Breton, Marc Chagall, Marcel Duchamp, Max Ernst, Jacques Lipchitz, André Masson, and Franz Werfel (whose wife, Alma Mahler, had been previously involved with Oskar Kokoschka—their tumultuous relationship at the center of some of his evocative works [see chapters 5 and 7]).

Not all refugees recognized the danger they faced. Marc Chagall, both Jewish and a "degenerate" artist, was reluctant to accept Fry's help, believing his fame would spare him. Without Fry's persuasion, Chagall might have perished. Even once he agreed to leave, his rescue almost failed. At the last minute, Chagall lacked the money to pay his transatlantic fare, so Curt Valentin, Solomon Guggenheim, Walter Arensberg, and Helena Rubinstein quickly stepped in to supply the necessary funds.[8]

In time, Varian Fry's operation grew in size. Fry learned to forge exit permits, transit visas, and other false documents and negotiate with the police, the authorities, and the underground. He set up safe houses and, at one point, even spied on the British. His undertaking did not please the French authorities nor William D. Leahy, the American ambassador to France, who wished to avoid provoking Vichy officials. By the summer of 1941, a year had passed since Fry's arrival, and both Leahy and the French were ready for the idealistic American to leave. When Fry's residency papers expired, he was still in Marseille. Believing Fry had overstayed his welcome, the French police arrested him and escorted him to the Spanish border. Like most of those he had assisted, Fry traveled from France to the port of Lisbon for his ocean voyage; he finally reached the United States in October 1941.

Fry and his colleagues had been very effective angels of mercy. He and his associates managed to save at least ten times their initial goal of two hundred threatened individuals. This accomplishment, especially by a novice administrator, has come to be regarded as "the most successful mission to rescue anti-Nazi artists, writers, intellectuals, scientists, and refugee politicians during World War II."[9]

Vice Consul Hiram Bingham IV

For those seeking refuge abroad, a departure from Europe was fraught with difficulties. The still-neutral United States was everyone's first choice of destination, but America doled out visas sparingly. Other countries were equally reluctant. At the time, Hiram (Harry) Bingham IV was a vice consul in charge of visas at the American consulate in Marseille. Bingham's compassion proved a unique exception to the prevailing inhumanity at most visa-granting institutions; his heroic actions alongside Fry would cost him his career. American consulates followed the dictates of the xenophobic Breckinridge Long, who oversaw the US State Department's Visa Division, which tried to impede the entry of refugees into the United States. Long even wrote a memo to consular officers suggesting they "put every obstacle in the way," as a mode of delaying visas to applicants.[10, 11]

Defying Long, Bingham and Fry began to collaborate. Often working clandestinely, the two rescued thousands of refugees from Vichy France. It is estimated that Bingham issued more than two thousand US visas in ten months. These life-saving documents were not restricted to famous artists and intellectuals. Three went to my best friend Dorrie L. and her parents, who were stranded in the Vichy zone. Today, a framed copy of the visa, signed by Miles Standish, Bingham's assistant, hangs over ninety-year-old Dorrie's bed in her New Jersey apartment. Not every refugee ended up in the United States. Fry helped my mother's cousin Franz Feuchtwanger, a former Communist, and his family. They managed to reach Mexico, where Franz sold insurance during the week and, on weekends, became an expert on Olmec art.

Bingham's liberal release of US visas did not escape his superiors, and they weren't pleased. On May 7, 1941, they transferred him from the US Consulate in Marseilles to the office in Lisbon. Within months, they moved him even further to the consulate in Buenos Aires. In 1944, he informed the State Department that Nazi war criminals—including Adolph Eichmann—were sheltering in Argentina but to no avail; they would not restore Bingham to France.

Passed over for promotions, Bingham resigned from the State Department in 1946. By then the father of eleven children, he decided to return to the family farm in Connecticut. He remained close friends with Varian Fry, who, in 1945, gave him a copy of his book *Surrender on Demand* with a handwritten inscription: "To Hiram Bingham my partner in the 'crime' of saving human lives."[12]

Obtaining a visa was, in fact, only half the battle. Refugees still had to navigate a complex obstacle course—with corresponding paperwork—to reach their ports of embarkation. Sparsely available transatlantic ships only left from Portugal; getting there entailed passing through Fascist Spain, which cooperated only reluctantly. The journey to Lisbon required French exit visas, Spanish transit visas, and a Portuguese residence permit: the dates of all these documents had to align. Authorities delighted in chicanery, so the manufacture of fake documents boomed.

Refugees with documentation were able to take trains from France to Lisbon. Those who failed to obtain the proper paperwork hired expensive guides to help them traverse the rugged Pyrenees. Some refugees crossed the Spanish border on their first attempt; others were apprehended and sent back to France. Most tried again. Escapes were expensive, and money was in short supply. Documents, including fake ones, were costly, as were transatlantic fares.

Regulations varied as to transporting possessions out of Europe, but many refugees took their art with them. Marc Chagall's daughter Ida succeeding in shipping her father's work to America; the crates packed with canvases weighed 1,300 pounds![13] Peggy Guggenheim wouldn't leave France until sending her extensive collection of modern art back to the United States. Meanwhile, artists like Max Ernst, Fernand Léger, and Jacques Lipschitz made the journey carrying works in progress.

Peggy Guggenheim and Max Ernst

In 1938 rebellious American heiress and avid art collector Peggy Guggenheim opened Guggenheim Jeune, her gallery in London. Over the next eighteen months she presented an impressive twenty-two exhibitions,[14] featuring major avant-garde figures from Jean Cocteau to Vassily Kandinsky. By 1939, she decided to found her own museum of Surrealist and abstract art—what she called "MMMM," short for "My Much Misunderstood Museum." However, the project seemed highly improbable, as she had not yet built her own collection. Therefore, she traveled to Paris where she assembled a collection at a an extremely ambitious pace. Though war was raging throughout Europe, Guggenheim embarked on a buying spree, acquiring "a painting a day." She amassed a superior collection of modern, Surrealist, and abstract art between 1939 and 1940—a remarkably short time—including pieces by Salvador Dalí, Fernand Léger, Piet Mondrian, and more.[15] In 1941 Guggenheim at last conceded to the danger of remaining in France. She managed to ship her pictures to the US together with linens and other furnishings as "household goods." For herself and her entourage, she booked seventeen seats aboard the new Clipper Service from Lisbon to New York.[16]

Peggy Guggenheim transported not only valuable art: she also helped artists in danger escape from Europe. One of these was Surrealist painter Max Ernst. Guggenheim had met the painter on his fiftieth birthday at the Villa Air-Bel rented by Varian Fry. It was love at first sight; she would marry Ernst once they reached the United States.[17] The Nazis had targeted him for his "degenerate" art, despite his service in the Kaiser's army during World War I. Ernst had long lived in France, but with the outbreak of War World II, he had suddenly become an enemy alien; following incarceration in several camps, he found himself stranded without valid documents in Vichy territory. His fate rested with Guggenheim and Fry. Guggenheim promised him one of her Clipper seats, and Fry created the necessary French exit visa.

Ernst took the train from Pau, a French city close to the Spanish border, intending to travel through Spain to Lisbon. At the border a customs officer stopped Ernst because his papers were supposedly not in order. The man took his passport and insisted that Ernst divulge the contents of his baggage, so he took out the numerous canvases he was carrying and spread them on the station platform. Ernst's wife Dorothea Tanning later wrote in her memoir, "So took place the exhibition of his life, with the unrolling of those wild and sumptuous canvases. . . . Travellers looked and marveled. There before them were the forests and their glistening basilisks, the green eyes of rampant nature."[18] After gazing at the extraordinary pictures for several minutes, the stunned official pulled Ernst aside: "Monsieur, I adore talent. You have a great talent. But I must send you back to Pau. There is the train to Pau. Here on the left is the train for Madrid. Here is your passport. Don't take the wrong train.'" He didn't. Ernst successfully crossed into Spain and continued his voyage to Lisbon and Guggenheim's waiting plane.[19]

Procuring visas, transportation, and necessary funds, Varian Fry, Peggy Guggenheim, and Harry Bingham made a remarkable effort to save refugees. However, they could only achieve so much. As more targeted individuals remained trapped in Europe, all too many joined the millions who lost their lives. Two painters who failed to reach America were Felix Nussbaum and Chaim Soutine.

Jewish Artists Felix Nussbaum and Chaim Soutine

In 1904, Felix Nussbaum was born into a middle-class Jewish family in the city of Osnabrück in northwestern Germany. Nussbaum's father possessed his own talent as an amateur artist, so both Nussbaum's parents encouraged their son's early aptitude for painting. By 1923 the young painter had moved to Berlin to study art and only five years later presented his first solo exhibition. In 1932 Nussbaum won an Italian fellowship to study at the German Academy in Rome, so he traveled to Italy, accompanied by his girlfriend he had met in Berlin, the Polish-Jewish artist Felka Platek. Unfortunately, Nazi power reached Italy in 1933: when Göbbels himself came to lecture on the correct themes for a Nazi artist to embrace, Nussbaum knew he had to leave. The couple made their way to Brussels, where they moved in with friends in 1935 and married two years later.[20] Everything changed on May 8, 1940, when the Germans invaded Belgium. Days later, the Belgian authorities shipped Nussbaum—as they had sent my own father—to Saint-Cyprien, the camp in southern France known as "the Hell of the Pyrenees." There, captives shared quarters with 7,500 other German Jews in shocking conditions.[21]

Nine months later, Nussbaum managed to return to his wife in Brussels. He had no means to support himself, so his friends kindly furnished him with a studio and art supplies, and he took up his brushes once more. His *Self-Portrait in the Camp* painted in 1940 documents his gruesome experience at Saint-Cyprien and is now at the Neue Galerie in New York (Figure 8.1).

Figure 8.1 *Felix Nussbaum,* Self-Portrait in the Camp *(1940). A chilling self-portrait of the artist, silhouetted against the Saint-Cyprien concentration camp in Southwest France. Credit: Neue Galerie/ HIP/Art Resource, NY*

On the one hand, the work feels reminiscent of Hieronymus Bosch, with a small figure in the background defecating into a large open container—Bosch's *Garden of Earthly Delights* teems with tiny naked figures in bizarre or obscene contexts—though according to painter Pat Lipsky, this literal act had not been depicted since a 1641 portrayal of Dutch peasants by Isack van Ostade.[22] On the other hand, Nussbaum's unshaven face and very clear eyes very much spell twentieth-century Expressionism. The sight of this painting makes me shiver, reminding me how much my fastidious father must have suffered for close to a year of captivity in French concentration camps.

By 1942 the couple had to hide. In 1943 their landlord gave them a space in the attic to take cover during Gestapo raids.[23] Nussbaum constantly moved back and forth between their apartment and this hiding place. At this time, he stopped using oil for fear the smell of turpentine

would give him away. In May or June of 1943, Nussbaum moved his workplace to a basement studio where he painted his final works, including *Self-Portrait with a Jewish-Identity Card*. The painting shows him wearing the dreaded Jewish star and holding up a Belgian identity card stamped "Juif-Jood." This work takes me back to 1942, when I, too, sewed such a star onto my clothes. Nussbaum's somber palette reflects the desolation of his circumstances. Yet he looks out at the viewer with an expression of defiance.

Despite Nussbaum's valiant efforts to stay concealed, an informer must have noticed the occasional opening of the attic window and exposed him.[24] Both Nussbaum and his wife were arrested in June 1944 and transferred to Auschwitz that August, just weeks before I cautiously stepped from my own hiding place in Brussels.[25] Nussbaum's story is not just tragic, it is also remarkably similar to that of Hermann Lismann, whose double portrait of *Francesca da Rimini and Paolo Malatesta* I describe in chapter 1.

Over the decades that followed, Nussbaum's hometown of Osnabrück gathered 206 of his works and in 1998 opened a museum dedicated to this brilliant chronicler of the Holocaust. The town now displays these haunting images, including many self-portraits, in the Felix Nussbaum Haus, an intimate, boxlike wood structure, conceived by renowned Polish American architect Daniel Libeskind. His design features triangular windows that appear to pierce the outside walls; the windows are small, as if to keep the sunlight from intruding into the sanctuary-like space.[26] According to Studio Libeskind, "With sudden breaks in its pathways, unpredictable intersections, claustrophobic spaces, and dead ends, the structure of the building reflects Nussbaum's predicament as a Jewish painter in Germany before WWII." The award-winning Osnabrück project earned Libeskind the opportunity to design Berlin's Jewish Museum.

Chaim Soutine was born in 1893, the tenth of eleven children in the Orthodox Jewish shtetl of Smilovitz, Russia (now Belarus). The darkness of his adult character no doubt had its seed in his earliest childhood—a time of poverty, hunger, and rejection. Soutine began sketching at a young age, but his community held strict religious views forbidding pictorial representation. When he produced a portrait of a known religious figure, he was physically attacked by the man's sons. In 1909 he managed to escape the village at age sixteen, enrolling in Vilna's academy of art. In Vilna he met a kind Jewish doctor who enabled Soutine to make the journey to Paris—a destination the young artist looked to as "the promised land."[27] By 1913 he arrived in the French capital, where he would become a significant member of the School of Paris—the influential group of foreign, primarily Jewish artists who converged upon the city in the first few decades of the twentieth century. These visionaries included Marc Chagall, Amedeo Modigliani, Jacques Lipshitz, and others. Soutine and Modigliani, who both lived at La Ruche ("the beehive"), a group of low-cost

artists' studios and residences in Montparnasse, became particularly close friends, despite their ostensible differences: Modigliani was erudite and polished, Soutine, unkempt and asocial. But Modligliani believed in his friend's genius and introduced him to his dealer Leopold Zborowski.

Soutine's style is very much his own, though his impasto streaks of pigment, bold colors, and distortions are reminiscent of the Expressionists and van Gogh. Inspired by Rembrandt's *Slaughtered Ox* at the Louvre, Soutine purchased raw sides of beef and dead fowl as subjects to paint in his studio. To the chagrin of his neighbors, the raw flesh rotted within days, producing a horrific stench. His neighbors called the department of health, which instructed him to inject the meat with formaldehyde. This dried the meat but faded its color, so he painted it with fresh blood, and his series of carcass paintings feels strikingly vibrant.[28] The works had deep psychological significance: as a boy, Soutine had observed a butcher slaughter a goose and held back his impulse to cry out. He once explained, "This cry, I always feel it. . . . When I painted the beef carcass, it was still this cry I wanted to liberate."[29] Today the meat carcass paintings belong to museums such as the Buffalo AKG Art Museum and the Minneapolis Institute of Art Collection.

Albert Barnes, the Philadelphia collector, discovered Soutine in 1922. It was the portrait *The Pastry Chef* that first struck Barnes. The collector proceeded to purchase Soutine's entire output—more than fifty oils—twenty-one of which are now at the Barnes in Philadelphia. The sale gave Soutine his first taste of financial stability. Despite his success, the artist remained anxious and aloof, though in time, he acquired female companionship and devoted clients. In 1925, collectors Marcellin and Madeleine Castaing purchased their first piece by Soutine, *Standing Choirboy*, and quickly developed a close relationship with the artist. Soutine would paint Mme. Castaing's portrait, and after Zborowski passed away in 1932, Mr. and Mme. Castaing would become the painter's primary patrons, promoters, and defenders. Soutine had seldom exhibited his work, but with the patronage of the Castaings, he presented a solo show at the Arts Club of Chicago in 1935, then participated in a major exhibition at the Jeu de Paume in Paris in 1937, where he finally received the recognition he deserved.[30]

After the invasion of France in 1940, Soutine had to register as a Jew. He tried to emigrate to the United States but did not possess the necessary identity documents. He had to leave Paris and lived in various parts of France, moving frequently to avoid capture by the Nazis. All the while he painted captivating landscapes. By 1941 he was living with Marie-Berthe Aurenche, the former wife of Max Ernst, in the Loire Valley. Soutine was frail, suffering from ulcers, and did not have suitable food or adequate care. In 1943, his ulcer perforated. Aurenche got him admitted to a Paris hospital for emergency surgery, but a torturously indirect drive through Normandy took over twenty-four hours, and the operation was too late to save him. Picasso and Jean Cocteau paid their respects at Soutine's small funeral, and he was buried in Montparnasse cemetery.[31] Today, Soutine is recognized throughout the world as a master of Expressionism, and most major American museums own examples of his work.[32]

Peggy Guggenheim's Art of This Century

In October 1942, about a year after her return to the United States, Peggy Guggenheim opened her gallery Art of This Century in New York City. According to Philip Rylands, founding director of the Peggy Guggenheim Collection in Venice, "Art of This Century is inseparable from [her] claim to a place in the history of twentieth-century art."[33] Guggenheim's personal art collection filled three-quarters of the space, while temporary exhibitions and a sales gallery occupied the rest.

Visitors described it as one of the most creative museum exhibition spaces they had ever seen. The space was designed by avant-garde architect Frederick Kiesler, who produced interactive rooms in which light would switch on and off, viewers could rotate paintings, and furniture was multifunctional.[34] The gallery showcased the work of established European artists, including Jean Arp, George Braque, Salvatore Dalí, Alberto Giacometti, Vasily Kandinsky, and Yves Tanguy. Guggenheim also exhibited up-and-coming young American artists she had met upon her return to the United States, such as Jackson Pollock, Mark Rothko, Clyfford Still, and other future School of New York members. Art of This Century served as a meeting place for both exiled and American artists, and the mix resulted in lasting cross-fertilization.

By 1947 Guggenheim decided to close the gallery. Since its opening, it had mounted fifty-three exhibits featuring 103 artists. Guggenheim then returned to Europe where she moved her collection into the Palazzo Venier dei' Leoni on Venice's Grand Canal. The palazzo eventually became the home of the Peggy Guggenheim Collection, a branch of the Solomon Guggenheim Museum and a piece of American history in Italy.[35]

The Pierre Matisse Gallery and *Artists in Exile*

In 1931 Pierre Matisse opened his New York gallery on East 57th Street, where he introduced modern European artists to American collectors. When refugee artists arrived in the United States, they naturally sought the young dealer out as a fellow European immigrant and son of the great modernist Henri Matisse. Like the Galerie St. Etienne and Art of This Century, the Pierre Matisse Gallery functioned as a social club for European expatriates.

Matisse maintained close ties with his family in Europe and spent most of his summers in France. Though he did not act as his father's exclusive American dealer, Matisse corresponded regularly with his father on the topic of his art. Protecting his father's interests, he helped negotiate his contracts for important projects such as a fireplace surround for Nelson Rockefeller, and *The Dance* mural for Alfred Barnes.

In March 1942, Pierre Matisse organized a three-week exhibition titled *Artists in Exile*. A group photograph of the fourteen participants attests to the profusion of European artists that

flocked to America during World War II. In alphabetic order, they are Eugene Berman, André Breton, Marc Chagall, Max Ernst, Fernand Léger, Jacques Lipchitz, André Masson, Matta, Piet Mondrian, Amédée Ozenfant, Kurt Seligmann, Yves Tanguy, Pavel Tchelitchev, and Ossip Zadkine. Five of them—Breton, Chagall, Ernst, Lipchitz, and Tanguy—owe their life to Fry.[36]

James Thrall Soby, board member of MoMA and modern art collector, contributed the introduction to the show's catalog. He reflected:

> Here are fourteen artists who have come to America to live and work. They are a disparate group, but all belong to the rare company of those who have brought originality and authority to the art of their period. Their presence can mean much or little. It can mean a beginning of a period during which the American tradition of freedom and generosity may implement a new internationalism in art, centered in this country. Or it can mean the reverse; it can mean that American artists and patrons may form a xenophobic circle and wait for such men to go away, leaving our art as it was before.

Each of the invited artists exhibited a single work. Most of the pieces were recent creations. Here is a brief look at some of the artists who participated and the work they displayed at this historic show.

Max Ernst

Surrealist Max Ernst exhibited *Europe After the Rain II*. The painting depicts the darkness and decay he left behind in WWII, underscoring the motivation for these fourteen artists to migrate to the United States. The work is an example of Ernst's use of decalcomania, a technique in which the artist applies paint to the canvas, then another material on top such as paper or glass; removing this layer creates an unusual texture.[37] Ernst's resulting image is the desolate, bleak landscape with craggy rock-and-tree-like elements. A woman gazes into the distance next to a soldier—half-bird-half-man—with spear in hand. Beside the figures, the remnants of a pavilion are engulfed by the pulsating twists and turns of dead undergrowth. The colors of the painting, ranging from rust to green, feel autumnal, in line with the theme of decay. Ernst started work on the picture in Europe in 1940, and it was among those canvases that saved his life at France's border. He finished it in New York in 1942, the same year as the exhibition, where the Wadsworth Atheneum in Hartford acquired it from Pierre Matisse's gallery.

Ernst would return to France in 1950. During his stay in America, he completed two celebrated sculptures, *Capricorn* and *The King Plays with the Queen*. The title *Capricorn* refers to the zodiac sign represented by a goat and fish tail. The piece features a moon-faced, long-necked mermaid queen beside a horned king with a baby mermaid in his lap. In 1946 Ernst first assembled *Capricorn* from found objects, including scrap iron, milk cartons, eggshells, box tops, and cement; Ernst's wife Dorothea Tanning recalled that this "sculpture of regal but benign

deities . . . consecrated [their] 'garden'" and watched over their small home in Sedona, Arizona. The work was later cast in bronze in 1964, then again in 1975, and was acquired in 1979 by the National Gallery of Art in Washington, DC.[38] The second piece, *The King Plays with the Queen*, presents another horned king who plays a game of chess with his tiny queen. Ernst first conceived the work in 1944. MoMA owns a bronze cast from 1954.

Marc Chagall

Pierre Matisse was at the dock to welcome Bella and Marc Chagall when their wartime boat arrived in New York in 1941. Twenty years earlier, their paths had crossed in a Paris gallery where the young Matisse worked at the time. Now, the gallerist had become Chagall's American dealer and offered to give him an annual show. In 1942 Matisse included Chagall in the *Artists in Exile* exhibition with a work in watercolor and pastel titled *The Dream*. Chagall had created it in 1939, the year he fled Paris. Intertwining personal, biblical, and political elements, the image evokes love, harmony, and hope in a time of looming danger. The piece was acquired by the Phillips Collection in Washington, DC.

Born in Vitebsk, Russia (now Belarus) in 1887, Chagall never forgot his "sad and joyful town." (Like Soutine, Chagall grew up in a large, Yiddish-speaking family—in Chagall's case, the eldest of nine children—whose strict Jewish beliefs did not condone art.[39]) Throughout his life of ninety-eight years, the artist incorporated elements of Vitebsk—its church spires, synagogues, houses, Jews, peasants, and animals—into his colorful compositions. It was in Russia that Chagall first developed his craft: at nineteen he moved to St. Petersburg to study art.[40] At 24, he set out for Paris, where his style fused with French modernism. Living in Paris from 1911 to 1914 at La Ruche alongside other immigrant artists, Chagall created some of his greatest works: *To Russia, Asses and Others*; *The Violinist*; *The Cattle Dealer*; and *I and the Village*. France had become Chagall's new home.[41]

In June 1914, Chagall left Paris for Vitebsk to attend his sister's wedding. He stopped in Berlin, where gallery owner Herwarth Walden organized the artist's first solo exhibition, featuring 40 oils and 160 gouaches, most of which Chagall had painted in France.[42] Walden had named his gallery Der Sturm—"The Storm"—anticipating radical, modern ideas: he was an early advocate of the avant-garde, and the public sometimes viewed his artists as "a herd of paint-splattering howling monkeys."[43] But Chagall's exhibition was a great success. After the show, Chagall continued on to Vitebsk, where he married his fiancée Bella Rosenfeld. He had hoped to bring Bella to Paris three months later, but World War I, then the Russian Revolution, interfered; the Chagalls would not leave Russia until 1922.

When Chagall returned to Germany, he was a husband and a father—daughter Ida had been born in 1916. Most of the paintings he had left at Der Sturm gallery had been sold, but because of hyperinflation from the war, his earnings had shrunk to almost nothing. The works

had scattered throughout the country with their new owners; one was Herbert Garvens von Garvensberg, my mother's art dealer.

After a year in Germany, the Chagall family moved to Paris. Two photos from about 1924 show Chagall with his wife Bella and their daughter Ida in their Paris apartment, surrounded by familiar paintings: *I and the Village*; *Birthday*; *The Praying Jew*; *The Blue House*; and *The Poet Reclining*.[44] Today, all of these are in museums. In 1937, The Art Institute of Chicago (AIC) purchased *Praying Jew*—one of three versions—and in 1942, the Tate Museum in London acquired *The Poet Reclining*. The Nazis confiscated *The Blue House* from the Mannheim Museum and sold it at the 1939 Lucerne auction to the Liège delegation for the Liège Museum of Fine Arts (see chapter 5).

Both *Birthday* and *I and the Village* are now at MoMA, though they arrived by different routes. Collector Kurt Feldhäusser (see chapters 2 and 4) purchased "degenerate" art within the Reich from sales force member Ferdinand Möller, acquiring *Birthday* in 1935. After Feldhäusser's death in 1945, his mother brought the painting with her to the United States and sold it to MoMA through New York's Weyhe Gallery. The work depicts Bella floating across the canvas in a bright red dress, clutching her birthday flowers. Marc glides into Bella's space, his body paralleling hers, his lips stealing a kiss. The Chagalls' dinner is on the table, while ever-present Vitebsk is visible through a window.

I and the Village is perhaps Chagall's best-known work. The family of his German dealer Herwarth Walden returned it to Chagall in Paris in 1926; René Gaffé, a Belgian art critic and collector, acquired it the same year. Once Gaffé moved to America, he loaned the iconic painting to MoMA and finally sold it to the museum in 1945. Though Chagall remains stylistically unique, some whimsical elements of his work may recall the Surrealists: in *I and the Village*, a cow nuzzles a green-faced, white-lipped peasant, while a woman frolics upside-down on the village square. The painting is a kaleidoscope of geometric shapes and dreamlike perspective and color. When the poet Guillaume Apollinaire first viewed Chagall's wondrous imagery at his Paris studio, he cried, "*Surnaturel!*" meaning "supernatural." The poet soon changed the term to "Surreal," and the avant-garde group adopted it for their Surrealist Manifesto.[45] The Surrealists even invited Chagall to join their movement, but he refused, feeling his work did not represent their principles. Professor Michael Lewis of Williams College explains, "He evidently did not like their exaltation of the arbitrary and the random, feeling that his own personal language of symbols was meaningful and thoroughly sincere."[46]

More than two decades after *I and the Village*, Chagall painted *White Crucifixion* in 1937, a painting with profound political significance (Figure 8.2). According to the Art Institute of Chicago, which acquired the work in 1946 from Pierre Matisse, "*White Crucifixion* marked a critical turning point for Chagall."[47] Created during the tightening grip of Nazi power, the painting is "the first in [his] series of compositions that feature Jesus as a Jewish martyr and dramatically call attention to the persecution and suffering of Jews."[48] As befits Jewish oppression,

the painting's colors are subdued, and the emaciated Christ's loincloth is a tallit, a Jewish prayer shawl. The crown of thorns is a simple headdress, and the mourning angels that float above the cross are Jewish elders. The ground is strewn with books, a candelabra, and a Torah roll. More images of Jewish martyrdom fill the canvas: a pogrom, a burning village, refugees in flight carrying a Torah scroll, sacks filled with villagers' belongings. A boat crammed full of human cargo eerily projects the plight of twenty-first-century refugees. In 2015, *White Crucifixion* would travel to Florence, Italy at the request of Pope Francis, to take part in an exhibition of religious art. For the Pope's visit to Florence, the painting was moved to the Baptistry of St. John, where he viewed the work for the first time in person. It was one of Pope Francis's favorite paintings.[49, 50]

In September 1944, three years after Chagall and his family arrived in America, Bella—his great love and muse—fell ill with a viral infection; she died, aged fifty-two, within a few days. Her husband was devastated and, four years later, returned to his beloved France. Settling in Provence in the historic town of Vence, Chagall met Valentina Brodsky, known as "Vava." A Ukrainian Jewish woman who had been living in London and spoke multiple languages, Brodsky helped Chagall recover from the loss of Bella, and in 1952, the couple married.[51]

Though living in Europe, Chagall continued to maintain bonds with America. To Nelson Rockefeller he expressed a nostalgic desire to "paint . . . murals for a public building to commemorate his sojourn in America," and in 1966, he created *Les Sources de la Musique* and *Le Triomphe de la Musique* for New York's new Metropolitan Opera House.[52] Chagall's mythical beasts and figures fill the two enormous panels.

Late in life, Chagall produced stained-glass windows, an ideal medium for his mastery of color and fanciful characters. In the early 1960s, the Rockefeller family had asked him to create a window commemorating John D. Rockefeller Jr. in the small Union Church in Pocantico Hills, New York, where the family worshipped on weekends. The commission shares the spotlight with Henri Matisse's last work, a rose window designed in 1954 as a memorial for his friend Abby A. Rockefeller. Given the glory of these two stained-glass works, the family asked Chagall to replace the chapel's side windows. The result: a magical jewel box of shapes and colors.[53]

Yves Tanguy

Pierre Matisse would become Yves Tanguy's art dealer in America, but the two first met as schoolmates when they were boys in France. By 1923, Tanguy had completed his military service abroad and returned to Paris; he happened to see a painting by Giorgio de Chirico that so impressed him he resolved to become a painter in his own right. He became intrigued by Surrealism from reading the publication *La Revolution surrealiste*, and the next year, he met André Breton, the founder of the movement. Tanguy found inspiration in Carl Jung and his interpretation of dreams and occasionally derived painting titles from psychoanalysis. He developed a singular style, depicting the inner landscape characterized by a "flat, distant horizon, blank sky and scattering of unearthly croppings and growths."[54]

Figure 8.2 *Marc Chagall*, White Crucifixion *(1938). In his unique vision of the Crucifixion, Chagall depicts scenes of Jewish persecution surrounding the central figure of Jesus as a Jewish martyr. The painting migrated with Chagall from France to America in 1941.* Credit: The Art Institute of Chicago/Art Resource, NY. © 2025 Artists Rights Society (ARS), New York/ADAGP, Paris

In 1927, just four years after deciding to become an artist, the self-trained Tanguy presented his first one-man show at the Galerie Surréaliste in Paris. During the 1930s, he had a tempestuous affair with Peggy Guggenheim, who gave him an exhibition in 1938 at her London gallery Guggenheim Jeune. Their relationship ended the following year when Tanguy fell in love with American Surrealist painter Kay Sage and traveled back to the United States with her in 1939

with the help of Varian Fry. The two artists married in 1940 and settled in Connecticut, where Tanguy would remain until his death in 1955.

Tanguy was both prolific and popular, and his work significantly influenced both upcoming Surrealists and American Abstract Expressionists. He painted *Time and Again*, his contribution to the *Artists in Exile* exhibition, in 1942, a few years after he emigrated to America. In this otherworldly landscape, his elongated shapes cast a sharp shadow onto their sand-colored background. Madrid's Museo Nacional Thyssen-Bornemisza, which acquired the work in 1975, notes the painting offers a good example of Tanguy's formula for landscape, placing "several unidentifiable isolated forms in a deserted setting, with no horizon."[55] His works are now among numerous American collections: *The Great Mutation* at MoMA, *The Earth and the Air* at the Baltimore Museum, *Fear* at the Whitney, and *Indefinite Divisibility* at the Buffalo AKG Museum.[56]

Fernand Léger

Alongside Pablo Picasso, Georges Braque, and others, Fernand Léger developed a personal style of Cubism with his own visual vocabulary.[57] Filling his works with stylized figures, tubes, cylinders, and other geometric forms, Léger was energized by the modern era of the machine age and hoped to demonstrate its beauty. Léger established a professional relationship with MoMA when he first visited America during the mid-1930s. Alfred Barr included *Three Women*, one of Léger's major paintings, in his 1939 show, *Art of This Century*. MoMA would acquire the work in 1942.

In 1940 Léger was in France, attempting to return to the United States. While awaiting passage in Marseille, he caught sight of figures diving off the docks, which inspired a project that would occupy him throughout his years in America during World War II.[58] In 1942, *Study for Divers* took part in Pierre Matisse's *Artists in Exile* exhibition. Eventually, the series would include twenty-five paintings. One of these, *Divers, Black and Blue* (1942–1943)—combining bold primary colors with the energy of twisted limbs in thick, black outline—was acquired in 1957 by refugee collectors Natasha and Jacques Gelman, who eventually bequeathed it to the Metropolitan Museum of Art.

Jacques Lipchitz

Born in Lithuania in 1891, Jacques Lipchitz moved to France at age eighteen to study sculpture. In Paris he met the avant-garde circle of artists, including Cubists such as Picasso and Juan Gris, and Lipchitz began exploring Cubism in his own work.[59] Lipchitz blended the deconstructionism of Cubism with the pioneering approach of August Rodin, who rejected traditional representations of the ideal figure to show expressions of intense emotion, eroticism, and psychological depth.

Success came early to Lipchitz. In 1922 Alfred Barnes commissioned from him a series of reliefs for the exterior of his new foundation in Merion, Pennsylvania.⁶⁰ When Lipchitz received a commission from the Paris World's Fair of 1937, he created *Prometheus Strangling the Vulture*. Watching the gaining momentum of Fascism throughout Europe, Lipchitz saw in the towering mythological figure of Prometheus "the victory of mankind over these terrible forces."⁶¹ The work won a gold medal at the Fair. (For the same event, the Spanish Republican Government asked Picasso to create a mural for the Spanish Pavilion: the result was *Guernica*.)

The titles of Lipchitz's wartime sculptures *Flight*; *Arrival*; and *The Rape of Europa II* mirror his terror throughout the period. In 1935, three years before he sculpted *The Rape of Europa II* depicting a fierce bull attacking a maiden, Lipchitz had written, "I responded in my gut [to Nazism] as a Jew on behalf of my scattered and persecuted blood brothers. But this monster we are killing is not just antisemitism; it is, in fact, whatever keeps man from walking tall."⁶² In New York, Curt Valentin lent *The Rape of Europa II* to Matisse's *Artists in Exile* exhibition, and the work was donated anonymously to MoMA for its permanent collection in 1942.

In 1940 Lipchitz fled to unoccupied France, where Varian Fry would help him escape to the United States in 1941. Ultimately, Lipchitz would gain equal acclaim in Europe and America. Collectors Coco Chanel and Albert Barnes promoted Lipschitz in France and the United States, and their efforts substantially lifted public enthusiasm for his work.⁶³ The sculptor briefly returned to France after World War II but chose to live in New York. He died in Capri, Italy, during the summer of 1973 and was interred in Israel.⁶⁴

Both Pierre Matisse and the artists he represented achieved considerable success in America. Matisse became a prominent, well-respected dealer, and many of his refugee artists settled permanently in the United States. Following Matisse's death, his wife created the Pierre and Marie Gaetana Matisse Foundation and left the Metropolitan Museum their personal collection of about one hundred major art works.

The wartime migration of artists and their work from Europe to America had accelerated the worldwide unification of the art community. Once peace was restored, people and pictures alike freely hopped across the Atlantic. Even the *Mona Lisa* came to visit. Her sponsor was André Malraux, the celebrated French novelist and art historian whose words opened this chapter. President Charles de Gaulle appointed Malraux as France's Minister of Cultural Affairs in 1958. As a token of his friendship with Jacqueline Kennedy, Malraux sent the world's most famous painting to the United States, where, from January 9 to March 4, 1963, she smiled at 1.6

million fans from her perch at the National Gallery, then the Metropolitan Museum. A truly extraordinary exchange, considering the Nazis' dark attempts to strip France of its greatest art only two decades earlier. The *Mona Lisa* herself had been in hiding and remarkably escaped harm. The next chapter looks to France, where many great collections lost priceless treasures, yet some diligent owners successfully retrieved them.

9

Two-Faced France

Historically, France—the birthplace of *Liberté, Egalité, Fraternité*—has had two faces. One produced the revolution of 1789 that ushered in a more equal society, the rise of the middle class, and eventually, the Napoleonic Code, still the basis of democratic constitutions across the free world. This same face of the nation has encouraged avant-garde art and, at times, welcomed international dissidents seeking shelter. This France is filled with beauty, both natural and exquisitely crafted by the human hand. Its food is extraordinary, its wine delectable, its fashion alluring, and its national spirit ebullient. How can one not adore it?

Conversely, every so often in history, the other face appears as France turns on its non-Catholic inhabitants with a vengeance. The St. Bartholomew's Day Massacre of August 1572 claimed the lives of tens of thousands of French Protestants, known as Huguenots. Centuries later, in 1894, the French army court-martialed Captain Alfred Dreyfus, a Jewish artillery captain, on trumped-up charges of spying for the Germans. His conviction reflected and bolstered a virulent antisemitism that divided the nation for years to come.

The Dreyfus affair, however, was soon eclipsed by the more significant political crisis of World War I. The conflict was cruel, costly, and disruptive for all involved. Though Germany had initiated the war, the country suffered a terrible defeat. Moving forward, the opposing nations failed to settle into a harmonious coexistence. Totalitarian regimes emerged in Russia, Italy, Spain, and Germany. Adolf Hitler, whose appeal included a promise to negate the humiliation of the harsh 1919 Treaty of Versailles, was particularly successful in pursuing power. Throughout the 1930s, the Nazis rattled their sabers. France and Britain, not yet recovered from World War I and dreading a return to military conflict, favored appeasement. Nevertheless, another war seemed imminent by the end of the decade, and the guardians of the French art world, with invaluable foresight, set about preparing.

Jacques Jaujard, the director of the French National Museums, had already helped Spain safeguard the Prado's treasures from the bombs of the Spanish Civil War. With the Germans approaching in 1939, he tackled the Louvre, among the world's most respected art museums.[1] The task was enormous. In August 1939, the director hastily closed the museum for three days

and packed up its masterpieces, including the *Mona Lisa* and the Venus de Milo. Within this incredibly brief period, his team, supported by art students and staff from the Grand Magasins du Louvre department store, filled 1,862 crates with art and shipped them to the Château de Chambord in the Loire Valley and other châteaux for safekeeping.[2] The teetering descent of the giant Winged Victory of Samothrace (Nike) down the Louvre's Daru Staircase, from whose landing she had welcomed visitors since 1883, has become one of the iconic images of Paris during World War II. Thanks to the heroic effort of Jaujard's team and numerous volunteers, the museum's priceless paintings, stained-glass windows, tapestries, sculptures, church art, and porcelain reached suitable depots throughout France. Many of these items remained in their shelters until the end of the hostilities.

Coordinating the Plunder

Jaujard's intervention came just in time. World War II got underway on September 1, 1939. The guns were largely silent for the first nine months of the conflict. Both sides focused on strengthening their forces and evaluating the enemy's resources, leading to the period's moniker "the Phoney War."[3] But on May 10, 1940, the well-equipped Nazi army invaded Holland, Belgium, and France. By June 14, the Germans occupied Paris. France had long been the center of the art world, and the Nazis could not wait to ransack its treasures. As elsewhere in Europe, they moved quickly. On September 17, 1940, a decree by General Wilhelm Keitel, commander in chief of the Wehrmacht (German armed forces), issued instructions to cooperate with Alfred Rosenberg in seizing a broad range of cultural items.

To carry out Rosenberg's objectives, Hitler appointed Francophile Otto Abetz, a critical figure in the Nazi vanguard.[4] In his twenties, Abetz had joined the Nazi Party and founded a French-German youth movement. In the 1930s, he joined the German Foreign Service in Paris. There, he tried to bribe reporters to publish articles glorifying the Reich, but he was expelled from France in 1939. His exile wouldn't last for long. In May 1940, Germany invaded France, and Abetz set about the task of seizing Jewish-owned artworks, joining Alfred Rosenberg and his select commando unit, the Einsatzstab Reichsleiter Rosenberg, or ERR, with support from the German military and the Vichy government. In August, Abetz became ambassador to Vichy France, and by October 1940, the German consulate in Paris overflowed with looted art.[5] According to a 1946 article in the *Atlantic* by Monuments Man James S. Plaut, the Nazi directives for plunder "set in motion the most extensive and highly organized series of thefts devised by a nation in modern times. All told, some 21,000 works of art were looted from 203 French private collections."[6]

However, Abetz was not the only German overseeing art in France. Soon after the Nazis had conquered Paris, Count Franz von Wolff-Metternich arrived at the Louvre as director of Kunstschutz (art protection). Like many German aristocrats, Count Wolff-Metternich was

shocked by the Nazis' ruthless behavior, so when he took up his post in 1940, he was relieved to find the museum almost devoid of valuable art.[7] A professional art historian and university professor, Wolff-Metternich strongly advocated for Kunstschutz, a program the Germans had established during World War I and revitalized in 1940 to protect national art treasures. Wolff-Metternich used the provisions of the program to prevent the Nazis from sending state-owned French art to Germany. Abetz and Rosenberg resisted his efforts, but Wolff-Metternich ultimately prevailed. In 1952, at the suggestion of Jacques Jaujard, President Charles de Gaulle awarded Wolff-Metternich the Légion d'honneur for his honorable endeavors.[8, 9, 10]

Still, the Nazis managed to appropriate astonishing quantities of French art. When they realized they needed additional space to accommodate their pillage, they requisitioned the Jeu de Paume, built adjacent to the Louvre by Napoleon III as a court for a then-popular ball game, and converted into an art gallery in the early twentieth century. The Nazi occupants used it as a storage site-*cum*-trading post for looted art. Before handing the gallery over, however, Jacques Jaujard assigned Rose Valland as the French in situ supervisor of the building.

Rose Valland

The daughter of a mechanic, Rose Valland came from a working-class background in the village of Saint-Étienne-de-Saint-Geoirs in southeastern France.[11] Yet she was determined to join the art world. She already had a teaching degree when she began her training in art history, and supported herself by teaching high school. She continued her art education, earning diplomas from the L'École nationale des beaux-arts in Lyon, the École nationale supérieure des beaux-arts in Paris, and the École du Louvre.[12]

In 1932, she accepted a volunteer position at the Jeu de Paume. Those with private means usually filled the post, and she likely felt a bit of an outsider among her upper-middle-class coworkers and superiors. Already quiet by nature, she kept her personal life incredibly private—maintaining a longtime relationship with a woman who worked in the American Embassy, British PhD Joyce Heer. When Heer died in 1977, Valland buried her in the Valland family crypt and arranged for the posthumous publication of Heer's doctoral thesis.[13]

By 1938, Valland was an assistant curator. She befriended Jacques Jaujard and helped him during the evacuation of the Louvre's contents. At Jaujard's request, Valland stayed at the Jeu de Paume and became his watchdog during the occupation. As the sole French employee retained, Valland assumed her assignment would include registering the incoming art, but she was rapidly disabused of this idea. Soon, she began keeping notes on the objects that passed through the gallery.

Unbeknownst to the Nazi occupants of the building, Valland understood German and listened in on their conversations, as well as to others likely to possess vital information, like security

guards and drivers. She was blessed with a remarkable memory and, in the privacy of her home, recorded her observations, paying particular attention to the destinations of the looted art. She transmitted this information to Jaujard, who passed it on to the French Resistance. These fighters, in turn, advised the Allies, who instructed bombing crews to spare art storehouses. Meanwhile, Valland's notes led to locations filled with thousands of stolen artworks, such as Neuschwanstein Castle.[14] In 2005, a plaque was installed on the Jeu de Paume's exterior that recognized Valland's work as responsible for the discovery and restitution of forty-five thousand artworks.

The mass looting of art in France began as soon as the Nazis arrived and continued throughout the four years of their occupation. Many of the confiscated works came from the renowned Jewish collections of the Rothschild, Schloss, and David-Weill families and the inventories of France's numerous Jewish art dealers and galleries, including Paul Rosenberg, Georges Wildenstein, René Gimpel, and Bernheim-Jeune. But the Nazis also filled their coffers from an astounding number of lesser-known collections and with single works belonging to individuals. Other categories of seized art included pieces imported by refugees or sold under duress to finance their owners' escapes. The following stories trace Jewish collectors and dealers in France whose possession of valuable works of art made these individuals particular Nazi targets.

John and Anna Jaffé

"Living like a god in France" is a typical German saying implying luxury and indulgence. Indeed, at the end of the nineteenth century, many wealthy retirees moved to the Côte d'Azur to enjoy a carefree existence. So it was that the city of Nice welcomed John Jaffé, a wealthy Irish linen and lace merchant, and his wife, Anna Gluge Jaffé, the daughter of the Belgian king's physician.

The Jaffés were Jewish. They lived in a sumptuous house on the city's elite Promenade des Anglais and hosted prominent guests like Marcel Proust and Henry James. For their pleasure, they assembled a magnificent collection of old masters, including works by Goya, Constable, Turner, and Rembrandt. One work attributed to Rembrandt was titled *Portrait of Rembrandt's Father* (c. 1630)—though the artist allegedly depicted an elderly man who was not his father. Close to the couple's heart, the portrait hung in John and Anna's bedroom.[15]

Like many well-to-do residents, the Jaffés adored France, and to celebrate their diamond anniversary, they gifted the library of Emperor Napoleon to the French nation. To thank the couple for their generosity, the mayor of Nice awarded the Jaffés the medal of the Chevalier de la Légion d'Honneur in May 1934. John Jaffé died just a few days after the ceremony. Anna passed away in 1942, two years after the Germans had occupied France, but fortunately, before they could deport her to a concentration camp. Her will left her entire estate to her niece and nephews. But before her family could claim their inheritance, French collaborators emptied her house. They sent her collection of sixty oil paintings plus many additional works of art and

luxurious household items to the Hotel Savoy in Nice for sale at auction in 1943.[16] The auction house grossly undervalued the pilfered artworks, falsely marking some originals as "copies" or describing others as "school of" rather than attributing them to the actual artists. To enhance their profits, the buyers of these low-priced items corrected such intentional mislabeling before reselling them. In this way, the Jaffé paintings vanished into museums and private collections.[17]

Decades passed. Théophile Gluge, one of Anna's nephews, had perished in Auschwitz, but life continued. Gustave Cohen, another nephew, managed to identify and reclaim a work by Goya. Still, the legal costs were so high that he immediately had to resell the painting, and the heirs halted their efforts to retrieve the collection.[18]

When the Washington Principles' adoption finally favored returning looted art to its rightful owners, a dozen or so of the Jaffé heirs decided to pursue their claims again. Alain Monteagle, a history teacher and Gustave Cohen's grandson, assumed the almost hopeless task.

Monteagle's most significant obstacle to recovery was the lack of a title. The family lore of great-grandaunt Anna's art included a "wonderful Turner," but the painting's name was a mystery. Without an inventory of the collection, tracking down this work would be impossible. Monteagle knew that the Jaffé possessions had been auctioned at the Hotel Savoy in Nice, but he didn't have the catalog from the sale.[19]

By 2003, looted art had become big business. That year, Alain Monteagle received an unsolicited email from English researchers: they had purchased the auction catalog from the Hotel Savoy. The researchers claimed theirs was the only existing copy and offered access to its contents in exchange for half the profits from any recovered art. Monteagle refused their proposal and redoubled his efforts to track down another copy. He eventually found one, as well as a partial photographic record of the Jaffé collection, at the French Ministry of Foreign Affairs, whose files included dossiers of forced sales of Jewish property. The records detailed the items sold at the Hotel Savoy down to the last teaspoon.

Among the faded papers, Monteagle eventually came across a description of a Turner that could be a match. Then, the final key appeared in his grandfather Gustave Cohen's letters in the ministry's files. One letter referred to Turner's *Glaucus and Scylla* (Figure 9.1). An internet search revealed a Turner by that name at the Kimbell Art Museum in Fort Worth, Texas, so Monteagle contacted the museum.[20]

When acquiring a Turner titled *Glaucus and Scylla* in 1966, the Kimbell had paid little attention to the artwork's provenance. Some thirty years later, prompted by a tip from a British researcher, the museum hired a provenance investigator to look into the painting's past. The inquiry verified that the Turner belonged to the "forgotten" Jaffé collection—but couldn't confirm that the 1943 auction was coerced, so the Kimbell let the matter rest. Therefore, Alain Monteagle's letter regarding the work in 2005 came as a bit of a shock. However, after examining Monteagle's materials, the Kimbell expressed an interest in an "agreement" and invited him to Fort Worth.

Monteagle arrived a day before the meeting and anonymously visited the museum. He searched for "his" painting until, as reported by *Fort Worth Star-Telegram*'s Andrew Marton, "the glinting pigments of orange and red from J. M. W. Turner's *Glaucus and Scylla* caught his eye and lured him into its sun-kissed beauty. He was mesmerized by the mythological theme and transcendent power of the great English master painter's 1841 work."[21]

One of England's most celebrated romantic landscape painters, Turner created impressionistic images of shipwrecks and powerful forces of nature—terrifying storms and waves at sea—that were revolutionary in their treatment of light and color. The Kimbell's small gem depicts the legend of Glaucus, the fisherman-turned-sea-god who falls in love with the nymph Scylla. In the story, she rejects him, and a magic potion transforms her into a monster who eventually guards the Strait of Messina, separating Sicily from the Italian mainland. In his mountainous view, Turner portrays none of the horror of Scylla's future; instead, tiny figures skip around brilliantly illuminated pools and ochre-colored rocks.

The day after his solo visit to the museum, Alain Monteagle met with the Kimbell leadership, who formally agreed to the restitution. The Jaffé heirs promptly consigned the work to Christie's auction house, where the price realized was $6.42 million. The winning bidder was the Kimbell Art Museum, which returned the painting to its accustomed gallery, where it continues to delight visitors.[22]

The heirs of John and Anna Jaffé have gone on to recover a total of eleven artworks from the couple's outstanding collection, including the following:

- Francesco Guardi's *The Grand Canal in Venice with Palazzo Bembo*, now at the Getty Museum in Los Angeles
- Francisco Goya's *Portrait of Don Mañuel Garcia de la Prada*, now at the De Moines Art Center
- John Constable's *Dedham from Langham*, sold to a private buyer at Christie's in 2018. Before the painting was restituted to the Jaffé family in 2018, it had hung in a château in Switzerland for forty years.[23]

Moïse de Camondo

The story of the Camondo family, beautifully told by James McAuley in *The House of Fragile Things*, shares elements with the Jaffés but has a very different outcome.

In 1478, Spain's rulers King Ferdinand II of Aragon and Queen Isabella I of Castile officially launched the Inquisition. To protect against the threat of violent antisemitic mobs, some Spanish Jews converted to Christianity. These "conversos," as they were known, sometimes rose to levels of great authority—creating even greater animosity from Spanish Catholics. In 1478,

Figure 9.1 *J. M. W. Turner,* Glaucus and Scylla. *This romantic work portraying the tragic legend of a Greek fisherman-turned-sea-god and his doomed love for a nymph was part of the collection of John and Anna Jaffé. Confiscated in Nice by Vichy France and auctioned at the Hotel Savoy in Nice, the painting was finally restituted to the Jaffé heirs in 2006. Credit: Kimbell Art Museum, Fort Worth, Texas/Art Resource, NY*

the Inquisition legalized persecution of the "conversos" and, by 1492, expelled all Spanish Jews from their homeland, including the Camondos.

The Camondo family first resettled in Venice. In 1778, they relocated to Constantinople, founding the Camondo & Cie bank in 1802 and modernizing Turkey's banking system.[24] The family developed enormous wealth and was sometimes referred to as the Rothschilds of the East. By the second half of the nineteenth century, Abraham-Salomon Camondo was providing financial support to Italy's wars of independence; in 1859, these conflicts had ended Austria's

domination, and Italy's unification took place two years later, in 1861. A grateful King Victor Emanuel II ennobled the Camondo family, making Abraham-Salomon a count in 1867.[25]

Moïse de Camondo was born in Constantinople in 1860. Nine years later, the family moved yet again to a distant destination, this time to Paris. They bought property surrounding the Parc Monceau, a newly fashionable city neighborhood. Moïse was groomed to take over the family bank. He married Irène Cahen d'Anvers, the daughter of another prominent Jewish banking family. When Irène was eight, her father Louis Cahen d'Anvers commissioned a young Pierre-Auguste Renoir to paint her portrait. Surprisingly, when the painting was complete, Irène's father found it displeasing and hung it in the servant's quarters. Known as *The Little Girl with the Blue Ribbon* or *Little Irène*, the work is now considered one of Renoir's finest.

In the first few years of marriage, Irène and Moïse de Camondo had two children, Nissim and Béatrice. But it wasn't long before Irène fell in love with the family's stable master—an Italian count named Charles Sampieri—for whom she left her mortified husband. Moïse doted on their children in his wife's absence, especially his son.

In 1911, Camondo engaged architect René Sergent in building a grand mansion inspired by Marie Antoinette's Petit Trianon at Versailles. Camondo filled it with the finest eighteenth-century furniture—often pieces connected to the French aristocracy, such as a screen from Louis XVI's game room and a roll-top desk by Jean-François Oeben, cabinetmaker to Louis XV. Other exquisite items included the silver service Catherine the Great of Russia commissioned from Orloff, Savonnerie carpets woven for the Louvre in 1676, and a bust by Jean Antoine Houdon. Oils by Elisabeth Louise Vigée LeBrun, Marie Antoinette's portraitist, were particular favorites. The unusual octagonal salon accommodated seven pastoral scenes by Jean Baptiste Hurst. Meanwhile, a kosher kitchen attested to Camondo's deep attachment to his Jewish faith.[26]

The family moved into the fabulous residence in 1913, before construction was complete, but the Camondos' fortunes were about to turn. Nissim de Camondo was an early aviator during World War I, and in 1917, his plane was shot down in combat. His broken-hearted father cloistered himself in his gilded home, emerging only to host an occasional supper for friends. To honor his fallen son, he willed his beloved abode and its contents to Les Arts Décoratifs and the French State, which opened as the Musée Nissim de Camondo in 1936, the year after Moïse's death.[27] The donation preserved the extraordinary house-turned-museum. If it had remained in the hands of the Jewish Camondos, the Nazis would have ravaged the place and seized its priceless treasures. Instead, the museum offers a reminder of an unbelievably luxurious past.[28]

The martyrdom of the Camondos, however, was not yet complete. Moïse's daughter Béatrice was married to Léon Reinach, a musician and composer (and son of the eminent scholar and politician Théodore Reinach); the couple had two children, Fanny and Bertrand. During the German occupation of Paris, Béatrice and Léon divorced. Living separately, Léon was advised to flee. Béatrice had converted to Catholicism and believed her new faith and elevated social standing would protect her. The authorities felt differently. In 1942, they arrested Béatrice and

Fanny; a week later, they apprehended Léon and Bertrand en route to Spain. The family was reunited at Drancy, the best-known French internment camp, before their demise at Auschwitz.

Moïse's former wife Irène had become a Catholic like her daughter Béatrice. She had married her Italian count (though she would divorce him, too), and as Countess Sempieri, Irène was the sole member of the family to survive. Her childhood portrait by Renoir had not escaped Nazi greed. The Nazis confiscated it from the Château de Chambord, where it had been placed for safekeeping, and the insatiable Göring selected it for himself.[29] Using the services of Paris-based German art dealer Gustav Rochlitz, Göring traded it for a Florentine tondo (a circular work of art). At the war's end, the portrait was returned to Paris and appeared in the 1946 exhibition *Masterpieces of Private French Collections Found in Germany* (*Les Chefs-d'Œuvres des collections privées françaises retrouvés en Allemagne par la Commission de Récupération Artistique et les Services Alliés*) at the Musée de l'Orangerie. The painting was restituted to Irène that year. In 1949, she sold it to E. G. Bührle, a Swiss arms manufacturer and art collector. In the decades to come, Renoir's celebrated portrait would travel to numerous exhibitions and even appear in the 2014 film *The Monuments Men*.

Federico Gentili di Giuseppe

From 1963 to 1964, my family moved to England, as my husband was spending a sabbatical year at Oxford University. During our stay, we befriended Dr. Lionel Salem, a twenty-four-year-old French scientist in my husband's research group. Lionel often came over for dinner and bonded with our young children. Sixty-five years later, as I researched this book, I discovered that Giovanni Battista Tiepolo's painting *Alexander the Great and Campaspe in the Studio of Apelles*, now hanging at the Getty Center in Los Angeles, had been restituted to Lionel Salem's family in 1999. Before WWII, this work by the Italian Rococo painter had belonged to Federico Gentili di Giuseppe, Lionel's grandfather.

Bells went off in my head. How could I find Lionel Salem? By now, he would be eighty-three years old. The internet informed me that he was still living and had enjoyed a brilliant career. He had taught at Harvard, the Zurich Polytechnic Institute, and several French universities. He had made numerous significant contributions to quantum chemistry and mechanics, had written dozens of scientific articles, and had served as research director of the Centre National de la Recherche Scientifique. Following these discoveries, I came upon another story of art plunder in France—involving Göring and pitting the mighty Louvre against the Jewish Gentili heirs.

Federico Gentili di Giuseppe (1868–1940) was an Italian engineer who relocated to France, where his professional and financial success enabled him to assemble a significant art collection, including works by Strozzi, Tintoretto, Tiepolo, Titian, and Goya. Gentili died of natural causes in April 1940. Soon thereafter, the Nazis invaded France, forcing Gentili's son Marcello, daughter

Adriana, and their families to hastily leave Paris. Adriana's husband Raphael Salem had lost his post for being Jewish and been stripped of his citizenship, as well. He was sent to London to serve on the Anglo-French Coordinating Committee, a wartime economic planning body. Meanwhile, Adriana and the children, including three-year-old Lionel, fled to Bordeaux, from where they sailed on a tiny fisherman's boat to Great Britain. The Salems reunited in England, where they sheltered temporarily, then moved on to Canada, eventually settling in the United States.[30] Once the war was over, the Salem family returned to Paris.

In 1940, French authorities had been quick to appropriate Federico Gentili's art collection. Since they liked to disguise their actions in trumped-up legality, they seized upon a small debt the heirs owed Julian Girard, one of Gentili's creditors. Girard sued the family in the Tribunal civil de la Seine (Civil Court of First Instance), accusing the absent Gentili heirs of not showing any interest in the estate. This was absurd. But none of the heirs lived in France at the time of the trial, so by order "in absentia," the court appointed a manager to inventory Gentili's extensive possessions, including his large art collection. On March 17, 1941, the court authorized an auction to liquidate the estate and use its proceeds to pay any debts.[31]

At the auction, various art dealers and collectors purchased the listed paintings. Five of these works, including the Tiepolo, were acquired by representatives of Reichsmarshall Göring. After the war, these pieces were discovered among Göring's collection and sent back to the Louvre in France for safekeeping.

In 1950, Adriana Salem noted the presence of her father's paintings in the museum and requested their restitution. The Louvre turned down her appeal three times in 1951, 1956, and 1961—claiming she would have to supply proof that the 1941 auction had been forced. She told Lionel, "Those bastards at the Louvre don't want to give me back my father's paintings."[32]

During the subsequent decades, many artworks from the Gentili collection entered the open art market and were unobtrusively bought and sold. Fortunately, unlike the catalog from the Jaffé sale, the Gentili auction catalog survived and eventually helped the family recover works from the collection.

The Gentili heirs' luck would not change until the end of the twentieth century. On July 17, 1995, the newly elected French president Jacques Chirac addressed the nation. Acknowledging the fifty-third anniversary of the day that thirteen thousand Jews were arrested in the Vélodrome d'Hiver, a Paris stadium, he declared, "[T]hese dark hours forever sully our history and our tradition."[33] As part of the reparations process, Chirac had asked the Louvre to exhibit the artworks that had been returned to France after the war yet remained in the museum.

Adriana Salem was no longer alive at this point—she had died in 1976—so Lionel went to view Chirac's exposition at the Louvre; there he identified five of his grandfather's paintings. The heirs, led by Lionel, decided to make one more attempt to negotiate with the Louvre, yet the museum continued to drag its feet. Therefore, in 1998, the heirs filed a lawsuit against the Louvre. Lionel hired Corinne Hershkovitch, a twenty-eight-year-old lawyer who would

devote much of her professional life to fighting for the restitution of looted art. The museum's argument for keeping the paintings largely rested on the fact that the heirs did not appear at the proceeding that had authorized the auction of Gentili's possessions back in 1941. Aside from waiving statutes of time limitations, the court refused the heirs' claims to the paintings, so the family appealed the case. This time, the court of appeals rejected the museum's flimsy defense that the heirs did not attend the original trial because they were physically out of the country. In June 1999, the Paris Court of Appeals ruled that the Louvre Museum must return five Italian paintings to the heirs of Federico Gentili and pay various fees and compensations.[34] The Gentili-Salem families subsequently sold most of the works recovered in the proceedings.

The Getty purchased *Alexander the Great and Campaspe in the Studio of Apelles*, the Tiepolo painting that had initiated the family's inquiry. It is an imposing image of the Macedonian ruler, who sits beside his favorite concubine Campaspe as she poses for her portrait. Alexander's court artist Apelles, a celebrated painter of the ancient world, paints the young woman. "According to Pliny's Natural History of 77 A.D. . . . Apelles fell in love with his sitter as he captured her beauty on canvas. Alexander so esteemed his painter that he presented Campaspe to Apelles as a reward for the portrait."[35]

The story of Alexander and Campaspe fascinated Tiepolo so much that he painted it three times. In this version, he chose an opulent classical setting that enhances the majesty of the sitter, Alexander. With its figures sumptuously attired, the portrait celebrates the power of men and nobility. Göring undoubtedly loved it. The back of the work attests to its passage through the hands of Walter Andreas Hofer, the Reichsmarschall's principal art dealer.

By the late 1990s, when Lionel Salem searched for his grandfather's seventy-seven missing paintings, he had located five at the Louvre; the others had been widely dispersed. Some had presumably been destroyed, others had been acquired by unknown collectors, had changed hands, or were still available on the art market. Buyers were likely unaware of the paintings' dark pasts. During his initial search, Lionel Salem and his team identified several Gentili pieces in three US museum collections. They included the following:

- Corrado Giaquinto, *Adoration of the Magi*, Museum of Fine Arts Boston (acquired 1992)
- Francesco Mochi, *Bust of a Youth (St. John the Baptist?)*, Art Institute of Chicago (acquired 1988)
- Pinturicchio (Bernardino Di Betto), *Saint Bartholomew*, Princeton University Art Museum (acquired 1994)

For spreading Christianity through Armenia and India, the martyr Saint Bartholomew was flayed alive. When the curators at the Princeton University Art Museum bought Pinturicchio's *Saint Bartholomew* (Figure 9.2), they were likely attracted by the saint's scholarly demeanor. Pinturicchio was a prolific Italian Renaissance painter specializing in frescos. According to the

Figure 9.2 *Pinturicchio (Bernardino Di Betto),* Saint Bartholomew *(ca. 1497). Saint Bartholomew and the rest of the Gentili collection were auctioned and dispersed in Paris in 1941. Princeton University Art Museum bought the painting in 1994. In 2001, the museum reached a compensation agreement with the heirs to keep the image on display. Credit: Princeton University Art Museum/Art Resource, NY*

museum's notes, he contributed to the decoration of the Sistine Chapel, which includes a horrific depiction of Bartholomew holding his own skin.[36]

In the Princeton panel, the saint, luxuriously robed, holds a prayer book or Bible decorated with braided tassels. His eyes are cast down, and his expression is peaceful, though he holds a knife in his right hand—a nod to his martyrdom. A golden halo in gilt relief encircles his head.

The Princeton University Art Museum had purchased *Saint Bartholomew* from a reputable dealer before the French court declared the 1941 auction of the Gentili collection illegal. So the news that the museum had harbored stolen art must have been a terrible shock. However representatives of Princeton and the Gentili family reached an agreeable settlement, and *Saint Bartholomew* remains at the university's museum. Likewise, the Museum of Fine Arts Boston and the Art Institute of Chicago arrived at peaceful resolutions for the above cited artworks.

Not all restitutions from the Gentili collection were resolved so smoothly. When the Gentili heirs first embarked on their mission, they noted that their grandfather's magnificent *Christ Carrying the Cross* by Girolamo Romanino had ended up at Milan's Pinacoteca di Brera. Attempts at repossession failed, and in time, the family abandoned their pursuit. However, several years later, the Milan collection lent the work to the former Mary Brogan Museum in Tallahassee, Florida. In short order, the US Homeland Security office seized the painting, and a US district court awarded it to the heirs. Christie's sold the piece in New York in June 2016.[37]

In 2013, after the discovery of the Gurlitt loot, seventy-six-year-old Lionel gave an interview to *Deutsche Welle*. Even though he had only reclaimed eighteen to twenty of the seventy-seven stolen artworks from the Gentili collection, he reflected on the joy he had felt when he had recovered his grandfather's paintings and regretted that his mother had not lived to witness the return of the artworks herself.[38]

Paul Rosenberg

In France, as in Germany, many of the great art dealers were Jewish, and their extensive inventories and personal collections were prime targets of the Nazis. One such prominent dealer was Paul Rosenberg, whose gallery traded in popular nineteenth-century paintings and avant-garde, twentieth-century works. Like Justin Thannhauser in Munich and Jacques Goudstikker in Amsterdam, Paul Rosenberg was a second-generation gallerist. His father, Alexander Rosenberg, a native of Bratislava, Czechoslovakia, had opened the first Rosenberg art gallery in Paris in 1878. Recalling my arrival in Belgium some sixty years later, I can imagine how Alexander Rosenberg, a recent immigrant, embraced his new environment's freedom, tolerance, and intellectual stimulation. He loved everything French, especially art. His gallery, specializing

in antiques, Impressionist and Post-Impressionist art, was very successful. He had a good eye and an adventurous spirit and was one of the few art dealers who appreciated the shunned Vincent van Gogh during the late 1890s. He passed on his love of art to his French-born sons, Léonce and Paul. Both would become renowned art dealers, but at the start, young Paul was a bit skeptical of his father's taste. In an autobiography he once started, Paul shrinks from the sight of Vincent van Gogh. He recalls,

> One day, when I was about ten, my father led me to [a] shop window . . . to show me a painting that made me shriek with horror. . . . Imagine a very thickly painted picture made with violent colors, representing a modest bedroom with a wooden bed covered with a red blanket. . . . The floor looked oddly bowed to me, and the furniture seemed to be dancing, as if it wanted . . . to leap off the canvas and fly out through the window. My father calmed me down. . . . The canvas [*Room in Arles*] was by van Gogh; it's the one that's in the Art Institute of Chicago and which, by an irony of fate, I sold about thirty years later.[39]

Paul Rosenberg opened his eminent art gallery at 21 rue La Boétie in Paris in 1911 when he was thirty. A century later, his granddaughter Anne Sinclair, a French journalist and television commentator, published a loving memoir titled *My Grandfather's Gallery*, which looks back on the remarkable span of Rosenberg's extraordinary and heartbreaking moments.

As Sinclair writes, art consumed Rosenberg. He often reiterated that he would never sell a painting he wouldn't want to own himself. His gallery dealt with nineteenth-century masters, from Courbet and Corot to Degas and Cézanne. Still, his heart belonged to the avant-garde, and he did much to establish their popularity. For years, he was the exclusive representative of Pablo Picasso, George Braque, Fernand Léger, Henri Matisse, and Marie Laurencin. Rosenberg's friendship with Picasso was particularly noteworthy. In 1918, Rosenberg agreed to represent Picasso: the two made an arrangement that allowed the dealer first pick of the artist's new works; it also guaranteed that Rosenberg purchase a minimum of pieces—providing Picasso financial stability.[40] In 1919, Rosenberg suggested that Picasso move in next door. Many an evening, Picasso summoned Rosenberg to his window to show him the painting he had worked on that day.[41]

Rosenberg introduced his painters to the United States. He fostered the bond between Picasso and MoMA's Alfred Barr, who became Picasso's American champion, interpreter, and guardian of his art during World War II. MoMA sheltered *Guernica*, the painter's most famous work, for over four decades: from 1939 to 1981, when the painting finally traveled home to Madrid. Barr's books explain Picasso's work to the public and are still relevant today. In 1939, on the eve of war, Rosenberg helped Barr organize MoMA's exhibit, *Picasso: Forty Years of His Art*. For the exhibition, Rosenberg lent the museum forty of the artist's works, keeping them out of Nazi hands.[42] He shipped additional Picassos to galleries in London and New York.

When WWII officially erupted in September 1939, the Rosenberg family vacationed near Tours. Paul returned to Paris, closed his gallery, and moved his family to a large house in Floirac near Bordeaux. He tried to shield hundreds of artworks, distributing them throughout France. One batch he sent to a bank in Tours registered in the name of Louis Le Gall, his faithful chauffeur. Other paintings he stored in a bank vault in Libourne. More arrived at the Floirac domicile, where they hung on display—the Picassos decorated the dining room—reminding Rosenberg of his life's mission.[43] Many remained at Rosenberg's gallery-*cum*-residence at 21 rue La Boétie. The paintings in Tours managed to evade capture, but the Nazis would plunder all the other deposits, collecting a total of four hundred works.[44] In Paris, Rosenberg's concierge Monsieur Picard assisted the Nazis while helping himself to silver, linen, and furniture.

The Rosenbergs spent the winter of 1939–1940 at their Floirac home, but in June 1940, after the German invasion of France, the family decided to leave Europe—a clan consisting of seventeen members assembled in Floirac. They pulled strings and obtained valid passports, a three-day permit to cross Spain, and Portuguese visas. The family left by car, passed through Varian Fry's Marseille, and reached Portugal, temporarily settling in Sintra near Lisbon. With Alfred Barr's assistance, Paul, his wife, and their daughter Micheline received American visas and booked passage aboard a ship to New York. Their nineteen-year-old son Alexandre managed to reach England, where he joined Maréchal de Gaulle's Free French Forces. He would not see his family for the next five years and, to his parents' distress, was out of touch for prolonged periods.

New York welcomed Paul Rosenberg with open arms. Although he had worked with many museum directors and art dealers before, he intensified his efforts, building an especially close connection with the Phillips Collection in Washington, DC. Rosenberg soon rented an elegant gallery on 57th Street and added up-and-coming American artists such as Marsden Hartley and Max Weber to his roster, thereby strengthening the bonds between the art communities of France and the United States.

Nevertheless, the Rosenbergs were homesick. They volunteered for "Free French" organizations. In 1941, Rosenberg donated a Stinson 105 ambulance plane to the French Relief Committee. But he was devastated by the news of Vichy's antisemitic decrees, which included denationalization of those who had fled France.[45] Naïvely, Rosenberg protested the measure, writing telegrams and long letters denouncing the order. Such loss of citizenship was only one of the many unjust rules and regulations the Nazis enforced in Vichy France. Others included banning Jews from holding public office, confiscating property, imposing curfews, and compelling deportations.

Rosenberg missed the artists he had represented in France. He wondered how they fared under the Germans. Some had fled; others like Georges Braque, Henri Matisse, and Picasso stayed home and tended to their canvases. Many accepted Vichy and the Nazis.

The Art Community Carries on in Occupied Paris

If Paul Rosenberg had remained in Paris, what he saw there might have surprised him. Despite the Nazi occupation, the cultural life of the city continued with its renowned Parisian gaiety. Crowds packed nightclubs such as the Moulin de La Galette and the Bal Tabarin and jammed the Medrano Circus. Movie houses and concert halls bustled with activity. Filmmakers made quality films. Plays by Jean-Paul Sartre, Jean Cocteau, and Sacha Guitry filled the theaters with spectators. Even French couture houses survived the occupation.

The art market, too, was buoyant. The Hôtel Drouôt auction house did record business. During the winter of 1941–1942, it handled 2 million objects. According to Emmanuelle Polack's *Le Marché de l'art sous l'Occupation: 1940–1944* (The Art Market During the Occupation: 1940–1944),[46] paintings by Modigliani, Chagall, Léger, or Picasso were available to purchase at a fraction of their value. Art dealers bought and sold scores of pictures, many of them stolen from Jews.

A rare view of Paris's wartime cultural life emerges from a memoir by Dr. Werner Lange, titled *Artists in Nazi Occupied France: A German Officer's Memoir*.[47] Lange never published the manuscript; it fell into the hands of a friend, a prominent figure of Parisian nightlife, who later sold it to a Russian artist and collector. Eventually, it reached the eyes of publisher Victor Loupan, who released it in France in 2015.

With a doctorate in art history, Lange was an intellectual, a Francophile, and an enthusiast of modern art. Before the war, Lange held the position of assistant director at the Museum of Fine Arts in Berlin. He disagreed with Nazi policy on "degenerate" art, yet when Germany took control of Paris, "Lieutenant Lange" was recruited for the Propaganda Ministry of the German army to supervise French visual artists. In addition to spying on his charges, Lange was to ensure they "acted in the best interest of the German occupiers." He maintained routine relations with such artists as Kees van Dongen, Charles Despiau, Raoul Dufy, Maurice de Vlaminck, and Aristide Maillol. Lange writes: "Under the German Occupation, artists' societies continued to function almost as before. They would always organize their showings. . . . As far as I was concerned, they would inform me simply of their preparations, and I would pay them simply a 'supervisory visit.'" Lange did not protest when a gallery mounted a show of works by Georges Braque that included a small landscape entirely composed of cube-like forms. This painting had been among the pieces at Braque's groundbreaking exhibit many years before that generated the name of a new artistic style: according to Sabine Rewald of the Metropolitan Museum, "The French art critic Louis Vauxcelles coined the term Cubism after seeing the landscapes Braque had painted in 1908 at L'Estaque."[48]

The Nazis wished to maintain friendly relations with French artists. In October 1941, Otto Abetz and German sculptor Arno Breker, assisted by Lange, organized an official visit

to Germany for thirteen important French painters and sculptors, including Othon Friesz, Charles Despiau, Kees van Dongen, and Maurice Vlaminck. The following year, Arno Breker, Hitler's favorite sculptor who had accompanied the führer on his brief visit to Paris, opened a retrospective exhibit at the Orangerie in Paris. Abetz and Lange arranged for an introduction between Breker and celebrated French sculptor Aristide Maillol: they met in Paris and again at Maillol's residence in Banyuls in southern France, where the two artists sculpted likenesses of each other.

Lange's memoir also describes life among the artist community, such as dining at the Three Sisters, an underground restaurant that served black market delicacies. He recalls supping there the same evening as Pablo Picasso and his companion Dora Maar. The Nazis had placed Picasso on the "degenerate" list, but poet Jean Cocteau intervened, with support from his friend sculptor Arno Breker, so the maverick Spaniard remained unmolested.

Lange remained at his post with the German military until 1944. By then he had developed close friendships with artists like Maillol, Vlaminck, and Derain; following the war, he moved back to Paris as soon as possible. He wrote his memoir several decades later, in the 1980s, then regrettably took his own life—supposedly for reasons related to a love affair.

The Jeu de Paume and the *Salon des Martyrs*

During the period of occupation, the Jeu de Paume became a playground for powerful Nazis with a taste for art. By the time the Germans took possession of the gallery in October 1940, three months after the fall of France, they had already accumulated four hundred cases of purloined art. This was only the beginning. During the four years the Nazis controlled the Jeu de Paume, thousands of artworks passed through the museum.[49] Venerated artworks occupied the first floor, while the "degenerate" art they despised and mainly used as bargaining chips inhabited the second floor, or a room Rose Valland designated the *salon des martyrs*—"the room of martyrs." Carpets covered the floors of the galleries, and potted palms added glamour. When high-ranking visitors were expected, fresh flowers and special exhibits of available art enhanced the ambiance. During such events, champagne flowed liberally.

Göring, wearing one of his splendid uniforms, first appeared at the Jeu de Paume on November 3, 1940. He became the depot's best client, visiting more than twenty times.[50] A 1941 photograph shows him and Andreas Hofer, his chief art adviser, examining Matisse's *Daisies* (1939) and *Odalisque with Tambourine* (1926). Both works had been confiscated from Paul Rosenberg—as evidenced by the paintings' presence in a Matisse exhibition at 21 rue La Boétie in October–November 1938. After the war, both artworks were returned. Today, *Daisies* belongs to the Art Institute of Chicago and the *Odalisque* to the Norton Simon Museum in Pasadena, California.

Meanwhile, Rose Valland continued her work at the Jeu de Paume, quietly spying on the Germans' activities. She minimized her presence, when in truth, she was a giant. In addition to tracking the art that entered and left the building, she also took notes on the comings and goings of the Jeu de Paume's "clientele"—German and French art dealers, Nazi bigwigs, and other profiteers. Valland recorded details of these observations in a series of notebooks that would see publication in 2019, approximately forty years after her death.[51]

The War Escalates

While Hitler, Göring, and their sycophants helped themselves to Europe's art treasures, the Nazis worked to achieve the most sinister goals of their "Thousand-Year Reich." During the fall of 1941, the Nazis realized that they could not rid their territory of Jews—and other "subhumans," in their view—by nonviolent means. In January 1942, they convened a conference in Wannsee, near Berlin, where they decided upon a course of action. Euphemistically, they called it the "Final Solution": in truth, it was mass murder. Soon, numerous death camps were constructed in Germany and Eastern Europe to kill millions of innocent people.

At the same time, the Axis armies began to hit obstacles in North Africa and on the Eastern front. The town of Stalingrad in southern Russia had withstood the German armed forces for more than five months. In February 1943, these Russians finally forced the Germans to surrender—one of the significant Allied triumphs of World War II. At the time, I was a hidden child in Belgium. To celebrate, Nelly Wiame, the first "righteous gentile" to shelter me in Brussels, baked a fruit tart—a great extravagance. Victory appeared to hover on the horizon, but the war would last another two and a half years, accompanied by immense human and cultural loss.

The Allies' bombing of Germany increased dramatically. Everybody was hungry. Jews who were able went into hiding. Hitler's generals were at a loss, but their leader continued to "fiddle while Rome burned." He spent the spring of 1943 at the Berghof, his alpine retreat in Berchtesgaden, where the Linz Führermuseum seemed his primary concern. Linz museum director Hans Posse had died, but Hermann Voss, ably assisted by Hildebrand Gurlitt, replaced him. The looting of art increased to fill the much-anticipated museum.[52] The Linz Special Commission was so vital to Hitler's objectives that Voss, Gurlitt, and about ten other art dealers were exempt from military service because of their essential work on the project.[53]

On June 6, 1944, Belgians dropped all precautions and openly tuned in to the BBC radio broadcasts (prohibited to audiences under Nazi occupation). The news echoed throughout the city in just three words: "They have come." The phrase needed no explanation: 160,000 Allied soldiers endeavored to gain a foothold in Normandy. Millions of human beings would still die, and thousands of artworks would still crisscross Europe, but the end was in sight. It would be another year before the war ended, but France and Belgium would be free within three months.

Western Europe followed the Allies' progress with bated breath. In the evenings, everyone was glued to the BBC. In the Brussels house where I was hiding, we savored the opening bars of Beethoven's Fifth Symphony and listened closely to the day's news. (The Allies commonly used Beethoven's powerful music to represent victory. The rhythm of the familiar opening four notes spelled out the letter V in Morse Code: dot dot dot dash.[54]) Who were we to believe: the BBC speaking to hopeful listeners of "advances," or the local press warning readers that Axis forces were about to throw the Allies back into the sea?

Panic set in at the Jeu de Paume. German officials packed 967 artworks into 148 crates, and the ever-alert Rose Valland took a stealthy look at the shipping labels. As the Allies approached Paris, trucks transported the crates to Aubervillier, a railway depot north of Paris, and loaded them aboard train #40044, destination Nicholsburg—a Czech art storage depot. Valland passed on this information to the French Resistance, who managed to delay the train's departure until the Free French troops liberated Paris under the command of General Philippe Leclerc. The salvage of these thousand artworks from the train has become legendary. The 1964 film *The Train*, starring Burt Lancaster, Paul Scofield, and Jeanne Moreau, illustrates the hair-raising schemes involved. By chance, Paul's son Alexandre Rosenberg commanded the division that rescued this art: he immediately recognized the paintings he had last seen at his childhood home at 21 rue La Boétie.

Soon after Paris was set free, James Rorimer, a Monuments Man on loan from his post at New York's Metropolitan Museum, arrived at the Louvre. He and Rose Valland became good friends and collaborated on the enormous task of setting things right. Throughout the next thirteen years, Valland worked to recover looted art in what had been the Third Reich. Among her many discoveries was Göring's handwritten catalog of his cherished, ill-acquired collection. Valland kept the document among her papers until shortly before she died in 1980; the catalog arrived among a thousand boxes at the French Ministry of Culture. From there, it moved to the Ministry of Foreign Affairs.[55, 56]

In October 2015, French publisher Flammarion published a complete edition of Göring's art catalog. (An English edition followed in 2016.) At six hundred pages, the catalog records nearly 1,400 entries, the work of multiple hands. The earliest entry lists a painting of Venus by Jacopo de' Barbari, which Göring purchased in Italy in April 1933. At first, the collection grew slowly, but once the Reich expanded, Göring acquired an average of three pictures per week. However, by the time the catalog was published, the information it contained was no longer entirely novel. Nancy Yeide, head of the Department of Curatorial Records at the National Gallery of Art, had already reconstructed much of the content of Göring's collection in her 2009 book *Beyond*

the Dreams of Avarice: The Hermann Goering Collection. She also showed that despite Göring's claims that he had always paid for his acquisitions, he usually just bartered one set of artworks for another.[57]

Returning Looted Art in Postwar France

Of the one hundred thousand artworks the Germans looted from France, about sixty thousand were returned between 1945 and 1949. Approximately forty-five thousand pieces ended up with their rightful owners, but fifteen thousand remained unclaimed.[58, 59]

In 1946, France celebrated the restitution it had accomplished thus far by exhibiting 283 works at the Musée de l'Orangerie. The show, *Masterpieces of Private French Collections Found in Germany*, highlighted Vermeer's *Astronomer* and other looted masterworks that Hitler had prized. Of the fifteen thousand unclaimed items, thirteen thousand eventually sold at auction; the remaining two thousand were registered in a group called the Musées Nationaux Récupération (National Museums Recovery), or MNR for short.[60] Legally, these "orphaned" works did not belong to France but were under the state's jurisdiction until the rightful owners or heirs could prove ownership. Many of the two thousand orphaned paintings assigned to the MNR were distributed among the numerous French museums, including some in outlying provinces.

French authorities initially intended to return the artworks to their rightful owners. But, as in the Gentili case, they needed to make a greater effort to find these people. Indeed, between 1951 and 2020, the Louvre returned very few Nazi-looted paintings to the heirs of the original owners. This is not surprising. Many of the owners had vanished during the Holocaust, and some of their descendants overlooked family possessions or failed to pursue them.

In 2018, given shifting global attitudes toward stolen art, the Louvre decided to improve and renew its efforts to return Nazi-looted artworks. The museum displayed thirty-one orphaned paintings in two permanently dedicated galleries, hoping the rightful heirs would claim them.[61] The exhibition evoked mixed reactions. Some visitors were touched by the museum's effort to remind the public of the Nazis' art policies; others, including Marc Masurovsky of the Holocaust Art Restitution Project, felt "the creation of these MNR rooms at the Louvre is far too little, far too late."[62] On the exhibit's opening, a press release from the Louvre noted that the MNR still held 1,752 works, including 807 paintings.[63]

Thierry Bajou, a curator at the Culture Ministry, conceded: "For a long time, the administration merely waited for the beneficiaries to claim a given work of art. Now, we try to study the works' origin and identify who was despoiled at the time."[64] As a result of this shift, some heirs to orphaned works in France have begun to be reunited with long-lost family possessions. Christopher Bromberg and Henrietta Schubert received works that once belonged to their German grandparents, Henry and Hertha Bromberg. These include two sixteenth-century paintings: *Triptych of the Crucifixion* by an anonymous Antwerp master and Joachim

Patinir, who created the background landscape,[65] and a portrait of an unnamed man, whose sword and gloves indicate his elevated stature, attributed to Joos van Cleve or his son.[66] Both works were earmarked for Hitler's Linz museum. In 1938, the Brombergs were forced to sell their art collection to raise funds for their journey as they fled Germany for France, then continued to Switzerland, and finally made the transatlantic trip to America.[67]

Gaston Prosper Lévy

The auction of three paintings from the collection of Gaston Prosper Lévy by Sotheby's in February 2020 surprised the art world. Two of these works the French State had labeled as MNR and assigned to the Musée d'Orsay in 2000. The third painting had surfaced in the discovery of Cornelius Gurlitt's art trove.[68, 69]

Born in 1883 in Tours, Lévy was a successful property developer and a cofounder of the retail chain Monoprix, which still operates today. He lived with his wife Lilliane and their daughter Andrée in an elegant Paris apartment on Avenue Friedland; the family also had a country home, the Château des Bouffards, in the Loire Valley. During the 1920s, Lévy became a devotée of French Post-Impressionist art and patron of Paul Signac, with whom Lévy developed a close friendship.[70] When Signac, who was enamored of sailing, decided to paint 107 of France's ports, Lévy sponsored the project and had the first pick of each batch of watercolors. During his lifetime, Lévy would own close to fifty of Signac's oil paintings and wrote the artist's first catalog raisonné.

Signac had been a close associate of Georges Seurat, whose Pointillist technique Signac continued to explore after Seurat's early death at age thirty-two. Signac's work is often joyous and romantic. His pure, primary colors, applied in small strokes, dots, or even squares, merge at a distance, endowing his paintings with an impressionistic feel. His vision would influence both Henri Matisse and André Derain.

The three recovered paintings from Lévy's collection are extraordinary. Signac's *La Corne d'Or: Matin* (*The Golden Horn: Morning*) depicts neatly lined-up boats with raised sails, gondolas, and tall ships filling Constantinople's harbor; the multicolored vessels float on a shimmering sea lit by the morning sun. In contrast, the artist's second work, *Quai de Clichy: Temps Gris* (*Clichy Dock. Gray Day*), a symphony of blues and grays, examines a scene strikingly more subdued. Its detailed provenance shows that the painter initially traded it for a bicycle. In addition to Gaston Lévy's ownership, the painting had also once belonged to Felix Fenéon, a well-known French art critic and dealer, before it fell into the hands of Hildebrand Gurlitt.

The third work is Camille Pissaro's *Gelée blanche, jeune paysanne faisant du feu* (*White frost, young peasant woman building a fire*). Like the first two, this painting demonstrates a true mastery of the Pointillist technique. With small dabs of color, it depicts a young woman working to produce a fire and her daughter warming her hands before the blaze—its transparent smoke a painterly feat. Cows graze peacefully in the field behind.

In 1940, cognizant of the threat Hitler represented for the Jews, Lévy fled with his family to Tunisia, abandoning his collections both in Paris and at his château. The Germans billeted at Bouffards confiscated the art there; one piece was Signac's *Quai de Clichy*, which ended up in the possession of Hildebrand Gurlitt. The Nazis also seized the main collection in Lévy's Paris residence, including the Pissarro and Signac's *Golden Horn*; these works were shipped from Paris to Germany and were returned to France after the war in 1947. The state loaned them to French museums in recent decades, but restitution to the family did not occur until 2018. Gaston Lévy's grandchildren consigned all three paintings to Sotheby's, where the trio sold for almost $30 million.

Restoring the Rosenberg Collection

Shortly after the war concluded, Paul Rosenberg began to retrieve his looted artworks. His and his family's success greatly contrasts with the Louvre's dismal performance. His son Alexandre liberated quite a few pieces from the famously halted art train, and the Monuments Men freed several others from German depots. For decades, Rosenberg continued the hunt, recovering three hundred artworks before he died.

The first clue Paul Rosenberg discovered was that many of his plundered works had migrated to Switzerland. Art dealer and auctioneer Theodor Fischer of Lucerne's infamous "degenerate" art auction in 1939 handled the majority of the auction—his inventory included thirty-eight of Rosenberg's missing pieces. But he was not the only Swiss dealer who traded in stolen art: most claimed that, for various reasons, the art in their possession did not qualify as looted. However, further investigation by an independent British organization proved that Switzerland harbored hundreds of works from France's Jewish collections.[71] Many of these artworks had bypassed questioning at the border through transport via diplomatic pouch.

Fischer's best client was E. G. Bührle. Born in Germany, the Swiss arms manufacturer and dealer had begun collecting gilt-edged art in 1936 for his new residence in Zürich. When Rosenberg arrived in Switzerland to follow the trail of his plundered works, he visited the galleries of several Swiss art dealers and Bührle's home. The collector was most surprised to see Rosenberg—he had been told the French dealer was dead.

Inspection revealed that Bührle had come to possess six of Rosenberg's stolen paintings—some even bore Nazi marks confirming Rosenberg's ownership. Among these works were Corot's *La Liseuse* (*A Girl Reading*); Degas's *Avant le depart* (*Before the Start*); Pissarro's *Morning, after the Rain, Rouen*; and Matisse's *Odalisque with Tambourine (Harmony in Blue)*—the same Matisse in the 1941 photo of Göring at the Jeu de Paume, now at the Norton Simon Museum in California.

After some negotiation, Fischer and Bührle offered to return 80 percent of these artworks to Rosenberg if they could retain the remaining 20 percent. Rosenberg refused the compromise,

took them to court, and won the case. Bührle then legally acquired from Rosenberg four looted works he had hoped to keep, including the Corot and the Degas. Bührle's impressive collection is now open to the public at the Kunsthaus Zürich, though not without some controversy regarding both the source of Bührle's funds (selling arms to the Nazis) and continued discussions of provenance.[72]

Paul Rosenberg died in 1959. By then, he had become a vital presence in the New York art world. His major clients included the National Gallery of Art as well as Paul Mellon and Ailsa Mellon Bruce—the son and daughter of the museum's founder, Andrew Mellon. The National Gallery of Art (NGA) also came to possess many looted, restituted artworks that had once belonged to Rosenberg. The provenance of the following works at the NGA indicates that all had been seized from Rosenberg's gallery, and all but one (Matisse's *Woman Seated in an Armchair*) had entered the Reichsmarschall Hermann Göring collection.

- Henri Matisse, *Pianist and Checker Players*
- Henri Matisse, *Woman Seated in an Armchair*
- Pierre Bonnard, *Work Table*
- Jean-Baptiste-Camille Corot, *Madame Stumpf, and Her Daughter*
- Gustave Courbet, *La Bretonnerie in the Department of Indre*

Over the years, Paul Rosenberg maintained a close relationship with MoMA. The museum was one of his most faithful clients, acquiring significant works from him, such as Picasso's *Three Musicians*, painted at Fontainebleau in 1921.[73] Later, the Rosenbergs were among the donors of Vincent van Gogh's *Portrait of Joseph Roulin*, the Arles postman and van Gogh's close friend. For decades, Rosenberg provided MoMA with invaluable knowledge and insight, often loaning art for exhibitions from his gallery and collection. For his longtime contributions, MoMA named Paul Rosenberg in 1957 a "Patron of the Collections at the Museum." In 2007, at the family's bequest, the museum became the custodian of Rosenberg's vast archive—a wealth of correspondence, sales information, photographs, exhibition records, and crucial information about some of modern art's most significant figures.[74]

After Rosenberg's passing, his son Alexandre took over the gallery in New York. One of Alexandre's chief tasks was to continue recovering plundered art.[75] In the years ahead, the family unearthed missing works in various ways.

One lucky discovery occurred in 2005 when Elisabeth Clark, one of Paul Rosenberg's granddaughters, took a copy of Hector Feliciano's *Lost Museum* to a party. Feliciano's book includes a reproduction of Matisse's *Oriental Woman Seated on Floor*. At the party, Clark met Prentice Wright whose grandparents had once owned this painting. When Wright saw the image in the book, he recognized the painting from where it had hung in his grandparents' home. Wright's grandparents, Virginia and Prentice Bloedel, had bought the Matisse from the Knoedler Art Gallery in 1954 and eventually donated it to the Seattle Art Museum. A brief

investigation followed Clark and Wright's chance encounter, which confirmed the Matisse as one of Rosenberg's stolen works. At first, the museum refused to return it, but after much negotiation, the Rosenbergs regained possession of their long-lost painting.[76]

Other findings were equally fortuitous. In the 1970s, Alexandre reclaimed George Braque's *Table with Tobacco Pouch* from the daughter of a former leader within the Vichy administration. Another lost work given to a prominent Nazi was one of Claude Monet's *Waterlilies*, which had disappeared into the personal collection of German Foreign Minister Joachim von Ribbentrop: the family finally identified it in 1998 when the Musée des Beaux-Arts in Caen, Normandy loaned it to a major Monet exhibition at the Museum of Fine Arts, Boston.[77] Then 2012 saw the reappearance of two of the family's paintings by Matisse: *Woman in Blue in Front of a Fireplace* (also known as *Blue Dress in a Yellow Armchair*), on loan at the Pompidou Center in Paris from Oslo's Henie Ostad museum, and *Woman Sitting in an Armchair* in Cornelius Gurlitt's art trove.

In September 1941—just a year after the Rosenbergs had escaped France—the Nazis and their French collaborators turned Paul Rosenberg's Paris gallery and home into the Institute for the Study of the Jewish Question. That organization mounted shows, organized lectures, and produced vile antisemitic literature—copies of which still filled the galleries when the Rosenbergs finally repossessed the building. A declaration painted in the foyer demonized the French Jews. Taken from an antisemitic text written at the time of the Dreyfus Affair,[78] the deliberately divisive statement read as follows:

> The Jews are like an Asian colony established in France. They live among us as if in a foreign land. They are triply foreign: for they are neither French, nor Christians, nor even Europeans.[79]

Soon after it opened, the Institute organized an exhibition titled *The Jews and France* at the Palais Berlitz, whose visuals equaled the ferocity of Germany's *Stürmer*. The show was a sensation. During its five-month run, hundreds of thousands of people visited the exhibit. No wonder Paul Rosenberg never reopened his beloved gallery in its former home. However, today, a plaque affixed to the façade of 21 rue La Boétie attests to its more glorious past. It reads,

> Here, at 21 Rue La Boétie, Paul Rosenberg installed his art gallery between 1910 and 1940. He exhibited there the greatest modern painters, including his friends Picasso, Braque, Matisse, and Léger. In 1941, the Gestapo requisitioned the building to house the Institute for the Study of the Jewish Question.

After Paul Rosenberg's granddaughter Anne Sinclair published her captivating memoir *My Grandfather's Gallery* in 2014, the book served as inspiration for *21 rue La Boétie*, an exhibition

honoring Paul Rosenberg in 2016. Opening at La Boverie in Liège, Belgium and moving on to the Musée Maillol in Paris, the show featured sixty-three paintings that had passed through the Rosenberg Gallery, many of which had been looted and restituted.[80] Galleries and private collections from all over the world contributed pictures. The Centre Pompidou in Paris sent George Braque's *Duo* as well as Marie Laurencin's charming *La Répétition (The Rehearsal)*, an image of five brightly costumed dancers and a dog, which Paul Rosenberg had donated to the museum in 1947.[81] The exhibition also included Matisse's *Blue Dress in a Yellow Armchair*, which the Henie Onstad museum in Oslo had restituted to the family in 2014. The Foundation E. G. Bührle loaned Camille Corot's *A Girl Reading*—one of the paintings Bührle repurchased from Rosenberg, after Rosenberg won it back in court—and the Minneapolis Institute of Art (MIA) provided Fernand Léger's imposing *Breakfast*. Marie Laurencin's portrait of a four-year-old Anne Sinclair with very blue eyes closed the show.

Rosenberg would have been pleased with the tribute. However, after savoring this success, he likely would have encouraged his family to search for the sixty additional paintings still missing from the four hundred looted during Hitler's war on art.[82, 83] Today, the quest for future recoveries lies with Alexandre's daughter—Paul's granddaughter—Marianne, who in 2019, became the fourth generation of the family to head the gallery.

Armand Dorville

While the Rosenbergs continued to hunt for their family's missing works, the Louvre was examining its own collection. In January 2020, the Louvre hired Emmanuelle Polack, an expert on the French art market during WWII, to investigate the provenance of pieces acquired between 1933 and 1942 and unclaimed, looted works in the MNR.

The previous year, Pollack had presented an exhibition on the art market under Nazi occupation at the Shoah Memorial in Paris. Within that exhibit, Polack had traced three pieces loaned by the Louvre to the forgotten Dorville collection. When she arrived at the Louvre in her new position, Polack identified ten paintings in less than a month that had belonged to Dorville.[84, 85]

Armand Isaac Dorville was a highly distinguished Parisian: at once a prominent lawyer at the Court of Appeal of Paris, a Chevalier of the Légion d'honneur, and an illustrious art collector. Yet after the Vichy government took control of Paris in 1940, Dorville suffered persecution as a Jew and fled to his estate in the Dordogne, where he died of natural causes in 1941. His good friend Jacques Pfeiffer had been named executor of Dorville's will. Pfeiffer decided to sell Dorville's art collection and other possessions to prevent their looting or Aryanization of his estate. He hoped the proceeds would fund the family's escape to Spain or Switzerland.[86]

In June 1942, Dorville's remarkable collection of 450 artworks by Rodin, Manet, Fantin-Latour, and Degas was auctioned at the Hotel Savoy in Nice—the same site that had sold the

Jaffé collection. Museums and art dealers snapped up pieces of the extraordinary collection. Hildebrand Gurlitt, working in Paris and acquiring artworks for Hitler's projected Linz museum, picked up a portrait by French Impressionist Jean-Louis Forain. In time, the artworks widely dispersed, from French, German, and US museums to private collectors.

In a devastating turn, the Vichy government's commissariat-general for Jewish affairs sent Amédée Croze to the sale as a "provisional administrator" to Aryanize the profits. Due to Croze's presence, the heirs had no voice in the auction. The sale notably concealed Dorville's identity; the catalog listed the renowned Dorville collection as a "Cabinet d'un Amateur Parisien"—reducing the expert collector to a "Parisian amateur" or "art lover."[87] In the end, the total yield of the auction exceeded 9 million francs, even though the hammer price of individual items had been low. Croze seized this entire sum for the commissariat-general for Jewish affairs: Dorville's family received none of the earnings that might have saved them. Instead, Dorville's sister, two daughters, and two young grandchildren were deported to Auschwitz: none survived.

It was Gurlitt's acquisition at the auction that would prove critical to the eventual recovery of the Dorville collection. As a member of the task force investigating the Gurlitt hoard, Emmanuelle Polack spotted a yellowing label on the back of the Forain portrait. The label featured an item number that matched the catalog of the Dorville sale at the Hotel Savoy.

Another key figure to the Dorville team was attorney Corinne Hershkovitch. She had cut her teeth on the Gentili restitution and was now representing the Dorville family. This was the third time Hershkovitch, by now nicknamed "Madame Restitution," was confronting the Louvre.[88] In 2021 she requested the return of twenty-one Dorville items. The Louvre initially refused, claiming the auction had not been forced.[89] By 2022 the Louvre and the Dorville family came to an agreement: the Louvre would return twelve of the pieces—but only in exchange for the price paid at the auction. The remaining nine works belonged to other French museums. Since the state upheld the legality of the Dorville auction—as essentially an estate sale, rather than a sale under duress—the museums holding these works would be allowed to keep them.[90]

Hershkovitch and others kept pressing the French government to change the laws that governed the restitution of Nazi-looted art.[91] Their timing was good: France was finally starting to shift its position on the issue—for example, appointing a new task force to locate and return artworks that had been stolen and sold under pressure during the Nazi occupation.[92] The work of this team at last bore fruit. In 2023, the French National Assembly developed a new law to address the country's inconsistent efforts in dealing with its complicated past. Until then, France's heritage code had prevented public museums from returning looted art to their rightful owners, maintaining that state collections were "inalienable"—their contents were impossible to remove. The new legislation would finally override this code and allow museums to restitute stolen art. The assembly unanimously adopted the groundbreaking law on June 29, 2023.[93, 94]

On this hopeful note, the following chapter turns to Holland, whose collections of old Dutch masters proved irresistible to the desires of the rapacious, art-hoarding Nazis.

10

Holland

A Good Country Confronts Evil

On May 10, 1940, the Nazis invaded Holland, Belgium, and France, driving the Allied armies to retreat. In a matter of weeks, the Germans forced the British and French troops backward toward the French port of Dunkirk, where they found themselves trapped between oncoming enemy forces and the Channel. The Nazi strategy was so successful in stranding the Allied troops that an evacuation by sea became mandatory. Between May 26 and June 3, an armada of small boats rescued over three hundred thousand Allied soldiers—an extraordinary event known as "The Miracle of Dunkirk." While the mass rescue lifted the spirit of Britain's military and civilian population, Holland had already surrendered on May 14; Belgium followed on May 28, and France signed an armistice on June 22.[1, 2]

As World War II continued, Holland's fate would prove much worse than that of Belgium and France. Comparatively lenient military authorities administered France and Belgium, whereas fanatical Nazis and the SS took control of Holland's civilian government.[3] Reichskommissar Arthur Seyss-Inquart, a long-standing Austrian Nazi, headed the German administration and incited Dutch citizens to embrace antisemitism. In a speech delivered in March 1941, he declared, "We do not consider the Jews to be members of the Dutch nation. To us, the Jews are not Dutch. . . . We will smite the Jews where we meet them, and whoever goes along with them must take the consequences."[4] As a result of Seyss-Inquart's zeal, 75 percent of Holland's formerly integrated Jewish population was deported to camps—a more significant percentage of Jews than anywhere else in Western Europe. Among these was Anne Frank, the Holocaust's most beloved victim: Anne was sent to Auschwitz, then to the Bergen-Belsen concentration camp, where she died of typhus in 1945.[5]

The war also lasted longer for Holland than for Belgium and France. The latter two were liberated in August and September 1944, while Holland remained occupied until May 1945.

During the last winter of the war, the Netherlands suffered from the *hongerwinter*, or "Hunger Winter," during which 18,000 to 22,000 people starved to death.

Before World War II, the Netherlands had been a small, peaceful kingdom. Its laws were unusually progressive. Maternal- and child-care were exemplary, as was religious tolerance. The country had accepted its small, stable Jewish population, most of whom descended from the Sephardim, a community forced to leave Spain during the Inquisition. (The term Sephardim derives from the Hebrew word for Spain.) Some Jews even appear in Dutch art. Rembrandt himself selected some of his subjects from Amsterdam's Jewish Quarters. One of his most famous paintings is called *The Jewish Bride*.

The Birth of the Art Market, or the Popularization of Art

Art has always played an essential role in the Netherlands. During the fifteenth century, when still part of Catholic Spain, the region's artists produced magnificent religious works, such as the Ghent Altarpiece by Hubert and Jan van Eyck (the work has the dubious distinction of being the world's most frequently looted artwork). However, Dutch Protestants argued for religious freedom, and all citizens disputed excessive taxation, so the Netherlands entered an eighty-year struggle known as the Dutch Revolt; this conflict finally concluded in 1648 with the Netherlands' independence from Spain. As a result of this break, artists lost the church as their principal patron and began selling more modest works to the rising Dutch middle class.

Decorating one's home with art became an accepted custom in Holland. Burghers commissioned portraits and bought landscapes, still lifes, and genre paintings. Art emerged as a commodity, giving rise to the modern art market and its dealers, who strictly regulated transactions. It did not take long for Dutch art dealers to begin participating in the international European market.[6]

The Netherlands gloried in its Golden Age (1575–1675). Its most distinguished artists—Rembrandt, Frans Hals, Johannes Vermeer, Salomon van Ruysdael, and others—produced remarkable, highly coveted works. However, the demand for original art was large enough also to sustain the livelihood of less illustrious painters.

Painters of the Golden Age are not Holland's only contribution to art history. Though often associated with France, Vincent van Gogh was born in the Netherlands in the mid-nineteenth century and studied art in his native land. He produced his best-known paintings in southern France, but his early works from Holland and Belgium are also impressive. After van Gogh, Piet Mondrian became known for his highly abstract geometrical works; during the first half of the twentieth century, Mondrian represented Holland's major contribution to nonobjective art, Minimalism, and Abstract Expressionism. Mondrian left Europe in 1940 to join the New York art scene.

Given their admiration for old masters with a Nordic background, the Nazis were especially eager to plunder the Netherlands. As soon as the military had secured the territory, an army of art dealers, profiteers, and other officials descended on poor Holland. Noteworthy among these were Hans Posse, the ubiquitous Hermann Göring, and Göring's helpmates, including Kajetan Mühlmann and Alois Miedl.[7] As in Austria and France, the looters had done their homework and identified the owners of the art treasures they desired. No Rothschilds resided in Holland, but other significant Jewish collectors did; their collections included very little modern art and were therefore much to the Nazis' liking.

Fritz Mannheimer

One collection the Nazis planned to plunder belonged to Fritz Mannheimer, a German Jew who had settled in Holland during World War I. Born in Stuttgart, he trained as a lawyer in Heidelberg but soon joined Berlin's Mendelssohn & Co., a privately held Jewish bank, one of the oldest and most important in Germany. In 1920, he became the managing partner of the Dutch branch.

Mannheimer was an exceptionally skillful financier, exhibiting, in the words of the historian Lou Jong, "a mix of genius, talent, and bluff." In the aftermath of World War I, Mannheimer proved so adept at manipulating the valuation of currency that he was nicknamed the "King of Flying Capital." The Nazis found him so valuable that Mendelssohn was the last German–Jewish bank to be closed. Deutsche Bank took it over in 1938.

Like Alfred Flechtheim, Mannheimer had compulsively accumulated valuable art and sizable debts. During the 1930s, he acquired three thousand artworks by Rembrandt, Crivelli, Fragonard, Watteau, Boucher, Memling, and Chardin. According to Michael Gross's *Rogues Gallery*, these works' previous owners included David David-Weill, the Hermitage, and assorted German museums.[8, 9]

Mannheimer liked to live well and show off his possessions, a penchant frowned upon in sedate Holland. His many detractors dubbed his Dutch mansion *Villa Protsky* (a derivative of the Dutch word for "show off") and mocked that he never learned to speak Dutch. By the end of the 1930s, Mannheimer was in poor health. He nevertheless married the young and alluring Marie Annette Jane Reiss in 1939. At the time, Jane resided at Mannheimer's mansion in Vaucresson, near Paris. According to Gross's research, the groom had a heart attack during the wedding ceremony and needed to be revived.[10]

It was around this time that, unbeknownst to his creditors, Mannheimer shipped many of his most valuable artworks to France. Months after the wedding, on August 9, 1939, he died at his Vaucresson estate of causes that remain, to this day, unclear. Jane gave birth to a daughter four months later: that child, Anne France (known as Annette) Mannheimer, would grow up to

marry Dominican American fashion designer Oscar de la Renta and gain fame as the protector of Brooke Astor, doyenne of New York City's elite, during her painful old age.

As World War II heated up, France became less safe for Jane and Annette Mannheimer. When they finally fled, they took a circuitous route: Jane took off for Argentina, returned to France to pick up her daughter, and settled in the United States, where she married the American industrialist and precious metals magnate Charles W. Engelhard, Jr.

However, these events jump ahead of the story. Mannheimer had been defrauding the bank in Holland, using Mendelssohn's funds to purchase art for his collection. After his death, the Deutsche Reichsbank seized his assets, including the artworks. However, the art collection caught the attention of both Adolf Hitler and Hermann Göring. Soon after the Nazis invaded Holland, they forced the bank to sell it to them at a steep discount. The art Mannheimer had shipped off to Paris met a similar fate, and a significant portion of Mannheimer's legendary collection transferred into Nazi hands.

As discussed earlier, when peace returned, the Monuments Men retrieved the artworks hidden in Austria's Altaussee salt mine and returned them to the countries where they'd been seized. Eventually, Holland's museums absorbed the Mannheimer collection. His most coveted artwork, Carlo Crivelli's *Mary Magdalene*, is now at Amsterdam's Rijksmuseum. Mannheimer's legacy also includes Michiel Jansz. Van Mierevelt's *Child with Parrot*, Jean Honoré Fragonard's *A Woman Reading*, and Jacob van Ruisdael's *Ferryman*.

In 1945, Jane Mannheimer returned to Paris to reclaim some of her late husband's art. She was awarded three pictures, including Jean Siméon Chardin's *Soap Bubbles*, an intimate genre work. Chardin shared his subject's seriousness of purpose: blowing an immense, shimmering soap bubble that might burst any second. Chardin's palette, a subdued mix of browns and yellows, contributes to the general restraint of the painting. *Soap Bubbles* is now in the permanent collection of New York's Metropolitan Museum, which purchased it in 1949.

Hans Memling's *Madonna and Child with Angels* also has a Mannheimer connection but one unrelated to World War II. In 1927, Mannheimer sold the painting to Hugo Perls—a notable Berlin art dealer and champion of early modernist works (he managed to escape from France in 1941 and reach New York, but the Nazis appropriated his collection, too). Andrew Mellon purchased *Madonna and Child* in late 1927 and deeded it in 1931 to Washington's National Gallery of Art. It still hangs there today.[11]

Jacques Goudstikker

In 1845, Jacob Goudstikker founded an Amsterdam art dealership in his name. His son Eduard carried on the enterprise, and his grandson Jacques joined the family firm in 1919. With an exceptional eye for art, Jacques greatly expanded the gallery, adding German, French, and

Italian paintings to the mostly Dutch inventory. Jacques's business card, showing a patrician Amsterdam Herengracht Canal house, read "J. Goudstikker: Old Pictures of All Periods." Jacques acquired an international reputation early in his career, with a clientele ranging from tycoons to American museums. One of his exhibits even toured the United States in 1923. His significant sales included Johannes Vermeer's *Girl with a Flute* to the National Gallery of Art; Aert de Gelder's *The Banquet of Ahasuerus* to the Getty Museum in Los Angeles; and Frans Hals's *Portrait of Hendrick Swalmius* to the Detroit Institute of the Arts. Goudstikker became an influential tastemaker, remembered for his infallible judgment, knowledge of art history, and lavish lifestyle.

Goudstikker hosted groundbreaking exhibitions and art-related parties—even Dutch royalty were known to attend. In 1937, he organized an extravagant charity event titled Vienna on the [River] Vecht. The Dutch Concertgebouw Orchestra, the Birkmeyer Ballet, and Dési von Halban Kurz, an up-and-coming Austrian soprano, provided the entertainment. During the event, twenty-five-year-old Dési and the widowed, thirty-nine-year-old Jacques fell madly in love. A whirlwind courtship followed. In addition to jewelry, flowers, and a Siamese cat, Jacques sent the following message to Dési, living in Vienna on the verge of German annexation: "You should learn Dutch as soon as possible. . . . You are no longer safe in Vienna. I do not trust the Germans." The Goudstikkers married six months later. Eduard (Edo), their only child, was born in 1939.[12, 13]

During the late 1930s, Jacques Goudstikker anxiously watched Hitler's expansionist, antisemitic policies and considered leaving Holland. In preparation for such a move, he appointed Dr. A. Sternheim, his best friend and lawyer, as administrator of his affairs. Goudstikker applied for and secured American visas for his family. He also inventoried his collection. He alphabetically recorded details of his personal and business collections in a small, looseleaf leather notebook his descendants would call "the Blackbook." The typewritten list includes about 1,400 items.

Jacques Goudstikker did not listen to his own more cautious instincts. As clouds continued to gather over Western Europe, he tarried in the Netherlands. On the day of the Nazi invasion, Jacques, Dési, and Edo managed to board the SS *Bodegraven*, one of the last ships to leave embattled Holland for England and beyond. The SS *Bodegraven* sailed to Dover. On the second night at sea, Goudstikker told Dési he needed fresh air. He left the crowded hold of the ship and, while strolling about the deck, fell through an uncovered hatch and broke his neck. When he failed to return, Dési insisted that the captain organize a search party. They soon discovered Jacques's body. The little black book that listed the art dealer's entire inventory was in one of his pockets. Dési removed it before arranging his funeral in Falmouth, England. She could not attend the ceremony because, as an Austrian enemy alien, she was not allowed off the boat, but she requested that flowers adorn his gravesite, overlooking the sea.[14, 15]

When the ship docked in Liverpool, Dési was detained once again because of her enemy alien status. The American visas obtained by her husband had expired, and the embassy refused to

renew them. After a protracted bureaucratic struggle, Dési and Edo set sail for Canada, where Siegfried Kramarsky—who had transported Van Gogh's *Portrait of Dr. Gachet* to America (see chapter 5)—met their ship.[16] From there, mother and son traveled on to New York. To support Edo and herself, Dési resumed her singing career. A photograph of her performing at an outdoor show in New York's Times Square survived these harsh times.[17]

The speed with which profiteers pounce upon abandoned property can be shocking. Within weeks of Goudstikker's departure, vultures pecked at his possessions. Dr. A. Sternheim, to whom Goudstikker had entrusted his gallery, succumbed to a heart attack. Taking advantage of the now rudderless gallery, Jan Dik Sr. and Arie Albertus ten Broek, two allegedly trustworthy Goudstikker employees, stepped into the breach and coerced Jacques's elderly mother Emilie to put them in charge.

Enter Alois Miedl. Born in Germany in 1903, Miedl started out by working for several Munich banks. During the 1920s, he married a Jewish woman named Fodora—"Dorie"—Fleischer: standing by her throughout the reign of the Nazis may be one of Miedl's few honorable deeds. He moved his family to Holland in 1932 but continued his friendships with several high-ranking Nazis, including Hermann Göring, even visiting the Reichsmarshall's Carinhall retreat.[18]

Once settled in Holland, Miedl switched professions, working mainly as an art dealer. He befriended members of the emerging Dutch Nazi Party as well as prominent Jewish art collectors and other critical citizens. Despite his marriage to a Jewish woman, he threw parties to mark Hitler's birthday, donning an SS uniform for the occasion.[19]

Soon after the Nazi invasion of Holland, Miedl visited the Goudstikker Gallery and took over the business. He obtained the cooperation of Jacques's mother Emilie, who owned a minority of the gallery's shares, by promising her protection from the Nazis. He kept his word, and Emilie survived in her home in Holland. Miedl then made a deal partnering with the Reichsmarshall: Miedl appropriated the business itself—its name, goodwill, and stock-in-trade as the Goudstikker Gallery—while Göring walked away with three hundred artworks, including pieces by Memling, Cranach, Frans Hals, Rubens, Rembrandt, and Ruysdael. After selecting what he desired for his collection, Göring traded many of the artworks back to Miedl, who sold them at a profit.

Miedl continued to operate the Goudstikker Gallery until the end of the war. Its reputable name obscured the fact that he was selling looted property for which he had paid bargain basement prices, as well as trading favors such as exit visas and exemptions from reporting to concentration camps. One of these sweetheart deals involved Dr. Max Friedländer, a former director of the Kaiser Friedrich Museum in Berlin and an expert on Dutch masters, who provided Göring with professional expertise in exchange for protection (Friedländer was even retrieved from the Osnabrück concentration camp at one point). Like Dorie Miedl, Friedländer became an "honorary Aryan" and was exempt from wearing a yellow star.

Despite the dubious nature of his activities, Miedl's business flourished. He traded Goudstikker's paintings, helped loot Jewish collections, including Mannheimer's, and funneled additional works of art to Göring.[20]

Hitler and Göring, the Reich's Chief Collectors

Göring's exploits in looted art had already been prolific in France; now he was devoting excessive time to further enlarging his art collection in Holland. Ten days after the invasion of the Netherlands, Göring's personal curator Andreas Hofer traveled to Amsterdam to identify possible acquisitions.[21] Kajetan Mühlmann, an Austrian art historian characterized by Jonathan Petropoulos as "arguably the single most prodigious art plunderer in the history of human civilization," also stoked Göring's greed.[22]

James S. Plaut, the art historian, museum director, and Monuments Man, stresses that despite the two men's enormous collecting activity, neither Hitler nor Göring had any genuine appreciation of art. Both venerated Nordic paintings. Hitler adored saccharine German genre paintings of the nineteenth century. Both despised the art of their times, a dislike that aligned with the official National Socialist doctrine. Hitler sublimated his failure as a painter to his goal of becoming a great patron of the arts, but he mostly delegated the art's procurement to others. He stored most of the thousands of works he had acquired in various depots throughout Europe, waiting for the day he could install his collections in the vast Führermuseum he planned to build in Linz, Austria.[23, 24]

Göring was even more rapacious than Hitler. Plaut calls attention to the Reichsmarschall's "abominations of taste" and his preference for "the nineteenth century's overpowering, fleshy nudes," though he did also indulge his wife's love of the French Impressionists. He shipped most of the art he plundered to Carinhall, which Plaut describes as Göring's alter ego: "his sanctuary and his shrine, the perfect meeting ground of Rubens and the stuffed bull moose." Göring planned to turn Carinhall into a museum for the German people on the occasion of his sixtieth birthday.[25, 26]

Göring fancied himself a highly cultured Renaissance man, entitled to extra privileges. During Nazi rule he gathered titles, fancy uniforms, castles, intricate toys, and precious stones. He carried the latter loose in his pockets and liked to jingle them. He traveled on his own personal luxury train, which, to accommodate his girth, was equipped with oversized bathtubs.

Despite his poor taste, Göring possessed some very fine pictures. In 2009, the year that *Avarice* was published, Deborah K. Dietsch, a reporter for the *Washington Times*, asked Nancy Yeide, most likely the world's foremost expert on the quality of Göring's art collection, to select his ten most significant paintings. The following five are now in American art museums:

1. *Virgin and Child* (1520) by Jan Gossart. Looted in Paris from the collection of Dr. Max Wasserman. Featured by the US Postal Service as a Christmas stamp in 2002, the painting is now at the Art Institute of Chicago.
2. *The Crowning of Saint Catherine* (1633) by Peter Paul Rubens. Looted from German collector Leopold Koppel. Now at the Toledo Museum of Art in Ohio.
3. *River Landscape with Ferry* (1649) by Salomon van Ruysdael. Looted from the Amsterdam gallery of Jacques Goudstikker; now at the National Gallery of Art in Washington, DC.
4. *Alexander the Great and Campaspe in the Studio of Apelles* (1740) by Giovanni Battista Tiepolo. From Federico Gentili di Giuseppe's estate seized in Paris; now at the Getty in Los Angeles.
5. *Venus at Vulcan's Forge* (1769) by François Boucher. Looted from the French Rothschilds, now at the Kimbell Art Museum in Fort Worth.[27]

Like Hitler, Göring lusted after a work by Johannes Vermeer (1632–1675). During World War II, several unknown Vermeer paintings suddenly emerged in Holland. In 1942, Miedl told Göring of a Vermeer titled *Christ and the Adulteress* that had mysteriously appeared at the Goudstikker Gallery. Jan Dik, the previously mentioned Goudstikker employee, had authenticated it. Overjoyed, the Reichsmarshall purchased the work by trading roughly 150 looted paintings. *The Adulteress* became Göring's most precious possession; he believed that its sale would provide his wife and his daughter Edda with a comfortable income if Germany lost the war. However, by 1945 the truth came out: the painting was a fake by skilled forger Han van Meegeren. In fact, van Meegeren had painted all the recently discovered Vermeers, fooling the Dutch art community. No one was more enraged than Göring himself.[28]

Some artworks that entered Hitler's and Göring's collections were gifts. Germans have always placed stock in celebrating birthdays, cherishing the presents these can yield. Göring, as well as Hitler, made it known that art offerings were welcome. However, these randomly chosen donations did not always gratify Göring's taste, so his associates drew up lists of objects he hoped to own. From then on, potential donors contacted his staff and identified suitable gifts to please the Reichsmarshall.

Göring was particularly fond of Lucas Cranach and managed to assemble more than sixty of his works. One of these was a gift from the city of Cologne. Cranach's *The Virgin and Child* (sometimes called *Madonna and Child*) hung on the walls of the city's Wallraf-Richartz Museum. In 1938, the town obtained it from the museum and presented it to the Reichsmarshall at his daughter Edda's christening. After the war, Cologne tried to repossess the painting, claiming the gift had been involuntary. Edda Göring disputed the claim, but following a protracted legal battle, Cologne prevailed, and today, the painting is back at the museum.[29]

Cranach lived in Franconia. Born in 1472, one year after Albrecht Dürer, Cranach became a leading member of the Northern Renaissance. He was appointed court painter to Frederick III (1463–1525), the Wise, Elector of Saxony, who protected Martin Luther from persecution by the Catholic Church. Cranach immortalized the likenesses of both men.

Cranach led an enormous, active workshop in Wittenberg. He often painted multiple versions of a subject, each with slight variations. In addition to portraits of Martin Luther, Electors of Saxony, many private citizens, and genre scenes, Cranach produced several dozen versions of Adam and Eve before their expulsion from Paradise. Two of these panels belonged to Jacques Goudstikker, numbered 2721 and 2722, in his little black book.

Given his propensity for Cranach, Göring must have rejoiced in the find. In this particular portrayal, Cranach depicts Adam and Eve for the viewer's pleasure rather than spiritual education. Cranach's Eve, sinewy and lithe, enticingly grasps a branch of the apple tree, while Adam's lean physique and attractive, pensive face are equally striking.[30, 31] Göring acquired the paintings for himself, but after the war, they were returned to Holland, and in 1966, the Dutch government sold the panels to former Russian prince George Strongonoff Scherbatoff. The prince sold them to Californian Norton Simon in 1971, and Cranach's Adam and Eve entered the Norton Simon Museum in Pasadena, California. It wasn't until 2007 that Marei von Saher attempted to overturn the validity of the Dutch sale of Scherbatoff. She fought to reclaim the paintings for over a decade, but in 2018, a federal appeals court finally ruled against her case: the court argued that since she had never made her claim at the time of the Dutch sale decades earlier, the panels could remain at the museum.[32]

Göring's collection also included Cranach's *Portrait of a Man* and *Portrait of a Woman*, now at the National Gallery (Figures 10.1 and 10.2). The pair of sixteenth-century likenesses had earlier belonged to the Lederer collection in Vienna. Husband and wife August and Serena Lederer (see chapter 6) are best remembered as major patrons of Gustav Klimt.

The End Is in Sight

After the Allies' successful landing in Normandy, the defeat of the Third Reich seemed a foregone conclusion, and some profiteers tried to save their skin. One of these was Adolf Miedl. It is only in fairytales that evil always comes to a bad end, and Miedl was a cautious man. In 1944, perhaps sensing the imminent Nazi defeat, he sent some of his art to Fascist Spain. Likely concerned for his Jewish wife's safety in Nazi-controlled Holland, Miedl sent Dorie to Spain as well. Miedl joined her and his pictures. Later, at the request of American intelligence, Spanish authorities briefly detained him and confiscated some of his paintings. To avoid prosecution for his crimes, he ultimately agreed to turn over to the Dutch State most of the art he had brought

Figure 10.1 *Lucas Cranach,* Portrait of a Man *(1522).*

from Holland, but Mieldl's paintings in Spain only accounted for a small portion of his holdings. The vast majority of his looted collection vanished. Years later, he was known to retain bank vaults containing fine works of art. Today, it's most likely the looted paintings he amassed have widely dispersed.[33, 34]

Göring's collection, mammoth by the war's end, did not fare so well as Miedl's. In January 1945, when it became evident that the Russians were to occupy Carinhall, Göring disassembled his beloved fantasy world, packed his artworks aboard buses and trains, and shipped them to Berchtesgaden. Part of the collection was unloaded, but according to Lynn Nicholas, "far more remained in the trains" sitting in the station. Now, the local population of the village, long a Nazi playground, plundered those trains. The ill-gotten goods, including some looted works of Hitler's pals, were robbed by yet another group of people to whom they did not belong.[35]

Figure 10.2 *Lucas Cranach,* Portrait of a Woman *(1522). These two portraits had belonged to August and Serena Lederer of Vienna and were seized in 1938. The paintings were discovered in the Alt Aussee salt mines, restituted to the Austrian government in 1947, and returned to the Lederer heirs. The Samuel H. Kress Foundation purchased the pair in 1954 and gifted them to the National Gallery of Art in 1959. Credit (both): Courtesy National Gallery of Art, Washington*

The Gutmann-Goodman Family

The art collection of Frederick (Fritz) and Louise Gutmann was another the Nazis had earmarked for plunder before they invaded Holland. As his grandson Simon Goodman would relate in *The Orpheus Clock: The Search for My Family's Art Treasures Stolen by the Nazis*, Fritz had a "knack for being in exactly the wrong place at the precisely the wrong time." A scion of one of Germany's great Jewish banking families, Fritz had been living and working in England when World War I broke out in 1914. Because Fritz was an enemy alien, the British promptly interned him. Upon his release in 1918, he decided to avoid the chaos of postwar Germany and build a life with his wife Louise and their four-year-old son Bernard in Holland, where he went into business as a banker.[36]

Backed by the powerful Dresdner Bank his father Eugen had founded in Berlin, Fritz Gutmann's enterprises in Holland flourished. Fritz and Louise purchased Bosbeek, an estate on the outskirts of Amsterdam. By now they had a second child, Lili. The couple befriended other well-heeled, culture-minded families, including the Goudstikkers and Koenigs, who had negotiated the sale of the *Portrait of Dr. Gachet* with Göring (see chapter 5).

The Gutmanns' life was good. Soon Fritz started acquiring art. His wide-ranging collection included works by painters of the Italian and Northern Renaissance that would entice the Nazis. Fritz owned several works by Lucas Cranach, landscapes by Francesco Guardi, a Madonna by Hans Memling, a portrait by Frans Hals, Sandro Botticelli's portrait of a young man in a red cap, and The Temptation of St. Anthony by Hieronymus Bosch. He would loan the latter to the 1939 New York World's Fair. Daughter Lili showed a burgeoning appreciation for art in her own right; still young, she deemed her father's collection of old masters "boring" and "hideous" and must have been relieved when he purchased some more recent paintings by Degas and Renoir.

Fritz was not the first Gutmann to collect art. His father Eugen had assembled a world-famous collection of silver, including exquisite examples of German Renaissance workmanship. After Eugen died in 1925, Fritz became director of the Gutmann Family Trust and moved the silver to a special vault at Bosbeek. His attempt to protect this collection would place Fritz in grave danger and may even have precipitated his murder.[37]

As Hitler ascended in Germany, Fritz and Louise grew increasingly apprehensive but remained in Holland. They stored a portion of their liquid assets in Swiss banks and sent some of their best art to Paul Graupe, a Jewish art dealer in Paris. Unfortunately, the Gutmanns themselves did not flee. They were also too prominent to hide.

According to their grandson Simon Goodman (their son Bernard later anglicized the family name), Nazi agents showed up at Bosbeek to assess Fritz's art treasures a month after Holland surrendered. Over the next two years, they slowly forced Fritz to sell them these items. Karl Haberstock, Hitler's special art dealer, visited Bosbeek in March 1941, removing more than two hundred art objects from the home. Haberstock also insisted on taking possession of the Northern Renaissance paintings Fritz had sent to Paris. To legalize these transactions, the dealer deposited minor sums of money in a blocked Gutmann bank account, creating a false appearance that the Nazis had purchased the art in good faith. More importantly, the Nazi agents dangled a flimsy promise of protection for the Gutmanns. For a while, it seemed as if Fritz and Louise might be able to find safe harbor in Italy, where they had familial connections. Indeed, in 1942, the couple were informed that they had been granted first-class train passage to Florence, where their daughter Lili lived with her husband.

Instead, the Nazis hoodwinked the Gutmanns into traveling to Theresienstadt, the Reich's "model" concentration camp, where Fritz was beaten to death in 1944. Two months later, they shipped Louise to Auschwitz, where she, too, perished.[38]

Jacques Goudstikker's Heirs

As soon as the war was over, Jacques Goudstikker's widow, Dési, tried to repossess his collection. First, she visited the Netherlands Embassy and the US State Department in Washington, DC. The *Washington News* of September 8, 1945, reported on her errand, describing her as "youthful, slender, with the chic of her native Vienna" rather than "the usual elderly and sedate owner of a large art collection." Despite such media interest, her undertaking yielded no practical results.

In 1946, after an absence of six years, Dési Goudstikker returned to Holland. By then, the Monuments Men had identified the hundreds of artworks belonging to her husband among Göring's loot in Berchtesgaden. The paintings were shipped to the Central Collecting Point in Munich, and from there, returned to the Netherlands with instructions to restore them to their rightful owners. At this time, Holland had an organization called the Stichting Nederlands Kunstbezit (SNK, or Netherlands Art Property Foundation), which searched for owners and heirs of looted art. However, the Dutch authorities chose to assign Goudstikker's art to a special collection known as the Nederlands Kunstbezit-collectie (NK collection, or the Netherlands Art Property Collection), which assembled works of unknown origin: art placed here was considered not eligible for restitution and therefore entered the Dutch national collection.[39, 40, 41]

Dési Goudstikker's negotiations with the authorities had been disheartening—a reflection of Holland's hostile attitude toward restitution. The officials refused to restitute the artworks to her, claiming that their ownership had legally transferred to Miedl, since Goudstikker's mother had signed over the sale of her son's property to him. Assisted by lawyers and other experts, Dési Goudstikker spent the following seven years contesting the government over her husband's paintings. In 1952, she agreed to settle for a small portion of the collection, which did not include the hundreds of paintings taken by Göring. The artworks that were not returned to Dési became "National Property of the Netherlands" and were allocated to museums in the Dutch State.[42] According to Alan Riding's January 1998 piece in the *New York Times*, when Dési renounced her claims, she declared that the negotiations had caused her to endure "entirely unreasonable sacrifices" and that, ultimately, the decision was "unfair in the extreme." Deeply disappointed, she realized that obtaining any kind of justice would take years of legal battles.[43]

Dési did not fare much better in repossessing her Dutch real estate. When she came back to Holland, she had intended to resume her life at Oostermeer, the "most beautiful house in the world." Little of its former glory remained. Miedl had sold the furniture and torn the goblins from the walls. The boathouse on the river was destroyed, and the garden was in ruins. Meanwhile Edo missed his New York friends. So Dési returned to America and moved on with her life, marrying August von Saher, a lawyer who adopted Edo and gave them both a new name.

Dési's only positive experience in Holland had been the kindness of a former employee who revealed a painting wrapped in a blanket. It was a study of two young girls, thought to be a work

by Berthe Morisot, which the servant had shielded from the looters. The Morisot now hangs in the home of Dési's daughter-in-law in Connecticut.[44]

In 1963, Eduard (Edo) G. von Saher—the G. a reminder of his family name at birth—was stationed with the US Army in Germany when he met Marei Langenbein, a competitive ice skater. The couple married and had two daughters, Charlene and Chantal. The elder, Charlene, was born in England. The family then moved to Greenwich, Connecticut, where Marei resides today.

Dési von Saher and her second husband eventually returned to Holland. At this stage of her life, Dési was content, considering "she had much to be grateful for." She had decided to forget about her lost treasures, insisting she "did not want to make a fuss over a couple of pictures." Granddaughters Charlene and Chantal visited every summer. In 2010, Charlene recalled her annual holidays in Holland. Dési always drove her grandchildren past the Goudstikkers' old properties, including Oostermeer, the majestic family residence, and Nyenrode, the twelfth-century castle where Jacques held exhibitions and parties. When Charlene asked her grandmother why she no longer lived in her beautiful former home, Dési answered, "After the war, my sweet, things were different." Dési died of heart failure in 1996, a few months before Edo lost his own life from cancer. He, too, seemed to have forgotten about the family's former wealth and extraordinary art holdings.[45]

As the twentieth century drew to a close, looted property suddenly appeared. A series of investigations revealed that Swiss banks had defrauded Holocaust victims out of billions of dollars in assets. In the world of looted art, journalists made waves. In 1994, Lynn H. Nicholas published her epoch-making, *The Rape of Europa: The Fate of Europe's Treasures in the Third Reich and the Second World War*. Hector Feliciano followed with 1997's *The Lost Museum: The Nazi Conspiracy to Steal the World's Greatest Works of Art*. In 1998, Hubertus Czernin penned articles exposing the theft of the "golden" Adele Bloch-Bauer and other Klimts in the Austrian *Standard* newspaper.

That same year, Pieter den Hollander brought to light the tale of the Goudstikkers. *The Goudstikker Affair*, published in 1998, painstakingly details the family's story and how the Dutch government nationalized about three hundred of their artworks, distributing or selling them to seventeen different museums as well as other venues and even private individuals. Because Dési and Edo had changed their name from Goudstikker to von Saher, den Hollander encountered many difficulties contacting Jacques's heirs. Eventually, he located Marei von Saher and her daughter Charlene who reopened negotiations with the Dutch authorities.

In February 2006, after Marei von Saher had battled the authorities for eight years, the Dutch government agreed to return to her 202 artworks, mostly old-master paintings, valued at $79 million to $110 million. The Dutch authorities also allowed her to export these works to the United States. The decision left numerous blank spaces on the walls of Dutch museums—fifteen in the Rijksmuseum alone.

Marei von Saher decided to sell more than half of the recovered pictures at Christie's. Because the sale included multiple works painted by the same artist—six by van Ruysdael, six by David Teniers the Younger, and four by Jan van Goyen, among others—the auction house split these paintings into three different sales in New York, London, and Amsterdam.[46]

Apart from the works sold at Christie's, the Dutch government bought back four Goudstikker paintings that the Nazis had confiscated during the 1940s. These included *View of Delft* by Daniel Vosmaer; *Architectural Fantasy with Figures* by Dirck van Delen; plus two portraits by Paulus Moreelse. When Marei von Saher learned that *Child on Deathbed* by Bartholomeus Van der Helst was one of Professor Rudi Ekkart's favorite paintings, she donated it to the Netherlands in his honor. Dutch art historian Ekkart had championed the Goudstikker case during the prolonged negotiations with the government.[47]

Other restitutions also occurred. In 1927, Jacques Goudstikker had acquired Jan Steen's *Sacrifice of Iphigenia* (1671). The large seventeenth-century genre painting had hung in his Oostermere mansion, where his romance with Dési had blossomed. Göring looted it in 1940 and shipped it to Carinhall, but in 1945, the work was returned to Holland. It hung in the Rijksmuseum from 1960 to 2006 until its restitution to Marei von Saher, who sold it to a private party in 2008.[48]

The Netherlands' restoration of more than two hundred paintings to Marei von Saher is probably the largest restitution ever made; still, it represents only a fraction of the art Jacques Goudstikker lost. Moreover, most of the best works in his large inventory have never been found.

Once Marei von Saher secured the initial portion of the collection, she honored her father-in-law with a retrospective exhibition. Greenwich, Connecticut, is not a usual stop on the art circuit, but on May 10, 2008, its small Bruce Museum made history. Dignitaries, journalists, and neighbors attended the opening of *Reclaimed: Paintings from the Collection of Jacques Goudstikker*. The exhibition displayed some thirty-five of the artworks restituted to his family.[49]

The paintings on view at the Connecticut museum included Jan Steen's *The Sacrifice of Iphigenia*; Solomon J. van Ruysdael's *River Landscape with Ferry* (1649), which now belongs to the National Gallery of Art in Washington, DC (Figure 10.3); Jan Josephsz van Goyen's *View of the Oude Maas near Dordrecht* (1651); and many more.[50]

The *Reclaimed* exhibit was a triumph for Marei von Saher and her daughter. They met several people who had personally interacted with Jacques Goudstikker, the father-in-law and grandfather they had never met. One of the exhibition's visitors at the Contemporary Jewish Museum in San Francisco came forward and told Charlene that as a Kindertransport child, she had left Holland on the SS Bodegraven, the same boat on which the Goudstikkers traveled to the New World.[51] At another exhibition venue, the daughter of a former Goudstikker client introduced herself to Marei. She described the close relationship her parents had had with the Dutch art dealer whose life had been tragically cut short during his flight. These encounters provided historical details, making his collection's reassembly more accurate and meaningful.

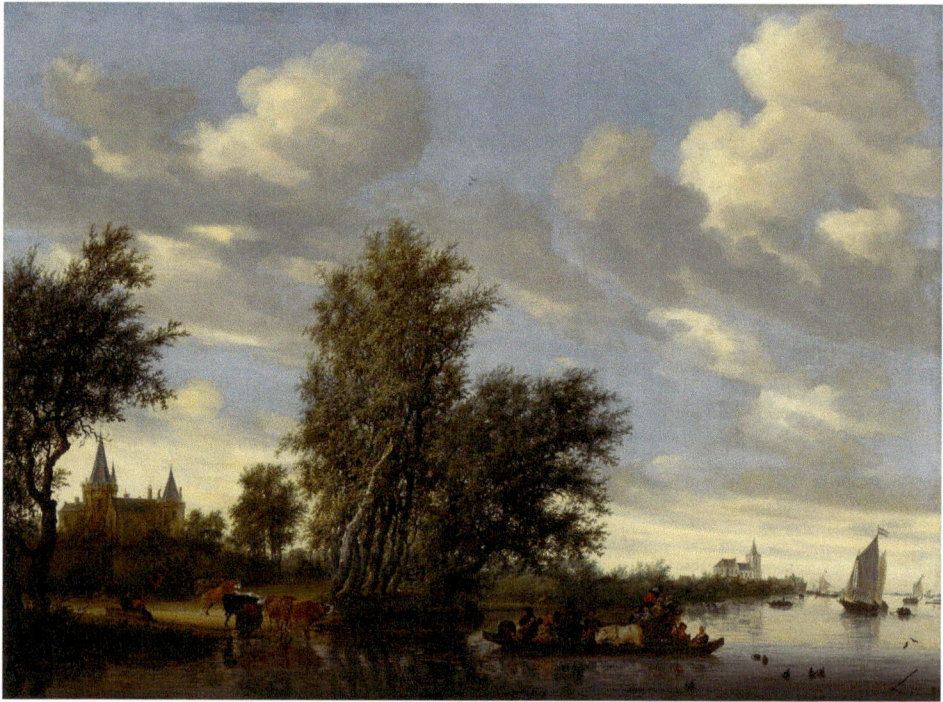

Figure 10.3 *Salomon van Ruysdael,* River Landscape with Ferry *(1649). In 1940, Alois Miedl and Hermann Göring took over Goudstikkers's Amsterdam Gallery and disposed of his inventory, including this Dutch Golden Age painting. Exhibited at the Rijksmuseum from 1960–2006, the work was finally restituted to Marei von Saher in 2006. Credit: Courtesy National Gallery of Art, Washington*

The exhibit in Greenwich also opened on a historic date, sixty-eight years after the Nazi invasion of Holland.

By examining thousands of individual paintings in museums and private collections worldwide, the Goudstikker team tracked down about a hundred of the dealer's artworks and achieved the restitution of thirty to forty of them. Despite the minimal nature of information contained in Jacques Goudstikker's Blackbook—usually just the artist's name, the work's title, size, date of purchase, and price paid—it served as the team's primary guide. Along the way, Marei von Saher hired Clemens Toussaint, a German art historian specializing in tracing lost art, to help her find additional Goudstikker works. During the exhibition's opening program in San Francisco, Toussaint described some of his methods.

In one example, Toussaint explained the process of locating a drawing by Edgar Degas. The Blackbook only specified that the Degas drawing depicted four dancers. Since the artist was highly prolific and specialized in ballerinas, pinpointing the correct drawing was like finding a needle in a haystack. Consulting numerous catalogs, the team narrowed the possibilities to a few dozen drawings depicting four dancers and, within this group, discovered several that showed

interruptions in provenance during the 1930s. Toussaint then examined a photographic archive, which contained an image of one of the drawings with missing provenance; it was stamped on the back by a Dutch photographer working in The Hague at the same time Goudstikker would have had possession of the Degas. The drawing shown was housed at the Israel Museum in Jerusalem, and indeed, as Toussaint suspected, the back bore the photographer's stamp. Lawrence M. Kaye, von Saher's American lawyer, shared the unwelcome news with the Israel Museum. After a year-long study, the museum concurred with the team's findings and returned the drawing to its rightful owner.

Toussaint also discussed the example of *Still Life of Flowers* by Rachel Ruysch (1664–1750), one of the few women painters of the Dutch Golden Age. Ruysch only painted still lifes, sometimes several versions of the same bouquets. One of these hung in the Dresden Galerie in Germany, which had—crucially—the exact dimensions as those listed in the Blackbook. A label on the back of the painting identified it as belonging to the Goudstikker Gallery, complete with an inventory number matching that in the Blackbook. It did not take Lawrence Kaye long to convince the Dresden Museum to relinquish a painting associated with the Holocaust.

The Heirs of Fritz and Louise Gutmann

Bernard Goodman, Fritz Gutmann's son born in England in 1914, would never discuss the loss of his parents during the Holocaust. Much like Secretary of State Madeleine Albright's family, who had converted to Catholicism to save their lives and never informed Albright of their Jewish identity, the Goodmans avoided speaking about their World War II history. Bernard, who anglicized the family name from Gutmann to Goodman, was silent on their Jewish background and revealed little to his children of his parents' lives.[52]

Yet unbeknownst to Simon and his brother Nick, Bernard and his sister Lili Gutmann, who had survived in Fascist Italy, had embarked on a decades-long quest to retrieve their father's art collection. Compiling information from sales bills, auction and exhibition catalogs, plus their own family memories, the siblings assembled a tentative list of Fritz Gutmann's possessions. Much of the finest art had been confiscated in Paris, where their father had sent it to dealer Paul Graupe in 1939 for safekeeping in case of a Nazi invasion of Holland. Graupe was a German-Jewish refugee art dealer who had fled to France. Eventually, he would escape to the United States. When he left Paris, the Einsatzstab Reichsleiter Rosenberg, or ERR, seized the Gutmann paintings.[53]

As with the Goudstikker collection, the Monuments Men returned hundreds of Gutmann's artworks to Holland after the war. But again, the Dutch authorities were reluctant to restitute these valuable paintings to their rightful owner. In this case, they insisted that the family

repurchase the looted works. In 1954, Bernard and his sister bought back sixteen paintings, including a Memling, an Isenbrandt, a Cranach, a Guardi, and a Fra Bartolommeo, as well as more than 150 antiques and artifacts. Bernard and Lili would have to sell most of their recoveries to cover restitution costs.[54]

The search was physically and emotionally exhausting, and Bernard Goodman never salvaged the rest of his father's collection. Fortunately, after he died in 1994, his companion Eva packed the documents of his decades-long quest into large boxes and mailed them to his sons in California. Simon and Nick were astonished by what they found.[55]

Simon decided to continue the search. His first find was Edgar Degas's work *Paysage*, now *Landscape with Smokestacks*. A faded negative of a photograph by Rose Valland, taken when the pastel passed through the Jeu de Paume museum, suggested that it originally belonged to Fritz Gutmann. Still, Simon had no idea where it had gone. He spent months looking through auction and exhibition catalogs featuring works by Degas. Finally, one evening, shortly before the close of the UCLA library where he was doing his research, he found the picture in the catalog of a Degas exhibit at New York's Metropolitan Museum of Art. Its provenance indicated that Fritz Gutmann had purchased it in 1932, and it was among the artworks he sent to France in 1939. Mr. and Mrs. Daniel Searle of Chicago were the current owners.

Like many other looted works, the Degas passed through several hands and eventually crossed the Atlantic. Daniel Searle, a trustee of the Art Institute of Chicago, had purchased it in 1987 from a New York collector who had owned it for thirty-six years. When Simon Goodman approached Searle in 1995, he was most reluctant to discuss restitution. Following an oftenugly legal battle that nearly went to trial in 1998, Goodman and Searle reached a deal splitting ownership 50/50: the work would go to the Art Institute of Chicago, which would pay the Goodman family for half of the Degas at the current estimated monetary value, while Searle would donate his half. The label would display the names of Friedrich and Louise Guttmann plus Daniel Searle.[56, 57]

Simon Goodman continued to recover artworks that had once belonged to his grandparents and great-grandparents. As he had done with Degas's *Smokestacks*, he usually identified the location of the works by searching exhibition and auction catalogs. One of his quarries was the sixteenth-century *Portrait of a Young Man with a Green Background* by Hans Baldung Grien, Albrecht Dürer's top student. This piece, too, had been shipped to Paris in 1939. However, it had vanished by the time Karl Halberstock, who had sold the painting to Hitler, went looking for it in 1941. It reappeared in 1953, eventually reaching the hands of German art historian Rudolf Heinemann, who donated the portrait to the Rutgers University Art Gallery. Goodman finally located the painting in an obscure German text from 1983 and visited the picture for the first time at the Zimmerli Art Museum at Rutgers University in October 2009. Opposed to the chilly reception he had experienced from Searle, the Zimmerli staff greeted him with open arms and let him commune with his freshly uncovered heritage. He was struck by the brightness of the

young man's face—nearly five centuries old. Reflecting on the moment in *The Orpheus Clock*, Goodman felt close to the grandfather he never knew through one of Fritz's precious art objects.

> I could only marvel at the power of art to survive, as I touched, tentatively, the ancient frame.... The colors had, fortunately, remained as vibrant as they must have been in Baldung's lifetime, especially the green background for which the artist had been famous.... The intricate black-on-white lacing of the *Young Man*'s snug-fitting jacket was a particular delight.[58]

Christie's sold the Baldung Grien to a private collector.

Still other works emerged that Fritz Gutmann had shipped to Paris and lost. *The Portrait of Isaac Abrahamsz. Massa* by Frans Hals was among those paintings. In 1947, art collectors Anne and Amy Putnam of San Diego—known as the Putnam Sisters—purchased the painting and donated it to the San Diego Art Museum, where it remains today. It is cheerful, like most works by Hals, with a sense of animation and movement created by the painter's characteristic flowing brushstrokes. The bareheaded sitter gesticulates with his left hand and freely gazes at the viewer. Instead of the black garb and starched ruffs typical of Dutch Golden Age portraits, Massa wears a soft white bib collar that illuminates the entire work.[59] A successful merchant and diplomat, Massa was, in fact, a good friend of Hals, who painted him a number of times throughout his life.[60]

Fritz Gutmann also sent to Paris Jan van Goyen's *Landscape with Two Horse Carts*, another seventeenth-century Dutch work. Hitler's dealers selected the idyllic landscape for the Linz museum in Austria. After the war, the Monuments Men shipped it back to France, and Rose Valland returned it to the Dutch authorities in Holland, who handed it over to the Goodmans in 1954. The Worcester Art Museum, headed by ex-Monuments Man George Stout, acquired it in 1956. This genre work depicts two horse carts traveling in tandem over rough terrain. The painting illustrates van Goyen's distinctive use of a monochromatic palette to present a detailed landscape in a range of subtle browns or grays.[61, 62]

Jean-Étienne Liotard's *Tea Set*, an eighteenth-century still life of a delicate porcelain service—six cups and saucers, a teapot, milk jug, and sugar bowl decorated with Chinese figures—also belonged to the group that traveled to Paris, where it, too, was selected for Hitler's Linz museum. After the painting's return to Holland, it was restored to Bernard and Lili; they sold it in Switzerland, where the work passed through the hands of Theodor Fischer of the infamous Lucerne auction. The Getty Museum in Los Angeles at last acquired the picture in 1984. The unusual image contrasts a rarefied upper-class lifestyle with soiled cups, half-eaten toast, and disarrayed silver spoons, which is utterly charming. By the time this was painted, around 1781–1783, the middle class had adopted tea-drinking as well: accordingly, Liotard places the high-priced china and silver on a tray in a cheap material called tole, tin painted to resemble Asian lacquer.[63, 64]

So far, the Goodmans have recovered one-third of their grandfather's collection and are hoping for an additional twenty artworks, plus hundreds of antiques, porcelains, and furniture. The family says it continues this pursuit to set right the wrongs of the past.

Surprises do happen. For close to eighty years since Fritz Gutmann's art was seized, Lucas Cranach's *Portrait of John Frederick I, Elector of Saxony* had disappeared from public knowledge. Then in 2017, the portrait suddenly reemerged: after reading *The Orpheus Clock*, one of the private owners anonymously contacted Christie's, which assisted in returning the work to the Goodmans. Cranach's colorful depiction presents the mighty ruler, known as the Magnanimous, looking grand in his red velvet and silk attire, elaborate cap, and festive gold jewelry. In April 2018, Christie's auctioned the painting for more than $7.7 million.[65] Goodman commented, "I have spent many years hunting for this marvelous painting. Among those pieces still missing from my grandfather Fritz Gutmann's collection, this was the piece I was the most doubtful of ever recovering."[66, 67]

At Last, Recognition

Jews arrived in Holland in the late fifteenth and sixteenth centuries, when Catholic Spain embarked on its Inquisition to root out heresy in the Catholic Church. When King Ferdinand of Aragon and Queen Isabella of Castille issued the Alhambra Decree banning Jews from the Iberian Peninsula in 1492, Holland welcomed Sephardic Jews exiled from their homes in Spain and Portugal and granted them full civil rights. (Amazingly, the Alhambra Decree was not officially repealed until 1968.) The Dutch Republic, with its seven provinces, was established in the sixteenth century, but Protestants continued to struggle for religious freedom: Catholic Spain didn't recognize the country's independence until the end of the Dutch Revolt, or Eighty Years War, in 1648.

In the centuries that followed, Jews became an integral part of the Dutch community until the rise of Hitler in the twentieth century. But events of the Nazi era demonstrate the fragility of democracy in the face of a well-oiled dictatorship. Though Dutch Jews lead a peaceful existence in Holland for hundreds of years, as noted earlier, approximately 75 to 85 percent of the community was murdered during the war—the highest percentage in Western Europe. If this weren't horrifying enough, the Nazis also did a thorough job of stripping the victims of their possessions.

According to Stuart E. Eizenstat and Julie-Marthe Cohen of *The Art Newspaper* (August 19, 1924), the Nazis plundered some six hundred thousand paintings overall throughout the war, the most valuable of which were reserved for the grand museum Hitler planned to build in his hometown of Linz. Of these paintings, only about a hundred thousand were recovered. Numerous works were retrieved from Nazi storage and sent back to Holland; but until the

passing of the Washington Principles, also engineered by Eizenstat (see chapter 6), the Dutch authorities proved surprisingly less than forthcoming in returning the art to rightful owners.

More recently, the Dutch acknowledged the unspeakable devastation of Holland's Jewish community with an official monument. In 2013 the Dutch Auschwitz Committee commissioned architect Daniel Libeskind, who had already built the Felix Nussbaum House in Osnabrück (chapter 8) and the Jewish Museum in Berlin, to create a Holocaust Memorial in Amsterdam. Libeskind's design features a series of brick walls that form the Hebrew letters for the phrase "in memory of." The walls consist of 102,000 bricks bearing the name, plus the birth and death dates of a Jewish victim. An additional 220 bricks provide the names of Sinti and Roma fatalities. The memorial gives those without a proper burial a place for remembrance. The Dutch Holocaust Names Memorial officially opened in 2021.[68]

In 2024, the Dutch also built a National Holocaust Museum, at whose dedication ceremony Dutch King Willem-Alexander declared, "Knowing about the Holocaust is not optional. This museum shows us what happened. And not so very long ago."[69] Based on 2,500 documents, the exhibits explore the past and present life of the Dutch Jewish community.

Holland's wealth of old Dutch masters fall far from the "degenerate" artworks the Nazis so reviled and forced to migrate to America for safety. The Nazis may have coveted these idyllic Dutch works most of all. Even Hitler and Göring dreamed of owning a Vermeer.

However, paintings of the Dutch Golden Age were also much admired by America's powerful tycoons, so these works had in fact been migrating to the United States long before World War II's wave of "degenerate" art. In 1908, two dozen American-owned Dutch masterworks were the pride of the Hudson-Fulton Exhibition, the Metropolitan Museum's first blockbuster show in New York. The exhibit provided the museum's contribution to New York City's celebration of the 300th anniversary of Henry Hudson's discovery of the city's harbor and the centennial of Robert Fulton's development of the steamboat.

Plunder and Survival raises several questions concerning art's migration. The number of items that arrived in the United States during the Nazi era is small in relation to the vast quantity of works America's museums hold in total. The United States is a nation of immigrants, and the art in American museums is equally far-reaching, displaying works from Asia, Africa, the Near East, Central America, Europe, the Ancient World and more. Are American museums at fault to place other nations' treasures on view? Or will these institutions assist the public in understanding and valuing the art's international identity? The population of the United States is now a highly complex blend of cultures. Many groups arrive here to escape unjust economic conditions or the dangers of war; others come simply with hopes for financial opportunity. Unsurprisingly, many works have come to America simply through the migration of families who brought their art with them. Such art is these immigrants' legacy. At the same time, other valuable art now in museums has certainly been plucked from its global origins for more

dubious reasons such as colonialist forces and conquest of native cultures—problematic issues of ownership that need resolution.

The wide assortment of art now on public view would not exist without the contributions of the numerous individuals behind the scenes—figures often unrecognized today. Among these are museum directors and curators who fell in love with new styles of art not yet popular; prosperous members of society who established small and large collections and willed them to the public; artists who created and sometimes donated their work; elected officials who purchased art with public funds; and scores of others. Also on this list were Hitler's many victims whose prized possessions got caught in an intricate labyrinth of greed, hatred, and bureaucracy—a web that eventually spewed these artworks to the world's four corners.

One cannot rewrite history, but today's efforts to track down lost art may increase the likelihood of identifying—and eventually restituting—looted art that has landed in museums and other venues. The authors have learned much in the course of researching the deplorable period of Nazi thievery during World War II and hope readers will share their grief and indignation.

Appendix A

A Treasury of Looted and Migrant Works in US Museums

The true number of artworks affected by the assault on European art by the Nazi regime will never be known. The estimated figure is a million items. A significant number of these were destroyed or simply vanished. Others were returned to their owners or heirs; others were auctioned, sold, entered national collections, or disappeared into private collections. Many migrated, more or less peacefully, with their owners to new lands. A tiny fraction of the objects found a new home in the art museums of the United States.

These artworks are a highly mixed group. Ranging from tremendous to more common pieces, these works include French Modern paintings, German Expressionist works, highly ornate, sentimental wall panels, abstractions, traditional portraits, landscapes, still lifes, and much more. They are a typical medley of what one would find in a general art museum. This appendix presents a selection of these treasures.

Modern technology lets you experience these images with the click of a finger. A rare Rubens in Toledo, Ohio; a Matthias Grünewald at the National Gallery of Art in Washington DC; or Gustav Klimt's Adele Bloch-Bauer I at the Neue Galerie in New York will materialize on your computer screen and allow you to bond with those who cherished these works long ago. Enjoy.

Artist	Painting/Sculpture	Museum
Beckmann, Max	*Bar Brown a.k.a. Bar Braun*	Los Angeles County Museum of Art
Beckmann, Max	*Departure*	Museum of Modern Art (MoMA)
Beckmann, Max	*Christ and the Sinner*	Saint Louis Art Museum
Beckmann, Max	*Hope Family Portrait*	Sidney And Lois Eskenazi Museum of Art at Indiana University

Artist	Painting/Sculpture	Museum
Boucher, François	Marquise de Pompadour at the Toilette Table	Harvard Art Museums
Boucher, François	Six Mythological Paintings	Kimbell Art Museum
Boucher, François	Aurora and Cephalus	The J.P. Getty Museum
Boucher, François	Venus on the Waves	The J.P. Getty Museum
Boudin, Eugène	On the Jetty	National Gallery of Art
ter Brugghen, Hendrick	Bagpipe Player	National Gallery of Art
The Brunswick Monogrammist	A Brothel Scene	Yale University Art Gallery
Castiglione, Giovanni Benedetto	Noah and the Animals Entering the Ark	Milwaukee Art Museum
Chagall, Marc	White Crucifixion	Art Institute of Chicago
Chagall, Marc	I and the Village	Museum of Modern Art (MoMA)
Chagall, Marc	Purim	Philadelphia Museum of Art
Corinth, Lovis	Portrait of Heinrich Thannhauser	Kimbell Art Museum
Corot, Jean-Baptiste-Camille	Pensive Young Brunette	Philadelphia Museum of Art
Cotán, Juan Sánchez	Still Life with Game Fowl	Art Institute of Chicago
Courbet, Gustave	Source of a Mountain Stream	Birmingham Museum of Art
Courbet, Gustave	Nude Reclining by the Sea	Philadelphia Museum of Art
Courbet, Gustave	Le Grand Pont	Yale University Art Gallery
Cranach the Elder, Lucas	Virgin and Child in a Landscape	North Carolina Museum of Art
Cuyp, Aelbert	River Landscape with Cows	National Gallery of Art
Dalí, Salvador	Multiple works	The Salvador Dalí Museum
di Paolo, Giovanni	Adoration of the Magi	The Metropolitan Museum of Art
Dossi, Battista	The Battle of Orlando and Rodomonte	Wadsworth Atheneum
Drouais, François Hubert	Portrait of the Children of the Comte de Bethune Playing with a Dog	Birmingham Museum of Art
Ernst, Max	The Return of the Beautiful Gardener	Menil Collection
Fantin-Latour, Henri	Still Life with Roses and Fruit	The Metropolitan Museum of Art
Gauguin, Paul	The Yellow Christ	Buffalo AKG Art Museum
Giaquinto, Corrado	Adoration of the Magi	Museum of Fine Arts
Grosz, Georg	Eclipse of the Sun	Heckscher Museum

Artist	Painting/Sculpture	Museum
Grosz, Georg	*Evening Street*	The John and Mable Ringling Museum of Art
Grünewald, Matthias	*The Small Crucifixion*	National Gallery of Art
Guardi, Francesco	*The Grand Canal in Venice with Palazzo Bembo*	The J.P. Getty Museum
Guillaumin, Armand	*The Quai d'Austerlitz*	Indianapolis Museum
Hals, Frans	*Portrait of Tieleman Roosterman*	Cleveland Museum of Art
Hals, Frans	*The Portrait of Isaac Abrahamsz. Massa*	San Diego Museum of Art
Master of the Harburger Altar	*St. John the Baptist*	The J.P. Getty Museum
Isenbrandt, Adriaen	*The Crucifixion*	Los Angeles County Museum of Art
Kandinsky, Vasily	*Improvisation 28 (2nd Version)*	Guggenheim Museum
Kirchner, Ernst Ludwig	*Self-Portrait as a Soldier*	Allen Memorial Art Museum
Kirchner, Ernst Ludwig	*Alfred Döblin*	Harvard Art Museums
Kirchner, Ernst Ludwig	*Berlin Street Scene*	Neue Galerie
Kirchner, Ernst Ludwig	*Sand Hills in Grünau*	Virginia Museum of Fine Arts
Klee, Paul	*Around the Fish*	Museum of Modern Art (MoMA)
Klee, Paul	*The Red Balloon*	The Simon R. Guggenheim Museum
Klimt, Gustav	*Portrait of Adele Bloch-Bauer I*	Neue Galerie
Klimt, Gustav	*Portrait of Mäda Primavesi*	The Metropolitan Museum of Art
Kokoschka, Oscar	*Portrait of Mrs. Karpeles (Frau K)*	Hirshhorn Museum and Sculpture Garden
Kokoschka, Oskar	*Bride of the Wind*	Kunstmuseum Basel
Kokoschka, Oskar	*Self-Portrait as a Warrior*	Museum of Fine Arts
Kokoschka, Oskar	*Knight Errant*	The Simon R. Guggenheim Museum
Largillierre, Nicholas de	*Augustus the Strong, Elector of Saxony and King of Poland*	Nelson-Atkins Museum of Art
Léger, Fernand	*The Aviator*	Cleveland Museum of Art
Lehmbruck, Wilhelm	*Standing Youth*	Museum of Modern Art (MoMA)

Artist	Painting/Sculpture	Museum
Lehmbruck, Wilhelm	*Kneeling Woman*	Museum of Modern Art (MoMA)
Lorrain, Claude	*Battle on a Bridge*	Virginia Museum of Fine Arts
Marc, Franz	*Grazing Horses IV*	Harvard Art Museums
Marc, Franz	*The Large Blue Horses*	The Walker Art Center
Martini, Simone	*Saint Luke*	The J.P. Getty Museum
Matisse, Henri	*Pianist and Checker Players*	National Gallery of Art
Matisse, Henri	*Still Life with Sleeping Woman*	National Gallery of Art
Matisse, Henri	*Woman Seated in an Armchair*	National Gallery of Art
Matisse, Henri	*Odalisque with Tambourine*	Norton Simon Museum
Matisse, Henri	*Bathers with a Turtle*	St. Louis Art Museum
Mochi, Francesco	*Bust of a Youth (St. John the Baptist?)*	Art Institute of Chicago
Monet, Claude	*The Parc Monceau*	The Metropolitan Museum of Art
Münter, Gabriele	*Boating*	Milwaukee Art Museum
Murillo, Bartolomé Esteban	*Saint Justa*	Meadows Museum at Southern Methodist University
Murillo, Bartolomé Esteban	*Saint Rufina*	Meadows Museum at Southern Methodist University
Nolde, Emil	*Woman of Mixed Race*	Harvard Art Museums
Nolde, Emil	*Masks*	Nelson-Atkins Museum of Art
Nussbaum, Felix	*Self-Portrait in the Camp*	Neue Galerie
Picasso, Pablo	*Woman with Pears*	Museum of Modern Art (MoMA)
Pinturicchio, Bernardino	*Saint Bartholomew*	Princeton University Art Museum
Renoir, Pierre Auguste	*Irène Cahen d'Anvers (Little Irene)*	Emil Bührle Collection
Renoir, Pierre Auguste	*Piazza San Marco*	Minneapolis Institute of Art
Master of the Richardson Triptych	*The Virgin and Child Enthroned with Angels and Saints, the Redeemer and the Annunciation*	Los Angeles County Museum of Art
Romney, George	*Portrait of Emma Hart, later Lady Hamilton*	Museum of Fine Arts
Rubens, Peter Paul	*The Crowning of Saint Catherine*	Toledo Museum of Art

Artist	Painting/Sculpture	Museum
Saenredam, Pieter Jansz	*The Interior of Saint Bavo, Haarlem*	The J.P. Getty Museum
Schiele, Egon	*Portrait of Wally Neuzil*	Leopold Museum
Schlemmer, Oskar	*Bauhaus Stairway*	Museum of Modern Art (MoMA)
Seewald, Richard	*Calves*	The John and Mable Ringling Museum of Art
Soutine, Chaim	*The Pastry Chef*	Barnes Collection
Steen, Jan	*Marriage at Cana*	Norton Simon Museum
Strozzi, Bernardo	*Saint Catherine of Alexandria*	Los Angeles County Museum of Art
Teniers the Younger, David	*Guardroom with the Deliverance of St. Peter*	The Metropolitan Museum of Art
Tiepolo, Giovanni Battista	*Alexander the Great and Campaspe in the Studio of Apelles*	The J.P. Getty Museum
Tintoretto, Jacopo	*Portrait of a Nobleman (Alvise Vendramin)*	Hearst Castle
Turner, J.M.W.	*Glaucus and Scylla*	Kimbell Art Museum
van Eyck, Jan	*Virgin and Child with St. Barbara, St. Elizabeth and Jan Vos*	Frick Museum
van Gogh, Vincent	*Self-Portrait Dedicated to Paul Gauguin*	Harvard Art Museums
van Ruysdael, Salomon	*View of Alkmaar*	Yale University Art Gallery
Vanloo, Carle	*Four Panels: Madame de Pompadour et les Arts*	Fine Arts Museums of San Francisco
Victors, Jan	*The Marriage Trap*	Milwaukee Art Museum
von Jawlensky, Alexei	*Seated Woman*	Cincinnati Museum of Art
von Lenbach, Franz Seraph	*Portrait of a Lady*	Sidney and Lois Eskenazi Museum of Art at Indiana University

Appendix B
Selected Cast of Characters

Barr, Alfred	Founding director of MoMA. On a sabbatical in 1932 Barr visits Germany and is horrified by the Nazis' suppression of modern art. He writes four articles exposing Nazi philosophy, but they remain unpublished, and the American press ignores his warnings about Hitler's Germany.
Bier, Justus	Jewish director of Hanover's Kestner Society (of contemporary art) until ousted by the Nazis. An offer to teach at the University of Cincinnati allowed Bier to emigrate to the United States. He later assumed the directorship of North Carolina's Museum of Art in Raleigh.
Böhmer, Bernard	One of Hitler's four "degenerate" art salesmen, Böhmer assembled a large art collection of his own. He resided in the region of Germany occupied by Soviet troops, and when they arrived, he committed suicide. Today, part of his collection is on view in the city of Rostock in East Germany.
Buchholz, Karl	Another one of the Reich's four salesmen of "degenerate" art. His associate, Curt Valentin, managed to obtain a blessing from the Nazi authorities to export art from Germany. Hundreds of artworks escaped via the Buchholz-Valentin combine.
Feldhäusser, Kurt	Art collector who bought "degenerate" looted artworks illegally in Germany during the Nazi regime. After World War II his mother sold his collection in the United States.
Fischer, Theodor	Swiss art dealer who organized the infamous auction of "degenerate art" in Lucerne in June 1939, two months before the beginning of World War II. Thereafter, Fischer participated in a number of sales involving looted art.
Flechtheim, Alfred	German-Jewish art dealer who championed French modern and German Expressionist art. The Nazis detested his flamboyant behavior and ethnic looks and elevated him to one of their major bêtes noires. (The Nazis included a caricature of his face on a *Degenerate Art* exhibition poster.)
Fry, Varian	Appointed head of the (American) Emergency Refugee Committee in Marseille in 1940. With the help of Vice Consul Harry Bingham, Fry enabled more than two thousand refugees, including many artists, to escape Continental Europe.
Göbbels, Joseph	Minister of Propaganda and Public Enlightenment and district leader of Berlin.

Göring, Hermann	Hitler's second in command. The nation's only Reichsmarschall (marshal of the realm) and commander in chief of the Luftwaffe (air force) was a rapacious art collector. He was particularly involved in acquiring looted art and taking advantage of forced sales of art.
Gurlitt, Hildebrand	One of Hitler's four salesmen of "degenerate" art. Gurlitt also served as a major supplier of art for Hitler's never-built Linz museum. In 2012, German tax collectors discovered a private hoard of more than 1,400 art works in his son Cornelius Gurlitt's Munich flat.
Himmler, Heinrich	The commander of the SS (Schutzstaffel), the dreaded black-clad paramilitary police unit that enforced Nazi policies. Himmler was also in charge of implementing the "Final Solution" of the Holocaust.
Jaujard, Jacques	Director of the National Museums of France during the Nazi era. Jaujard was responsible for safeguarding his country's art treasures. During the summer of 1939, he emptied the Louvre of its significant artworks, thereby protecting them from pillage. Jaujard also collaborated with Rose Valland and Count von Wolff-Metternich.
Justi, Ludwig	Assumed the directorship of Berlin's National Galerie from Hugo von Tschudi in 1909. Justi championed German Expressionism until the Nazis dismissed him in 1933. He was reinstated after World War II and rebuilt the museum's collection.
Möller, Ferdinand	One of Hitler's four salesmen of "degenerate" art. An avid admirer of German Expressionism, Möller continued to trade in "forbidden" art and attempted to protect threatened works. As part of this effort, he loaned twenty-one "degenerate" works to the Detroit Institute of Arts to keep them safe.
Hitler, Adolf	Adolf Hitler was born in Braunau, Austria, in 1889. He volunteered in the German Army and served during World War I. He joined the future Nazi Party in 1919 and rapidly became its führer. Elected chancellor in 1933, he served as Germany's head of state until his suicide on April 30, 1945.
Monuments Men	In 1943, Professor Paul J. Sachs, his student George Strout, and President Franklin D. Roosevelt established the MFAA: the Monuments, Fine Arts and Archives program. Known as the Monuments Men, this group fell under the US Army Civil Affairs and Military Government Division and collaborated with the Allied Forces. Charged with the protection of Europe's cultural property, the team of about 350 art professionals spent years recovering millions of looted art works and returning them to their place of origin.
Osthaus, Karl Ernst	Founder in 1902 of the pioneering Folkwang Museum, with the intent of providing cultural education to all classes of society. Osthaus acquired a leading collection of Modern and Expressionist Art. In 1932 Harvard Professor Paul J. Sachs described the Folkwang as "the most beautiful museum in the world." The Nazis confiscated more than 1,400 works from its collection in 1937.
Posse, Hans	Director of the Dresden Art Gallery, Posse was appointed by Hitler as founding director of the never-realized Führer Museum in Linz. He died of cancer in 1942, after procuring thousands of artworks for Hitler's ill-fated dream.
Rosenberg, Alfred	Architect of Nazi philosophy. His ERR (Einsatzgruppe Reichsleiter Rosenberg) carried out much of the looting of art in Germany and its conquered territories.

Rosenberg, Paul	French art dealer representing Picasso, Georges Braque, and Henri Matisse. The Nazis plundered four hundred works from his extensive stock, including the private collection at his Paris gallery, his Floirac residence, and a vault in Libourne.
Schames, Ludwig	German art dealer and founder of an important art gallery in Frankfurt that championed Expressionist art. His shows featured E. L. Kirchner, Emil Nolde, Franz Marc, and others.
Seyss-Inquart, Arthur	An early adherent of the Austrian Nazi Party and an advocate of the country's unification with Germany. Seyss-Inquart is best remembered as the Reich's commissioner of the occupied Netherlands, where his mass deportations lead to the genocide of 75 percent of Holland's Jewish population.
Swarzenski, Georg	Director of Frankfurt's Städel Museum from 1906 until 1938 when the Nazis ousted him for being Jewish. Swarzenski helped the museum acquire a major art collection, including van Gogh's *Portrait of Dr. Gachet*, as well as works by many upcoming modern and German Expressionist artists. He witnessed the Nazis confiscate hundreds of these artworks. Emigrating to America in 1938, Swarzenski forged a brilliant second career as a medievalist at the Museum of Fine Arts in Boston.
Tschudi, Hugo von	Art historian and director of the Nationalgalerie in Berlin from 1896 to 1908. The controversial director purchased French modern art for the museum, including van Gogh's *Self-Portrait Dedicated to Paul Gauguin*—in 1939 this would sell for the highest price at the Lucerne Auction.
Valland, Rose	Curator at the Jeu de Paume, an annex to the Louvre, which the Nazis used as a storage site and trading post for their massive quantities of stolen loot. Valland spied on the Germans and informed the Resistance of the destination of the Nazis' art shipments. This helped protect the art from Allied bombings and would later facilitate recovery.
Valentin, Curt	US immigrant art dealer and associate of Karl Buchholz. Their New York gallery facilitated the transfer of art confiscated by the Nazis to American ownership.
Valentiner, William	German art historian hired in 1908 as a Met curator by J. P. Morgan. A key figure in the American art world, contributing to the development of five US museums.
Wolff-Metternich, Franz von	Art historian assigned by the German military as director of Kunstschutz or "protection of art" in France. However, when Wolff-Metternich arrived at the Louvre, his efforts to prevent the Nazis from sending French art to Germany were so effective that President Charles de Gaulle awarded him the Légion d'Honneur in 1952.
Ziegler, Adolf	Hitler's favorite painter. In charge of confiscating "degenerate" art from German museums in 1937. His committee assembled sixteen thousand artworks for the *Degenerate Art* exhibit.

Notes

Chapter 1

1. Josef Motschmann, "250 Jahre Synagoge von Horb am Main. Ein galizischer Künstler gestaltete 1735 eine fränkische Dorfsynagoge" (A 250 Year-Old Synagogue from Horb on the Main. In 1735 an artist from Galicia created a village synagogue in Franconia), *Vom Main zum Jura. Heimatgeschichtliche Zeitschrift für den Landkreis Lichtenfels Heft 2*. Lichtenfels 1985, 10.

2. Jason Farago, "In 'Afterlives,' About Looted Art, Why Are the Victims an Afterthought?" *The New York Times*, September 30, 2021, https://www.nytimes.com/2021/09/30/arts/design/afterlives-looted-art-jewish-museum.html.

3. I had believed that Jussuf Abbo was untraceable, but unexpected discoveries are among the joys of in-depth research. Searching the internet, I came upon a website on the elusive artist that displays his photograph. It appears that Ludwig and Rosy Fischer (see chapter 2) owned one of his sculptures and eight of his drawings, now at the Virginia Museum of Fine Arts (VMFA).

4. As in the case of Abbo, I believed that history had swallowed him up, but to my surprise, he appeared in Jackie Wullschläger's 2008 biography of Marc Chagall.

5. Wieland Schmied, *Wegbereiter zur modernen Kunst: 50 Jahre Kestner Gesellschaft* (Trailblazer for Modern Art: 50 Years of Kestner Society). Hannover: Fackelträger, 1966, 63.

6. "Bier, Justus," Dictionary of Art Historians, https://arthistorians.info/bierj/.

7. Papers of Alexander Dorner, 1893–1957, Harvard Art Museum Archives.

8. Claude P. Bamberger, *Art: A Biographical Essay*, Tenafly, NJ, 1989.

Chapter 2

1. Christophe Otterbeck, *Expressionismus im Rhein-Main-Gebiet: Künstler, Händler, Sammler* (Frankfurt: Museum Giersch and Michael Imhof Verlag, 2011), 233–34.

2. Art to Appreciate: Learning with the Open College of the Arts, "Exercise: Annotate a Self-Portrait, Part 4, Project 2," June 6, 2014, http://art2appreciate.blogspot.com/2014/06/exercise-annotate-self-portrait-part-4.html.

3. Peter Selz, "Kirchner's Self Portrait as a Soldier in Relation to Earlier Self-Portraits." *Allen Memorial Art Museum Bulletin,* XIV #3, 90–97.

4. Ernst Fischer, "A Memoir," Virginia Museum of Fine Arts (VMFA) Exhibition Catalog.

5. E. Fischer, An Exhibition Catalogue, Virginia Museum of Fine Arts, 1978.

6. Kathleen Chapman, "The Ludwig and Rosy Fischer Collection of German Expressionist Art: Preserving links to Germany's avante-garde past," *Transatlantic Perspectives*, February 9, 2014, updated February 28, 2014, http://www.transatlanticperspectives.org/entry.php?rec=157.

7. Fred Brandt, Interview with Mrs. Ernst Fischer, February 6, 1986 RG 31, VMFA Archives transcript, 3.

8. Emil Nolde, *The Mulatto*, Harvard Art Museums, https://harvardartmuseums.org/art/223804.

9. The Museum of Modern Art Archives Collectors 20 Feldhausser: Meine Gemäldesamlung, Berlin 1943.

10. VMFA Press Room, "German Expressionist work is reunited with Ludwig and Rosy Fischer Collection," May 6, 2016.

11. VMFA Press Room, "Virginia Museum of Art Acquires Work by German Expressionist Ernst Ludwig Kirchner." January 21, 2021. https://www.vmfa.museum/pressroom/news/virginia-museum-art-acquires-work-german-expressionist-ernst-ludwig-kirchner/.

12. Sothebys, "Two Expressionist Masterworks Restituted to the Heirs of Collector, Dealer, and Bon Vivant Alfred Flechtheim," October, 29, 2018, https://www.sothebys.com/en/articles/two-expressionist-masterworks-restituted-to-the-heirs-of-collector-dealer-and-bon-vivant-alfred-flechtheim.

13. Nina Burleigh, Arts: *Haunting MoMA: The Forgotten Story of "Degenerate" Dealer Alfred Flechtheim*, February 14, 2012.

14. Alice Goldfarb Marquis, *Alfred H. Barr, Jr.: Missionary for the Modern* (Contemporary Books, 1989).

15. MoMA, "Seven Major Paintings in Ernst Ludwig Kirchner's Street Scene Series Shown Together for First Time in New MoMA Exhibition," July 29, 2008. See also Deborah Wye, MoMA: *Kirchner and the Berlin Street*, 2008.

16. Personal recollection of the author.

17. Alfred and Thekla Hess, *Dank in Farben* (Thanks in Color) (R. Piper & Co. Verlag, 1962).

18. Exchange with Sue Lupton, June 2024.

19. Karlheinz Gabler, *E. L. Kirchner—Dokumente* (Museum der Stadt Aschaffenburg, 1980).

20. David Brown, "Patrolling the Neighborhood of Golders Green as a Fire Guard in the Civil Defence," Leo Baeck Institute, November 1, 2019, https://www.lbi.org/news/Art-of-Exile-and-Search-for-Samson-Schames/.

Chapter 3

1. "How We Made the Peace: Armistice," IWM (Imperial War Museums), https://www.iwm.org.uk/history/how-we-made-the-peace-0.

2. Yad Vashem, the World Holocaust Remembrance Center, http://www.yadvashem.org.

3. William L. Shirer, *The Rise and Fall of the Third Reich*, 50th Anniversary Edition, Simon and Schuster, 1960, 36–44.

4. "The Nazi Rise to Power," Holocaust Encyclopedia, United States Holocaust Memorial Museum, https://encyclopedia.ushmm.org/content/en/article/the-nazi-rise-to-power.

5 Loraine Boissoneault: "The True Story of the Reichstag Fire and the Nazis' Rise to Power," *Smithsonian Magazine*, February 21, 2017.

6 Shirer, *The Rise and Fall of the Third Reich*, 196–97.

7 Shirer, *The Rise and Fall of the Third Reich*, 241.

8 Peter Schjeldahl, "Hitler as Artist," *The New Yorker*, August 11, 2002.

9 Frederic Spotts, *Hitler and the Power of Aesthetics* (New York: Abrams Books, 2002), 158.

10 Stephanie Barron, *"Degenerate Art": The Fate of the Avant Garde in Nazi Germany*, Los Angeles County Museum of Art 1991, 13.

11 Catherine Hickley, "Dresden Buys Back Kirchner Painting Seized by Nazis as 'Degenerate Art,'" *The Arts Newspaper* January 19, 2016; News Desk, "Dresden Buys Back Kirchner Painting Confiscated by Nazis," ArtForum, January 20, 2016.

12 Christie's, "10 Things to Know About George Grosz," January 8, 2020, https://www.christies.com/en/stories/10-things-to-know-about-george-grosz-17d96bb67bfb4461bf202cd833894692.

13 Mary M. Lane, *Hitler's Last Hostages* (New York: Public Affairs, 2019), 76–77.

14 Neue Galerie 2019: Eclipse of the Sun: Art of the Weimar Republic. https://www.neuegalerie.org/exhibitions/eclipse-of-the-sun

15 Sabine Rewald, *Georg Grosz in Berlin* (Metropolitan Museum of Art, 2022), 90.

16 Collection Spotlight: "George Grosz and Eclipse of the Sun," October 2019, Heckscher Museum of Art, https://www.heckscher.org/5048-2/.

17 Sabine Rewald, *Georg Grosz in Berlin* (Metropolitan Museum of Art, 2022), 90.

18 For more on the Reich Chamber of Visual Arts see Stephanie Barron, *"Degenerate Art,"* 10; and Shirer, *The Rise and Fall of the Third Reich*, 241–44.

19 Christoph Zuschlag, "An Educational Exhibition," in Stephanie Barron, *"Degenerate Art,"* 83–104.

20 Alice Goldfarb Marquis, *Alfred H. Barr, Jr. Missionary for the Modern* (Chicago: Contemporary Books, 1989), 104–10.

21 Alfred Barr, "Art in the Third Reich—Preview, 1933," *Magazine of Art* 38, no. 6, October 1945, 212.

22 Barr, "Art in the Third Reich," 214.

23 Goldfarb Marquis, *Alfred H. Barr, Jr.*, 118.

24 Barr, "Art in the Third Reich," 212–23.

25 Shirer, *The Rise and Fall of the Third Reich*, 232–33.

26 Spotts, *Hitler and the Power of Aesthetics*, 155.

27 Spotts, *Hitler and the Power of Aesthetics*,163, 179.

28 Stephanie Barron, *"Degenerate Art,"* 45–82.

29 Herbert von Garvens-Garvenburg, my mother's legendary art dealer, owned Nolde's *Nudes and Eunuch: The Keeper of the Harem* from 1918 to 1925. The painting has been at the museum at Indiana University since 1976.

30 In 1943, the Nazis captured Freundlich in France, shipped him to Poland, and murdered him in the Lublin-Maidanek concentration camp.

31 Peter Guenther, "Three Days in Munich, July 1937," in Stephanie Barron, *"Degenerate Art,"* 33–43.

32 Barron, *"Degenerate Art,"* 90.

33 Lynn H. Nicholas, *The Rape of Europa* (New York: Random House, 1995), 20.

34 Jonathan Petropoulos, *Art as Politics in the Third Reich* (Chapel Hill, NC: University of North Carolina Press, 1996), 55–57.

35 Petropoulos, *Art as Politics*, 82.

36 "Swarzenski, Georg." Dictionary of Art Historians, https://arthistorians.info/swarzenskig/.

37 Cynthia Salzman, *Portrait of Dr. Gachet* (London; New York: Penguin Group, 1998).

38 Salzman, *Portrait of Dr. Gachet*, 36; Steven Naifeth and Gregory White Smith, *Van Gogh, The Life* (New York: Random House, 2011).

39 Uwe Fleckmer and Max Hollein, editors, *Museum im Widerspruch: Das Städel und der Nationalsozialismus Akademischer (Verlag Berlin 2011).*

40 Salzman, *Portrait of Dr. Gachet*, 179.

41 Salzman, *Portrait of Dr. Gachet*, 179–80.

42 The author thanks Cynthia Salzman for her remarkable retelling of the history and martyrdom of van Gogh's *Portrait of Dr. Gachet*.

43 Salzman, *Portrait of Dr. Gachet*, 181.

44 Shirin Fozi, "The Time Is Opportune. The Swarzenskis and the Museum of Fine Arts in Boston," *Journal of History of Collections* 27, no. 3 (2015): 424–39.

45 Otto Goetz (ed.) *Essays in Honor of Georg Swarzenski* (Chicago: Henry Regnery; Berlin: Verlag Gebr. Mann, 1951).

Chapter 4

1 Jonathan Petropoulos, *Art as Politics in the Third Reich* (Chapel Hill: The University of North Carolina Press, 1996), 76–80.

2 Petropoulos, *Art as Politics in the Third Reich*, 76–80.

3 Petropoulos, *Art as Politics in the Third Reich*, 80.

4 Petropoulos, *The Faustian Bargain: The Art World in Nazi Germany* (New York: Oxford University Press, 2000).

5 Meike Hoffmann, *Bernard A. Böhmer Und Sein Nachlass* [*Bernard A. Böhmer and his Legacy*] (Berlin: Akademie Verlag, 2010).

6 Eberhard Roters, *Galerie Ferdinand Möller: Die Geschichte einer Galerie für Moderne Kunst in Deutschland 1917–1956* [*Gallery Ferdinand Möller: The History of a Gallery of Modern Art in Germany 1917–1956*] (Mann, 1984).

7 In 1951 Tannahill would donate the portrait to the Detroit Institute of the Arts (DIA). Under William Valentiner's guidance, Tannahill became a major benefactor of the DIA, eventually leaving the museum his impressive one-thousand-piece collection and a considerable financial endowment. Tannahill was not

simply an admirer of German Expressionist art. With Valentiner he had visited the Nazis' *Degenerate Art* show in Munich in 1937, which had shocked both men with its incendiary message. Upon their return to Detroit, the two organized an exhibition displaying paintings by such "degenerates" as Otto Mueller, Emil Nolde, Käthe Kollwitz, and Lyonel Feininger to inform Detroiters of what was taking place in Germany. The display gave visitors the opportunity to decide for themselves whether the art was "degenerate" or not. At the time such support for artistic freedom was indeed rare. (See George Bulanda, "Portrait of a Collector: Robert H Tannahill," *Hour Detroit Magazine*, August 20, 2001.)

8 Folkwang Museum, History/Architecture, "Chronicle," https://www.museum-folkwang.de/en/chronicle.

9 Meghan E. Mette, "Icon of Heroic 'Degeneracy': The Journey of Ernst Ludwig Kirchner's *Self-Portrait as a Soldier*," Digital Commons at Oberlin, Honors Papers, 2016, 237, https://digitalcommons.oberlin.edu/cgi/viewcontent.cgi?article=1236&context=honors.

10 Berlinische Galerie Museum of Modern Art, "The Documentary Estate of Ferdinand Möller." https://berlinischegalerie.de/en/berlinische-galerie/research/provenance-and-art-market-research/estates-of-ferdinand-moeller/.

11 Archives of American Art, New York, The Jane Wade Papers: Microfilm reel 2322, Reichskammer der bildenden Künste, authorization for Curt Valentin (November 14, 1936).

12 Michael Hulton, *Jewish, Gay, and Avant-Garde in Nazi Germany* (Santa Barbara, CA: Kieran Publishing, 2018).

13 Meike Hoffmann and Nichola Kuhn, *Hitlers Kunsthändler: Hildebrand Gurlitt, 1895–1956*, (CH Beck, 2016).

14 Kunst Museum Bern, Art and Exhibition Hall of the Federal Republic of Germany, *Gurlitt: Status Report* (Bonn: Hirmer, 2018), 68–85, 160–319.

15 "Time for a Reckoning with the Cornelius/Hildebrand Gurlitt Saga—Part One," Plundered Art, January 19, 2014, the Holocaust Art Restitution Project, https://www.lootedart.com/news.php?r=QGEO40269061.

16 Art and Exhibition Hall of the Federal Republic of Germany, Kunstmuseum Bern, *Gurlitt: Status Report* (Munich: Hirmer Publishers, 2018), 84.

17 Michael Leidig, "New Find May Bring Nazi-Tainted Art Trove to $2B." *The Times of Israel*, March 30, 2014, https://www.timesofisrael.com/new-find-may-bring-nazi-tainted-art-trove-to-2-billion/.

18 Melissa Eddy and Alison Smale, "Cornelius Gurlitt, Scrutinized Son of Nazi-Era Art Dealer, Dies at 81," *The New York Times*, May 6, 2014, https://www.nytimes.com/2014/05/07/arts/design/cornelius-gurlitt-son-of-nazi-era-art-dealer-has-died.html.

19 Jeevan Vasagar and Elizabeth Paton, "Art: Lost and Found," *Financial Times*, November 8, 2013, https://www.ft.com/content/b6c4c78e-4860-11e3-a3ef-00144feabdc0.

20 Catherine Hickley, "David Toren, Who Fought to Recover Nazi-Looted Art, Dies at 94," *The New York Times*, April 30, 2020, https://www.nytimes.com/2020/04/30/obituaries/david-toren-dead-coronavirus.html.

21 Catherine Hickley, *The Munich Art Hoard: Hitler's Art Dealer and His Secret Legacy* (London: Thames & Hudson Ltd., 2015).

22 Leo Baeck Institute, "The Return of the Basket Weavers," March 19, 2018, https://www.lbi.org/news/return-basket-weavers/.

23 Michael Kimmelman, "The Void at the Heart of 'Gurlitt: Status Report.'" *The New York Times*, November 19, 2017, https://www.nytimes.com/2017/11/19/arts/design/the-void-at-the-heart-of-gurlitt-status-report.html.

Chapter 5

1. Cynthia Salzman, *Portrait of Dr. Gachet* (London; New York: Penguin Books, 1998), 198–202.

2. Salzman, *Portrait of Dr. Gachet*, 205–7, 211–12.

3. Salzman, *Portrait of Dr. Gachet*, 247.

4. Salzman, *Portrait of Dr. Gachet*, 219–24.

5. Martin Bailey "Where Is the Portrait of Dr. Gachet?" *The Art Newspaper*, November 15, 2019, https://www.theartnewspaper.com/2019/11/15/where-is-the-portrait-of-dr-gachet-the-mysterious-disappearance-of-van-goghs-most-expensive-painting.

6. Martin Bailey, "Van Gogh and Germany: Frankfurt Mounts Best Show on the Artist in Recent Years," *The Art Newspaper*, https://www.theartnewspaper.com/2019/10/25/van-gogh-and-germany-frankfurt-mounts-best-show-on-the-artist-in-recent-years.

7. Report of Restitution Committee, Recommendation in the case of Königs Request Number RC 4,123 November 12, 2013.

10. The collection-Franz Koenigs Official Site; Franz Koenigs Collection Boijmans Museum.

11. NGA: Matthias Grünewald, *The Small Crucifixion*, Provenance.

12. Seraina Werthemann, "'Degenerate Art' for Basel," Kunstmuseum Basel (blog), April 16, 2020, https://kunstmuseumbasel.ch/en/visit/blog/2024/38.

13. Eddie Silva, "Help the Nazis Turn a Profit, or Let a Great Artwork Be Destroyed?" *St. Louis Turtle Diary Riverfront Times*, July 12, 2000.

14. Stephanie Barron, *The Galerie Fischer Auction* in *"Degenerate Art": The Fate of the Avant-Garde in Nazi Germany* (New York: Harry H. Abrams, 1991), 135–48.

15. Lynn H. Nicholas, *The Rape of Europa* (New York: Vintage Books, 1995), 4.

16. Hugo von Tschudi, International Architecture Database, https://www.archinform.net/arch/59403.htm.

17. "Erica, X. Eisen, Portrait of the Artist: Behind van Gogh's 'Self-Portrait Dedicated to Paul Gauguin,'" March 3, 2015, *The Harvard Crimson*, https://www.thecrimson.com/article/2015/3/3/arts-cover-van-gogh/.

18. Laurie A. Stein, *Henri Matisse: The History and Reception of Matisse's Bather's with Turtle in Germany, 1908–1939* Bulletin (St. Louis Art Museum) New Series, 1998, vol. 22, no. 33, 50–73.

19. From remarks by Angelica Zander Rudenstine at funeral of Joseph Pulitzer Jr. in 1993, *Harvard University Art Museums Bulletin* (Winter 1995) 3, no. 3.

20. Silva, "Help the Nazis Turn a Profit."

21. *Oskar Kokoschka's Portraits of Tubercular Patients*, London, Royal Academy Schools, 2017; Oskar Kokoschka, *My Life*, (London: Thames & Hudson, 1974).

22. Catherine Hickley, "Kirchner and Kokoschka Paintings Returned to Jewish Dealer's Heirs," *The Art Newspaper*, October 19, 2018.

23. Jean-Patrick Duchesne, editor, *L'Art Degenére Selon Hitler: La vente de Lucerne, 1939* (University de Liege Press, 2014).

24 Jean-Patrick Duchesne, "The Acquisitions by Liège at the Sale of 'Degenerate Art' in Lucerne," La Boverie, https://en.laboverie.com/the-collections/the-beaux-arts-de-liege-collections/survey-of-the-acquisitions-by-the-city-of-liege/the-acquisitions-by-liege-at-the-sale-of-201cdegenerate-art201d-in-lucerne.

25 Karen K. Ho, "Munich Museum Takes Down Picasso Portrait amid Ownership Dispute," *ARTNews*, https://www.artnews.com/art-news/news/pinakothek-der-moderne-picasso-painting-ownership-dispute-1234662945/.

26 La Boverie, "Marc Chagall—La Maison Bleue," La Boverie, https://en.laboverie.com/news/archives/en-attendant-la-reouverture/quelques-chefs-doeuvre-en-video/marc-chagall-la-maison-bleue?searchterm=Chagall.

27 Kunstmuseumbasel, "Castaway Modernism: Basel's Acquisitions Of 'Degenerate' Art," exhibition booklet, 32.

28 The National Gallery, *The Sorcerer of Hiva Oa*, https://www.nationalgallery.org.uk/exhibitions/past/the-credit-suisse-exhibition-gauguin-portraits/a-new-chapter-tahiti-and-the-marquesas-islands.

29 Guggenheim, Franz Marc, https://www.guggenheim.org/teaching-materials/the-great-upheaval-modern-art-from-the-guggenheim-collection/franz-marc.

Chapter 6

1 Anne-Marie O'Connor, *The Lady in Gold* (New York: Knopf, 2015); Melissa Müller and Monika Tatzkow, "Adele and Ferdinand Bloch-Bauer," *Lost Lives, Lost Art* (New York: Vendome Press, 2010), 156–71.

2 William L. Shirer, *The Rise and Fall of the Third Reich*, Chapter 11, "Anschluss: The Rape of Austria" (New York: Simon & Schuster, 1960), 322–56.

3 James S. Plaut, "Hitler's Capital," October 1946, *The Atlantic Monthly*, https://www.theatlantic.com/past/docs/unbound/flashbks/nazigold/hitler.htm.

4 Jonathan Petropoulos, *The Faustian Bargain* (Oxford: Oxford University Press, 2000), 52–55.

5 Plaut, "Hitler's Capital," 1946; Lynn Nicholas, *Rape of Europa* (New York: Vintage, 1995).

6 Petropoulos, *The Faustian Bargain*.

7 O'Connor, *The Lady in Gold*.

8 Godfried Friedl, *Klimt* (Cologne: Taschen, 2006), 140–43, 218, 220.

9 Gustav Klimt, "Mäda Primavesi," 1912–1913, Metropolitan Museum of Art, https://www.metmuseum.org/art/collection/search/436819.

10 Rita Reif, "'Lost' Klimt to Be Sold in Auction," *New York Times*, May 9, 1987, https://www.nytimes.com/1987/05/09/arts/lost-klimt-to-be-sold-in-auction.html.

11 Fritz Altmann, "My Adventures and Escape from Nazi Germany," April 23, 2015, Schoenblog.com, https://schoenblog.com/?p=656.

12 Müller and Tatzkow, *Lost Lives, Lost Art*, 163–65.

13 O'Connor, *The Lady in Gold*; Hubertus Czernin, *Die Fälschung: Der Fall Bloch-Bauer und das Werk Gustav Klimts* [*The Falsification: The Case of Ferdinand Bloch-Bauer and the Work of Gustav Klimt*] (Vienna: Czernin Verlag, 1999), 2.

14 Zachary Pincus-Roth, "Return of a Treasure," *Princeton Alumni Weekly*, May 13, 2015, https://paw.princeton.edu/article/return-treasure.

15 Elizabeth Simpson, ed., *The Spoils of War* (New York: Harry N. Abrams, 1997).

16 Under Secretary Stuart Eizenstat, "Closing Plenary Statement at the London Conference on Nazi Gold," December 4, 1997, https://1997-2001.state.gov/policy_remarks/971204_eizen_nazigold.html.

17 Office of the Special Envoy for Holocaust Issues, "Washington Conference Principles on Nazi-Confiscated Art," December 3, 1998, https://www.state.gov/washington-conference-principles-on-nazi-confiscated-art/.

18 Catherine Hickley, "Nations Agree to Refine Pact That Guides the Return of Nazi-Looted Art," March 5, 2024, https://www.nytimes.com/2024/03/05/arts/nations-agree-to-refine-pact-that-guides-the-return-of-nazi-looted-art.html/.

19 Steven Dale, "Tragedy Beyond the Canvas: Gustav Klimt's Elisabeth Lederer," *National Gallery of Canada Magazine*, July 10, 2018.

20 Neue Galerie, Gustav Klimt, *The Dancer* (1916–1917), https://www.neuegalerie.org/collection/klimt-the-dancer-1916-17.

21 Frederic Morton, *The Rothschilds: A Family Portrait* (New York: Atheneum, 1966).

22 Müller and Tatzkow, "Alphonse Mayer and Louis Nathaniel von Rothschild," *Lost Lives, Lost Art*, 198–215.

23 Müller and Tatzkow, *Lost Lives, Lost Art*, 212.

24 Jane Perlez, "Austria Is Set to Return Artworks Confiscated from Jews by Nazis," *New York Times*, March 7, 1998, https://www.nytimes.com/1998/03/07/arts/austria-is-set-to-return-artworks-confiscated-from-jews-by-nazis.html.

25 Carol Vogel, "Austrian Rothschilds Decide to Sell; Sotheby's in London Will Auction $40 Million in Art Seized by Nazis," *New York Times*, April 10, 1999. https://www.nytimes.com/1999/04/10/arts/austrian-rothschilds-decide-sell-sotheby-s-london-will-auction-40-million-art.html?searchResultPosition=2.

26 Vogel, "Austrian Rothschilds Decide to Sell," 1999.

27 Vogel, "At $90 Million, Rothschild Sale Exceeds Goals," *New York Times*, July 9, 1999, https://www.nytimes.com/1999/07/09/world/at-90-million-rothschild-sale-exceeds-goals.html?searchResultPosition=1.

28 Malcolm Gay, "Nazi-Looted Rothschild Art Goes to MFA," *Boston Globe*, February 22, 2015, https://www.bostonglobe.com/arts/2015/02/22/rothschild-heirs-donate-works-once-looted-nazis-mfa/64Axq5tuhcHrKxR4kVI0sI/story.html.

29 Andrea Shea, *MFA Receives Trove of Art Seized by the Nazis*, WBUR Local Coverage, February 23, 2015, https://www.wbur.org/news/2015/02/23/mfa-rothschild-gift-nazi-stolen-art.

30 Dr. L. Lilienfeld, *Nature* 142, (August 13, 1938), 282, https://www.nature.com/articles/142282a0.pdf.

31 Associated Press, "California to Return Paintings to Holocaust Victims' Heirs," April 10, 2009, *The Guardian*, https://www.theguardian.com/artanddesign/2009/apr/10/california-art-holocaust-victims.

32 Sophie Lillie, *Was Einmal War* [*What Once Was*] (Vienna: Czernin Publishers Ltd., 2003), 697.

33 Victoria S. Reed, "Frans Hals, Hitler and the Lilienfeld Collection. A Case Study of Expropriation in Austria," *Journal of the History of Collections* 30, no. 3 (November 2018): 471–86.

34 *Portrait of a Man*, Frans Hals, MFA Boston, https://collections.mfa.org/objects/33984.

35 Austria, Holocaust Encyclopedia, United States Holocaust Memorial Museum, https://encyclopedia.ushmm.org/content/en/article/austria.

Chapter 7

1. "How Many Refugees Came to the United States from 1933–1945?" Holocaust Encyclopedia, United States Holocaust Memorial Museum, April 1, 2011, https://exhibitions.ushmm.org/americans-and-the-holocaust/how-many-refugees-came-to-the-united-states-from-1933-1945.

2. Susan King, "Classic Hollywood: German Emigres' Effect on U.S. Cinema Saluted," *Los Angeles Times*, August 16, 2014; Anthony Heilbut, *Exiles in Paradise: German Refugee Artists and Intellectuals in America from the 1930s to the Present* (Boston: Beacon Press, 1984).

3. Peter Watson, *From Manet to Manhattan* (New York: Random House, 1992), 45; Ken Johnson, "Paul Durand-Ruel: The Paris Dealer Who Put Impressionism on the Map," *New York Times*, July 22, 2015, https://www.nytimes.com/2015/07/24/arts/design/paul-durand-ruel-the-paris-dealer-who-put-impressionism-on-the-map.html; Philadelphia Museum of Art, "Exhibition: Discovering the Impressionists: Paul Durand-Ruel and the New Painting," July 24–September 13, 2015, The Visionary Art Dealer Paul Durand-Ruel, https://www.philamuseum.org/calendar/exhibition/discovering-the-impressionists-paul-durand-ruel-and-the-new-painting.

4. National Gallery of Art, "Buchholz Gallery, New York, Biography," https://www.nga.gov/collection/provenance-info.20221.html#biography.

5. MoMA Art Archive, Valentin III. A.13[7].

6. National Gallery of Art, "Ernst Ludwig Kirchner, Biography," https://www.nga.gov/collection/artist-info.1436.html.

7. Godula Buchholz, *Karl Buchholz Buch-und Kunsthandler im 20st Jahrhundert* (DuMont, 2005).

8. Alice Goldfarb Marquis, *Alfred A. Barr Jr. Missionary for the Modern* (Contemporary Books, 1989), 178.

9. Lynette Roth, *Max Beckmann at the Saint Louis Art Museum: The Paintings* (New York: Del Monico Books/Prestel, 2015), 132.

10. "On His Way to The Met: *Max Beckmann in New York* with Sabine Rewald," Rachel High, October 25, 2016, https://www.metmuseum.org/perspectives/max-beckmann-on-his-way-to-the-met.

11. Beckmann on *Departure*, letter to Valentin, March 11, 1938, Alfred H. Barr papers, reel 3149:1105.

12. Buchholz, *Karl Buchholz*, 112.

13. Sabine Rewald, *Beckmann in New York* (New York: The Metropolitan Museum of Art, 2016), 21.

14. Rewald, *Beckmann in New York*, 22.

15. Heather Hess, Max Beckmann, *Descent from the Cross*, German Expressionist Digital Archive Project, German Expressionism: Works from the Collection, 2011. https://www.moma.org/s/ge/collection_ge/object/object_objid-79759.html.

16. Perry T. Rathbone, *In Memory of Curt Valentin, 1902–1954: An Exhibition of Modern Masterpieces Lent by American Museums* (New York: Curt Valentin, 1954).

17. Lucy Davies, "A Legend Laid Bare; Egon Schiele Exhibition," May 19, 2011, https://www.telegraph.co.uk/culture.

18. Kimberly Bradley, "Wally Neuzil: The Secret Life of Schiele's Muse," February 27, 2015, https://www.bbc.com/culture/article/20150227-artists-muse-a-secret-life.

19. Bradley, "Wally Neuzil."

20. Jane Kallir, *Egon Schiele: The Complete Works (Including Biography and Catalogue Raisonée)* (New York: Harry N. Abrams, 1990).

21 *Egon Schiele: In Search of the Perfect Line*, Galerie St. Etienne, New York, November 2018–March 2019, https://www.gseart.com/exhibitions-essay/1100.

22 Jane Kallir, *Saved from Europe* (New York: Galerie St. Etienne, 1999).

23 Julia Eßl, Lea Bondi Jaray, Lexikon Der Österreichischen Provenienz Forschung, March 21, 2022, https://www.lexikon-provenienzforschung.org/en/bondi-jaray-lea.

24 Kallir, *Egon Schiele: The Complete Works.*

25 Sophie Lillie, *The Collection of Ronald Lauder and Serge Serbasky* (New York: Neue Galerie, 2007).

26 Klaus Albrecht Schröder, *Egon Schiele* (New York: Prestel, 2005).

27 Jane Kallir, *Egon Schiele's Women* (New York: Prestel, 2015).

28 Jonathan Petropolous, "Bridges from the Reich: The Importance of Émigré Art Dealers as Reflected in the Case Studies of Curt Valentin and Otto Kallir—Nirenstein," *Kunstgeschichte, Open Peer Reviewed Journal*, par. 46, https://www.kunstgeschichte-ejournal.net/305/1/PETROPOULOS_Bridges_from_the_Reich.pdf.

29 Petropoulos, "Bridges from the Reich," par.62.

30 Nina Siegal, "When the Wild Child Egon Schiele Grew Up," *The New York Times*, April 3, 2025, https://www.nytimes.com/2025/03/26/arts/design/egon-schiele-last-years-leopold-museum.html?searchResultPosition=1.

31 Galerie St. Etienne, "Saved from Europe," *In Commemoration of the 60th Anniversary of the Galerie St. Etienne*, November 6, 1999, to January 8, 2000, https://gseart.com/exhibitions-essay/985.

32 Robert M. Edsel, *The Monuments Men* (New York: Center Street, Hachette Book Group, 2009).

33 Petropolous, "Bridges from the Reich," par. 37, 56, 66.

34 Judith H. Dobrzynski, "The Zealous Collector—A Special Report; A Singular Passion for Amassing Art, One Way or Another," *New York Times*, December 24, 1997, https://www.nytimes.com/1997/12/24/arts/zealous-collector-special-report-singular-passion-for-amassing-art-one-way.html.

35 Dobrzynski, "The Zealous Collector," 1997.

36 Dobrzynski, "The Zealous Collector," 1997.

37 Holland Cotter, "Art Review; Fervidly Drafting the Self and Sex," *New York Times*, October 10, 1997.

38 Judith H. Dobrzynski, "Modern Is Urged to Play Solomon in Paintings Dispute," *New York Times*, January 1, 1998, https://www.nytimes.com/1998/01/01/arts/modern-is-urged-to-play-solomon-in-paintings-dispute.html.

39 Lucinda Franks, *Timeless* (New York: Farrar, Straus and Giroux, 2015).

40 Lee Rosenbaum, "'Portrait of Wally,' Settlement: What's Wrong with This Picture?" *CultureGrrl Lee Rosenbaum's Cultural Commentary*, August 4, 2010, https://www.artsjournal.com/culturegrrl/2010/08/portrait_of_wally_settlement_w.html.

Chapter 8

1 Jeffrey Meyers, "Revelation and Insight in Autobiography: Leonard Woolf, Arthur Koestler, André Malraux, and Vladimir Nabokov," *The Article*, May 9, 2021, https://www.thearticle.com/revelation-and-insight-in-autobiography-leonard-woolf-arthur-koestler-andre-malraux-and-vladimir-nabokov.

2 "The Exodus Day After Day," Museé de la Libération de Paris, https://www.museeliberation-leclerc-moulin.paris.fr/en/exodus-day-after-day.

3 Suzanne Loebl, *At the Mercy of Strangers: Growing Up on the Edge of the Holocaust* (Nampa, ID: Pacifica Press, 1997).

4 Alice Goldfarb Marquis, *Alfred H. Barr, Jr.: Missionary for the Modern* (Contemporary Books, Inc., 1989), 186.

5 "Varian Fry," Holocaust Encyclopedia, United States Holocaust Memorial Museum, https://encyclopedia.ushmm.org/content/en/article/varian-fry.

6 Andy Marino, *A Quiet American: The Secret War of Varian Fry* (New York: St. Martin's Press, 1999).

7 Varian Fry, *Assignment Rescue: An Autobiography* (New York: Scholastic, Inc., 1968).

8 Jackie Wullschläger, *Chagall: A Biography* (New York: Alfred A. Knopf, 2008), 389.

9 Elizabeth Kessin Berman, "Moral Triage or Cultural Salvage," *Exiles + Emigrés: The Flight of European Artists from Hitler*, eds. Stephanie Barron, Sabine Eckmann, and Matthew Affron (Los Angeles County Museum of Art, 1997), 99–112.

10 "Hiram Bingham and U.S. State Department Chronology," Rescue in the Holocaust, https://www.holocaustrescue.org/bingham-and-us-state-department-chronology.

11 Peter Eisner, "Saving Jews in Nazi France," *Smithsonian Magazine*, March 2009.

12 "Hiram Bingham and U.S. State Department Chronology," Rescue in the Holocaust; Eisner, "Saving the Jews of Nazi France."

13 Wullschläger, *Chagall: A Biography*, 393.

14 Ellen Mara de Wachter, "Avant-Garde Adventurer," *World of Interiors,* December 2019, https://www.ordovasart.com/cms/wp-content/uploads/World-of-Interiors_Peggy-Guggenheim.pdf.

15 "About Peggy," Peggy Guggenheim Collection, https://www.guggenheim-venice.it/en/art/in-depth/peggy-guggenheim/about-peggy/#:~:text=In%20July%201941%2C%20Peggy%20fled,husband%20a%20few%20months%20later.

16 Mary V. Dearborn, *Mistress of Modernism: The Life of Peggy Guggenheim* (New York: Houghton Mifflin, 2004) 168–79.

17 Dearborn, *Mistress of Modernism,* 184.

18 Michael Dirda, "Surreal Lives," *Washington Post*, November 14, 1999, https://www.washingtonpost.com/wp-srv/WPcap/1999-11/14/119r-111499-idx.html.

19 Tom Ambrose, *Hitler's Loss: What Britain and America Gained from Europe's Cultural Exiles* (London: Peter Owen Publishers, 2007).

20 "Felix Nussbaum 1904–1944: The Fate of a Jewish Artist," Yad Vashem, https://www.yadvashem.org/yv/en/exhibitions/nussbaum/about_nussbaum.asp (June 12, 2024).

21 "Felix Nussbaum Collection," Museum Quarter Osnabrück https://www.museumsquartier-osnabrueck.de/ausstellung/sammlung-felix-nussbaum/.

22 Pat Lipsky, "A Painter of the Holocaust for Our Times," *Tablet*, June 17, 2019, https://patlipsky.com/writing/a-painter-of-the-holocaust-for-our-times.

23 "Felix Nussbaum Collection," Museum Quarter Osnabrück, https://www.museumsquartier-osnabrueck.de/ausstellung/sammlung-felix-nussbaum/.

24 Mose Apelblat, "Who Was Felix Nussbaum?" *The Brussels Times,* January 6, 2015, https://www.brusselstimes.com/30951/who-was-felix-nussbaum.

25 Derek Blyth, "Hidden Belgium: Felix Nussbaum and Felka Platek," *The Brussels Times*, August 22, 2023, https://www.brusselstimes.com/657212/hidden-belgium-felix-nussbaum-and-felka-platek.

26 "Felix Nussbaum Haus," Museum Quarter, https://www.museumsquartier-osnabrueck.de/?house=81#haus.

27 "The Metamorphosis of Chaïm Soutine: The Shtetl and the Outsider," Ori Hashmonay with Stephen Brown, The Jewish Museum, August 9, 2018, https://stories.thejewishmuseum.org/the-shtetl-and-the-outsider-the-metamorphosis-of-chaim-soutine-591eb0730b7d.

28 "Carcass of Beef, Chaïm Soutine," MIA, https://collections.artsmia.org/art/1325/carcass-of-beef-chaim-soutine.

29 "Chaïm Soutine, Carcass of Beef," Buffalo AKG Art Museum, https://buffaloakg.org/artworks/rca1939132-carcass-beef.

30 "Soutine, Chaïm," Galerie Le Minotaure, https://galerieleminotaure.net/artist/soutine-chaim/.

31 Stanley Meisler, "Soutine: The Power and the Fury of an Eccentric Genius," *Smithsonian Magazine,* November 1988, https://www.stanleymeisler.com/article/soutine-the-power-and-the-fury-of-an-eccentric-genius.

32 Stanley Meisler, *Shocking Paris: Soutine, Chagall and the Outsiders of Montparnasse* (New York: Palgrave Macmillan, 2015).

33 Philip Rylands, "The Master and Marguerite" in *The Story of Art of This Century* (Solomon R. Guggenheim Foundation, 2004), https://www.guggenheim-venice.it/en/art/in-depth/peggy-guggenheim/art-of-this-century/.

34 "Peggy's Circle of Friends: Frederick Kiesler," Francesca Panseri, Peggy Guggenheim Collection, https://www.guggenheim-venice.it/en/art/in-depth/peggys-friends/frederick-kiesler/.

35 Dearborn, *Mistress of Modernism,* 200–209; Rylands, *The Story of Art of This Century.*

36 *Artists in Exile,* Exhibition Catalog, Pierre Matisse, 1942.

37 "Max Ernst, *Europe After the Rain II,*" Wadsworth Atheneum Museum of Art, https://5058.sydneyplus.com/argus/final/Portal/Public.aspx?lang=en-US.

38 "Max Ernst, Capricorn, model 1947, cast 1975," National Gallery of Art, https://www.nga.gov/collection/art-object-page.57105.html.

39 Joseph A. Harriss, "The Elusive Marc Chagall," December 2003, *Smithsonian Magazine*, https://www.smithsonianmag.com/arts-culture/the-elusive-marc-chagall-95114921/.

40 "10 Things to Know About Marc Chagall," Christies, https://www.christies.com/en/stories/guide-to-marc-chagall-1a2864b8ebc243a09543fd54075bd5d8.

41 Wullschläger, *Chagall: A Biography.*

42 "Chagall, Lot 146, Catalog Note," Impressionist and Modern Art Day Sale, Sothebys, 2014, https://www.sothebys.com/en/auctions/ecatalogue/2014/impressionist-modern-art-day-sale-n09416/lot.146.html.

43 Wullschläger, *Chagall: A Biography*, 177.

44 Two photographs by Thérèse Bonney, ca. 1923–1924. Marc and Ida Chagall Archive. https://www.marcchagall.com/en/discovery/studio/1923-1940/marc-bella-and-ida-chagall-living-room-his-studio-110-avenue-dorleans-paris-circa-1923-1924; https://www.marcchagall.com/en/discovery/studio/1923-1940/marc-bella-and-ida-chagall-studio-110-avenue-dorleans-paris-circa-1923-1924.

45. Michael Lewis, "Whatever Happened to Marc Chagall?" *Commentary,* October 2008, https://www.commentary.org/articles/michael-lewis/whatever-happened-to-marc-chagall/.

46. Lewis, "Whatever Happened to Marc Chagall?"

47. "Chagall Homecoming, Mar 10–May 8, 2016," Art Institute of Chicago, https://www.artic.edu/exhibitions/3072/chagall-homecoming.

48. "White Crucifixion, Marc Chagall," Art Institute of Chicago https://www.artic.edu/artworks/59426/white-crucifixion.

49. "Chagall Homecoming, Mar 10–May 8, 2016," Art Institute of Chicago, https://www.artic.edu/exhibitions/3072/chagall-homecoming.

50. For more about this work, see Ziva Amishai-Maisels' "Chagall's *White Crucifixion*" in *Art Institute of Chicago Museum Studies*, Vol. 17, No. 2, 1991.

51. Wullschläger, *Chagall: A Biography*.

52. Suzanne Loebl, *America's Medicis* (HarperCollins, 2010), 254.

53. Loebl, *America's Medicis*, 360–62.

54. "Yves Tanguy Biography," Sothebys, https://www.sothebys.com/en/artists/yves-tanguy.

55. "Yves Tanguy, *Time and Again*," Museo Nacional Thyssen-Bornemisza, https://www.museothyssen.org/en/collection/artists/tanguy-yves/time-and-again.

56. Jennifer Tonkovich, *Pierre Matisse and His Artists* (Pierpont Morgan Library 2002), 88.

57. Fernand Léger, Metropolitan Museum, https://www.metmuseum.org/toah/hd/leger/hd_leger.htm.

58. "Divers on a Yellow Background, Fernand Léger," Art Institute of Chicago, https://www.artic.edu/artworks/111082/divers-on-a-yellow-background.

59. "Jacques Lipchitz," Metropolitan Museum, https://www.metmuseum.org/research-centers/leonard-a-lauder-research-center/research-resources/modern-art-index-project/lipchitz.

60. Henry R. Hope, *The Sculpture of Jacques Lipchitz* (The Museum of Modern Art, 1954), 88, https://www.moma.org/documents/moma_catalogue_2913_300062136.pdf.

61. "The Sculpture of Jacques Lipchitz," MoMA, https://www.moma.org/documents/moma_catalogue_2913_300062136.pdf.

62. E. M. Benson, "Seven Sculptures," *The American Magazine of Art*, August 1935, 28, 458.

63. "Jacques Lipchitz," Metropolitan Museum, https://www.metmuseum.org/research-centers/leonard-a-lauder-research-center/research-resources/modern-art-index-project/lipchitz.

64. Matthew Affron, "Constructing a New Jewish Identity: Marc Chagall, Jacques Lipchitz," *Exiles + Émigrés: The Flight of European Artists from Hitler*, eds. Stephanie Barron, Sabine Eckmann, Matthew Affron (Los Angeles County Museum of Art, 1997), 120–25.

Chapter 9

1. Lynn H. Nicholas, *The Rape of Europa: The Fate of Europe's Treasures in the Third Reich and the Second World War* (New York: Vintage, 1995), 87–88.

2. Nicholas, *The Rape of Europa*, 54–55.

3. "Phoney Air War in France," RAF Museum, https://www.rafmuseum.org.uk/research/online-exhibitions/history-of-the-battle-of-britain/phoney-air-war-in-france/#:~:text=The%20'Phoney%20War'%20offered%20both,to%20assess%20their%20opponents'%20capabilities.

4. Nicholas, *The Rape of Europa,* 119.

5. Nicholas, *The Rape of Europa*, 125.

6. James S. Plaut, "Loot for the Master Race," *The Atlantic*, September 1946.

7. "Nazi Looting Organizations: The So-Called KUNSTSCHUTZ in the Art Looting Investigation Red Flag Names," Open Art Data, July 18, 2020, https://www.openartdata.org/2020/07/nazi-looting-kunstschutz.html.

8. Nicholas, *The Rape of Europa*, 119–25.

9. Robert M. Edsel with Bret Witter, *The Monuments Men* (New York: Center Street, 2009), 122–34.

10. Agnès Poirier, "Saviour of France's Art: How the Mona Lisa Was Spirited Away from the Nazis," *The Guardian*, November 22, 2014, https://www.theguardian.com/world/2014/nov/22/mona-lisa-spirited-away-from-nazis-jacques-jaujard-louvre.

11. Eleanor Ross, "Rose Valland," Dictionary of Art Historians, https://arthistorians.info/vallandr/#:~:text=Valland%20was%20born%20to%20Francisque,1918%20with%20a%20teaching%20degree.

12. "Rose Valland 1898–1980," Monuments Men and Women Foundation, https://www.monumentsmenandwomenfnd.org/valland-capt-rose.

13. Corinne Bouchoux, *Rose Valland: Resistance at the Museum* (Miller Place, NY: Laurel Publishing, 2006).

14. "Rose Valland 1898–1980," Monuments Men and Women Foundation.

15. "Rembrandt van Rijn (attributed to) (1606–1669) *Portrait of Rembrandt's Father* (c. 1630)," Monuments Men and Women Foundation, https://www.monumentsmenandwomenfnd.org/join-the-hunt/wwii-most-wanted-rembrandt#:~:text=Portrait%20of%20Rembrandt's%20Father%20was,not%20the%20artist's%20actual%20father.

16. Alexander Forbes, "Nazi-Looted Constable Painting Exposes Worrying Gap in Restitution Law," ArtNet, March 20, 2014, https://news.artnet.com/art-world/nazi-looted-constable-painting-exposes-worrying-gap-in-restitution-law-6495.

17. Judit Kiraly, "John and Anna Jaffe: The Art Lovers from Belfast Who Gave the Emperor's Library to a Nation," *The Riviera Reporter*, September 17, 2013, https://www.rivierareporter.com/history-and-traditions/618-john-and-anna-jaffe-the-art-lovers-from-belfast-who-gave-the-emperors-library-to-a-nation.

18. Andrew Marton, "Stealing Beauty, Part 1," *Fort Worth Star-Telegram*, June 9, 2006, https://www.lootedart.com/news.php?r=ML28KF668241.

19. Marton, "Stealing Beauty, Part 1."

20. Andrew Marton, "Stealing Beauty, Part 2," *Fort Worth Star-Telegram*, July 9, 2006, https://www.lootedart.com/news.php?r=ML28RC939791.

21. Marton, "Stealing Beauty: Part 1."

22. "Museum Re-Acquires 1841 Turner Oil," Entertainment News, UPI, April 20, 2007, https://www.upi.com/Entertainment_News/2007/04/20/Museum-re-acquires-1841-Turner-oil/54471177106065/.

23. "Old Masters Evening Sale," John Constable, R.A. (East Bergholt 1776–1837 London), *Dedham from Langham*, https://www.christies.com/en/lot/lot-6152964.

24 "The Origins of the Family and the Bank," Musée Nissim De Camondo, https://madparis.fr/the-origins-of-the-family-and-the-bank.

25 "Abraham-Salomon de Camondo (1781–1873)," Musée Nissim de Camondo, https://madparis.fr/abraham-salomon-de-camondo-1781-1873.

26 Sara Houghteling, "Hunting for Looted Art in Paris," *New York Times*, November 17, 2010, https://www.nytimes.com/2010/11/21/travel/21lootedart-cultured.html.

27 "Moïse de Camondo (1860–1935)," Musée Nissim de Camondo, https://madparis.fr/moise-de-camondo-1860-1935-6225#:~:text=In%20October%201891%20he%20married,and%20B%C3%A9atrice%20two%20years%20later.

28 James McAuley, "A Secret Paris Museum and an Aristocratic Family Decimated by the Holocaust," *Town & Country*, February 9, 2017, https://www.townandcountrymag.com/leisure/arts-and-culture/a9474/camondo-museum-paris/.

29 James McAuley, *The House of Fragile Things,* excerpt in *Tablet*, October 7, 2021, https://www.tabletmag.com/sections/history/articles/vichy-france-jewish-art-collectors-james-mcauley.

30 Alice Werblowsky, "Five Yards from the 'Mona Lisa,'" *Haaretz*, June 8, 2012, https://www.haaretz.com/2012-06-08/ty-article/.premium/five-yards-from-the-mona-lisa/0000017f-f5ac-d47e-a37f-fdbc49f20000?v=1723317086513.

31 Anne Laure Bandle, Alessandro Chechi, and Marc-André Renold, "Case Five Italian Paintings—Gentili di Giuseppe Heirs v. Musée du Louvre and France," Platform ArThemis (http://unige.ch/art-adr), Art-Law Centre, University of Geneva, https://plone.unige.ch/art-adr/cases-affaires/five-italian-paintings-2013-gentili-di-giuseppe-heirs-v-musee-du-louvre-and-france.

32 Devorah Lauter, "France's New Restitution Law for Nazi-Looted Art Reveals the Country's Inconsistent Efforts in Dealing with Its Complicated Past," *ArtNEWS*, October 9, 2023, https://www.artnews.com/art-news/news/new-french-restitution-law-nazi-looted-art-complicated-history-1234681413/.

33 Marlise Simons, "Chirac Affirms Guilt in Fate of Jews," *New York Times,* July 17, 1995.

34 Anne Laure Bandle, Alessandro Chechi, Marc-André Renold, "Case Five Italian Paintings—Gentili di Giuseppe Heirs v. Musée du Louvre and France," Platform ArThemis (http://unige.ch/art-adr), Art-Law Centre, University of Geneva.

35 *Alexander the Great and Campaspe in the Studio of Apelles*, Giovanni Battista Tiepolo, Getty, Museum Collection, https://www.getty.edu/art/collection/object/108G18.

36 Pinturicchio (Bernardino di Betto), "Saint Bartholomew," ca. 1497, Princeton University Art Museum, https://artmuseum.princeton.edu/collections/objects/34115.

37 Paul Jeromack, "Old Masters Looted by Nazis Is Returned," Artnet, January 26, 2012.

38 Eliran Levy, "Nazi-Looted Art Is Germany's Achilles' Heel," *Deutsche Welle,* November 20, 2013, https://www.lootedart.com/news.php?r=QCXV8O358171.

39 Anne Sinclair, *My Grandfather's Gallery: A Family Memoir of Art and War,* trans. Shaun Whiteside (New York: Farrar, Straus and Giroux, 2014), 80.

40 "Paul Rosenberg and Company: From France to America," *The rue de la Boétie in Les Années folles: Modernism, Creation, and Upheaval*, MoMA, https://www.moma.org/interactives/exhibitions/2010/paulrosenberg/#:~:text=Rosenberg%20(1881%E2%80%931959)%2C,half%20of%20the%20last%20century.

41 Sinclair, *My Grandfather's Gallery*, 110–39.

42 Hugh Eakin, *Picasso's War: How Modern Art Came to America* (New York: Crown, 2022).

43 Benjamin Sutton, "The Famed Jewish Art Dealer Who Fought to Retrieve 400 Stolen Works from the Nazis," *Artsy*, January 14, 2019, https://www.artsy.net/article/artsy-editorial-famed-jewish-art-dealer-fought-retrieve-400-stolen-works-nazis.

44 Charles Delheim, *Belonging and Betrayal* (Waltham, MA: Brandeis University Press, 2021), 485–89, 532–39.

45 Delheim, *Belonging and Betrayal*, 539.

46 Emmanuelle Polack, *Le Marché de l'Art sous l'Occupation: 1940–1944* (Paris: Tallandier, 2019).

47 Werner Lange, *Artists in Nazi Occupied France: A German Officer's Memoir*, trans. Leonard Rosmarin (Ontario: Mosaic Press, 2019).

48 Sabine Rewald, "Cubism," *Heilbrunn Timeline of Art History* (New York: The Metropolitan Museum of Art, 2000), http://www.metmuseum.org/toah/hd/cube/hd_cube.htm (October 2004).

49 Nicholas, *The Rape of Europa*, 126.

50 Sara Houghteling, "Hunting for Looted Art in Paris," *The New York Times*, November 17, 2010.

51 Emmanuelle Polack and Philippe Dagen, *Les Carnets de Rose Valland: Le Pillage des collections privées d'oeuvres d'art en France Durant la Seconde Guerre Mondiale* (Paris: Fage Editions, 2019).

52 Mary M. Lane, *Hitler's Last Hostages* (New York: Public Affairs, 2019), 151–67.

53 Catherine Hinkley, *The Munich Art Hoard* (London: Thames and Hudson, 2015), 87.

54 "Beethoven's Fifth: The World's Most Famous Symphony" Houston Symphony, July 9, 2018, https://houstonsymphony.org/beethoven-5-famous-symphony/.

55 Sarah Wildman, "The Revelations of a Nazi Art Catalog," *The New Yorker*, February 12, 2016, https://www.newyorker.com/books/page-turner/the-revelations-of-a-nazi-art-catalogue?_sp=47ef1268-56ce-48e3-b0da-b7b3e18209a7.1730129736823.

56 Nancy Yeide, *Beyond the Dreams of Avarice* (Miller Place, NY: Laurel Publishing Company, 2009).

57 Wildman, "The Revelations of a Nazi Art Catalogue," *The New Yorker*.

58 Hector Feliciano, *The Lost Museum* (New York: Basic Books, 1997), 221–24.

59 Aurelien Bredeen, "We Are Amplifying the Work: France Starts Task Force on Art Looted Under Nazis," *New York Times*, August 15, 2019.

60 "The MNR (National Recovery Museums) at the Orsay Museum," Musée d'Orsay, https://www-musee-orsay-fr.translate.goog/fr/collections/recherche-de-provenance-et-mnr/mnr-au-musee-dorsay?_x_tr_sl=fr&_x_tr_tl=en&_x_tr_hl=en&_x_tr_pto=sc.

61 "Two New Rooms at the Louvre for Stolen Paintings Recovered After WWII," Louvre Museum press, February 9, 2018, https://presse.louvre.fr/two-new-rooms-at-the-louvre-for-stolen-paintings-recovered-after-wwii/.

62 James McAuley, "The Louvre Is Showing Nazi-Looted Art in a Bid to Find Its Owners. Some Wonder Why It Took So Long," *The Washington Post*, February 2, 2018, https://www.washingtonpost.com/world/europe/the-louvre-is-showing-nazi-looted-art-in-a-bid-to-find-its-owners-some-wonder-why-it-took-so-long/2018/02/02/2964bbb8-06a4-11e8-aa61-f3391373867e_story.html.

63 "Two New Rooms at the Louvre for Stolen Paintings Recovered After WWII," Louvre Museum press, February 9, 2018, https://presse.louvre.fr/two-new-rooms-at-the-louvre-for-stolen-paintings-recovered-after-wwii/.

64 Aurelien Breeden, "Art Looted by Nazis Gets a New Space at the Louvre. But Is It Really Home?" *New York Times*, February 8, 2018, https://www.nytimes.com/2018/02/08/world/europe/louvre-nazi-looted-art.html.

65 "Antwerp Master, circa 1515–1520 and Joachim Patinirdinant (?) or Bouvignes circa 1480—before 5 October 1524 Antwerp | A triptych: The Crucifixion (central panel); Saint Leonard (left wing); Augustus and the Tiburtine Sibyl (right wing)," Old Masters Evening Sale /Lot 9, Sotheby's, https://www.sothebys.com/en/auctions/ecatalogue/2018/old-masters-evening-l18033/lot.9.html.

66 Aurelien Breeden, "France Returns 16th-Century Portrait to Descendants of Jewish Couple," *New York Times*, November 28, 2016, https://www.nytimes.com/2016/11/28/arts/design/france-returns-16th-century-portrait-to-descendants-of-jewish-couple.html.

67 "Three Restituted Masterpieces Offered at Auction in London," Sotheby's, July 17, 2018.

68 "Artworks Restituted to the Heirs of Gaston Lévy, Three Exceptional Paintings Led by Camille Pissarro's Prime Pointillist Masterpiece to Make Auction Debut," Sotheby's Press Release, January 14, 2020, https://www.sothebys.com/en/press/three-works-restituted-to-the-heirs-of-art-collector-gaston-levy-to-make-their-auction-debuts.

69 Fang Block, "Sotheby's to Auction Three Works Restituted to Gaston Lévy's Heirs," *Penta*, January 14, 2020.

70 Kim Willsher, "French Masterpieces Looted by Nazis Set to Fetch £20m at Auction," *The Guardian*, January 11, 2020.

71 Feliciano, *The Lost Museum*, 155–62, 196–211.

72 Catherine Hickley, "A Nazi Legacy Haunts a Museum's New Galleries," *The New York Times*, October 11, 2021.

73 "Pablo Picasso, Three Musicians," MoMA, https://www.moma.org/collection/works/78630.

74 "Paul Rosenberg and Company: From France to America," MoMA, https://www.moma.org/interactives/exhibitions/2010/paulrosenberg/#:~:text=In%202007%20The%20Museum%20of,at%20the%20Museum%20in%201957.

75 Patricia Cohen and Tom Mashberg, "Family, 'Not Willing to Forget,' Pursues Art It Lost to Nazis," *The New York Times*, April 26, 2013, https://www.nytimes.com/2013/04/27/arts/design/rosenberg-familys-quest-to-regain-art-stolen-by-nazis.html.

76 Mark D. Fefer, "Au revoir, Odalisque," *The Seattle Weekly*, October 9, 2006.

77 Alan Riding, "France Restores a Looted Monet to Owners Heirs," *New York Times*, April 30, 1999, https://www.nytimes.com/1999/04/30/arts/france-restores-a-looted-monet-to-owner-s-heirs.html#:~:text=French%20Government%20returns%20Monet%20painting%20of%20Waterlilies,but%20was%20identified%20as%20from%20Rosenberg%20collection.

78 Steven Wilson, *Ideology and Experience: Antisemitism in France at the Time of the Dreyfus Affair* (Cambridge, MA: The Littman Library of Jewish Civilization, 2007), 370.

79 Sinclair, *My Grandfather's Gallery*, 35–41, illustration #23.

80 Catherine Bennett, "Art Meets History in Homage to Legendary French Jewish Dealer," *The Times of Israel*, September 24, 2014.

81. "Marie Laurencin, La Répétition, 1936," Centre Pompidou, https://www.centrepompidou.fr/en/ressources/oeuvre/cKaj6jA.

82. Doreen Carvajal, "Paintings That Bear the Scars of War," *The New York Times*, October 5, 2016.

83. Benjamin Sutton, "The Famous Jewish Art Dealer Who Fought to Retrieve 400 Stolen Works from the Nazis," *Artsy*, January 14, 2019.

84. Naomi Rea, "Expert Found 10 Ill-Gotten Works Hiding in Plain Sight," Artnet, January 22, 2020, https://news.artnet.com/art-world/restitution-nazi-loot-louvre-france-1758900.

85. Elaine Sciolino, "The Louvre's Art Sleuth Is on the Hunt for Looted Paintings," *The New York Times*, July 16, 2021, https://www.nytimes.com/2021/07/16/arts/design/louvre-art-sleuth-emmanuelle-polack.html.

86. "Dorville, Armand (Nachlass/estate)," Lost Art Database, German Lost Art Foundation, https://www.lostart.de/en/lost/person/dorville-armand-nachlassestate/614969.

87. Sciolino, "The Louvre's Art Sleuth," *The New York Times*, 2021.

88. Lauter, "France's New Restitution Law for Nazi-Looted Art," *ArtNEWS*, 2023.

89. Vincent Noce, "Dorville Sale: French Government Rejects Restitution." *La Gazette Drouot*, June 14, 2021.

90. Sciolino, "The Louvre's Art Sleuth," *The New York Times*, 2021.

91. Corinne Hershkovitch, "Restitution of Nazi-Looted Art: The French Law of 2022," *Art Antiquity and Law* 27, no. 1 (2022).

92. Aurelien Breeden, "'We Are Amplifying the Work': France Starts Task Force on Art Looted Under Nazis," *The New York Times*, April 15, 2019.

93. Tessa Solomon, "France Passes New Law Allowing Museums to Restitute Nazi-Looted Artworks," ARTnews, July 3, 2023, https://www.artnews.com/art-news/news/france-passes-law-museums-restitute-nazi-looted-artworks-1234673197/.

94. Lauter, "France's New Restitution Law for Nazi-Looted Art," *ArtNEWS*, 2023.

Chapter 10

1. William Shirer, *The Rise and Fall of the Third Reich* (New York: Simon & Schuster, 2011), 720–59.

2. "What You Need to Know About the Dunkirk Evacuations," IWM (Imperial War Museums), https://www.iwm.org.uk/history/what-you-need-to-know-about-the-dunkirk-evacuations.

3. "The Netherlands: The Highest Number of Jewish Victims in Western Europe," Anne Frank House, https://www.annefrank.org/en/anne-frank/go-in-depth/netherlands-greatest-number-jewish-victims-western-europe/ (April 19, 2024).

4. "Seyss-Inquart Warns the Dutch Jews," Anne Frank House, https://www.annefrank.org/en/timeline/69/seyss-inquart-warns-the-dutch-jews/ (April 19, 2024).

5. "Who Was Anne Frank?" Anne Frank House, https://www.annefrank.org/en/anne-frank/who-was-anne-frank/ (September 19, 2024).

6. John Michael Montias, "Art Dealers in the Seventeenth-Century Netherlands," *Simiolus: Netherlands Quarterly for the History of Art* 18, no. 4 (1988): 244–45.

7 Jonathan Petropoulos, *The Faustian Bargain: The Art World in Nazi Germany* (Oxford: Oxford University Press, 2000), 170.

8 Michael Gross, *Rogues' Gallery: The Secret Story of the Lust, Lies, Greed, and Betrayals That Made the Metropolitan Museum of Art* (New York: Penguin Random House, 2000), 380–92.

9 Kees Kaldenbach, "Mannheimer: An Important Art Collector Reappraised," LootedArt.com, November 12, 2014, https://www.lootedart.com/U7G5FX294681.

10 Gross, *Rogues' Gallery*, 375–86.

11 Hans Memling, *Madonna and Child with Angels*, National Gallery of Art, Provenance, https://www.nga.gov/collection/art-object-page.48.html#provenance.

12 Melissa Müller and Monika Tatzkoff, *Lost Lives, Lost Art: Jewish Collectors, Nazi Art Theft, and the Quest for Justice* (New York: The Vendome Press, 2010), 220–21.

13 Peter C. Sutton, "Jacques Goudstikker (1897–1940): Art Dealer, Impresario and Tastemaker," *Reclaimed: Paintings from the Collection of Jacques Goudstikker* (Greenwich, CT: Bruce Museum, 2008), 14–34.

14 Lawrence M. Kaye, "The Restitution of the Goudstikker Collection," *Reclaimed: Paintings from the Collection of Jacques Goudstikker* (Greenwich, CT: Bruce Museum, 2008), 57.

15 Sutton, "Jacques Goudstikker (1897–1940): Art Dealer, Impresario and Tastemaker," 40.

16 Lynn H. Nicholas, *The Rape of Europa* (New York: Random House, 1995), 85.

17 Sutton, "Jacques Goudstikker (1897–1940): Art Dealer, Impresario and Tastemaker," 32.

18 Nicholas, *The Rape of Europa*, 85.

19 Jonathan Petropoulos, *Göring's Man in Paris: The Story of a Nazi Art Plunderer and His World* (New Haven: Yale University Press, 2021), 195–200.

20 Nicholas, *The Rape of Europa*, 101.

21 Nicholas, *The Rape of Europa*, 99.

22 Petropoulos, *The Faustian Bargain*, 170.

23 James S. Plaut, "Hitler's Capital," *The Atlantic*, October 1946.

24 James S. Plaut, "Loot for the Master Race," *The Atlantic*, September 1946.

25 Plaut, "Loot for the Master Race," 1946.

26 Sarah Wildman, "The Revelations of a Nazi Art Catalogue," *The New Yorker*, February 12, 2016.

27 Deborah K. Dietsch, "Goering's Top Ten Pictures," *The Washington Times,* August 30, 2009, https://www.washingtontimes.com/news/2009/aug/30/goerings-top-10-pictures/.

28 Jonathan Lopez, *The Man Who Made Vermeers* (Boston: Houghton Mifflin, 2008).

29 "Edda Goering Loses Round," *The New York Times*, April 22, 1964, https://www.nytimes.com/1964/04/22/archives/edda-goering-loses-round.html.

30 "Eve," Norton Simon Museum, https://www.nortonsimon.org/art/detail/M.1991.1.P (May 17, 2024).

31 "Adam," Norton Simon Museum, https://www.nortonsimon.org/art/detail/M.1971.1.P (May 17, 2024).

32 Kate Brown, "Following an 11-Year Legal Battle, Cranach's Nazi-Looted Adam and Eve Paintings Will Remain at a California Museum," ArtNet, July 31, 2018, https://news.artnet.com/art-world/lucas-cranach-ruling-1326245.

33 Nicholas, *The Rape of Europa*, 101.

34 Petropoulos, *Göring's Man in Paris*, 195–200.

35 Nicholas, *The Rape of Europa*, 320.

36 Simon Goodman, *The Orpheus Clock* (New York: Scribner, 2015), 66–67.

37 Press release, "The Metropolitan Museum of Art and New York State Department of Financial Services Announce the Return of a 16th-Century Silver Stem Cup to the Heirs of the Eugen Gutmann Estate," Metropolitan Museum of Art, February 19, 2020, https://www.metmuseum.org/press/news/2020/the-met-and-nysdfs-announce-return-of-16th-century-silver-stem-cup-to-heirs-of-eugen-gutmann-estate.

38 Goodman, *The Orpheus Clock*, 129–36, 153, 156.

39 "NK Collection and Restitution," Mauritshuis, https://www.mauritshuis.nl/en/our-collection/restoration-and-research/provenance-research/nk-collection-and-restitution/.

40 Lawrence M. Kaye, "The Restitution of the Goudstikker Collection," *Reclaimed: Paintings from the Collection of Jacques Goudstikker* (Greenwich, CT: Bruce Museum, 2008), 58.

41 Nina Siegel, "Are the Dutch Lagging in Efforts to Return Art Looted by the Nazis?" *The New York Times*, May 12, 2017.

42 Anne Laure Bandle, Alessandro Chechi, and Marc-André Renold, "Case 200 Paintings—Goudstikker Heirs and the Netherlands," Platform ArThemis, Centre of Art-Law, University of Geneva, https://plone.unige.ch/art-adr/cases-affaires/200-paintings-2013-goudstikker-heirs-and-the-netherlands.

43 Alan Riding, "Heirs Claim Art Lost to Nazis in Amsterdam; Another Collection Joins the Disputes Over Who Owns War's Cultural Booty," *The New York Times*, January 12, 1998.

44 Karen Rosenberg, "Tale of Return, Vividly Illustrated," *The New York Times*, March 19, 2009, https://www.nytimes.com/2009/03/20/arts/design/20goud.html.

45 Charlene von Saher, "Opening Talk | Reclaimed—Paintings from the Collection of Jacques Goudstikker," October 28, 2010, https://vimeo.com/188553061.

46 Carol Vogel, "Recovered Artworks Heading to Auction," *The New York Times*, February 22, 2007, https://www.nytimes.com/2007/02/22/arts/design/22heir.html.

47 "Heir to Nazi-Looted Art Donates Painting to the Netherlands," *CBC Arts*, March 6, 2007, https://www.cbc.ca/news/entertainment/heir-to-nazi-looted-art-donates-painting-to-the-netherlands-1.686943.

48 Wouter Kloek, "Sacrifice of Iphigenia," The Leiden Collection Catalogue, ed. Arthur K. Wheelock Jr., New York, 2017, https://www.theleidencollection.com/archive/.

49 Benjamin Genocchio, "Seized, Reclaimed and Now on View," *The New York Times*, April 27, 2008.

50 Peter C. Sutton, *Reclaimed: Paintings from the Collection of Jacques Goudstikker* (Greenwich, CT: Bruce Museum, 2008).

51 Margie Shafer, "San Francisco Exhibit Reminds Visitors About the Horrors of the Holocaust," *KCBS*, October 29, 2010, https://www.cbsnews.com/sanfrancisco/news/san-francisco-exhibit-reminds-visitors-about-the-horrors-of-the-holocaust/.

52 Goodman, *The Orpheus Clock*, 6–13.

53 Goodman, *The Orpheus Clock*, 180.

54 Goodman, *The Orpheus Clock*, 192.

55. Goodman, *The Orpheus Clock*, 197–98.

56. Goodman, *The Orpheus Clock,* 202–217.

57. Judith H. Dobrzynski, "Settlement in Dispute over a Painting Looted by Nazis," *New York Times*, August 4, 1998, https://www.nytimes.com/1998/08/14/us/settlement-in-dispute-over-a-painting-looted-by-nazis.html.

58. Goodman *The Orpheus Clock,* 285–86.

59. Goodman. *The Orpheus Clock*, 11, 85.

60. The San Diego Museum of Art, *The Portrait of Isaac Abrahamsz, Massa*—Frans Hals. https://collection.sdmart.org/objects-1/info?query=sort_artist%20has%20words%20%22Frans%20Hals%22%20or%20Disp_Title%20has%20words%20%22Isaac%20Abrahamsz.%20Massa%22&sort=9&page=30&objectName=Portrait%20of%20Isaac%20Abrahamsz.%20Massa.

61. Goodman, *The Orpheus Clock*, 232–33.

62. Jan van Goyen, *Landscape with Two Horse Carts*, Worcester Art Museum, https://worcester.emuseum.com/objects/14039/landscape-with-two-horsecarts.

63. Goodman, *The Orpheus Clock*, 212.

64. *Still Life: Tea Set*, Jean-Étienne Liotard, Getty, https://www.getty.edu/art/collection/object/103RG0?altImage=4bab9e19-d286-44a2-9ccb-6099af1d967b#full-artwork-details.

65. Christies, Live Auction 15654, Old Masters Part I, April 19, 2018, https://www.christies.com/en/lot/lot-6136743.

66. Catherine Hickley, "Cranach Portrait Stolen Almost 80 Years Ago Returns to Heirs of Jewish Banker," *The Art Newspaper*, March 21, 2018, https://www.theartnewspaper.com/2018/03/21/cranach-portrait-stolen-almost-80-years-ago-returns-to-heirs-of-jewish-banker.

67. Christie's, "Returned to Its Rightful Owners After Nearly 80 Years," December 11, 2018, https://www.christies.com/en/stories/returned-to-its-rightful-owners-after-nearly-80-years-af98c0caea94402c9d2bf89b68550fb5.

68. Holocaust Memorial of Names, "Presentation of New Design for Dutch Holocaust Names Memorial," https://www.holocaustnamenmonument.nl/en/holocaust-memorial-of-names/concept/.

69. Sarah Kuta, "With New Holocaust Museum, the Netherlands Reckons with Its Past," *Smithsonian*, March 11, 2024, https://www.smithsonianmag.com/smart-news/with-new-holocaust-museum-the-netherlands-reckons-with-its-past-180983924/.

About the Authors

Suzanne Loebl is the author of fourteen books, most recently *America's Medicis: The Rockefellers and Their Astonishing Cultural Legacy*. She was born into an art-collecting family in Germany and escaped the Nazis as a teenager by hiding in Belgium. Her other books include *America's Art Museums: A Traveler's Guide to Great Collections Large and Small* and a memoir on her experience during World War II, *At the Mercy of Strangers: Growing Up on the Edge of the Holocaust*. In 2012, Loebl received the Lifetime Achievement Award from the American Society of Journalists and Authors. She splits her time between New York and Maine.

Abigail Wilentz has developed books on art, design, photography, fashion, lifestyle, and other topics as an editor at Universe Publishing, a division of Rizzoli International Publications, at Watson-Guptill Publications, and independently with agents and authors. She has written books commissioned by publishers and directed a custom publishing line for the luxury fashion brand Brioni. She lives in Manhattan with her husband.

Index

Abbasi, Riza 10
Abbo, Jussuf *8, 8–9*, 10, 25
Abetz, Otto 136
Academy of Fine Arts 41
acquisition prices 50
Adoration of the Magi (di Paolo) *101*
Adoration of the Magi (Giaquinto) 145
African tribal art 20
air raids, Allied 62
Albright, Madeleine 177
Alexander the Great and Campaspe in the Studio of Apelles (Tiepolo) 143, 145
Allen Memorial Museum 27
Allied air raids 62
Allied forces 39, 93
 in Normandy 152–53, 169
Altmann, Fritz 91–92
Altmann, Maria 91–92
American aid 43
Americans: German Expressionists and 25
 interrogation of Gurlitt 66
antisemitic laws 40–41
antisemitism 3, 86, 158, 161
anti-Vietnam War protests 44
Apelles 145
Argentina, Nazis sheltering in 120
Around the Fish (Klee) 105
Art in Our Time exhibition 105
Artists in Exile exhibition 126–27, 128, 132
Artists in Nazi Occupied France (Lange) 150–51
Art of Our Time exhibition (MoMA) 34
Art of the Middle Ages exhibit 54
Art of This Century gallery 126
Association for the Assertion of German Culture (*Kampfbund für deutsche Kultur*) 46
auctions: Dorville 160
 Galerie Fischer 75–80
 Gentili 144–45
 of Klimt works 92
Auschwitz 124

Austria: Nazis annexing 83, 85–87
 relinquishing of plundered arta 92
Austrian Expressionist art 113
Austrian Jews 86, 102
Austrian Monuments Protection Agency 100
Austrian porcelain 91
Austrian refugees, support for 114
Austro-Hungarian Empire 85
avant-garde art collection 11–12

Bajou, Thierry 154
Bamberger, David 3
Bamberger, Else (author's aunt) 15
Bamberger, Gerald P. 16
Bamberger, Hugo (author's father) 5, 14
Bamberger, Jetta (author's aunt) 12
Bamberger, Otto (author's uncle) 7, 11–12
 art collection of 16
Banquet for Hindenburg in the Town Hall 6
Bar, Brown (Beckmann) 66
Barlach, Ernst 59
Barnes, Alfred 133
Barr, Alfred 29, 189
 Beckmann and 106
 Valentin and 105–6
 visiting Germany 45–49
Barron, Stephanie 49
bartering art 62
Bartholomew (saint) 145–47, *146*
Basel, Kunstmuseum 73–75
Bathers with a Turtle (Matisse. H.) 77–78
Baudissin, Klaus Graf von 62
Bauhaus design school 7
Bauhaus furniture 11–12, 16
Bauhaus Stairway (Schlemmer) 46, *47*
Bauhaus-style 45
Beckmann, Max 28, 49, 54, 63, 106–9, 183
 Christ and the Woman Taken in Adultery 78, 109
 Departure 106, *107*

Descent from the Cross 73, 109
fleeing Nazis 106
Beindorff, Fritz 10
Belgium 117–18
 purchases at auction 80–81
Belling, Rudolf 28–29
 Head in Brass 60
Belvedere Museum 85, 92, 115
Berlin Museum of Modern Art 62
Berlin Nationalgalerie 42
Berlin Street Scene (Kirchner) 31, 32, *33*, 34
Bern Art Museum 31
van Beuningen, Daniel G. 73
Bier, Justus 10–11, 189
Bingham, Hiram (Harry) IV 120–21
The Birth (Gauguin) 77
Birthday and I (Chagall) 129
Bloch, Ferdinand 88–89, 91–92
Bloch-Bauer, Adele 85, *86*, 88–89, 90–91
The Blue Window (Matisse, H.) 105
Bode, Wilhelm von 11
Böhmer, Bernard Alois 58, 189
 in Hitler sales force 59–60
Böhmer, Marga 59
Böhmer (Ottes), Hella 59–60
Boijmans Museum 72
Bondi, Lea 112, 115–16
Bondy, Elisabeth 102
Bondy, Oscar 102
Bondy collection 102
Bosbeek 172
Boucher, François 184
Boudin, Eugène 184
Der Boxer (Belling) 28
Bride of the Wind (Kokoschka) 50, 73–74
Brougier, Gabriele 80
The Brunswick Monogrammist 184
Brussels, Belgium 13, 152
Buchenwald concentration camp 45
Buchholz, Karl 34, 189
 Beckmann and 108
 in Hitler sales force 63
 Valentin and 104
Buchholz Gallery 63, 104, 105
Bührle, E. G. 156–57
Burr, Bettina 99
Bust of a Youth (Mochi) 145
Bust of Dr. Hugo Bamberger 8

CAM. *See* Cincinnati Art Museum
de Camondo, Béatrice 142–43
de Camondo, Moïse 142
de Camondo, Nissim 142
Camondo family 140–43
Capricorn (Ernst) 127
Carus, Carl Gustav 59
carvings, wood 22
Castaway Modernism exhibition 74
Castiglione, Giovanni Benedetto 184
Chagall, Marc 26, 49, 62, 119, 184
 Birthday and I 129
 I and the Village 129
 as refugee 128–30
 White Crucifixion 129–30, *131*
 works shipped to US 121
Chamber of Horrors 45
Christ and the Woman Taken in Adultery (Beckmann) 78, 109
Christie's auction house 98, 140, 179
Cincinnati Art Museum (CAM) 78
Circus Rider (Kirchner) 78
Civil Defence Service 37
concentration camps. *See specific camps*
confiscation, of art 57–58
Congregation Habonim 37
The Conquerors (Malraux) 117
Constable, John 140
Constantine, Thomas 43
Corinth, Lovis 4, 184
Corot, Jean-Baptiste-Camille 184
Cotán, Juan Sánchez 184
Courbet, Gustave 184
Cranach, Lucas 168–69
 Portrait of a Woman *171*
 Portrait of John Frederick I, Elector of Saxony 180
Cranach the Elder, Lucas 184
Crivelli, Carlo 164
Croze, Amédée 160
Crucified Christ (Gies) 51
crucifixion paintings 73
Cubism 132
"cultural disintegration" 49
Cuyp, Aelbert 184
cyanide poisoning 59–60

Dachau concentration camp 32
 Altmann, F. at 91
 Grünbaum at 114

Dalí, Salvador 184
Daman, Ruth 6
The Dancer (Klimt) 95
Dannemann, Karl 6–7
Daubigny's Garden (van Gogh) 72
Death and the Masks (Ensor) 82
Dedham from Langham (Constable) 140
Degas, Edgar 176–77, 178
"degenerate" art 41–42
 as inspiration 65
 returning of 67–69
 sales of 57–58, 65
 sold in United States 63
Degenerate Art According to Hitler exhibition 81
Degenerate Art exhibition 11, 26, 49–52, 60
"degenerate" artists 45
Degenerate Art Research Center 59, 62
de László, Philip 99
Denmark 10
Departure (Beckmann) 106, *107*
Derain, André 105
Descent from the Cross (Beckmann) 73, 109
Detroit Institute of the Arts (DIA) 61, 196n7
Dieckmann, Erich 7
displaying art 11
Dix, Otto 29, 61
Dollfuss, Engelbert 85
A Dordrecht Nobleman on Horse with Retainers and Groom (Maes) 99
Dorner, Alexander 11
Dorville, Armand Isaac 159–60
Dorville auction 159–60
Dossi, Battista 184
drawing collection, Koenigs 72–73
Dresden Gemäldegalerie 42
Dreyfus, Alfred 135
Dreyfus Affair 158
Drouais, François Hubert 184
The Duchess (Kokoschka) 78, *79*
Dunes at Fehmarn (Kirchner) 26, 27
Durand-Ruel, Paul 104
Düsseldorf Museum 61
Dutch Golden Age 181
Dutch Jews 180–81
Dutch Republic 19

Eclipse of the Sun (exhibition) 44
Eclipse of the Sun (Grosz) 43–44, *44*
EER. *See* Einsatzstab Reichsleiter Rosenberg
Ehrlich, Franz 45

Einsatzstab Reichsleiter Rosenberg (EER) 87
Einstein, Albert 39
Emergency Rescue Committee (ERC) 118–19
emigration 13–17
Enabling Act 40
Ensor, James 80
ERC. *See* Emergency Rescue Committee
Erfurt, Germany 31
Erfurt Museum 30
Ernst, Max 121–22, 184
 Capricorn 127–28
 Europe After the Rain II 127
Europe After the Rain II (Ernst) 127
"the Exodus of 1940" 117–18
Expressionist art 20–21
 audience reaction to 50
 Austrian 113
 German 30–31
 Möller and 60–61
 Schames, L., and 36
 United States and 61
van Eyck, Jan 187

La Famille Soler (Picasso) 81
Fantin-Latour, Henri 184
Fascism 86, 118, 133
"Faustian Bargain" 58
Fauvist art 19
Fauvist painters 19
Feigl Gallery 26
Feininger, Lyonel 35, 49
 Green Bridge 61
 Zirchow VI 82
Feldhäusser, Kurt 23, 26, 27, 189
Felix Nussbaum Haus 124
Female Saint (Riemenschneider) 11
Female Torso (Lehmbruck) 12
"Final Solution," from Nazis 152
Fischer, Anne 25
Fischer, Ernst 24–25
Fischer, Ludwig 23–28
Fischer, Max 23, 26
Fischer, Rosy 23–28
Fischer, Theodor 75, 156, 189
Flechtheim, Alfred 28, 50, 63, 189
 art collection 29–30
 art returned to 67
flight tax, Nazi 31
Foch, Marshal Ferdinand 39
Folkwang Museum 52, 61–62

Four Elements (Ziegler) 49
France 118
 boycotting auction 81
 returning looted art to 154–55
 two-face 135–36
French Impressionist art 19
French Paintings from David to Toulouse-Lautrec
 exhibition 72
French Resistance 138
Freudenthal, Ruth Iris 12
Freundlich, Otto 50
Friedländer, Max 166
Fry, Varian 118–19, 120, 189
Führer Museum 64, 87–88, 99
furniture, Bauhaus 11–12, 16

Galerie Fischer auction 75–80
Galerie Schames 24, 36
Galerie St. Etienne 113
Garth, Otto 45
Garvens-Garvensburg, Freiherr Herbert von 9–10
Gauguin, Paul 76–77, 184
 The Sorcerer of Hiva Oa 82
Gehrer, Elisabeth 98
Geier, Paul E. 80
Gemäldegalerie 73
gems, selling of 66
genocide, Nazi 114
Gentili auction 143–45
German ancestry, acceptance of 17
German Art Show 51
German Expressionist art 30–31
German Expressionists 20–21, 25
German hyperinflation (1920s) 10
German Impressionism 60
German-Jewish history 3–9
German Military Reserve 22
German Refugee Scholars Program 10
Gestapo 13
 arresting Swarzenski 54
Giaquinto, Corrado 184
 Adoration of the Magi 145
Gies, Louis 51
Girard, Julian 144
di Giuseppe, Federico Gentili 143
Glaucus and Scylla (Turner) 139–40, *141*
Göbbels, Joseph 48, 57, 189
 manifesto by 41–43
 Reich Chamber of Culture and 44
gold, looted by Nazis 93–94

Goldschmidt, Bertha (Betty) 28
Goodman, Bernard 177–78
Goodman, Simon 172
Göring, Hermann 57, 73, 151, 190
 art catalog of 153
 art collection of 167–69
Goudstikker, Dési 165–66, 173–75
Goudstikker, Jacob 164–65
Goudstikker Gallery 166
le goût juif (Jewish taste) 88
Goya, Francisco 139
 Portrait of Don Mañuel Garcia de la Prada 140
van Goyen, Jan 179
Grabfelder, Adelheit 3
The Grand Canal in Venice with Palazzo Bembo
 (Guardi) 140
Green Bridge (Feininger) 61
Grien, Hans Baldung 178–79
Gropius, Walter 7
Grosz, Georg 10, 185
 Eclipse of the Sun 43–45, *44*
Grünbaum, Fritz 114
Grünewald, Matthias 185
 The Small Crucifixion 73, *74*
Guardi, Francesco 185
 The Grand Canal in Venice with Palazzo Bembo 140
Guenther, Peter 50–51
Guggenheim, Peggy 121–22, 126, 131
Guggenheim, Solomon 62
Guillaumin, Armand 185
Gurlitt (catalog) 65
Gurlitt, Cornelius 31, 67–69
Gurlitt, Hildebrand 58, 190
 in Hitler sales force 64–67
Gurs concentration camp 16
Gutmann, Frederick (Fritz) 171–72, 177–80
Gutmann, Lili 177–78
Gutmann, Louise 171–72

Hagemann, Carl 32
Halpin, Anita 32–33
Hals, Frans *97*, 97–98, 185
 Portrait of a Man 100
Hanover, Germany 6
Hart, Emma 99
Harvard Art Museums 26
Haus der Deutschen Kunst (House of German Art) 51
Head in Brass (Belling) 60

Heckel, Erich 109
Heckscher Museum 43
Heine, Theodor *21*
Hershkovitch, Corinne 160
Hess, Alfred 30–35
Hess, Hans 31
Hess, Thekla 30–35
hiding, family in 14
Himmler, Heinrich 190
Himmler's Secret Service (SS) 10
Hindenburg, Paul von 6, 40, 43
Hitler, Adolf 11, 39–40, 43, 190
 art school rejection 41
 in Austria 87
 Mein Kampf 87
 sales force for 57–58, 60–61, 69
 Ziegler and 48–49
Hitler and the Power of Aesthetics (Spotts) 41
Hitler Jugend (Nazi youth movement) 48
Hoffmann, Meike 59
Holland 161–62
 Jews arriving in 180
 Nazis invading 73, 164
Holocaust Art Restitution Project 65
Holocaust Memorial Museum, US 94, 103
Holzinger, Ernst 32
Homecoming of the Monks to the Monastery (Carus) 59
homosexuality 10
Horb shul 3, 17
Horb synagogue *2*, 2–3
Horses in a Meadow (Marc) 82
Hôtel Drouôt auction house 150
Hotel Savoy collection 138–39, 159–60
The House of Fragile Things (McAuley) 140
House of German Art (*Haus der Deutschen Kunst*) 51
hyperinflation, German 10

I and the Village (Chagall) 129
Immendorf Castle 94
impounding, of art 52
Impressionism, German 60
Impressionist painters 20
Impressionists 104
Improvisation 28 (Kandinsky) 62
Industrial Revolution 20
influenza pandemic of 1918, 111
insomnia 22, 45
Institute of Archaeology in Munich 49

internment camp, French 117
Isenbrandt, Adriaen 185
Israel 2–3
Israel Museum 2, 3, 177
Italian Renaissance 19

Jaffé, Anna Gluge 138–39
Jaffé, John 138
Japanese woodcuts 20
Jaujard, Jacques 135–36, 190
Jawlensky, Alexei von 187
Jeu de Paume 137, 151–52, *153*
Jewish, German- history 3–9
Jewish Museum Frankfurt 25
Jewish refugees 103, 118, 121
 into US 120
Jewish taste (*le goût juif*) 88
Jews 19–20
 Austrian 86, 102
 Dutch 180–81
 emigration of 13
 Spanish 140–41
The Judgment of Paris (Ziegler) 49
Judith I (Klimt) 89
Judith II (Klimt) 89
Jung, Carl 130
Justi, Ludwig 42, 190

Kaesbach, Walter 30
Kallir, Jane 116
Kallir, Otto 112–15
Kampfbund für deutsche Kultur (Association for the Assertion of German Culture) 46
Kandinsky, Vasily 10, 21, 185
 Improvisation 28 62
 Picture with White Form 1 61
Kaulbach, Wilhelm von 6
Kestner Society 9–11
Kiesler, Frederick 126
The King Plays with the Queen (Ernst) 127–28
Kirchner, Ernst Ludwig 21, 50, 185
 Berlin Street Scene 31, 32, *33*, 34
 Circus Rider 78
 Dunes at Fehmarn 26, 27
 Portrait of Alfred Döblin 26
 Self-Portrait as a Soldier 22, *23*, 26
 Six Dancers 25
 Street Scene (Berlin) 104
 Street Scene in Front of a Hair Salon 42
 Street Scenes 104–5

Taunus Road 28
Two Streetwalkers 25
Valentin and 104
View from the Window 78
Klee, Paul 50, 185
 Around the Fish 105
 Parade on Wheels 72
 Twittering Machine 104
Klimt, Gustav 185
 auction of works 92
 The Dancer (Klimt) 95
 Judith I 89
 Judith II 89
 Lederer family portraits 94–95
 Mäda Primavesi 90, *90*
 Portrait of a Lady 85, *86*, 88–89
 Schiele and 110
Kneeling Woman (Lehmbruck) 12, 50, 105
knickknacks, Rothschild family 98
Koenigs, Franz 71–73
Kokoschka, Oscar 42, 88, 185
 Bride of the Wind 50, 74
 The Duchess 78, *79*
 Tower Bridge London 82
König-Albert Museum 64
Kramarsky, Siegfried 71–72
Krebs, Friedrich 53
Kristallnacht pogrom 32
Kubin, Alfred 10
Kunsthalle Hamburg 52
Kunsthalle Mannheim 45, 109
Kunsthistorisches Museum 115
Kunstkabinett Dr. H. Gurlitt gallery 64
Kunstmuseum 69
Kunstverein 64

Landscape with Two Horse Carts (Goyen) 179
Lange, Werner 150–51
Largillierre, Nicholas de 185
The Last Cartload (Schmidt-Rotluff) 61
Lauder, Ronald 34, 92
Lederer, August 94–95
Lederer, Serena 94–95
Lederer family portraits 94–95
Léger, Fernand 132, 185
Lehmbruck, Wilhelm 185–86
 Female Torso 12
 Kneeling Woman 50, 105
 Standing Youth 29
Leicester Museum and Art Gallery 35

Lenbach, Franz Seraph von 187
Leo Baeck Institute 37
Leopold, Rudolf 115–16
Leopold Museum Private Foundation 116
Lévy, Gaston Prosper 155–56
Lichtenfels, Germany 3
Liebermann, Max 67, *68*
Liège delegation (Belgium) 80–81
Liège exhibition 81–82
Lilienfeld, Antonie 100
Lilienfeld, Leon 100
Linz Museum 66
The Lion Tamer (Beckmann) 67
Liotard, Jean-Étienne 179
Lipchitz, Jacques 132–33
liquidation policies 57
Lismann, Hermann 15–16
Loebl, Ernest 87
Looram, Bettina (neé von Rothschild) 98, 99
Lorrain, Claude 186
Los Angeles, Jewish immigrants in 103
Lost Lives, Lost Art (Müller) 96
Louvre Museum 135–36, 145, 154
 Dorville collection and 160
Lupton, Sue 35

Mäda Primavesi (Klimt) 90, *90*
Madonna and Child with Angels (Memling) 164
Maes, Nicholas 99
Majdanek death camp 16
Making van Gogh (exhibit) 72
Malraux, André 117
Manifesto, by Göbbels 41–43
Mannheimer, Anne France 163–64
Mannheimer, Fritz 163–64
Mannheimer, Jane 163–64
Man with a Pipe (Pechstein) 75
Marc, Franz 186
 Horses in a Meadow 82
Marshland with Red Windmill (Schmidt-Rottluff) 65
Martini, Simone 186
Mary Magdalene (Crivelli) 164
masked balls 9
Master of the Harburger Altar 185
Master of the Richardson 186
Matisse, Henri 186
 Bathers with a Turtle 77–78
 The Blue Window 105
 Oriental Woman Seated on Floor 157–58

Matisse, Pierre 126–27
Mayer, Isaac (author's great-grandfather) 4
McAuley, James 140
meat carcass paintings (Soutine) 125
Mein Kampf (Hitler) 87
Memling, Hans 164
Met. *See* Metropolitan Museum of Art
"Metamorphosis" (cartoon) 20, *21*
Metropolitan Museum of Art (Met) 11, 14
Meyer, Mathilde (author's great-grandmother) 4
MFA. *See* Museum of Fine Arts
MIA. *See* Minneapolis Institute of Art
Miedl, Adolf 169–70
Miedl, Alois 166
military-industrial complex 44
Minneapolis Institute of Art (MIA) 82
mixed race (*Mischling*) 64
MMMM. *See* My Much Misunderstood Museum
Mochi, Francesco 186
 Bust of a Youth 145
modern art 62
Moderne Galerie Thannhauser 28
Modern German Paintings and Sculptures exhibition (MoMA) 28–29
modernists, Western 20
Moderson-Becker, Paula 73
Modigliani, Amedeo 124
Möller, Ferdinand 58, 190
 in Hitler sales force 60–62
Mona Lisa 133
Monet, Claude 186
Monteagle, Alain 139–40
Monumental Head (Freundlich) 50
Monuments Men 114, 190
 art returned by 177–78
Morgan, J. Pierpont 11
mosaics 37
Müller, Melissa 96
Munch, Edvard 20
Münter, Gabriele 186
Murillo, Bartolomé Esteban 186
Musée de l'Orangerie 154
Musée National de l'Art Moderne 29
Musées Nationaux Récupération 154
Museum of Fine Arts (MFA) 54, 98–99
Museum of Modern Art (MoMA) 27, 116
 Art of Our Time exhibition 34
 Modern German Paintings and Sculptures exhibition 28–29
 Rosenberg, P., and 157

museums. *See specific museums*
music: advances in 88
 Nazis condemning 62
My Much Misunderstood Museum (MMMM) 121

Napoleonic Code 135
National Gallery of Art (NGA) 157
National Gallery of Art in Washington 73
National Holocaust Museum, Holland 181
National Socialism 13, 82
Nazi genocide 114
Nazi ideology 46
Nazi propaganda 46
Nazis 100, 136
 art confiscations by 17, 54, 57–58
 Austria annexed by 83, 85–87
 beginnings of 39–40
 Expressionist art and 20
 flight tax by 31
 Galerie Fischer auction and 75
 gold looted by 93–94
 Holland invaded by 73, 164
 Kestner Society and 10
 looting French art 137–38
 music condemned by 62
 Nolde as 45
 plundering art 37
 relationship with artists and 150–51
 removing art 17
 selling confiscated art 57–58
 sheltering in Argentina 120
 take over by 39
Nazism, defiance of 64
Nazi sympathizer 11
Nazi youth movement (*Hitler Jugend*) 48
Nederlands Kunstbezit-collectie (NK collection) 173
Netherlands 175
Neue Galerie 34, 95, 112
Neuzil, Valerie (Wally) 110–11
New York, moving to 14
NGA. *See* National Gallery of Art
NK collection. *See* Nederlands Kunstbezit-collectie
Nolde, Emil 48, 50, 186
 as Nazi 45
 South Seas Landscape 27
 Woman of Mixed Race 24, 26, 50
Nordau, Max 41
Normandy, Allied forces in 152–53, 169
North Carolina Art Museum 11

North Carolina Museum of Art 25, 61
nudes 49
Nuremberg race laws 13
Nussbaum, Felix 122–24, 186
 Self-Portrait in the Camp 122–23, *123*
 Self-Portrait with a Jewish-Identity Card 124

offending art 52
Olympic games (1936) 48
Oriental Woman Seated on Floor (Matisse, H.) 157–58
Osthaus, Karl Ernst 62, 190
 Bathers with a Turtle (Matisse, H.) and 77

di Paolo, Giovanni 184
 The Adoration of the Magi 101
Paolo Malatesta and Francesca da Rimini 15, *15*
Parade on Wheels (Klee) 72
Paris 124
 art community in occupied 150–51
Pascin, Jules 29
The Pastry Chef (Soutine) 125
Pauson, Stefan 30
Pechstein, Max 75
Peilike, Marie 5–6
permits, to transport art 112–13
Peterich, Lucas 73
Petropoulos, Jonathan 58
Picasso, Pablo 28, 186
 La Famille Soler 80
 Rosenberg, P., and 148
Picture with White Form 1 (Kandinsky) 61
Pierre and Marie Gaetana Matisse Foundation 133
Pierre Matisse Gallery 126–27
Pinturicchio, Bernardino 186
 Saint Bartholomew (Pinturicchio) 145, *146*
Plaut, James S. 167
plundering art, Nazis 37
Pointillist technique 155
porcelain, Austrian 91
Portrait of a Lady (Klimt) 85, *86*, 88–89
Portrait of Albert Paris von Gütersloh (Schiele) 114
Portrait of Alfred Döblin (Kirchner) 24, 26
Portrait of a Man (Hals) 100
Portrait of an Old Man (Schiele) 112
Portrait of a Woman (Cranach) *171*
Portrait of a Woman (Hals) 98
Portrait of a Young Man with a Green Background (Grien) 178–79
Portrait of Don Mañuel Garcia de la Prada (Goya) 140
Portrait of Dr. Gachet (van Gogh) 52–53, 69
 journey of 71–73
The Portrait of Isaac Abrahamsz (Hals) 179
Portrait of John Frederick I, Elector of Saxony (Cranach) 180
Portrait of Joseph Roulin (van Gogh) 157
Portrait of Oskar Schlemmer (Kirchner) 26
Portrait of Rembrandt's Father (Rembrandt) 138
Portrait of Wally (Schiele) 111, 116
The Portrait of Wally (documentary) 116
Portugal 149, 180
Posse, Hans 42, 43, 73, 190
 art collected by 88
 Führer Museum and 87–88
Pot, Hendrick Gerritsz 100
Primavesi, Mäda 89–90
Prometheus Strangling the Vulture (Lipchitz) 133
propaganda, Nazi 46
Provinzial Museum 11
Pulitzer, Joseph, Jr. 77

Der Querschnitt (magazine) 28

race laws, Nuremberg 13
The Rape of Europa (book) 93
Reclaimed exhibit 175
reclaiming, of artwork 67
recovery, of art collection 32
Redslob, Edwin 30
refugees. *See* Jewish refugees
rehabilitation 17
 of German art world 66
Reich Chamber of Culture 44
Reich Chamber of Music 62
Reich's Chamber of Fine Arts 63
Reich's Chamber of Visual Arts 49
Reichstag building 40
relinquishing, of plundered works 92
Rembrandt 10
Renoir, Pierre Auguste 186
restitution process 93–94
Restoring a Legacy (exhibition) 99
Riemenschneider, Tilman 10
 Female Saint (Riemenschneider) 11
River Landscape with Ferry (van Ruysdael) 175, *176*
Robertson, Anna Mary 114
Rockefeller, Abby 45

Rohlfs, Christian 6
Romney, George 186
room of martyrs (*salon des martyrs*) 151
Roosevelt, Eleanor 119
Rorimer, James 153
Rosenberg, Alexandre 157–58
Rosenberg, Alfred 190
Rosenberg, Anne 24–25
Rosenberg, Paul 147–49, 191
Rosenberg collection, restoring 156–59
Rosenberg Gallery 159
Rostock Cultural History Museum 60
Rothschild, Alphonse von 96
Rothschild, Louis von 96
Rothschild, Meyer Amschel 95
Rothschild, Salomon Mayer 95–96
de Rothschild, Clarice 99
Rothschild family collection 95–99
Rubens, Peter Paul 186
Rudolf Steiner School 12
Ruysch, Rachel 177
van Ruysdael, Salomon *176*, 187

Saenredam, Pieter Jansz 187
Saher, Marei von 174
Saint Bartholomew (Pinturicchio) 145, *146*
Saint-Cyprien camp 117, 122
Saint Louis Art Museum (SLAM) 78
Saito, Ryoei 72
Salem, Lionel 145
Salem, Raphael 144
sales force, for Hitler 57–58, 60–61, 69
salon des martyrs (room of martyrs) 151
salt mines, storing art 96
Saved from Europe exhibition 113
Schames, Ludwig 19, 191
 Expressionist art and 20–21
Schames, Samson 36–37
Schames's gallery 22
Schiele, Egon 110, 187
 Portrait of Albert Paris von Gütersloh 114
 Portrait of an Old Man 112
 Portrait of Wally 111, 116
Schlemmer, Oskar 46, 187
 Bauhaus Stairway 46, *47*
Schmidt, Georg 73
Schmidt-Rotluff, Karl 61
 Marshland with Red Windmill 65
School of Paris 124
Schubring, Paul 9

Schwarzhaupt, Emmanuel (author's great-grandfather) 4
Schwarzhaupt, Gretel (author's mother) 5–7
Schwitters, Kurt 9
sculptures 133
Seewald, Richard 187
Selected Works from the Fischer Auction Now in the US 78
Self-Portrait (Dix) 61
Self-Portrait as a Soldier (Kirchner) 22, *23*, 26
Self-Portrait as Semi-Nude with Amber Necklace (Moderson-Becker) 73
Self-Portrait in the Camp (Nussbaum) 122–23, *123*
Self-Portrait Dedicated to Paul Gauguin (van Gogh) 76, *76*
Self-Portrait with a Jewish-Identity Card (Nussbaum) 124
Seltz, Peter 22
Seurat, Georges 155
Seyss-Inquart, Arthur 161, 191
sheltering art from war 135–36
Signac, Paul 155–56
Simplicissimus (magazine) 20
Simpson, Elizabeth 93
Six Dancers (Kirchner) 25
SLAM. *See* Saint Louis Art Museum
The Small Crucifixion (Grünewald) 73, *74*
Soby, James Thrall 127
Sonnenhaus home 7
The Sorcerer of Hiva Oa (Gauguin) 82
South Seas Landscape (Nolde) 27
Soutine, Chaim 122, 124–25, 187
 meat carcass paintings 125
 The Pastry Chef 125
Spanish Jews 140–41
The Spoils of War symposium 93
Spotts, Frederic 41
Sprengel, Bernard 65
Sprengel Museum 9, 36, 65
spying, on Germans 152
SS. *See* Himmler's Secret Service
Staatliche Galerie Moritzburg 24
Städel Museum 22, 32, 53, 72
Standing Youth (Lehmbruck) 29
St. Bartholomew's Day Massacre (1572) 135
Steen, Jan 187
Still Life of Flowers (Ruysch) 177
Street Scene (Berlin) (Kirchner) 104
Street Scene at Dusk (Feininger) 35
Street Scene in Front of a Hair Salon (Kirchner) 42

Street Scenes (Kirchner) 105
Strozzi, Bernardo 187
Study for Divers (Léger) 132
Stuttgart Art Club 46
suicide, as escape 59–60
survivors, of Holocaust 16
Sussmann, Eliezer 2
Swarzenski, Georg 11, 22, 42, 191
 at MFA 54–55
 Portrait of Dr. Gachet and 52–53
swastika 46, 99
sympathizer, Nazi 11
synagogue, Horb 2, 2–3
syphilis 110

Tanguy, Yves 130, 131–32
Tannahill 196–97n7
Tanning, Dorothea 122
Taunus Road (Kirchner) 28
Tea Set (Liotard) 179
Teniers the Younger, David 187
ter Brugghen, Hendrick 184
Thanks in Color (guest book) 34
Third Reich art dealers 59
"Three Days in Munich, July 1937"
 (Guenther) 50–51
Tieleman Roosterman (Hals) 96, *97*
Tiepolo, Giovanni Battista 143, 145, 187
Tintoretto, Jacopo 187
Toren, David 67–68
To the Convalescent Woman (Heckel) 109
Tower Bridge London (Kokoschka) 82
Trevor, Thomas 34–35
Tschudi, Hugo von 77, 190
Turner, J. M. W. 187
 Glaucus and Scylla 139–40, *141*
Twittering Machine (Klee) 104
Two Riders on the Beach (Liebermann) 67, *68*
Two Streetwalkers (Kirchner) 25

United States (US) 58
 "degenerate" art sold in 63
 Expressionist art and 60–61
 Holocaust Memorial Museum 94, 103
 Jewish refugees and 120
University of Louisville 10
US. *See* United States

Valentin, Curt 42, 63, 104–6, 191
 Beckmann and 108
Valentiner, William 11, 25, 60–61, 191, 196–97n7
Valland, Rose 137–38, 152, 191
Valley of the Lot at Vers (Derain) 105
valuables, as money 72
van Gogh, Vincent 20, 148, 187
 Daubigny's Garden (van Gogh) 72
 Portrait of Dr. Gachet 52–53, 69, 71
 Portrait of Joseph Roulin 157
 Self-Portrait Dedicated to Paul Gauguin 76, *76*
Vanloo, Carle 187
Vermeer, Johannes 168
Vichy France 118, 120, 149
Victors, Jan 187
Vienna, Austria 87
View from the Window (Kirchner) 78
Virginia Museum of Fine Arts (VMFA) 25, 27
visa, American 14
VMFA. *See* Virginia Museum of Fine Arts

Walden, Herwarth 128, 129
Waldmüller, Ferdinand Georg 91
Wanzke, Charlotte 26
Washington Principles on Nazi-Confiscated
 Art 27, 93–94, 139
Weimar Republic 43
Wertheim, Maurice 77
Western modernists 20
White Crucifixion (Chagall) 129–30, *131*
wicker industry 12, 35
Wilhelm, Kaiser II 39
Wolff-Metternich, Franz von 136–37, 191
Woman of Mixed Race (Nolde) 24, 50
Woman Seated at a Table (Pot) 100
wood carvings 22
World War I 5, 22, 39, 135
World War II 19, 136
 escalation of 152–53
Würtemberg Art Club 46

Ziegler, Adolf 49, 191
 art impounded by 52
Zirchow VI (Feininger) 82
Zurich Art Museum 32